Monet

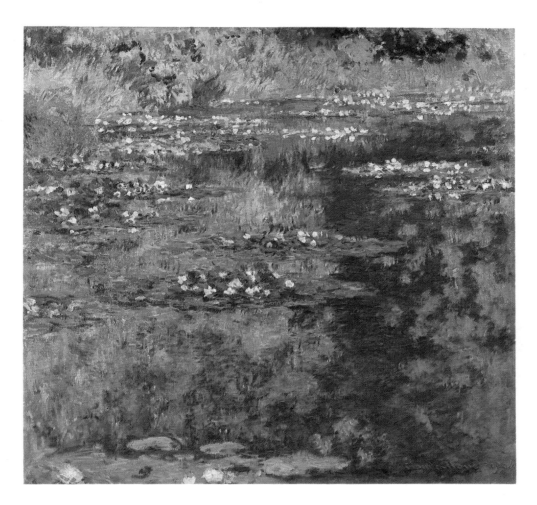

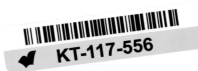

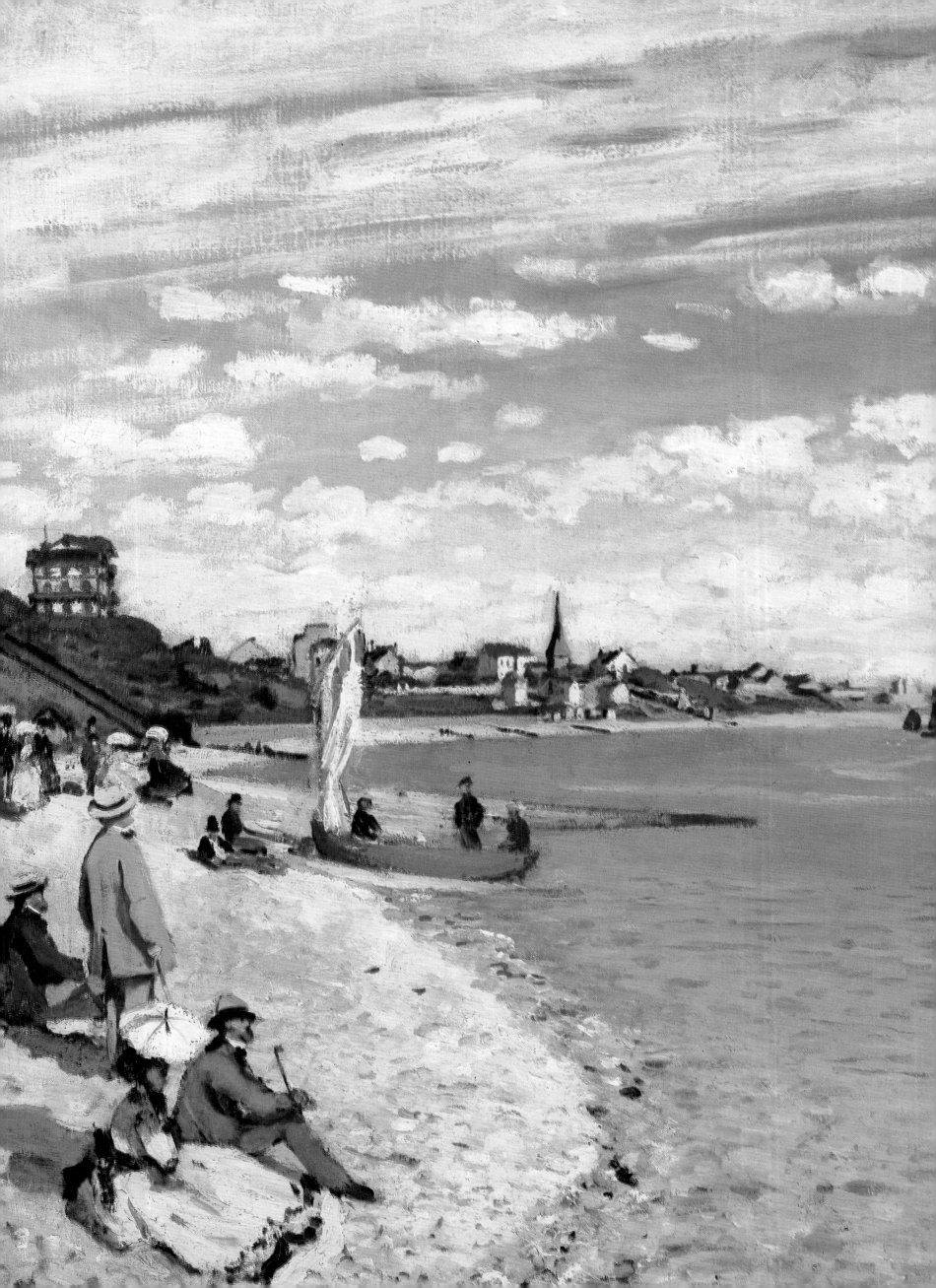

Monet

MICHAEL HOWARD

PARK LANE

Published by Park Lane
An imprint of Books & Toys Ltd
The Grange
Grange Yard
London SE1 3AG

Produced by
Bison Books Ltd
Kimbolton House
117A Fulham Road
London SW3 6RL

ISBN 1-85627-123-4

Reprinted 1992

Printed in Spain

Page 1: *Waterlilies* 1904

Pages 2-3: *The Regatta at Sainte-Adresse* 1867

Right: Claude Monet on his eightieth birthday,
painting the waterlilies in his studio at Giverny.

Contents & List of Plates

Introduction		6
The Early Years, 1840-1870		**32**
Normandy Farmyard		34
Rue de la Bavolle, Honfleur		35
La Pointe de la Hève at Low Tide		36
The Blue Wave		37
The Road from Chailly to Fontainebleau		38
The Road from Chailly to Fontainebleau		39
Le Déjeuner sur l'Herbe (final study)		40
Le Déjeuner sur l'Herbe (fragment)		41
Camille (the Green Dress)		42
Women in the Garden		43
Jeanne-Marguerite Lecadre in the Garden		44
The Garden of the Princess, Louvre		45
The Cradle – Camille and the Artist's Son Jean		46
The Regatta at Sainte-Adresse		47
The Quai du Louvre		48
The Beach at Sainte-Adresse		50
Seascape: Storm		51
On the Seine at Bennecourt		52
The Luncheon		54
Madame Gaudibert		55
Cliff at Etretat		56
Stormy Sea at Etretat		58
The Magpie, Winter		60
Bathers at La Grenouillère		62
La Grenouillère		63
Train in the Country		64
The Red Cape, Madame Monet		65
The Hôtel des Roches Noires at Trouville		66
The Beach at Trouville		67
The Independent Painter, 1870-1880		**68**
The Thames and Westminster		70
Meditation, Madame Monet		72
Springtime		74
Still Life with Melon		76
The Pont Neuf, Paris		78
Bridge at Argenteuil under Repair		80
Monet's House at Argenteuil		82
The Luncheon		84
A River Scene, Autumn		86
The Seine at Argenteuil		87
River Basin at Argenteuil		88
Ships in a Harbor		90
Impression, Sunrise		92
Boulevard des Capucines		94
Boulevard des Capucines		95
Wild Poppies		96
Railway Bridge at Argenteuil		98
Bridge at Argenteuil on a Gray Day		100
The Studio Boat at Argenteuil		102
Woman with a Parasol–Madame Monet and her Son		103
Train in the Snow		104
The Tuileries–Etude		106
A Corner of the Apartment		107
Gladioli		108
La Japonaise		109
The Hunt		110
The Turkeys		111
The Gare Saint-Lazare		112
The Pont de l'Europe		114
Outside the Gare Saint-Lazare, Signal		115
La Rue Montorgueil, la fête du 30 juin, 1878		116
Camille Monet on her Deathbed		117
Toward a Grander Vision		**118**
The Ice Floes		120
View of Vétheuil, Winter		121
Bouquet of Sunflowers		122
The Artist's Garden at Vétheuil		123
Sunken Pathway in the Cliffs at Varengeville		124
Cliff at Dieppe		125
Stormy Sea at Etretat		126
The Nets		128
The Church at Varengeville		130
The Cliffs at Etretat		132
Cap Martin, near Menton		134
Rainy Weather, Etretat		136
The Manneporte		137
Tempest, Coast of Belle-Ile		138
Fishing Boats, Etretat		139
The Pyramides at Port-Coton		140
Boat at Giverny		142
Boat		144
Poppy Field near Giverny		145
Champs de Tulipes en Hollande		146
Field of Iris at Giverny		148
Valley of the Creuse, Sunset		150
Haystack in Winter		151
Grain Stacks at Sunset		152
Haystacks: Snow Effect		153
Poplars on the Epte		154
Poplars		155
The Four Poplars		156
Rouen Cathedral–Tour d'Albane, Early Morning		157
Rouen Cathedral–The Portal and the Tour Saint-Romain, Full Sunlight: Study in Blue and Gold		158
Rouen Cathedral at Sunset		159
The Ice Floe		160
Sandvika, Norway		161
Branch of the Seine near Giverny (II)		162
Chrysanthemums		164
London, Houses of Parliament, Sunset		166
London, Houses of Parliament		167
Gondola at Venice		168
The Dario Palace, Venice		169
The Grand Canal, Venice		170
The Garden at Giverny		**172**
The Garden in Flower		174
Pathway in Monet's Garden		175
The Flowering Arches		176
The Japanese Bridge (Le Bassin aux Nymphéas)		177
The Japanese Bridge		178
The Clouds		180
Waterlilies		181
Waterlilies		182
Weeping Willow		184
Waterlilies		185
The Path with Rose Trellis		185
Wisteria		186
Clouds		186
The House from the Garden		188
Clouds		189
Weeping Willow, Morning Effect (detail)		189
Green Reflection		190
Green Reflection (detail)		191
Acknowledgments		**192**

Introduction

Some artists are characterized by a single statement, painting, or image which can often hinder a fuller understanding of their works. Paul Cézanne's annoyingly ambiguous statement that 'Monet is only an eye, but my God, what an eye,' has to some extent inhibited a fair assessment of Claude Monet's achievement.

This book is about the life and work of a man obsessed by the nature of light. Few other artists have been driven by so singular and possessive a daemon as Monet, and few have lived long enough to present the public with such a vast body of work to enjoy. Monet's works are instantly recognizable even to those who profess to know little about painting. They are without doubt some of the most popular and accessible works in Western Art, although this has not always been the case. Perhaps his present popularity is based upon his exploration of a problem that all of us gifted with sight share to an extent – how do we make sense of the visible world? For nearly seventy years Monet dedicated himself to the re-creation of visual experience through the medium of oil paint on canvas and his early explorations of the subject are very different from the profound meditations of his later years. The more one looks at his work the more intriguing it becomes. Some of the late paintings may appear on first encounter unconventional and even bizarre but the interested viewer can easily test their validity by standing on the banks of an open stretch of water for five minutes and imagining how best that experience could be represented on a flat canvas.

Claude Oscar Monet was born in Paris on 14 November 1840 at number 45 rue Lafitte. When he was about five years old his family settled in Le Havre on the northern coast of France where he grew up surrounded by the comings and goings of that great commercial port and the ever-changing effects of sea and sky. His father joined the profitable ship's chandlers business run by his relatives the Lecadres, which allowed the family to enjoy a comfortable middle-class life. As a youth, Monet attended the Collège du Havre, where he was taught by an ex-pupil of the celebrated Neoclassical painter David. In his spare time Monet drew caricatures of local figures which he exhibited in shop windows. At 20 francs each they sold well enough to allow him to amass the sum of 2000 francs. A number of landscape sketches of this period survive which, like his caricatures, are drawn in the manner of popular lithographs of the day and consequently they reveal little of the originality of Monet's talent.

Around 1856 he made the acquaintance of the bohemian marine and landscape painter Eugène Boudin, who specialized in scenes of the locality. Boudin invited the young artist to accompany him on a painting excursion and Monet later confessed:

I wasn't thrilled by the idea. Boudin set up his easel and began to paint. I looked on with some apprehension, then more attentively and then suddenly it was as if a veil was torn from my eyes; I had understood, I had grasped what painting could be; the sole example of this painter's absorption in his work and his independence of effort were enough to decide the entire future and development of my painting.

Boudin at that time had no real reputation beyond Le Havre, but his impact upon Monet was immediate and longlasting.

In 1859 Monet's application to the town council for a scholarship to study art in Paris was refused, but even before hearing the result of his request he had set off for the capital, where he arrived in the spring of that year. He was able to support himself from his savings and from the money he received from his father and his aunt, Jeanne-Marie Lecadre. Written in 1859, a letter from Emile Zola to Paul Cézanne gives a good idea of an art student's likely expenditure at this time:

A room at 20 francs a month; lunch for 18 sous and dinner for 22 sous comes to 2 francs a day or 60 francs a month, plus another 20 for the room makes 80 francs a month. You then have your studio fees to pay; Suisse, which is one of the cheapest, is 10 francs a month, I think; allow another 10 for canvases, brushes and colors, which make 100. You have 25 francs left for laundry, light, the hundred and one small necessities that arise, your tobacco, and little luxuries.

With the sum he had saved and the financial assistance from his family, Monet could afford to live as a student in Paris in relative comfort.

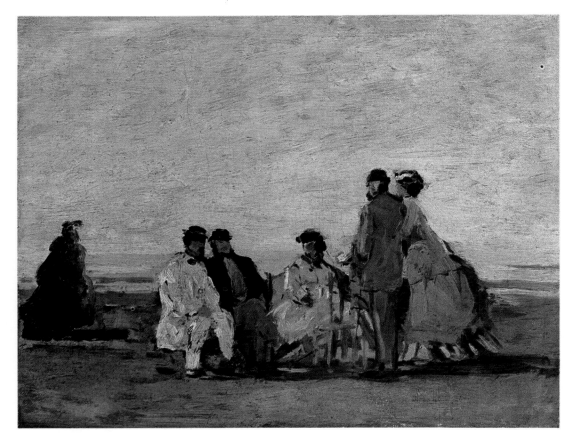

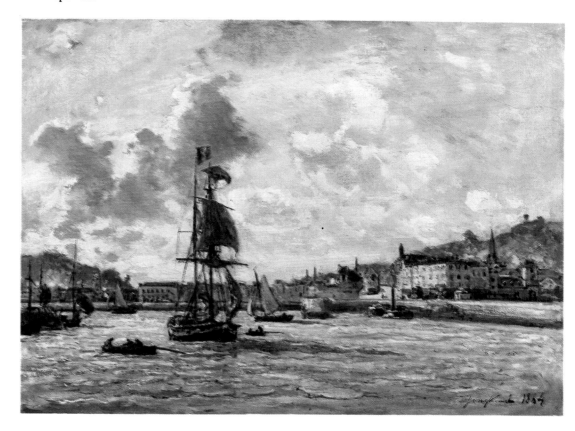

Monet's aunt and Boudin were friendly with several Parisian painters including Armand Gautier and Constant Troyon, both of whom were popular and respected artists of the time. These painters confirmed Boudin's belief in Monet's talent and advised him to enroll in a recognized artist's studio, to work from the life model and study in the Louvre; all of which was the conventional practice of the time. Monet, however, preferred to visit bohemian haunts such as the famous Brasserie des Martyrs, that included among its clientele the radical realist artist Gustave Courbet. Instead of following his father's wishes and enrolling with an established artist who could ease his way into the École des Beaux-Arts and thence to a respectable career as a Salon painter, Monet attended the famous Académie Suisse where he could draw the life model in an informal atmosphere without the interfering supervision of a tutor. It was here that he met Camille Pissarro who was to become one of his staunchest friends and also one of his severest critics.

According to the practice of the time Monet had been obliged to enter his name for the military lottery and in 1861 he was unlucky enough to find himself drafted for service. His father offered to buy him out of his obligation on the condition that he joined the family business. Monet refused and soon found himself in the uniform of

the dashing Chasseurs d'Afrique serving in Algiers on the Mediterranean coast of North Africa. Like so many other French artists he was astounded by the splendor of the light and the luxuriance of the vegetation he experienced there. In 1862 after completing one year of his service he was invalided out of the army and returned home to Le Havre. Here he met the quixotic Dutch landscape and marine painter Johann Barthold Jongkind, to whom Monet later said he owed 'the final education of my eye.' On his return to Paris in the fall of that year he registered at the studio of the Swiss academic painter Charles Gleyre, where he stayed until 1864. It was in this studio that Monet met fellow students Pierre-Auguste Renoir, Frédéric Bazille, and Alfred Sisley. Gleyre was a complex personality who nevertheless was a celebrated teacher. Although he learned a good deal about technique and studio practice from his master, Monet was from the very first to find the call of the world beyond the studio irresistible.

Paris at this time was in the midst of a massive program of rebuilding, initiated by Napoleon I at the beginning of the nineteenth century and continued by his nephew Napoleon III under the auspices of the Baron Haussmann. Most of these developments took place between the 1850s and the 1870s and are now so much an integral part of our conception of Paris that it is easy to forget that then the destruction of

the old city of Paris was an important and traumatic cultural event. Broad and anonymous boulevards cut their way through the warrens of narrow streets, displacing their former inhabitants and changing the social, political, and architectural structure of the city. These changes were seen by many as signaling the end of an epoch; the medieval past was swept away and Paris was no longer a city fit for poets, but a modern Babylon dominated by the twin specters of commerce and materialism.

It was in the capital that the great annual or biennial official exhibition of painting and sculpture took place. This exhibition, commonly referred to as the Salon, had a long history stretching back to 1663 when a decree had been passed establishing the Royal Academy of Painting and Sculpture. Since that time it had undergone many transformations but it was still almost the only place where an ambitious young artist could show work. The French establishment had always considered the arts as an essential part of national life and accepted the idea that in some intangible way the state of the arts was a reflection of the moral strength of the country. The favored paintings were those that took as their model in style and content the great history paintings of the past. Every year subjects from classical legend, ancient history, and patriotic scenes celebrating France's glorious past lined the walls of the Salon. The genres of landscape, still life,

and portraiture which were the bread and butter of most artists were considered to be very inferior forms of cultural activity in comparison with the elevated genre of High Art.

In 1855, a few years before Monet arrived in the capital, a Universal Exhibition was held in Paris. The Fine Arts were given a place of honor at the vast exhibition, but despite the agreed superiority of official French painting over that of other nations, many critics voiced their anxiety that their country's ascendancy in this particular area was now under threat. The painters who carried away the laurels from the exhibition were artists who had made their reputations in the previous generation and who were now old men. Where were the young artists who would take their place and continue the great tradition of history painting? Most of those painters who attempted to continue this tradition have now been largely forgotten. The artists that we recognize as depicting the life of the latter part of the nineteenth century were not members of the official world of High Art, but those artists who at the time were considered to be dragging the noble name of art into the gutter. Gustave Courbet had set up an independent

Pavillon du Réalisme containing forty of his paintings immediately adjacent to the official Palais des Beaux-Arts. A pamphlet listing the works contained a preface which included a declaration of his ambition, which had been to 'record the manners, ideas and aspect of the age as I myself saw them – to be a man as well as a painter, in short to create a living art – that is my aim.' Aided by the financial backing of the son of a rich businessman from the south of France, Courbet had set out to establish an opposing set of criteria for art to that sanctioned by the State.

The exhibition was seen and admired by a young artist called Edouard Manet who decided to follow Courbet's example in

challenging the clichéd practices of those artists trained at the École des Beaux-Arts by producing pictures inspired by his experience of modern life. In 1863 he produced two paintings that shook the Parisian art world. One was called *Le Bain*, which could be best translated as the 'bathing woman,' but which became known as the *Déjeuner sur l'Herbe*. This painting shows a group of people seated on the shaded banks of a river, two of whom are respectably dressed young men who converse while one of their female companions washes herself in the water. The other woman sits naked, ignoring the conversation as she turns her head to coolly address the viewer who by implication has

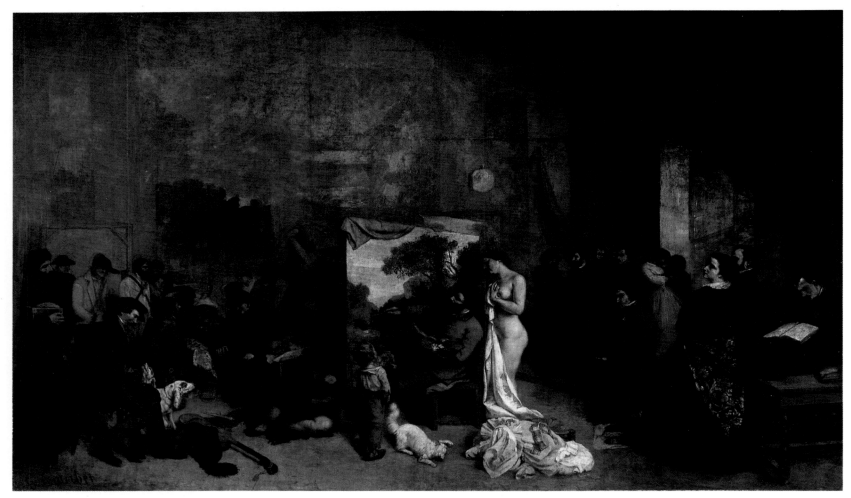

Right: *Le déjeuner sur l'herbe* 1863, by Manet, friend and associate of the Impressionists.

Below right: Contemporary photograph of Paris showing an elevated view of the Ile de la Cité from the Right Bank.

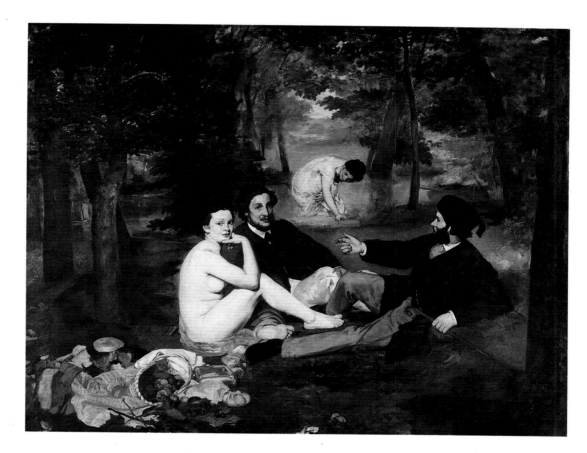

stumbled across this rather risqué picnic scene. Manet's other painting was the provocatively titled *Olympia,* which he held back from public view until 1865. These two works were a direct challenge to traditional assumptions about art; the *Déjeuner sur l'Herbe* by updating a subject that had been treated by the artists of the Renaissance and had given an outworn subject a contemporary relevance that his audience found deeply offensive. The *Olympia* was considered equally distasteful. It was essentially a reworking of Titian's famous masterpiece the *Venus of Urbino* of 1538. Despite its reference to the work of the Renaissance master and its pseudo-classical title, Manet's version was understood by its audience to represent not a goddess from antiquity, but a prostitute from the back streets of Paris. Even worse, her blank gaze out of the picture created an unavoidable rapport with the unsuspecting male viewer. Art in the hands of people like Courbet and Manet was no longer a comfortable vision of some misty past or distant land but an activity that could raise often uncomfortable issues concerning the realities of contemporary life.

Monet and his friends became so fired with enthusiasm for the work of these two avant-garde artists that they became known as *la bande de Manet* and met as a group to discuss their ideas in the cafés around the Boulevard des Batignoles on what was then the outskirts of city. These gatherings also attracted the young Edgar Degas, who at this time was moving away from his early ambition to be a history painter in the manner of Ingres or Delacroix in order to pursue a career as a painter of modern life. His inspiration was to be founded upon the study of the manners and mores of his own circle and the various aspects of Parisian life with which he came into contact. In the second half of this decade these formidable ambitions were also held in some measure by Monet.

In order to establish a reputation and secure future commissions it was necessary for any artist to make a successful debut at the Salon and the most obvious way to do this was to produce a large figurative composition. Mindful of the ideas and opinions of his friends, Monet began work on a large and complicated version of a *Déjeuner sur l'Herbe.* Two years earlier Manet's painting of the same subject had been one of over 4000 pictures rejected by the Salon jury and had been shown instead at a specially convened Salon des Refusés.

Until that time Monet had concerned himself almost exclusively with land and seascapes but, with this project, he was firmly associating himself with the new school of painting and by doing so, putting his professional career at risk.

Some years later, Monet told Émile Zola, the famous novelist, critic, friend and supporter of the Impressionists, of his ambition to give form to 'the dream of every painter: to put life-size figures into the landscape.' This was a challenge that was to continue to attract both avant-garde and establishment painters throughout the nineteenth and twentieth centuries. The idea of painting a landscape peopled with figures is one of the great ideas in European art and as such had been the basis of the work of artists as diverse as Michelangelo, Raphael, Giorgione, and Titian, as well as French painters such as Poussin and Watteau. Manet had been very aware of this tradition when he had painted his *Déjeuner sur l'Herbe,* or luncheon on the grass, which for all its modernity, was still very much a studio concoction. Monet, inspired by the example of Boudin and Jongkind, decided to depart from Manet's subversive use of the nude and his sophisticated references to the art of the past. Instead he decided to work on a Watteauesque picnic scene, which would be bold enough in coloration and handling to give the sensation of direct experience of the scene depicted.

to the work of the more acceptable painters at the Salon, such as the highly fashionable portraitist Carolus-Duran, and Alfred Stevens, a Belgian who specialized in small intensely worked paintings of scenes in which the ladies of the haute-bourgeoisie engage in the minor dramas of domestic life. Both these painters were good friends of Monet.

Inspired by the relative success of these two pictures at the Salon and by the experience of his uncompleted *Déjeuner*, Monet embarked on another consciously avant-garde painting, known as the *Women in the Garden*. Begun in spring 1866 it

In 1865, before the opening of the Salon of that year, which contained two of his seascapes, he left for the town of Chailly, about twenty-five miles southeast of Paris on the edge of the forest of Fontainebleau. He was determined to work as closely as he could to nature and to produce a work at least as large as similar works by Courbet. That artist features in one of the surviving fragments of the final painting as the rather corpulent bearded man seated among the ladies, close to the wine and food. In conventional fashion, Monet made a number of freshly handled sketches of the various forest *allées,* in which he sought to preserve the qualities of light and the vividness of perception that can be caught by working in the open air. From these sketches and studies he began work on a canvas, 15 by 20 feet, which he was unable to resolve in time for the 1866 Salon. In 1878, chronically short of money, he left it as security with his landlord at Argenteuil and did not retrieve it until 1884, by which time it had been badly damaged by damp. The two surviving fragments are all that remain of what must have been a startlingly ambitious project. In its place, Monet decided to send a large study of the Bas-Bréau road at Chailly which he had produced during his six-month period of preparation for the picnic canvas. He also managed (apparently in the space of four days), to complete a full-length portrait of his model and companion, Camille Doncieux. These two works and the unfinished *Déjeuner* reveal Monet to have been an extremely talented and ambitious young artist. The Camille portrait was conceived primarily as a commercial venture in the fond hope of procuring future portrait commissions. With its robust handling of paint it reveals the influence of Courbet and gives more than a passing nod

represents a consolidation of ideas and themes apparent in his earlier work and is a further link with the work of Courbet and Manet. Monet was now living in the Batignolles area on the right bank in Paris and had firmly identified himself with *la bande de Manet.*

His early association with Boudin and Jongkind reinforced the belief that his work should be painted in the open air, *en plein air* before the motif. The *Women in the Garden* followed the pattern set by his monumental *Déjeuner sur l'Herbe,* but in order to avoid the complications involved in painting a large group of figures, Monet reduced the composition to four individuals, at least three of whom are based on Camille. The women are posed in an artificial manner reminiscent of fashion plates and contemporary photographs in the garden of a house he had rented close to the station at Ville d'Avray. The size of the painting, which is over eight feet high, is an indication of Monet's continued ambition to create a reputation at the Salon and to win the admiration of his friends, critics, and public alike.

Rather than following the traditional procedure of using sketches and studies made in the open air as the basis for a painting wholly created in the studio, Monet decided to paint the entire work out of doors. To overcome the practical problems involved he excavated a trench which allowed the canvas to be raised or lowered as necessary. Monet continued to develop his unconventional art practice by using a manner of painting associated with the preparatory sketch for a large-scale work. By applying the paint in separate, clearly defined strokes of a broad brush fully loaded with pigment, he deliberately avoided the usual 'polished' surface of a conventionally finished painting. Strokes of separate color laid down in broken areas of violets, lilacs, and deep pinks serve to describe the upcast shadows which cause the features of the model to be registered in a novel way. The brushmarks record not the objects themselves, but rather the fall of light upon them.

There is an awkwardness about the final composition that may in part be deliberate. Like Courbet and Cézanne, Monet nurtured a certain naivety of vision. He once said that he wished he had been born blind and suddenly given the gift of sight in order to see nature stripped bare of the visual conventions accrued over a lifetime. Throughout his life Monet stressed the

spontaneous, personal, and intuitive elements of his art, and played down the valuable lessons it is evident he must have learned from his time spent in Gleyre's studio. He also tended to understate the importance of his practice of reworking his first responses to the motif in the studio. Such practices reveal Monet to be anything but a naive, untutored artist who rushed to express his all-too-powerful emotions directly on the canvas before they drained away. On the contrary, a careful examination of almost any canvas by Monet will reveal traces of much consideration and overpainting at a later stage.

With these two major works Monet achieved what must surely have been at least part of his ambition; to produce a monumental art equal to anything in the museums or the Salon; an art dedicated to the pleasures and pastimes of his own class that would be in harmony with the modernist principles propounded by his friends and in line with his own deeply held conviction to keep as close as possible to the veracity of visual experience. And yet, for all his concern with these ideas, he took the still unfinished canvas to Honfleur where he continued to work upon it through the early part of 1867, far away

Right: The beach and cliffs at Etretat, a scene much painted by Monet.

Below: *Bathing at Etretat* by Eugène Le Poitevin, 1865, a bathing scene featuring Monet's friend the writer Guy de Maupassant.

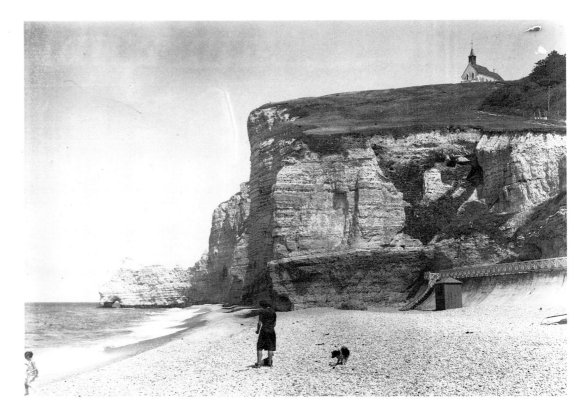

from both model and motif. It was submitted to that year's Salon but was rejected by the jury. Despite the painting's absence from the walls of the exhibition, Émile Zola made a point of mentioning it in his review of that year's Salon:

I have seen a work of Claude Monet's that has qualities of real flesh and blood. . . . Nothing could be more strange in its effect. One must deeply love one's own time to dare such a tour de force. . . .

Monet's friend Bazille bought the painting for 2500 francs, which was paid to the grateful painter in monthly installments.

The rejection of *Women in the Garden* necessarily consolidated his position as a member of the avant-garde. It is easy for us, looking back from the viewpoint of the latter part of the twentieth century, to gain a distorted idea of what Monet was trying to achieve, and the apparent 'heroism' with which he single-mindedly followed his own creative impulses. There is no doubt that Monet did suffer, and that his genius was to a large degree unrecognized or ignored by the establishment for some considerable time, but this does not mean that he scorned professional success. Monet wanted to sell his work, and had need to do so, especially now that his father had withdrawn his financial support because Monet had decided not to marry his pregnant mistress. From his earliest years he had regularly sent work to the Salon and one of the major reasons he and his friends set up the Société Anonyme, subsequently thought of as the First Impressionist

exhibition of 1874, was precisely in order to find a venue to sell their works when the traditional shop window of the Salon was refused them.

Despite his sporadic success at the Salon, Monet found it difficult to live on what he earned from his irregular and unreliable pattern of sales. In 1867 circumstances forced him to stay at his father's house in Sainte-Adresse, a fashionable resort near Le Havre, leaving Camille in Paris in the care of a medical-student friend. In late 1868 his painting of *Camille* was bought by Arsène Houssaye, the influential editor of the periodical *L'Artiste,* but no further commissions followed and in real terms Monet was in a continuing state of financial hardship. Inevitably, he leant heavily upon his more prosperous friends such as Courbet, Gustave Caillebotte, and particularly Bazille. An extract from one of

his letters shows how adept Monet was at appealing to the good nature of his friends: 'For eight days we have had no bread, wine, fire to cook on or light.' Despite the probable exaggeration of his plight, his situation became more serious with the birth of his son Jean in August 1867. Monet received no help from his own family at Le Havre, but he was fortunate in winning the support of a wealthy Le Havrais merchant family, the Gaudiberts. Due to their support he was able to rent a house at Etretat, where he could work in relative tranquility. In 1868 he produced a portrait, *Madame Gaudibert,* which may be considered as a companion piece to the *Camille.* By then Monet was clear about his direction, and the paintings of this period illustrate his continuing interest in out-of-doors scenes, painted with a synoptic brevity in a series of slab-like brushmarks.

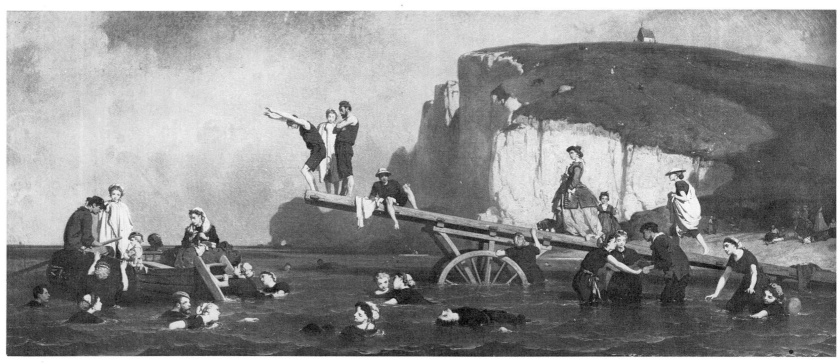

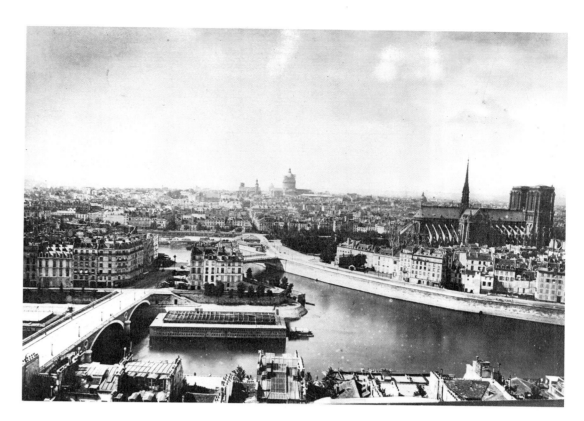

His interest in the contemporary world meant that it could only be a matter of time before he would attempt to record something of Parisian life. Monet's cityscapes painted in the spring of 1867 bear witness to his obvious delight in the urban scene. Along with Renoir, who paid close attention to the innovations of his friend, he produced a series of views of the city that are surprising in their assurance and originality. They build upon the achievements of the Dutch masters of the seventeenth century and the more contemporary French painters such as Corot and Lepine and in their turn they form the basis of similar works by Caillebotte, Bonnard, Vuillard, and Matisse. These works document Monet's growing confidence in depicting movement. His drawing of the figures scurrying to and fro are informed by an awareness of the traces and blurs left by moving figures in the photographs of the 1850s and 1860s. The camera may also have acted as an important influence on Monet's choice of composition. In *Rue de la Bavolle* of about 1866, he chose a traditional compositional structure that pushes the street, flanked with its buildings, deep into the middle distance in a series of measured perspectival intervals. His city paintings, such as the *Jardin du Princesse* of 1867, are very different. Due to the specific nature of their lenses, contemporary photographers attempting to record the visual format of a city like Paris were required to maneuver themselves into vantage points where as much of its spectacle would be available to them as possible. The obvious choice would be a high place such as the balcony of the Louvre, which was utilized not only by Monet for his paintings, but also by photographers like Alphonse Braun and Nadar.

Monet chose two paintings for submission to the Salon of 1869, a snowscape and a painting of fishing boats; both were rejected by the jury. In May of that year he moved from Etretat to a rented property at Bougival, to the west of Paris. The strength of Monet's growing reputation among his circle of friends was shown by their frequent visits to paint in his company. He and Renoir set out to paint some views of a popular bathing spot on the banks of the River Seine. There is nothing in the resulting pictures that suggests the trials that

he and his family were suffering at this time. He had to rely upon Bazille to send him canvases, and Renoir, whose family lived nearby, is supposed to have helped him by bringing scraps of food taken from his parents' table. It was clear to Monet that success at the next Salon was a necessity. It seems that his idea was to produce a version of a painting of the same subject that had been popular at the Salon a few years earlier. His work, however, was to be painted in a more modern and, given the nature of the subject, in a more suitable style. As he wrote to Bazille:

I have a dream, a picture, the bathing place at La Grenouillère, for which I have made some bad sketches, but it is a dream. Renoir who has been spending two months here, wants to do this picture too.

Monet was unduly modest about the resulting paintings. They are far more than mere sketches. The value they place upon the immediate transposition onto a canvas of perceptual experience means that it is with these paintings that one can begin to recognize a way of working that justifies the use of the term 'Impressionist.' With his brush fully charged with paint, Monet, instead of vainly trying to imitate an external reality made up of 'things,' has described the effect of light falling upon the scene. The small scale of the canvases he used reduced the problems encountered in his previous experiments on a large scale and allowed him to concentrate upon the business of capturing a complicated field of visual phenomena by considering it as a screen of color patches. Breaking up the canvas surface into a rhythm of broken brushmarks which create a surface pattern dictated by shifts of hue and color, Monet constructed an image that is almost tangible in its sensation of atmospheric unity. The air in the picture is one that we can breathe; we are presented with a space inhabited by people we can feel at ease with, and one that in our imagination we can also inhabit. Monet and Renoir painted a number of views of this popular and rather disreputable establishment, often setting up their easels only a few feet apart.

The painting intended for the Salon of that year was never completed and one of the sketches he sent in its place was rejected. It was clear that Monet's way lay outside the official world of art. His virtuosity and apparent confidence in his powers as a painter are evident in his work of this time, and yet one of the hallmarks of

his long career was his propensity to slip into moods of desperate depression and self-doubt. In 1866, when he was living at Ville d'Avray, he is recorded as having destroyed some two hundred canvases. If these had survived they would have added to our awareness of the extraordinary diversity of his early work and might have served to reiterate his interest in painting the figure, which, despite his later almost total dedication to the landscape, continued to fascinate him.

At this time Monet was spending much of his time in the vicinity of Paris, but with the development of the railway system in France he was able to travel with ease along the Seine valley to the Normandy coast. Visits to the seaside had become a popular and fashionable Parisian pastime during the period of the Second Empire. The Emperor Napoleon's half-brother, the Duc de Morny, leader of fashion and entrepreneur par excellence, had taken a leading role in exploiting the natural resources of this area, and had created splendid beaches that now, thanks to the railway, were within easy traveling distance from the capital. Monet's mentor Boudin had

written: 'The peasants have their painters of predeliction, do not these men and women . . . have a right to be fixed on canvas?' Monet must have admired the way in which Boudin's paintings capture the most ephemeral of things, the movement of the clouds and the sea, the casual pose of a fashionable lounger or the sudden billowing of a flag or dress.

Monet's beach scenes were painted just after his marriage to Camille in June 1870. They illustrate how much he assimilated from the work of his first master. They also exhibit the immediacy with which Monet could translate perception into pigment, availing himself of the almost infinite repertoire of possibilities that belong to the malleable medium of oil paint. His remarkable studies of Camille are highly original in their composition and in the effective use of opaque layers of impasto set against the suggestive properties of the untouched canvas. Monet was able to capture an atmosphere, or 'enveloppe' as he later termed the air that circulates around objects modifying their appearance and uniting disparate objects into a natural harmony of color, light, and tone. His

works are some of the first in the nineteenth century that succeed in uniting the figure with the natural landscape in such a way as to suggest an enveloping atmosphere in which we feel his people can live and move as we do in the real world. Degas is recorded as having said that '. . . the air one sees in the paintings of the masters is not the air one breathes.' This is never the case in Monet's paintings. The ease with which we can relate to his vision of reality in the works of his early years is extraordinary and the closeness to experience contained in such paintings as the *Hôtel des Roches Noires,* the *Magpie* or the *Bridge at Argenteuil* is remarkable even within his own *oeuvre.* His paintings of the figure and the urban environment have acquired with the passing of time a certain period charm that invests them with a very particular attractiveness, but his pure landscapes that are free of this nostalgic overlay are capable of producing a powerful, almost physical shock of actuality.

In the Fall of 1870 Monet fled to London to escape the Franco-Prussian war to which, still being on the reserve list, he was especially vulnerable. He was followed shortly by Camille and the new baby. This was to be the first of many expeditions to the smog-ridden city of London which

eventually resulted in some of his most familiar works. The exact details of his first trip are a little hazy, but it is known that he made contact with fellow refugees Pissarro, Charles Daubigny and Paul Durand-Ruel. Durand-Ruel was an independent dealer who had transferred his gallery and some of his stock to London and his support of Monet and the Impressionists was a vital factor in their ability to develop as artists outside the Salon system. The first of Durand-Ruel's exhibitions opened on 10 December 1870 and included a painting by Monet entitled *Entrance to Trouville Harbor.* Monet visited the various galleries in London with Pissarro and admired the paintings of Constable and Turner. However, the influence of the latter was not to reveal itself until much later in his career. Monet worked on his own, painting scenes of the city, its green parks and the evocative silhouette of the Houses of Parliament. His treatment of these subjects is intriguingly different from the highly detailed paintings and drawings of his English counterparts and those of his fellow countryman Gustave Doré, whose response to London would appear two years later in Blanchard Jerrold's *London: A Pilgrimage.* However, both Monet and Pissarro found it difficult to sell their work in

England and it was not until the mid-1880s that the work of the Impressionists made any noticeable impact upon the British art scene, and then, predictably, it was as a *succès de scandale* rather than a serious consideration of its merits.

He returned to France by way of Holland in the fall or winter of 1871. The picturesque aspects of Amsterdam and Zandaam, just to the north of the city, inspired him to produce a number of canvases, and one of these, the *Montelbaanstoven on the Oude Schaus,* is particularly luminous. Its loosely knit weave of vivid eccentric strokes and stabs of broken color radiate an energy and light, while the economy and verve of its handling begs comparison with the works painted over thirty years later of similar subjects by Matisse and Derain.

In his early work Monet exploited to the full the light gray priming of his canvases which allowed the viewer's eye to link apparently disparate elements of the composition into a unified whole. Monet had developed a more rhythmically paced series of brushmarks to replace his earlier staccato dabs of pigment. It was only later that he made use of a white canvas and still later that he developed his technique so as to produce canvases thickly encrusted with a corrugated paint surface. His

manner of working was still an adaptation of the traditional esquisse. The esquisse or sketch was essentially the first design for a picture which was usually small in scale and abbreviated in handling. Its purpose was to establish the main elements of the composition, its *mise-en-scène,* light effects, and major masses. Monet treated the motif with a light rapid assurance that gave to his work an impression of freshness, brilliance, luminosity, and transience that we associate with visual experience. Monet's manner of painting contained certain key differences from the traditional practice of painting: he excluded black from his palette, ignored the smooth imperceptible tonal gradations of chiaroscuro, and deliberately neglected to make use of aerial perspective. In practice this

meant that his colors were equally intense from the foreground of the picture through to the horizon, where traditionally they should pale into oblivion. He refused to follow the usual procedure of organizing and tidying up the original perceptions before the motif in an academically acceptable manner. One of the great achievements of Monet that has helped generations of painters since, was his conception of light as something that, except under exceptional conditions, is always present and which should be perceived as shifting contrasts of hue and not as part of a preconceived tonal scale. The Impressionists exhibited their works against the traditional dark background which caused the high tonalities of their pictures to appear even more strident than ever, especially

when seen in comparison with those of most of their contemporaries. By deliberately flouting the accepted values of the day Monet and his friends laid themselves open to accusations of sloppiness, laziness and even the suspicion that they were unwilling or perhaps unable to complete a painting in the accepted manner, with the customary degree of detail and 'finish.'

On his return to Paris, Monet would have learned of the death of his close friend Bazille, who had been killed at the battle of Beaune-la-Rolande, in the course of the Franco-Prussian War. To escape the horrors that ensued after the fall of the Paris Commune, Monet moved with his family to Argenteuil, a town situated about 6 miles (10km) away from the capital on the banks of the River Seine. Here he settled

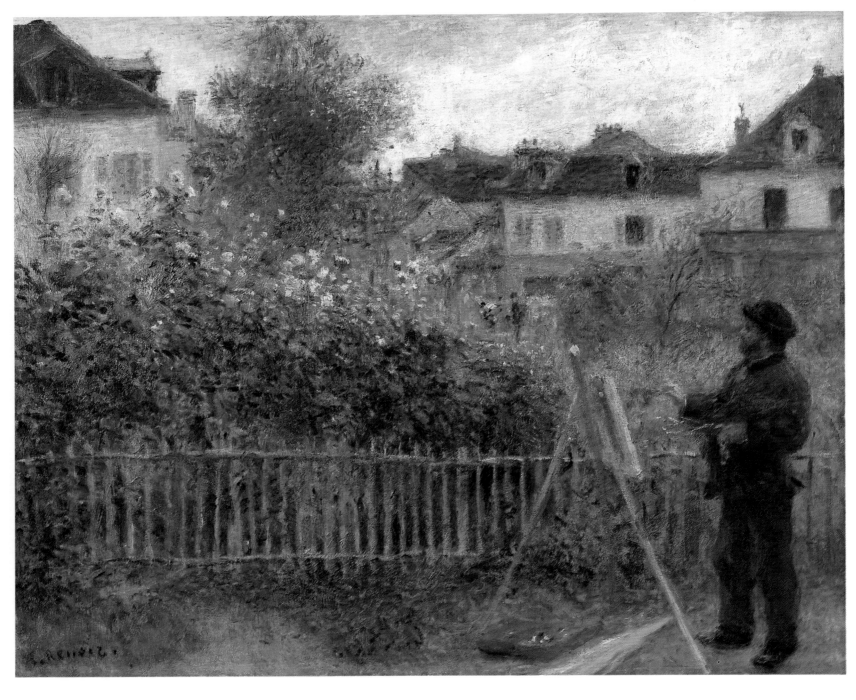

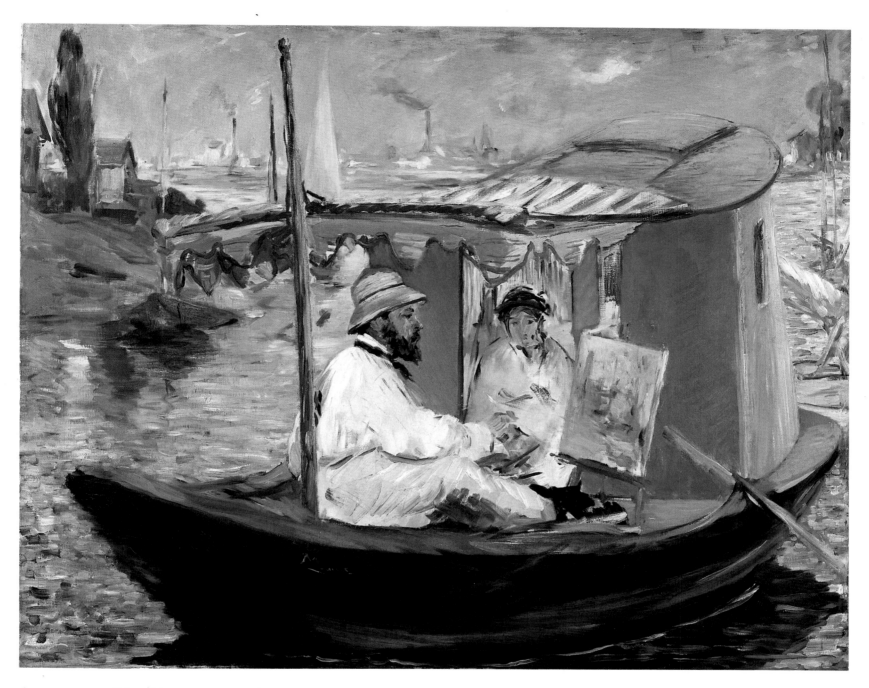

down to consolidate his career as an independent painter supported by a small but growing number of patrons and dealers. It was a period of transition, experimentation, and change in his work. He stayed there for six years and depicted the rapidly developing town and its environs no less than 170 times. Once again he was visited frequently by his friends Renoir, Sisley, and Manet. His closeness to Manet is indicated by Manet's painting of 1874 featuring Monet and Camille in their studio-boat which has become one of the standard images of the Impressionist painter. The artist was no longer bound to the fixed space of the studio but had become mobile and, thanks to the availability of easily transportable tubes of paint, had gained direct access to the infinite possibilities of the natural world. The

painter casually dressed with his baggy shirt and sporting a straw hat could easily be mistaken for a petit-bourgeois enjoying an afternoon's boating with his wife. Monet's boat had been built two years earlier following the example set by Daubigny who had traveled around the rivers of France painting and etching the passing landscape. Manet's painting is intriguing as it shows that sophisticated artist self-consciously adopting a number of Monet's stylistic habits, returning the compliment that the younger artist had paid him in his paintings of the 1860s.

During this period Monet produced some of his most magical and well-known images; reproductions of these are now so familiar to the present-day viewer that we are our slightly jaded, and perhaps too readily seduced into accepting them as

faits accomplis. By doing so we overlook the achievement of the artist who has created such powerful illusions of reality on nothing but a piece of linen stretched over a wooden framework.

Like many artists of the period Monet and his friends continually railed against the injustices of the Salon system. Cézanne had made an unsuccessful request to the Minister of the Fine Arts for the institution of another Salon des Refusés. In 1873 Monet suggested that they should organize a group exhibition to be funded by themselves. Pissarro agreed and one year later they organized an independent exhibition that was to become the first of eight group shows. It was held at a photographic studio that their friend Nadar had just vacated on the second floor of the rue Danou which leads off the Boulevard des Capucines

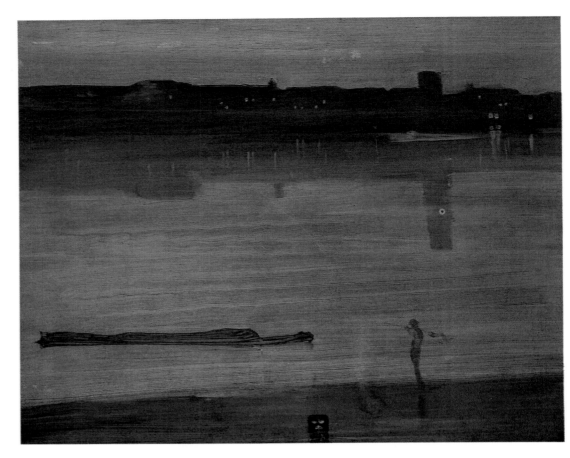

close to the chic Avenue de l'Opéra. This has become known to history as the first Impressionist exhibition, although it was only later that Monet and his friends accepted the term to describe themselves and their work. The term was that used in an unsympathetic account of Monet's painting *Impression, Sunrise* of 1872 in Louis Leroy's review in the journal *Le Charivari*. It had been used by critics before, in reference to the work of Corot and others, but Leroy gave it a new frame of reference. This painting itself may well have been influenced by James McNeill Whistler's Nocturnes of the Thames which had been exhibited at Durand-Ruel's the previous year. With its thin veil of almost monochromatic blues loosely brushed in a series of broad fluid washes, it hardly corresponds to our idea of a typical Impressionist painting, although its harmonious coloration hints at some of Monet's future concerns. Monet and his colleagues preferred to be known as *Intransigeants* or *Indépendants*, terms which stressed not a unity of technique, which was only shared by a few of the exhibitors, but their independence and separateness from establishment art practice. One of the twelve works that Monet exhibited at the show was a view taken from Nadar's studio looking down upon the Boulevard des Capucines. In its

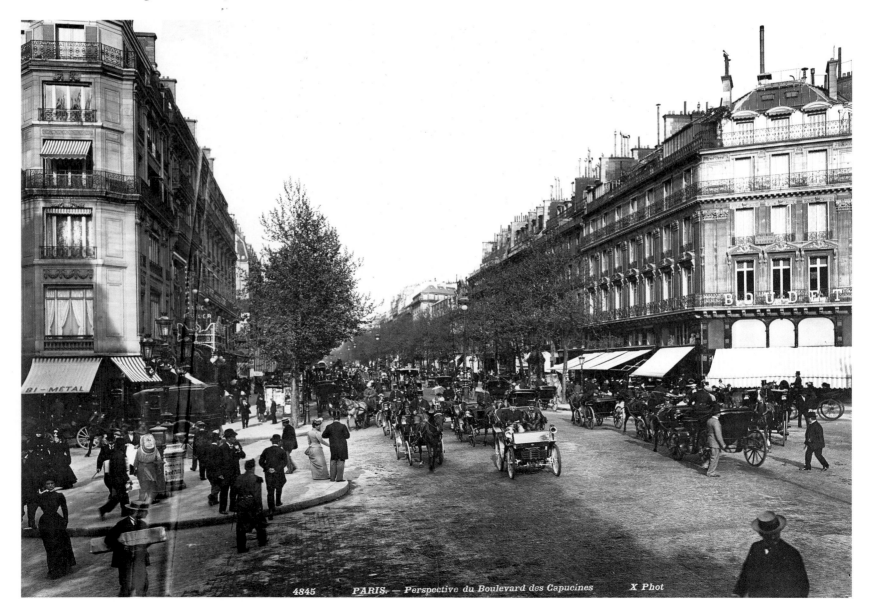

4845 PARIS. — Perspective du Boulevard des Capucines X Phot

masterly evocation of light, movement, and atmosphere this painting is much closer to our idea of a typical Impressionist painting. It sets down a bold challenge to the claims of verisimilitude made by the supporters of the camera by celebrating in the most subtle manner the element which that medium most singularly lacked at that time – color. The figures on the right of the canvas, standing on the balcony of a neighboring building, invite the viewer to test the work's closeness to perceptual truth by imitating their actions.

The Impressionists were among the first to respond to the new environment and they deliberately set out to paint the modern city in a specifically modern way. The new Paris was at that time free of the aura of nostalgia that the city evokes in present-day visitors and to many of Monet's contemporaries viewing the works in the 1870s, the image of Paris purveyed by the Impressionists must have looked brash and distinctly unromantic.

The exhibition did not receive overwhelming popular or critical support, and those newspapers that did give favorable reviews of the exhibition were often those with left-of-center sympathies. Typical of the reaction of those antagonistic to the show was that of Louis Leroy. In his review he imagined an academic painter fuming before Monet's painting of the Boulevard des Capucines:

'Ah-ha!' says the painter. 'Is that brilliant enough, now! There's impressionism, or I don't know what it means. Only, be so good as to tell me what those innumerable black tongue lickings represent?'

'Why, those are people walking along,' I replied.

'Then do I look like that when I'm walking along the boulevard des Capucines? Blood and thunder! You're making fun at me . . .'

A more intelligent and perceptive analysis came from the critic Ernest Chesneau who wrote of the same work:

Never has the prodigious animation of the public thoroughfare, the swarming of the crowd on the pavement and the carriages in the street, the movement of the trees in the dust and the light along the boulevard; never has the elusive, fleeting, the instantaneous character of movement been caught and fixed in its wonderful fluidity as in this extraordinary, this marvellous sketch.

Critics and public alike were not accustomed to this new way of seeing and representing the world and found it difficult to come to terms with the painting except as a brilliant sketch for a more finished and comprehensible work.

Later Monet was to concentrate almost exclusively on the landscape but the 1870s saw some remarkable experiments in the field of figure painting. Whistler's influence was not confined to Monet's landscapes, for Monet's rather gaudy *La Japonaise* of 1876 suggests a knowledge of Whistler's more subdued figurepieces in

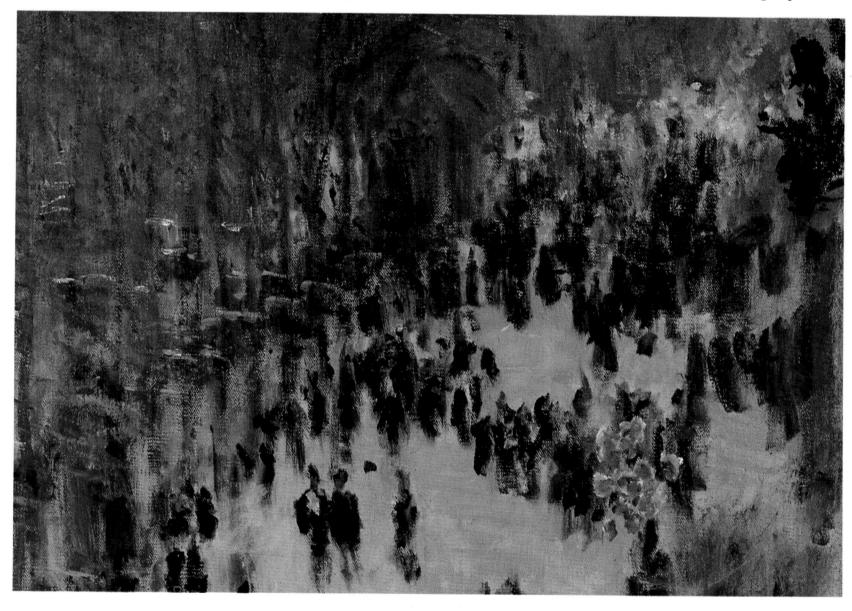

the same genre. The painting is a good example of Monet's attempt to produce a work that would be accessible to a broad section of the public. From the early 1860s Japonisme had been a pervasive fashion in Paris and Monet eventually acquired a large collection of Japanese prints, which had a considerable effect upon his work. In this painting the oriental motif is used in a superficial way for strictly commercial ends. Camille is shown dressed in a Japanese kimono flaunting her very European charms (and a blond wig) in a studio setting surrounded by an array of oriental fans. In his later work Monet was to assimilate oriental motifs and compositional ideas into his work in a much more thorough manner. Japanese prints had played an influential role in the work of Jean-François Millet, the Barbizon painter whose idiosyncratic treatment of the landscape had an effect on many of Monet's own compositions.

In the summer of 1876 Monet received a commission from a wealthy Parisian businessman, Ernest Hoschedé, to produce a series of four large decorative canvases for his country château of Rottembourg at Montgeron. One of these, *The Hunt*, sees the bringing together of a group of figures in a tunnel of foliage interlaced with a network of swirling brushmarks. These go beyond describing tangible reality and may be read as painterly signs for the filtering effect of the branches and the all-enveloping light that surrounds the figures. It was probably at this time that Monet, who was a frequent guest at the Château, entered into a relationship with Ernest's wife Alice which was to affect profoundly the rest of his life.

In 1877 Monet began work on a group of paintings based in the rail terminal of Saint-Lazare which concentrate upon the atmospheric effects created by the coming together of steam, smoke, iron, and light. Interestingly, Monet must have deliberately decided to turn his back on the large crowds of people who would have thronged the building. This avoidance of the human figure became increasingly common in Monet's work, as did the idea of producing several related paintings of the same subject seen under different atmospheric conditions. In many of the paintings of the terminus the solid structure of stone and cast iron and the huge rounded forms of the locomotives are transformed into shifting, insubstantial images, obscured by wreaths of steam.

These highly subjective interpretations correspond not so much to the physical facts of the terminus as might appear in an illustrated magazine of the time but to the visual and psychological reality of a station as a place where people come and go in endless tides of arrivals and departures with all the emotional turmoil such activities involve.

In September 1878 Monet moved farther into the country, to Vétheuil, a small town further along the Seine Valley from Argenteuil. Many of Monet's paintings celebrate the support that he received from his family and, despite the poor health of his wife following the birth of their second son Michel in 1878, his work continued to celebrate the cycle of bourgeois domesticity. The standard of living these paintings portray became increasingly difficult for him to afford in the years following the financial crisis of 1875, which affected Monet and his patrons alike. His friend and patron Ernest Hoschedé was declared bankrupt in 1877 and a year later he and his wife with their six children went to live with Monet and his family at Vétheuil. Ernest decided to move back to Paris in order to try to regain his fortune and despite their physical separation he remained married to Alice until his death in 1891. A year later Monet and Alice were married.

The need for commercial success continued to press hard on Monet and pleas for help to collectors and dealers occur constantly in his letters. His aesthetic ideals and also perhaps the need to support his enlarged household encouraged him to tighten up his open, sketch-like manner of working. Durand-Ruel urged him to give more 'finish' to his pictures to expand their appeal to a broader commercial base, and there is no doubt that Monet's output was, to a degree, mediated by market forces. In 1880 he once again entered the public arena of the Salon that he had shunned for so long. His reason for doing so may have been prompted by his financial situation which must have been aggravated by his new domestic situation. It has been suggested that his unorthodox relationship with Alice had caused some estrangement from his Impressionist colleagues and that this may have encouraged him to hope to win for himself the success that Renoir had enjoyed at the Salon of 1879 with his painting *Madame Charpentier and her Children* and Monet must have hoped that his moment of public recognition was near. He sent in two works based on studies he had

made of the River Seine but only one of them was accepted and that was hung at too high a level to be properly appreciated. It was to be the last time that he exhibited work at the Salon, but his desertion of the Impressionist camp was the cause of much bitterness among his friends. Degas broke off relations with him for a number of years and his relationship with the habitually amicable Pissarro was put under severe pressure. However, Monet's involvement with the Impressionists had never been as close as might sometimes be imagined; he participated in only five of the Impressionist shows and abstained from showing his work at the 1880, 1881, and 1886 exhibitions. Monet always considered himself as an independent artist as opposed to a member of an avant-garde clique.

Throughout the 1870s Monet had enjoyed little financial success and by the end of the decade he was in severe financial trouble. In 1875 he was reduced to asking his friend Manet for a loan of a mere 20 francs, and although a year later one of his paintings was sold at the second Impressionist show for 2000 francs, by the autumn of 1877 he was offering the collector Chocquet two of his pictures for forty or fifty francs each or whatever the collector felt he could afford. In September 1879 his worries were augmented by the death of Camille, after a period of prolonged and painful suffering. Monet sat by her deathbed and, distressed though he was, he found himself mechanically analyzing the tones and colors that death had brought to her face. The resulting painting is a poignant document of his loss, the brushstrokes creating a veil-like effect in keeping with its melancholy subject matter.

In the period immediately after Camille's death he produced a series of often startlingly luscious still lifes. He had occasionally painted still lifes in the past, but his concentration upon a genre that did not make the same emotional or intellectual demands on him as did the landscape may have been a way of coping with his recent bereavement. Above all, it allowed him to remain indoors, surrounded and supported by his family and to produce work that conveys no shadow of the deep sense of loss he must have experienced. True to his ambitions as an artist, Monet recorded the effects of that winter, the frozen River Seine and its subsequent thaw. These landscapes are obviously more than simple records of visual experience. Some writers have considered

Below: *Cliffs at Gruchy* 1871, by Millet. Millet's paintings have many affinities with Monet's works, in their composition, broken touch, and unexpected coloration. Like Monet, Millet was much influenced by Japanese prints.

them to be in some way analogies of his own emotional state. As one might expect, the landscapes of that winter, which was ferociously bitter, were marked by a deep melancholy and a pervasive sense of solitude, but one should perhaps avoid the temptation to play the amateur psychologist, for all works of art are complex packages bedded with layers of significance for artist and viewer alike, and attempting to reveal an artist's motives for producing a particular work is a difficult and tendentious affair. Monet's paintings of La Grenouillère for example, that he produced ten years earlier, convey no sense of the private distress he must have been experiencing at the time. Art can never be a direct transposition of visual reality, it must always be mediated by the hand that makes it, the mind that directs it and the

means by which it is created and, inevitably, its significance will vary from viewer to viewer.

Whatever the reason, it would appear that the death of Camille did mark a shift in the artist's work as it became more obviously the product of a sensibility concerned with the flux of experiential time and the mediating effect of personality and atmosphere on the subject. Accordingly his choice of motif became more and more quixotic and idiosyncratic as he continued to generalize his forms and simplify his compositions ever more drastically. His choice of subject matter was at one level typical of anything that might be seen in the annual Salons, but his treatment of it normally excluded any elements that might suggest some cozy or reassuring narrative. Sentimental peasants never

appeared in his paintings, rural customs were left unrecorded, and not a single painting of the nude either as a subject or incidental motif survives in his work.

Monet found himself forced to produce works and adopt strategies that would help him support his two families. Once again he followed Renoir's example and through his friend's influence in 1880 he held an exhibition at offices of the journal *La Vie Moderne.* His work of this decade reflected a dissatisfaction with his now fully developed Impressionist technique. He was aware of the nature of the unfavorable critical response to aspects of his work and was deeply concerned with resolving his pictures so that they would not run the risk of being seen as mere sketches, but clearly declare themselves as complete and considered statements in their own right. The

Right: Photograph of the Needle at Etretat and la Porte d'Aval at low tide. The Manneporte may be seen clearly in the distance.

Below: Although a popular tourist resort, Etretart still possesses a fishing fleet.

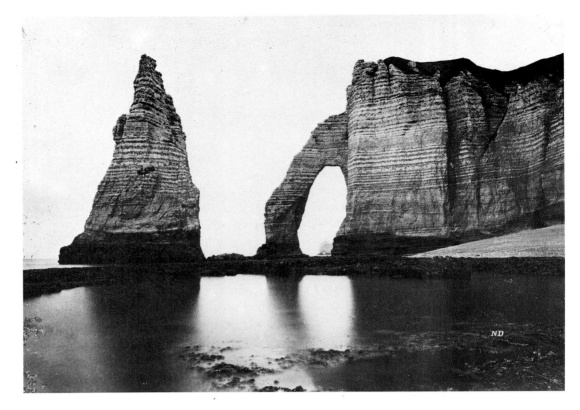

summer of 1880 saw his return to the Normandy coast where he experienced a period of revitalization, which was aided by an improvement in his rarely smooth relationship with Durand-Ruel. Monet received monthly payments from the dealer in return for a regular shipment of works, which were sometimes accompanied by letters warning the dealer of the hazards of the still-wet paint! Monet had at last entered a period of financial stability that would last until the end of his life. His growing sense of well-being must have been enhanced by the resolution of a number of complications in his personal life. The support of Alice was of great help to him. On each of his many trips away from his family he wrote to her daily and her letters to him arrived with the same regularity.

These letters record dramatic shifts in his self-confidence as a painter. Habitually, his first encounter with a site resulted in a feeling of great enthusiasm and elation, only to be followed by a rush of panic, linked with waves of terrible depression that were only thrown off with great difficulty. From his letters and the comments of contemporaries it is clear that he saw himself engaged in a combat with the elements, wresting his works of art from an unwilling and intractable nature.

The cliffs and beaches of Pourville, just a few miles west of Dieppe, and a little later the area around Etretat provided Monet with inspiration for numerous canvases. He began to work on the well-known motif of the spectacular cliffs at Etretat which reveal his continued desire to test himself against the painter heroes of his youth. In a letter written to Alice he revealed that he was planning a large painting of the cliffs, 'after Courbet.' These paintings often involved no small risk to himself; on one occasion he was nearly swept away by a wave as he painted the Manneporte from the beach.

In April 1883 he and his household moved to Giverny, a small village on the banks of the River Seine, half-way between Rouen and Paris. The move from Poissy, where he had been living and which he hated, was a complicated business. Not only was there his enlarged family, furniture, paintings, and studio paraphernalia to transfer to their new home, but also the four boats he now owned. Sadly, any happiness felt by their installation at Giverny must have been diminished by the news of the death of their close friend Manet.

Despite Paul Durand-Ruel's shrewd attempts to introduce Impressionism to

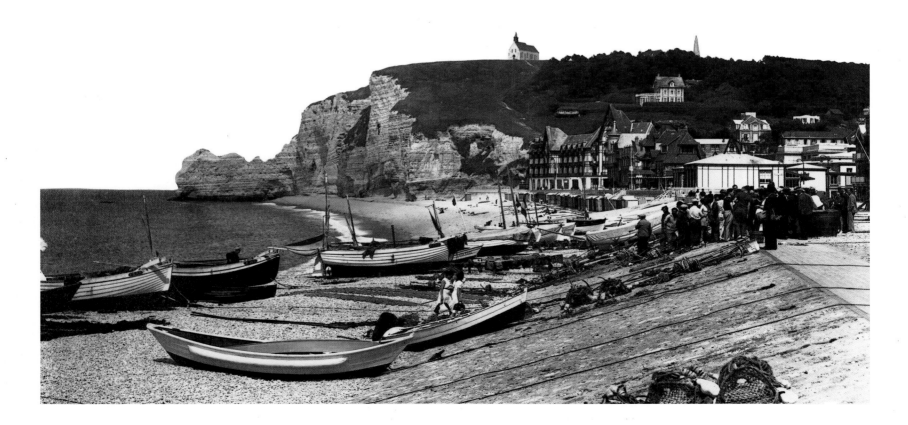

Right: *Portrait of Monet painting in his Bateau-Atelier* c. 1885-90, by Sargent. This virtuoso painting captures the spirit and excitement of working *en plein-air*. It is one of the few canvases in which the American artist comes close to an Impressionist style.

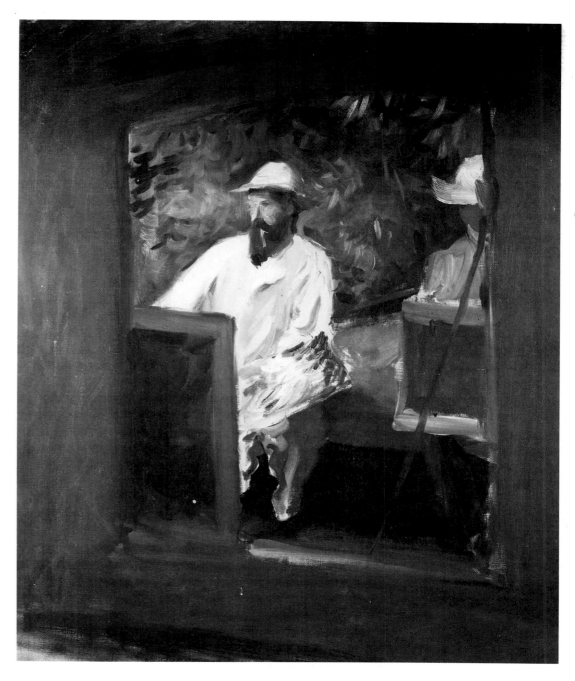

the United States, Monet refused to travel there himself. 'You have seen Durand's letter,' he wrote to Alice from one of his painting trips, 'He certainly has his mind set on my going to America, but nothing doing – my short trips are already far enough as they are.' Despite his refusal to travel to the States, it was his popularity among collectors there that was to be the main cause of his prosperity in the later part of his life.

Shortly after his move to Giverny, Monet painted a number of ambitious paintings which in their figurative bias hark back to works of the 1860s and early 1870s. In 1887 he wrote to his friend the critic Théodore Duret:

I'm working like never before, with new ideas, figures seen in the open air, as I understand them, painted as it were, like landscapes. It's an old dream that has always fascinated me, and that I would like, at least once, to realize; but it's so difficult! In the end I've done myself nothing but harm, as it has occupied me until it's almost made me ill.

Although not resolved into a series of major masterpieces as he may have wished, they nevertheless include the breathtaking paintings of Suzanne Hoschedé, a favorite model of Monet's, in a number of pictures which exploit the advantages of painting from unexpected viewpoints; from high above his model as in the *Barque at Giverny* of 1886-7, or from immediately below as in his *Woman with a Parasol* of the same period.

The next twenty years or so of his life were marked by a frenetic pattern of travel. He visited his stepson in Norway, made a succession of trips to London and made the obligatory pilgrimage to Venice. Within France he traveled not only to the Mediterranean coast, where he was to re-experience the shock of his first visit to that region in 1861, but also to the area around the Massif Central and to the wild shores of Belle-Île. The rugged coastline of that island afforded him ample opportunity to respond to one of his major preoccupations – the relentless battle of the elements which was to result in some of his most beautiful paintings. Another reason for his ceaseless traveling was his continuing and sometimes desperate search for a motif to correspond with his own sensibility. Even when such a landscape was found his troubles were not over. Gustave Geffroy, who had introduced him to the area around the River Creuse in the Massif

Central, received a letter, an extract from which indicates the extent of Monet's self-imposed difficulties:

I follow nature without the power to seize it; and then there is this river which falls and rises, one day green, then yellow, sometimes dry, and which tomorrow will be a torrent after the awful rain which is falling at the moment! To be brief, I am quite restless. Write to me; I am in great need of comfort.

During the 1880s Monet's work had moved away from the self-conscious concern with modernity that had been one of the major preoccupations of the 1860s and 1870s. His friends too, were reconsidering their painterly ambitions. Renoir, the artist who had been closest to him at that time, had turned his back on the landscape and had returned to the art of the museums to pursue his painting of the human figure and especially the female nude. Symbolism, in all its varied aspects, was now the vogue. As proof of this, the main attraction of the last Impressionist show in 1886 was the *Sunday Afternoon on the Island of la Grand Jatte,* Seurat's highly formalized and

synthetic interpretation of the riverside scene, familiar from so many Impressionist paintings. Monet's art of the later part of his life may be seen and analyzed in the light of the prevailing trends of this period. For most contemporaries there was no clear dividing line between Impressionism and Symbolism, as both were vague terms capable of infinite interpretations and Monet's paintings, possibly much against his will, were frequently talked about in the jargon of this latest artistic fashion.

In 1889 Monet's work was the subject of a retrospective exhibition at the highly fashionable Galerie Georges Petit which gave him the opportunity to review his career. It was during this period of self-examination that he organized the controversial public subscription to acquire Manet's *Olympia* for the nation, by doing so, consciously or otherwise, Monet was also securing recognition for a genealogy that would consolidate his own future reputation. Having reached his middle age and now a prosperous man, he relished the material pleasures and comforts that success made available to him. He was, for

example, to become a great connoisseur of motor cars. His prices reflect this improved financial position. In 1883 he could ask 500 or 600 francs for his canvases. Six years later Theo Van Gogh, Vincent's brother and a dealer in sympathy with the avant-garde, sold one of Monet's Antibes paintings to an American collector for 10350 francs, a considerable sum of money at the time.

In 1888 Monet found a subject that was once again to put him at the forefront of the contemporary avant-garde. It was a key year in the development of European Symbolism, the year that Gauguin painted his *Vision after the Sermon* and Van Gogh painted his now much celebrated series of *Sunflowers*. Monet embarked upon a group of highly unusual paintings of haystacks, or, as they should more correctly be called, grainstacks. In May 1891, 15 of his 22 canvases of the subject were shown at Durand-Ruel's gallery and all were sold within three days. The paintings were successfully received by critics, buyers and the public, despite the obvious fact that the artist's main concern was the depiction of highly exaggerated color effects, unexpected harmonies and eccentric compositional ideas. The paintings also exhibited an ever more free and expressive brushmark combined with a generality of drawing that was unique in the art of that time. His friend Pissarro, who was still experiencing difficulties in selling his own work, wrote rather caustically:

People want nothing but Monet's . . . Worst of all they all want Stacks at Sunset! Always the same story, everything he does goes to America at prices of four, five, and six thousand francs.

Monet was motivated by a desire to render his feelings before nature and felt no need to record any kind of precise topographical reality. He wrote:

I am driven more and more frantic by the need to render what I experience. Working so slowly I become desperate, but the further I go the more I see that one must work very hard to succeed in rendering what I am looking for: 'Instantaneity,' especially the envelope, the same light that diffuses everywhere and, more than ever, things which come easily and at once disgust me.

In the early 1890s Monet turned away from the study of the landscape to work on a cycle of paintings dedicated to the great Gothic cathedral at Rouen. In February 1892 he rented a room on the first floor of 81 rue Grand-Pont directly opposite the Cathedral. He was suffering from rheumatism which made prolonged periods in the open air unwise and this fact as much as any other may have determined his choice of a subject that he could work on at his leisure behind closed doors. Unlike natural phenomena it was hardly liable to drastic organic change, but merely to respond to the inevitably changing effects of light and atmosphere.

The old houses from where Monet painted were destroyed in 1940 and the present-day buildings no longer correspond exactly to the former street plan. This is unfortunate because the paintings of the Cathedral façade present a good example of Monet's working practice. The closeness of his viewpoint to the Cathedral, directly opposite the Tour de Beurre, to the southwest of the central portal, meant that the building presented itself ready-framed by the window, its stonework filling his field of vision and producing the cut-off composition that we are familiar with from Monet's canvases of the subject. He stayed in Rouen until April and then returned again in March for several weeks more, then, as was his usual practice, work continued in his studio, away from the motif. Monet, his family, friends and biographers fostered the myth that he painted only from nature. Theoretically it is a relatively simple matter to deduce the places in which Monet has continued to develop a canvas that has previously been worked on. Wet paint laid on top of an already dry layer of paint will reveal on its surface the textured trace of the paint beneath it. Such reworkings could possibly be the result of a return trip to the same spot at some later date, but usually they record the traces of substantial studio-based work. Photographs of the artist show him working on canvases in the studio; although many, if not all, of these photographs were posed

and may not necessarily depict an actual working session. Later working sessions in the studio were the artistic norm rather than otherwise. Many artists including Wassily Kandinsky (whose encounter with one of Monet's stacks was a decisive turning point in his thinking about art), have also felt the limitations of paintings made directly before the motif and have preferred to work at one remove from the experience and situation that engendered their paintings. Monet would never have agreed with Degas that, 'a picture is something that requires as much trickery, malice, and vice as the perpetration of a crime, so create falsity and add a touch from nature.' Nevertheless much of Monet's skill lay in producing work that looked as though it had been begun and finished in the open air when, in fact, much of the final effect of the pictures was created by paint applied in the studio.

In May 1895 20 canvases of the Cathedral series, which in their entirety may well have originally numbered over forty, were exhibited at Durand-Ruel's Paris gallery. It was a great success and a number were sold at the then very high price of 15000 francs. His close friend the politician and writer Georges Clemenceau wrote an article published in the journal *La Justice* entitled 'Révolution de Cathedrales.' In it he interpreted the series from a materialist as opposed to the religious standpoint that their subject may initially suggest. He considered the exhibition as a group of separate moments brought together by the artist to be experienced as a complete unit in itself and not as a collection of individual works. He unsuccessfully urged the state to purchase the whole series. Twenty-five years later he did achieve his aim when he was instrumental in the acquisition of Monet's water lily series for the French nation. He was not alone in realizing the significance of Monet's highly original exhibition. Camille Pissarro wrote to his son Lucien: 'If only you would get here before Monet's show closes; his "Cathedrals" will be scattered everywhere and these particularly ought to be seen in a group.'

By exhibiting his paintings as a group, Monet made the series a tangible record of the changing mood and consciousness of the artist before the motif, showing that any expression of external reality is inevitably interlocked with the psyche of the artist. They represent his conscious attempt to build an art based upon his own accumulated perceptions and his

deliberate eschewal of traditional art practice. Although it should be noted that these developments in Monet's art sprang not from self-conscious theorizing, but were firmly founded upon his own empirical study of reality.

From as early as 1880 Monet had been planning to return to London, and his friends were aware of his ambition to paint a series based upon the particular atmospheric effects of the great smog-shrouded metropolis. In September 1889 he arrived

in the capital and began the first of several painting expeditions that continued until 1901. Monet focused his attention on the silhouettes of Hungerford Bridge at Charing Cross and the Victorian Gothic Houses of Parliament. Whistler, who had become close to the artist in the 1880s, had also made the river the subject of many evocative canvases. His famous *10 O'Clock* lecture includes the following lines, which must have been as familiar to Monet as were his friend's paintings:

Below right: Photograph of Monet taken by Baron Mayer, 27 October 1905.

Below: J M W Turner *The Dogano, San Giorgio, Citella, from the Steps of the Europa*, exhibited in 1842.

Right: Monet's garden at Giverny.

And when the evening mist clothes the river-side with poetry, as with a veil, and the poor buildings lose themselves in the dim sky, and the tall chimneys become campanili, and the warehouses are palaces in the night, and the whole city hangs in the heavens, and fairyland is before us.

Monet's paintings are very different from Whistler's but the American's insistence upon the primacy of the artist's carefully nurtured sensibility and his idea of the work of art as a quintessence of recollected experience transformed into a harmonious and unified decoration must have had an effect upon him.

On 11 March he wrote to his step-daughter, Blanche (who through marriage to his son Jean, was also his daughter-in-law):

A moment ago, I began my fiftieth canvas. That is to say, that I seldom remain without painting and that things change so often here, it's enough to drive me crazy.

The Duc de Trevise recorded that he found Monet surrounded by a hundred canvases

in his Savoy Hotel room and as always with this painter we do not know how many he may have later destroyed. A few months before the exhibition of these paintings was due to open in Paris he wrote to Durand-Ruel:

I cannot send you a single London canvas, because, for the work I am doing, it is indispensable that I have them all before my eyes . . . I develop them all together . . . and I do not know yet how many I will be able to exhibit, because what I am doing now is very delicate.

After the inevitable retouching and re-working in the studios back home in France, he exhibited 37 of the paintings at Durand-Ruel's entitled *Vues de la Tamise à Londres,* which ran from May until June 1904.

In the same year he made a trip by car to Madrid with the express purpose of studying the paintings of the seventeeth-century painter Diego Velasquez. The work of Velasquez was much in vogue at this time and was considered by some critics to be the truest and earliest example of Impressionism. According to this school of

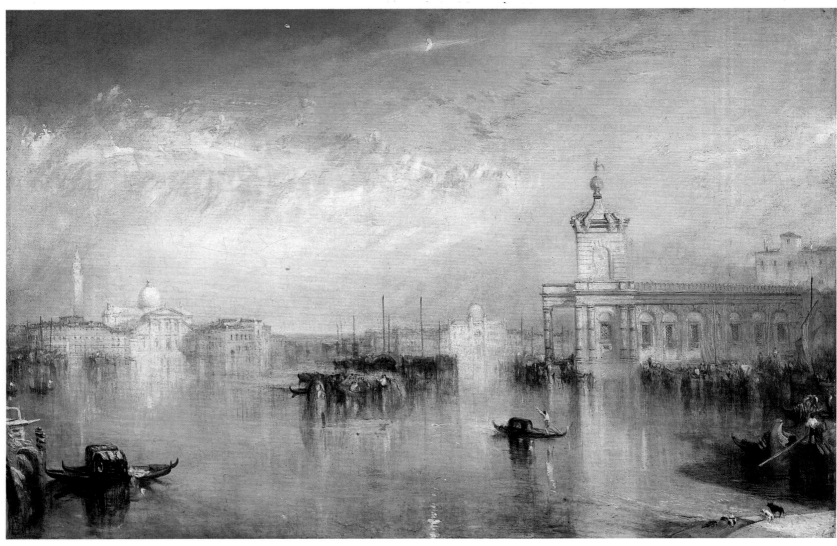

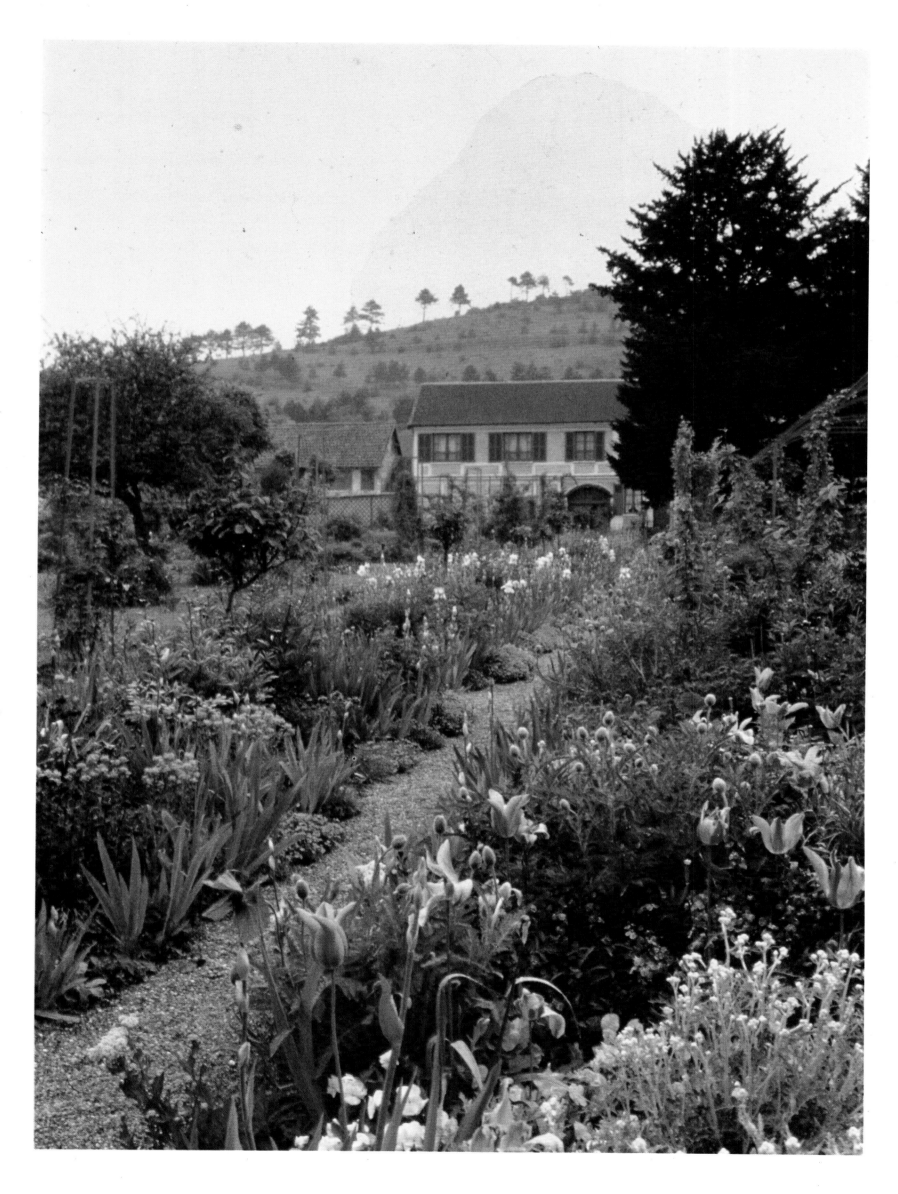

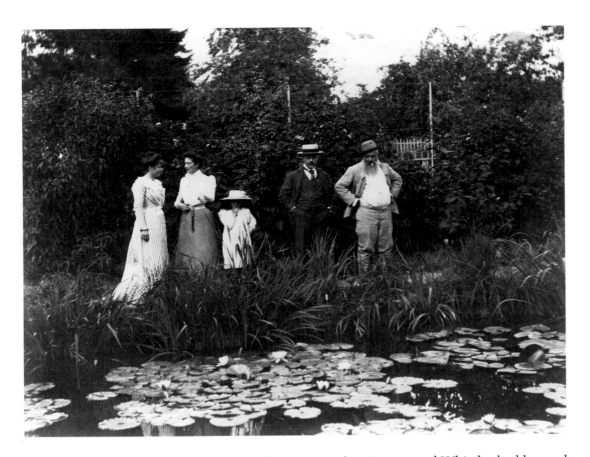

Carolus-Duran had adopted Velasquez's style to their own ends. There is little overt influence of the artist on Monet, although his study of the paintings must have consolidated his belief in the primacy of the 'impression' as the basis of his art.

In 1908 he traveled to Venice, which being surrounded and cut into by water, gives the impression of having been designed specifically to capture and reflect light. It offered Monet, as it had Turner and countless other artists, the opportunity to study a host of spectacular optical effects. One can imagine Monet, Baedecker in hand, content with the most familiar of topographical views of the city, unlike Whistler, who in the 1880s had combed the narrow canals for interesting or unusual compositions. Monet admitted to experiencing great difficulty with these paintings, partly for the reasons discussed below, and, as he had done with his Rouen series, they returned with the artist to his studios at Giverny to be beaten into shape.

thought, Impressionism was not to be characterized by the use of a brilliant palette and broken brushwork but in the creation of a harmonious ordering of visual perception. Many of Monet's circle such as Courbet, Manet, and Whistler had learned a great deal from Spanish painting and well before the end of the century artist friends like the American Sargent and the successful high-society French portrait painter

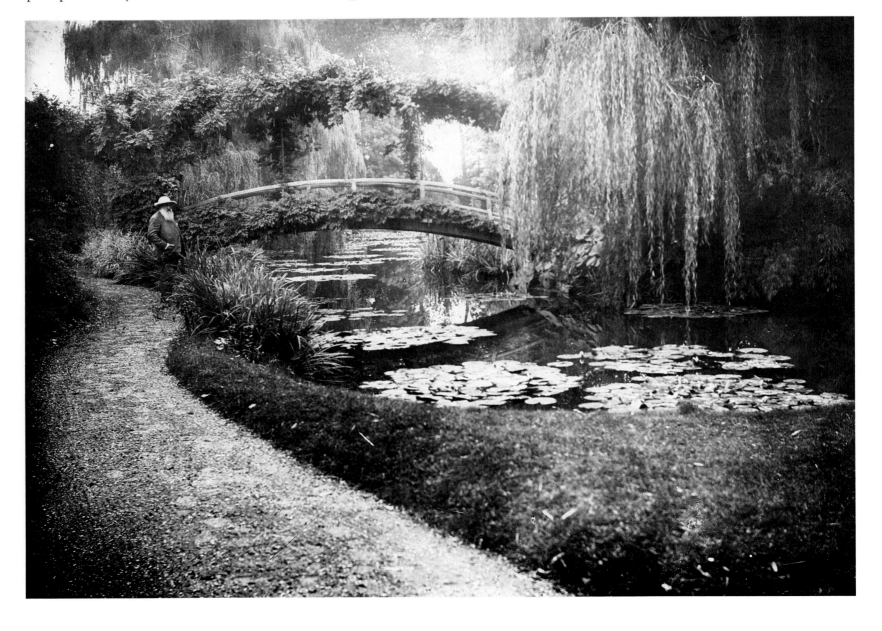

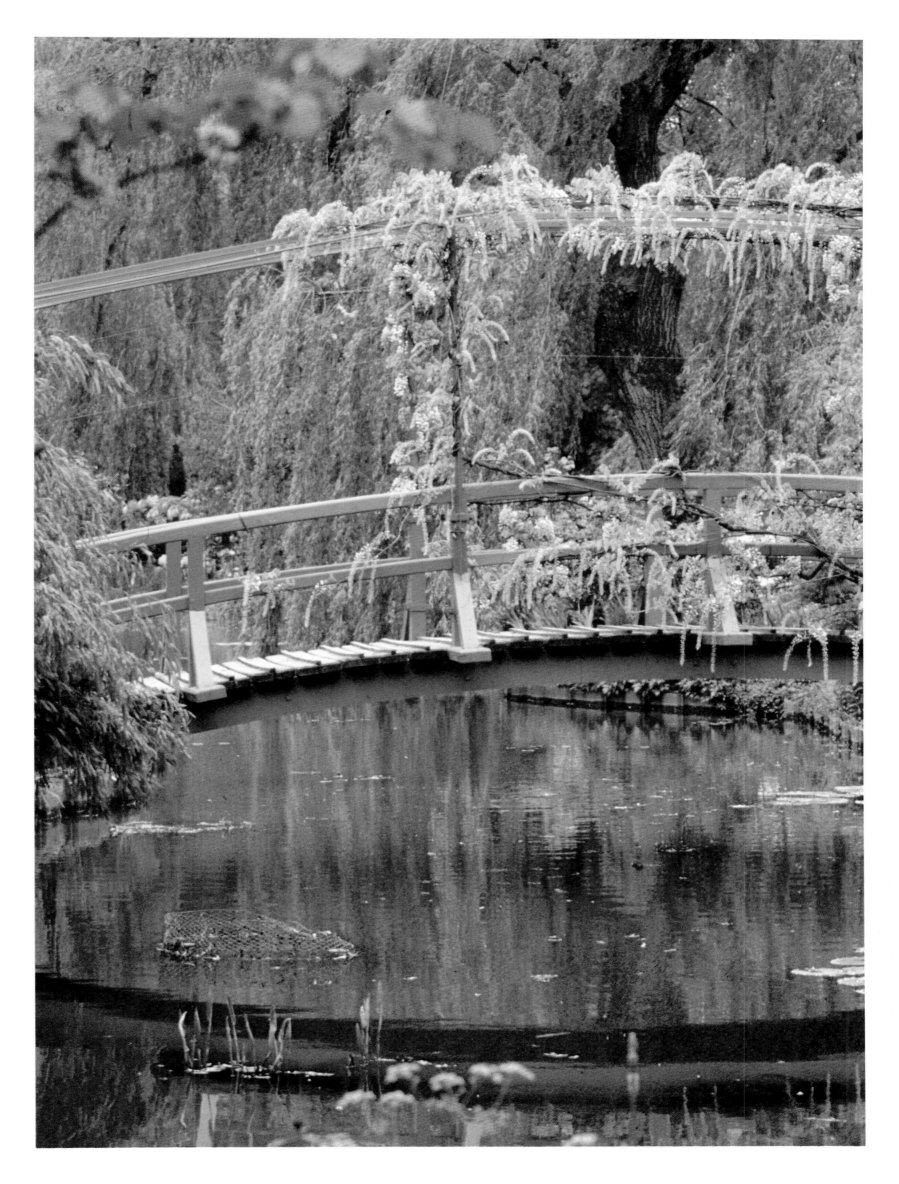

Left: Monet painting a version of *The Flowering Arches*, illustrated on page 176.

extensions of the boat subjects of the 1890s but differ in their use of the reflective qualities of the water surface. As time progressed he omitted any reference to the surrounding landscape from his canvases and the only evidence of the sky was the reflected blue scattered in a broken pattern across the surface of the lily-strewn pond. In 1902 the American painter Mary Cassatt wrote: 'Monet is painting a series of reflections in water; you see nothing but reflections.' After several difficult years working on the paintings, Monet was eventually happy enough with the results to exhibit them in 1909 as a group entitled *Les Nymphéas, Paysages d'Eau* at Durand-Ruel's Paris gallery. The show was a resounding success with contemporaries and again it was noted with sadness the inevitable dispersion that would follow the closing of the exhibition.

In 1916 the famous sculptor Auguste Rodin donated his life's work to the nation and his example may have strengthened Monet's resolve to leave a similar memorial dedicated to his own work. Prolonged periods of depression, perhaps exacerbated by fears for his eyesight, made it difficult for him to continue with his work but these bouts rarely stopped him painting, although some of his output from the late years did not survive the effects of the artist's destructive and self-critical nature. In 1922 he engaged in an orgy of picture burning and the number of canvases destroyed is not known.

Gradually Monet began to pursue the idea of creating a suite of paintings based upon his gardens at Giverny that would hang together permanently as a single unit in a purpose-built gallery. The water-lily pond and its surrounding gardens became the basis of some of the most extraordinary and bizarre paintings in European art, so original in conception and execution are they that despite their popularity and familiarity they still take some deciphering, even by modern-day viewers.

As the First World War ran its course, Georges Clemenceau and Monet's old friend Gustave Geffroy persuaded the painter to continue work on a large decorative frieze based upon his water lilies which would be housed in a special museum. It was initially planned as a morale-boosting action, to celebrate the glory of the nation emerging from the dark shadows of the war years. The plan was kept secret and after a catalog of delays and misunderstandings, eventually the cycle of

In 1912 the critic Octave Mirabeau wrote the catalog introduction to an exhibition of the Venetian works which was held at the Galerie Bernheim-Jeune in Paris:

The light arranges and reveals the objects . . . When the sun is high, the atmosphere applies itself and sumptuously gives body to the vertical surface of the walls and the horizontal surface of the water; it is mixed with the color as though it had passed through the rose of a stained glass window.

In 1911, when Monet was over 70 years old, his second wife, Alice, died and a few years later, in 1914, he lost his eldest son, Jean. That same year the catastrophe of the Great War engulfed the landscape of Northern France. Added to these terrible events, Monet's sight had become an increasing cause for concern and in 1912 cataracts were diagnosed which eventually led to a series of hazardous operations. After his trip to Venice in 1908 he made no further major journeys and concentrated his energies on the gardens he had created at Giverny. Growing in the garden were not only the traditional French garden

plants but also more exotic species such as bamboo, rhododendron, and Japanese flowering apple and cherry trees. Artfully placed weeping willows and irises lined the pools to offer interesting perspectives and to present different effects as the seasons changed. Monet planted and planned the garden with the possibility of painting its magical landscape never far from his mind. In 1890, before his first attempts to paint the water lilies, he wrote to his friend Gustave Geffroy:

Once more I have undertaken things which are impossible to do; water with grasses waving in the depths . . . It's wonderful to see but it drives you mad to want to do it. But I am always trying things like that.

A month later he continued on the same theme:

I am bitterly and profoundly discouraged with painting. It is certainly a continual torment! Don't expect to see anything new, the little I've been able to do recently is destroyed, spoiled, or torn up.

His paintings of the lily pond are clearly

Monet had traveled a long way from his early depictions of an idealized bourgeois life-style of picnics and days in the country to this sustained contemplation of the nature, most reminiscent of Chinese landscape painting. The essence of his work lies in his ambition to record the profundity of one person's meditations upon the external world and the basic desire of humanity to share its experience in visible form. As Turner noted.

He that has that ruling enthusiasm which accompanies abilities cannot look superficially. Every glance is a glance for study . . . Every look at nature is a refinement upon art. Each tree and blade of grass or flower, is not to him the individual tree, grass or flower, but what it is in relation to the whole, its tone, its contrast and its use, and how far practicable: admiring Nature by the power and practicability of his Art, and judging of his Art by the perceptions drawn from Nature.

paintings was opened to the public in the year after the artist's death. Monet had wanted to create a mood of quiet meditation and originally the building contained a large vestibule which had been designed specifically to act as an antechamber, separating the bustle of the busy city and the incessant traffic outside from the rarified, mystical nature of the exhibits on the walls of the oval galleries within.

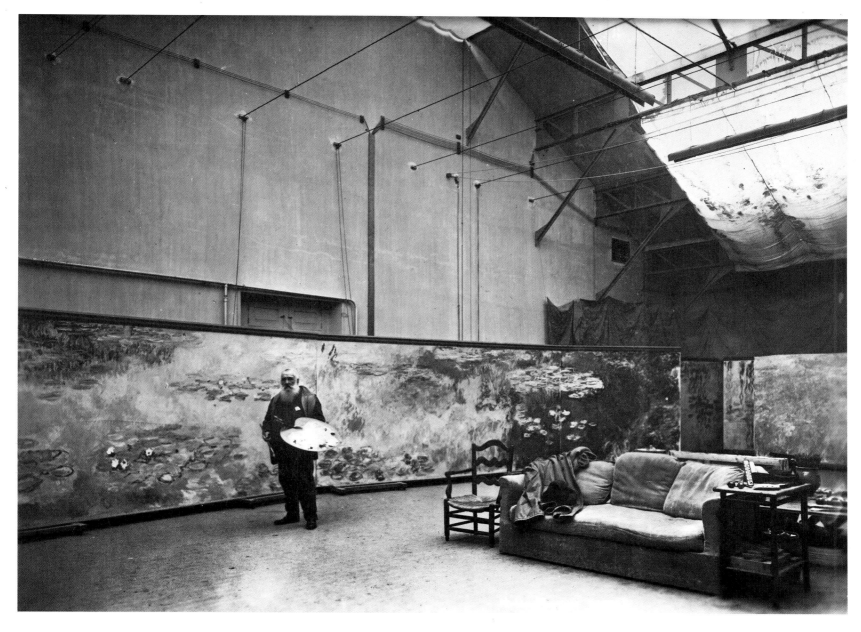

The Early Years

1840-1870

The work of Monet's early years is of interest not only for its own qualities, but also because it forms the basis of the work for which he is better known. From the outset Monet's art was motivated by his confrontation with visual reality. In this he was continuing the tradition initiated by the Barbizon painters of the previous generation and the art of his friend Eugène Boudin. He paid great attention to the structure of his pictures, producing works that have a weight and mass that correspond to the physical facts of the external world.

Monet considered his *Normandy Farmyard* of about 1863 to be his 'first big picture' and it reveals the extent of his debt to Boudin and the Barbizon painters in its use of thickly encrusted impasto paint and abrupt divisions of tone. Its pleasing aura of rustic solidity is enhanced by the broad slab-like brushmarks that describe the forms and the rather naive way in which each element in the picture is balanced by a partnering shape within the composition. Even at this date Monet's concern for creating a strong surface pattern across the canvas is apparent in his avoidance of any dramatic spatial recession. The trees and farm buildings form a solid mass, repeated in the conventionally considered reflections of the pool which add a further stabilising force to the composition. The discrepancy between the scale of the farm laborer and the farm animals gives an extra charm to the painting.

Monet's concern with topographical reality may be appreciated in his two paintings of the *Rue de la Bavolle at Honfleur*, one of which is illustrated here. It reveals his interest in the changing effects of light upon an essentially static scene, in this case, the simple architecture of a street. Although light had played an important role in his earlier painting of the farmyard scene, here it comes to the fore as the major articulating force of the picture. The rather generalized light effects of the former painting have been exchanged for a highly particularized evocation of a specific moment in time.

By the mid-1860s Monet had emerged as a determined and independently minded artist, whose work would be a catalog of ambitious self-directed experiments. The first major example of his originality was his attempt to paint the large-scale composition of the *Déjeuner sur l'Herbe* which he began in 1865 and worked on until 1866. To preserve the éclat of actuality he followed the usual procedure, making a series of vivid sketches of the setting which would serve as records or aide-memoires for his picture. One of these sketches, *The Road from Chailly to Fontainebleau*, was brought to a degree of finish that rendered it acceptable to the Salon jury of 1866. The *Déjeuner* only survives in fragmentary form, although a sketch for the ensemble reveals his project to have been a celebration of middle-class life. For all his interest in modernity, Monet's painting was a carefully processed view of reality. Like a modern-day advertising executive, he has presented his audience with an idealized view of their own lifestyle, the sun shines, there is food and wine for all and even a footman waits on to attend to the needs of the merrymakers.

Monet's subjects correspond with his movements from Paris to his father's house on the Normandy coast and include 'twenty canvases . . . some stunning marines, and figures and gardens, in a word, everything.' His scenes of the coastline are freshly handled within a simplified tonal range and eschew the polished finish and chiaroscuro effects of contemporary art practice. Two of his paintings of 1867 take contrasting approaches to the same motif; one shows a number of holiday makers admiring the regatta at Sainte-Adresse, the other shows the same beach, seen from almost the same viewpoint, in which a solitary sightseer looks out to sea, outnumbered by a small group of fishermen who stand conversing close by their boats. By painting the pictures as a pair, Monet was obviously interested in exploring the changes that a landscape undergoes when subject to different atmospheric conditions, but, consciously or not, he has also produced a social document which reflects the gradual takeover of the channel ports by the tourist industry. With its bold composition, high-keyed color, and its sense of studied informality the regatta picture makes an interesting comparison with Seurat's work of the 1880s, such as the famous *Bathers at Asnières* and the *Sunday Afternoon on the Ile de la Grande Jatte*.

Monet's love of the sea is evident in many of his works. The *Blue Wave* of 1865 captures the thrill of a boat cresting through the open sea, the undulating mass of the water caught in a single sweeping movement that dominates the entire canvas. The high horizon line and the placing of the boats add to the immediacy of the scene. A certain roughness of finish was tolerated in what were considered to be the comparatively minor genres of landscape and seascape. Some of Monet's paintings such as his *Seascape: Storm* have a brevity and surety of handling that may remind the modern viewer of paintings from the early years of the twentieth century. Unlike paintings of more recent times however, these were intended as sketches for larger, more finished works. In his *Women in the Garden* of 1867 Monet attempted to use such techniques as ends in themselves to produce a large picture entirely out of doors. The difficulties inherent in the project remain clearly visible in the final canvas. His deliberate avoidance of conventional ways of painting may be seen in many different parts of the picture, and especially in the blue and violet reflections on the principal figure's face and its overall brilliance of coloration. His refusal to comply with the traditional conventions of chiaroscuro and narrative is proclaimed in the flat coloration of the stiff fashion-plate figures and boldly simplified shallow space of the garden setting. The painting of *Jeanne-Marguerite Lecadre in the Garden* was probably painted while he was working on his *Women in the Garden*, and explores the same concerns on a more modest scale. The figure of Jeanne-Marguerite is seen from the back promenading in the family garden. Simple oppositions of light and shade dramatize the brightness of the sunlight which floods into the garden. The whiteness of her dress and parasol create an effective foil against the sharply contrasting tones of green in the garden.

During the first months of 1869 Monet produced a number of snowscapes which are small miracles of painting. *The Magpie* is an extraordinary evocation of the snow-bound chill of a late winter's afternoon. The blueness of the long shadows creates a delicate contrast with the creamy whites of the sky and landscape. In spite of these qualities it was rejected from the Salon of 1869.

Monet's views of Paris are as recognizable to a twentieth-century audience as they would have been to the people of his own time. Monet was given permission to paint from an elevated vantage point in the Louvre. Three of the paintings that survive from this period record the different views available to him from this unusual viewpoint. *Saint-Germain l'Auxerrois* was painted in the spring of 1867, the ordered architecture contrasting sharply with the untidy foliage of the trees and random groupings of the figures beneath. The figures are described with notational brushstrokes; they wander about the square with the casual movements of Sunday promenaders as unaware as the cab-horses that they are the subjects of the artist's scrutiny. No picturesque conventions interfere with the picture; no passing parade or church procession adds an easy popular appeal to the scene, a decision helped, perhaps, by Monet's awareness of contemporary photography. In the *Garden of the Princess* and its partnering canvas, *The Quai du Louvre*, Monet again used his elevated position, familiar from photographs of the period, to great effect. These paintings present views which contain important buildings, but the arbitrary and even awkward manner in which Monet has chosen to depict them denies them much of their cultural significance.

Monet left many intimate and touching images of his wife, family and home environment which appear intermittently throughout his work until the late 1880s. There are few single full or even half-length portraits in Monet's oeuvre. He seems to have been relatively uninterested in the genre and rarely attempted to produce the penetrating psychological studies that we associate with Degas. His 1866 portrait, known as *The Green Dress*, of his companion Camille Doncieux was a conscious attempt to woo the art-buying public, and his later portrait of *Madame Gaudibert* reveals little of the inner life of the sitter. His paintings of his family fulfil the very human desire to document aspects of his personal life, and of course an artist's family represents an invaluable source of available, cheap and reliable models. Two of his early depictions, *The Cradle – Camille and the Artist's Son Jean,* of 1867 and the famous *Luncheon* of 1868, are interesting for these reasons and also because they were painted when the artist was apparently desperately short of money. Paradoxically, both images present a lifestyle complete with nurse and maidservant that suggests a standard of living below which he, or perhaps Camille, was determined not to fall. In the *Luncheon* the viewpoint is that of the artist standing in the doorway looking into the room. The artist himself is absent from the scene as he is after all engaged in painting it. His presence is suggested by the chair set at an angle to the table, where a place is set ready for him and a newspaper, *Le Figaro*, lies folded ready for him to read. Like many of Monet's paintings of his family, it is constructed with a novel sense of casual intimacy that is most attractive; although unsentimental in tone it reveals a deep attachment to his subjects. This particular work may be seen as a development of Edouard Manet's images of the domestic life of the middle classes and Monet may have modified his domestic circumstances to appeal to their tastes. The painting's impressive size and its deeply enigmatic and evocative atmosphere made it a model for later painters like Caillebotte, Signac, Vuillard, and Matisse.

A number of Monet's works stand out both for the radical nature of their technique and for the effective way in which they evoke a sense of place. Many, such as the *Cliff at Etretat* c. 1868, and *Rough Weather, Etretat*, of 1868-9, were of subjects that he developed into a number of famous canvases in later years. Some, such as *On the Seine at Bennecourt* of 1868 and the famous series of sketches at La Grenouillère establish the parameters of the Impressionist technique which would serve as the basis for his art of the next decade. The painting of the riverbank once again shows Camille, this time seated under a tree gazing across the water at the bank beyond. In its synoptic handling and broken patches of paint, each interlocking to form a powerful unity of touch across the canvas surface, the painting represents a milestone in the development of Monet's art. The blues and pinks counterpointed by the range of greens create a simple and effective sequence of color. Monet has used the reflections on the river to continue the line of buildings that are obscured by the abundant foliage that covers over a third of the canvas. Camille's face, considering the closeness of her relationship with Monet, has been treated in a surprisingly severe manner, defined by a single patch of paint set squarely against the parallel line of the inverted reflection of the building on the other side of the river. Monet's painting makes great play of the tension between the physical flatness of the canvas surface and the illusion of depth that the layer of paint creates. The abbreviations in the painting reinforce the feeling that the canvas could only be a sincere and truthful response to the problems posed by painting in the open air. The necessary speed with which the artist was forced to work resulted in many of the painting's formal inventions. Vertical strokes of violet suggest the structure of the tree trunk and the light reflected from the sitter's blouse, while fluid, loosely bonded areas of paint convey the impression of the flat surface of the water.

In 1874 Jules-Antoine Castagnary, the first critic to be favorably disposed to the Impressionists, wrote of Monet and his friends that 'They are impressionists in the sense that they render not a landscape, but the sensation produced by the landscape.' Many volumes have been written on Impressionism and how it should most exactly be defined, but this brief perceptive statement together with *On the Seine at Bennecourt* or one of the views of La Grenouillère contain the basis from which any debate on the subject should be developed.

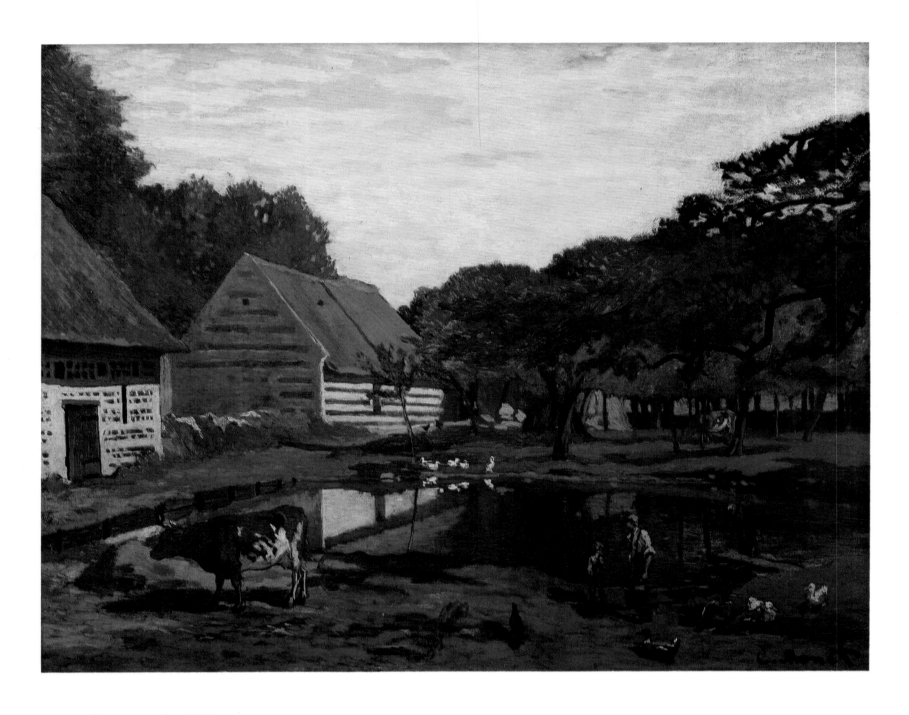

Normandy Farmyard c. 1863
Oil on canvas
25½×32in (65×81.3cm)
Musée d'Orsay, Paris

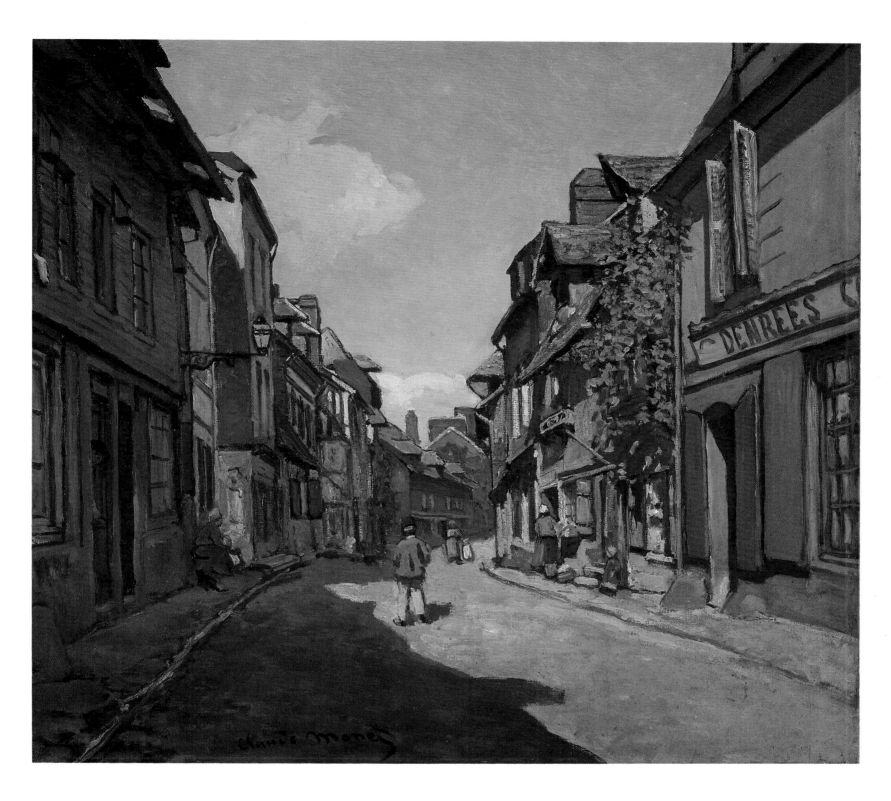

Rue de la Bavolle, Honfleur 1864
Oil on canvas
22×24in (55.9×61cm)
Museum of Fine Arts, Boston

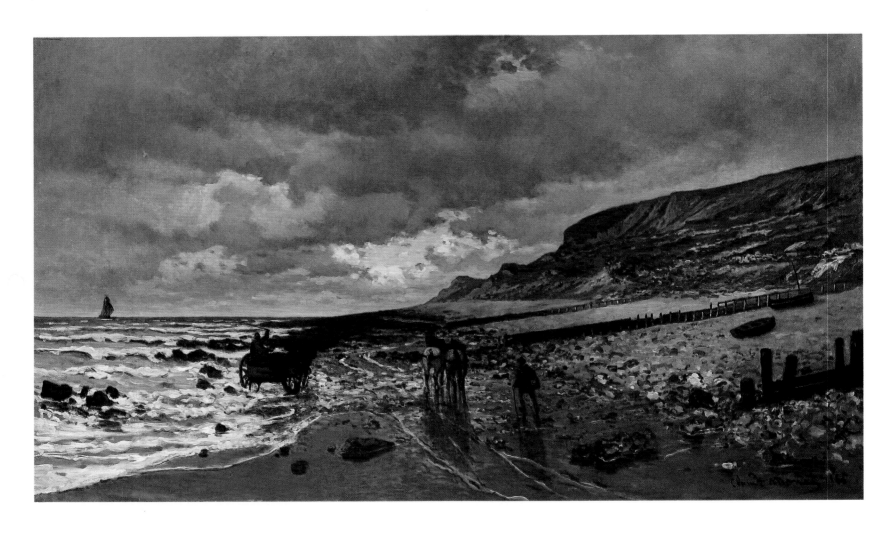

La Pointe de la Hève at Low Tide 1864-65
Oil on canvas
35½×59¼in (90.2×150.5cm)
Kimbell Art Museum, Fort Worth, Texas

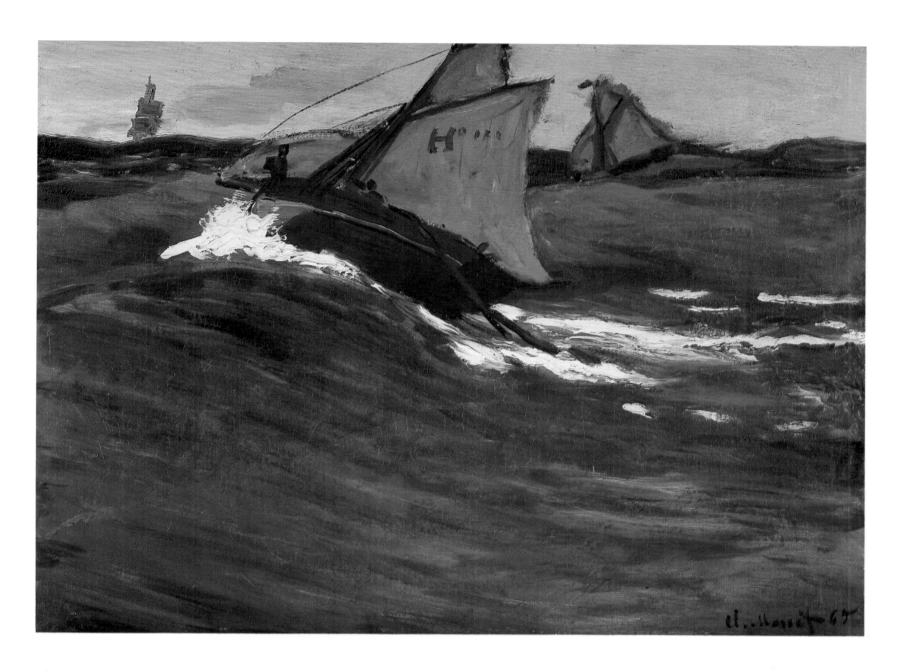

The Blue Wave 1865
Oil on canvas
19¾×25½in (48.6×64.8cm)
Metropolitan Museum of Art, New York

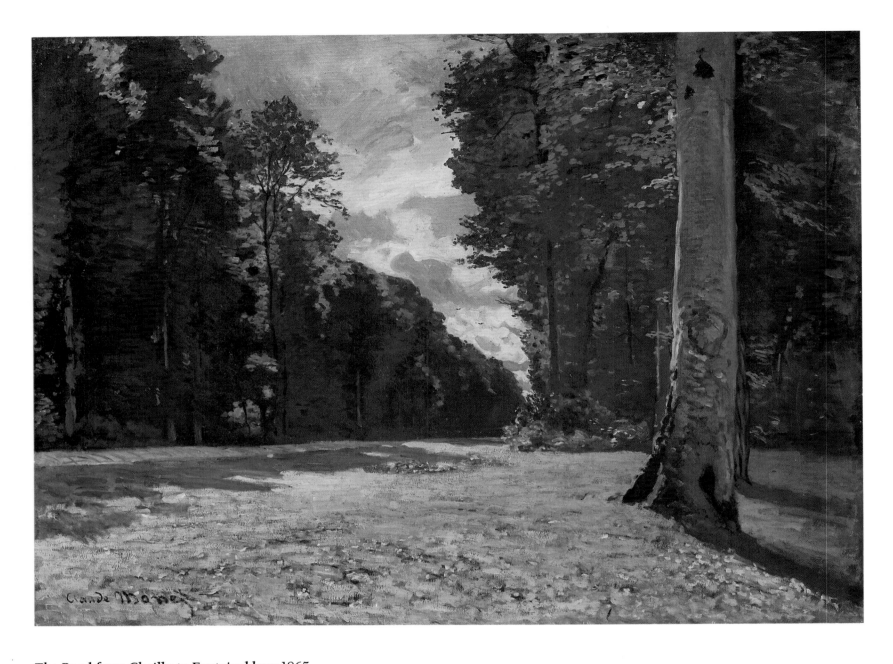

The Road from Chailly to Fontainebleau 1865
Oil on canvas
38¼×51¼in (97×130cm)
The Ordrupgaard Collection, Copenhagen

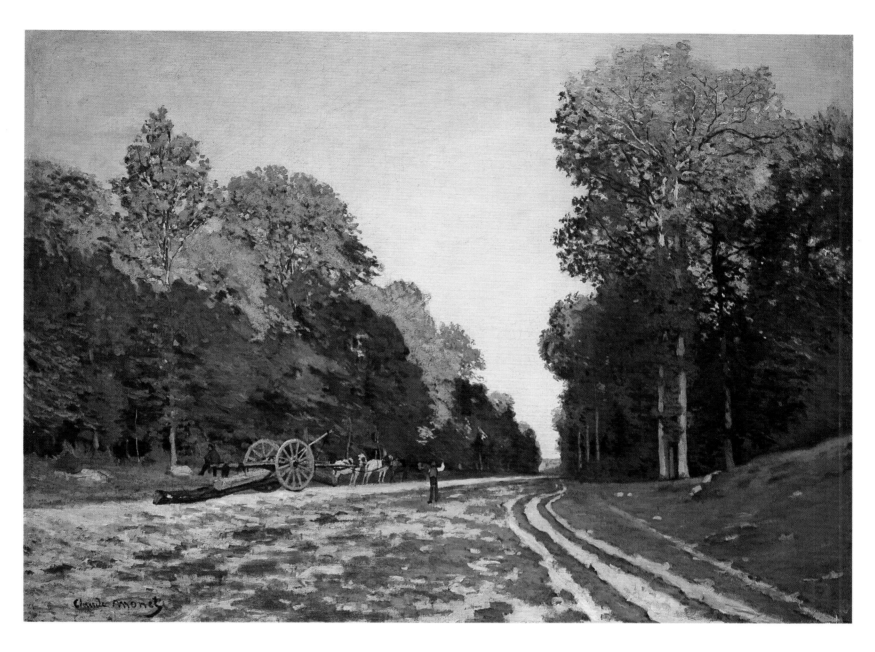

The Road from Chailly to Fontainebleau
1864-65
Oil on canvas
38½×40½in (98×103cm)
Private Collection

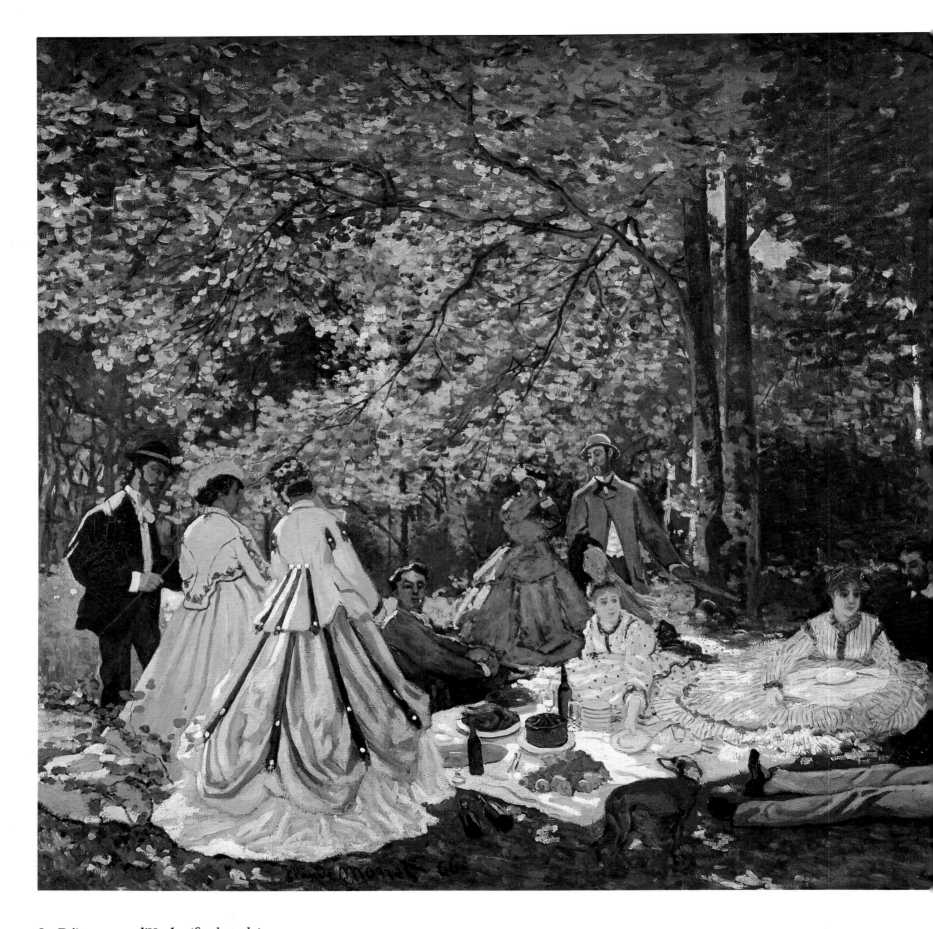

Le Déjeuner sur l'Herbe (final study)
1865 (dated 1866)
Oil on canvas
51¼×71¼in (130×181cm)
Pushkin Museum, Moscow

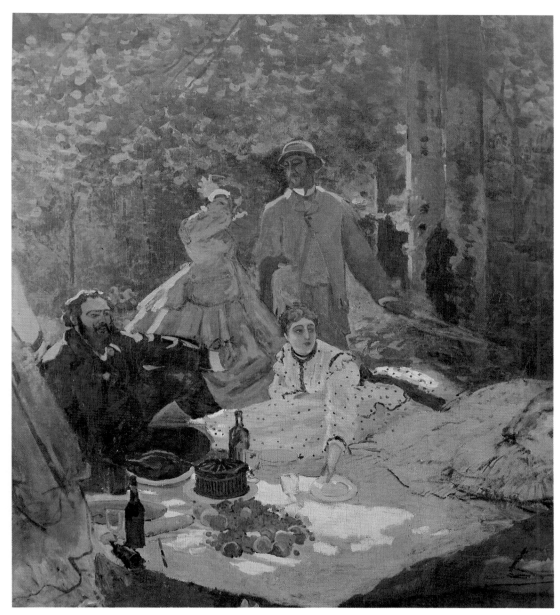

Le Déjeuner sur l'Herbe
(fragment, central area) 1865-66
Oil on canvas
97½×59in (248×150cm)
Eknayan Collection, Paris

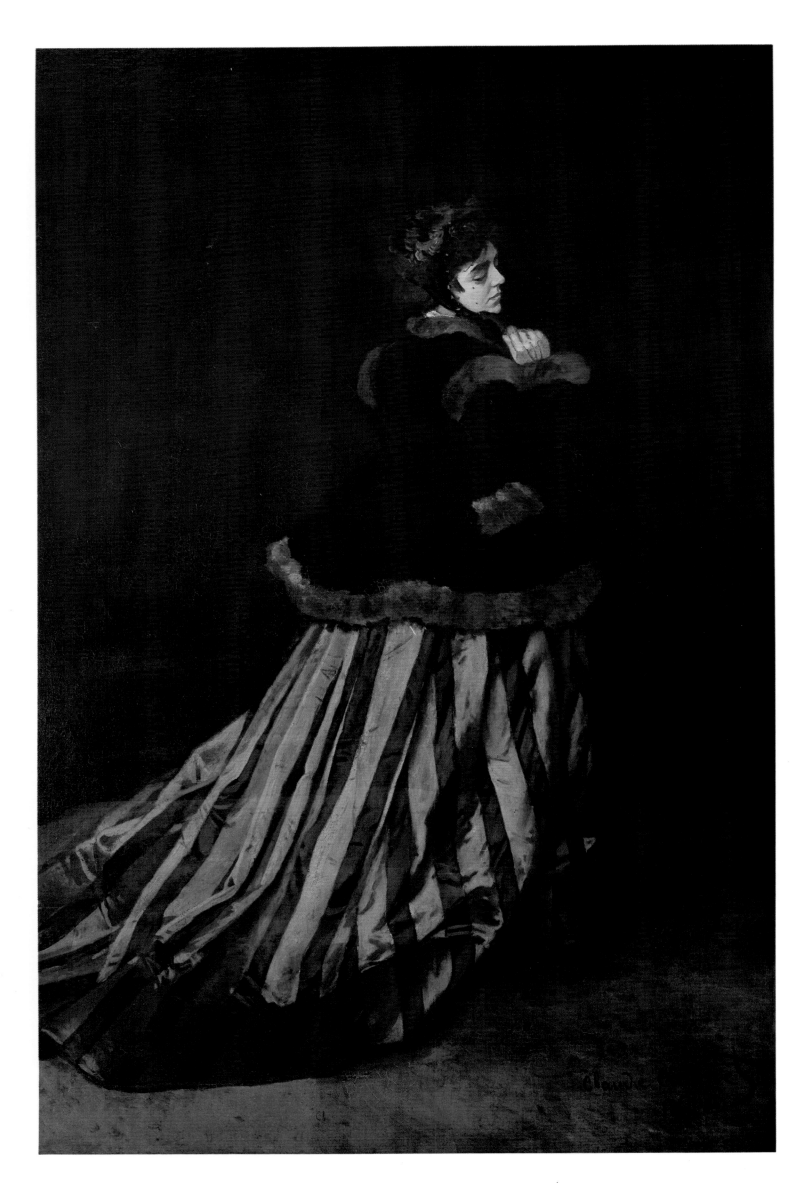

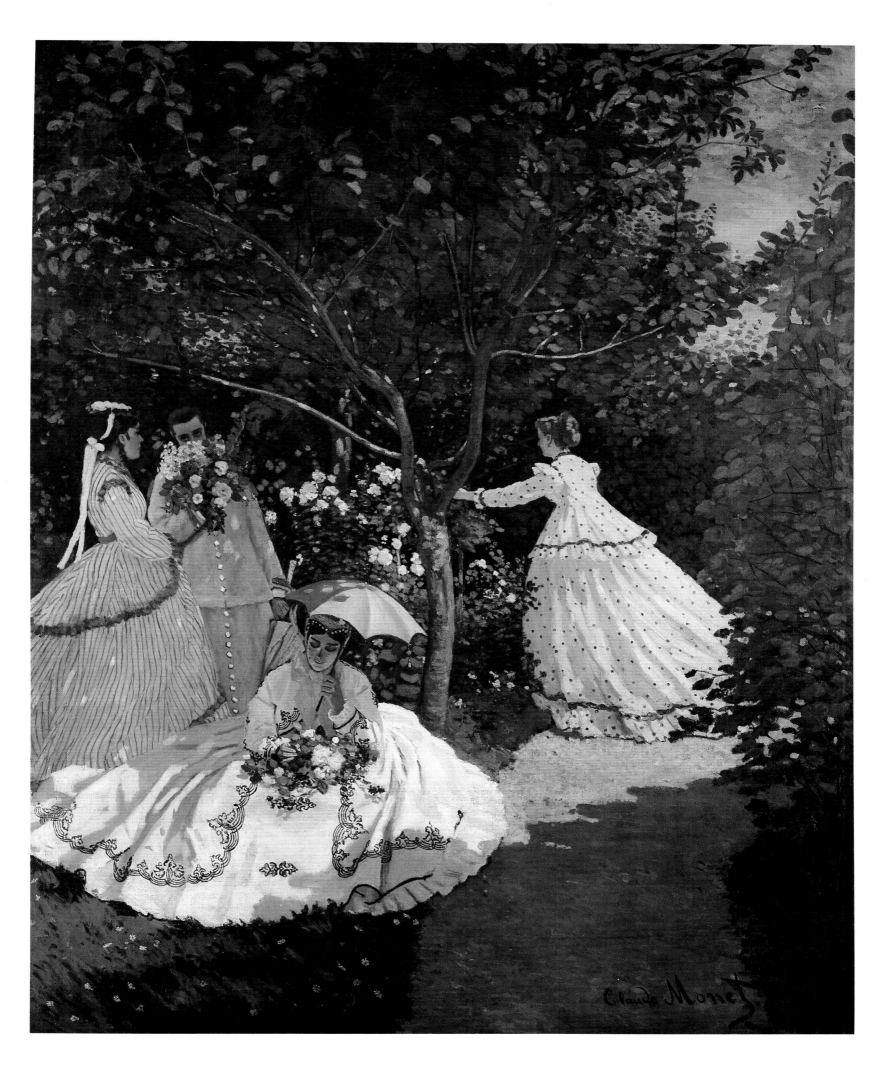

Left:
Camille (the Green Dress) 1866
Oil on canvas
91×59½in (231×151cm)
Kunsthalle, Bremen

Above:
Women in the Garden 1866-67
Oil on canvas
100½×80¾in (255×205cm)
Musée d'Orsay, Paris

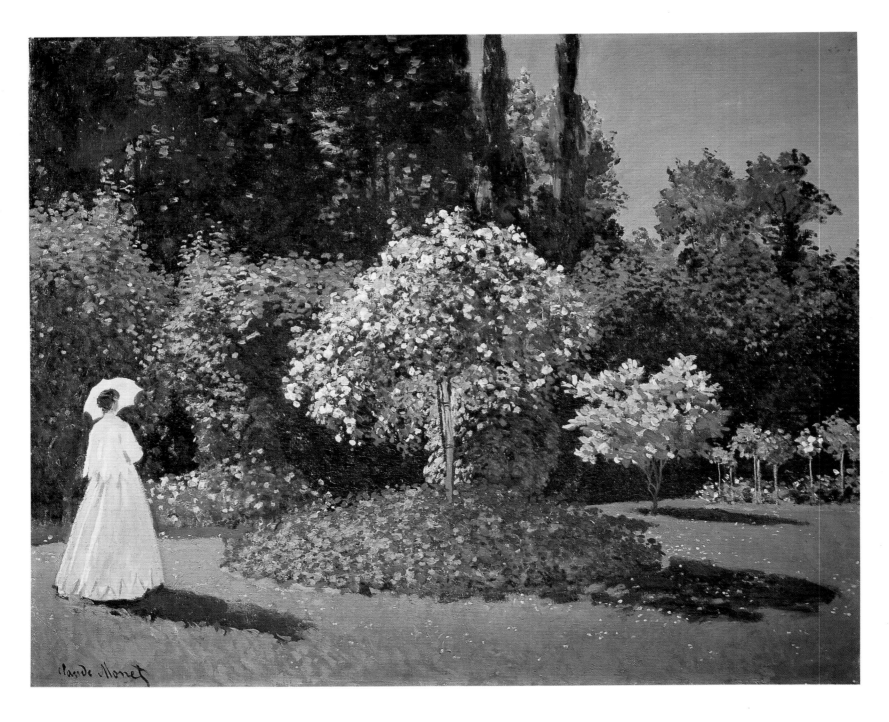

Jeanne-Marguerite Lecadre in the Garden
c. 1866
Oil on canvas
31½×28in (80×109.9cm)
Hermitage Museum, Leningrad

The Garden of the Princess, Louvre 1867
Oil on canvas
35¾×24½in (91×62cm)
Allen Memorial Art Museum,
Oberlin College, Oberlin, Ohio

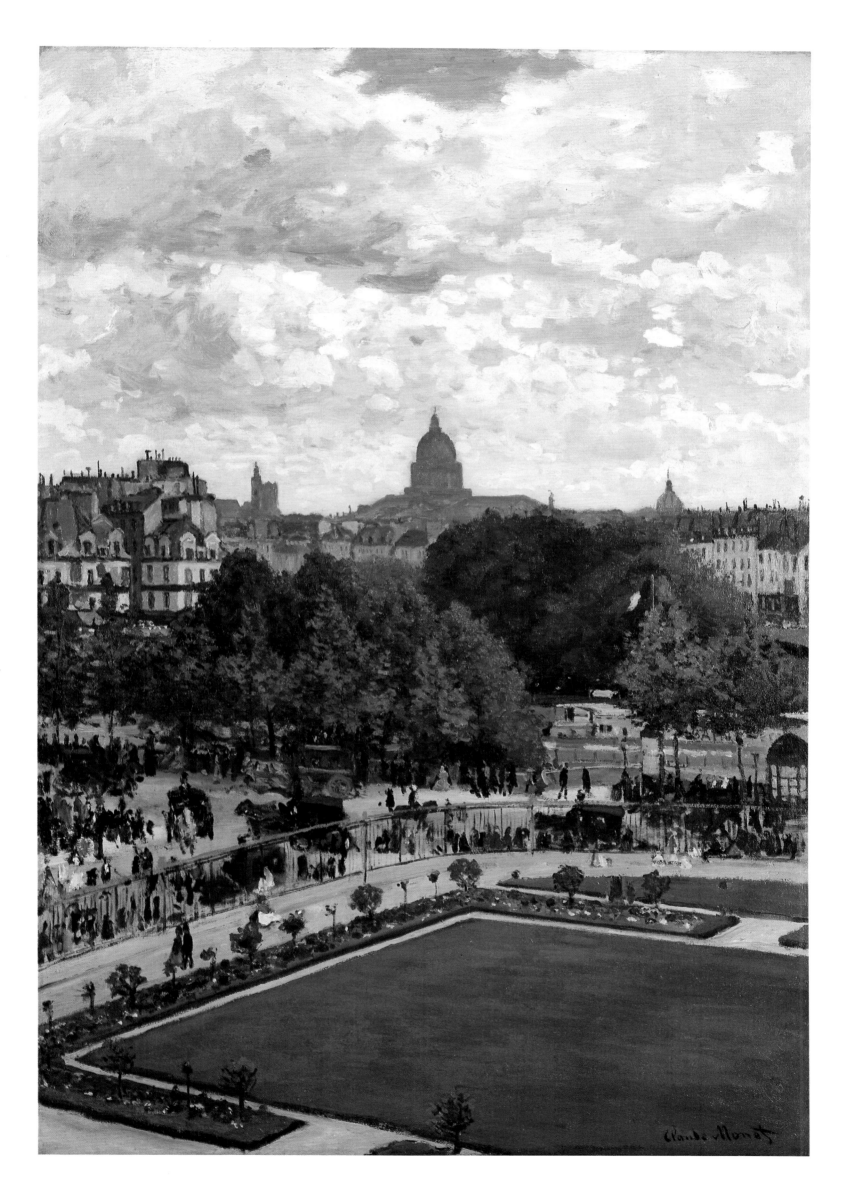

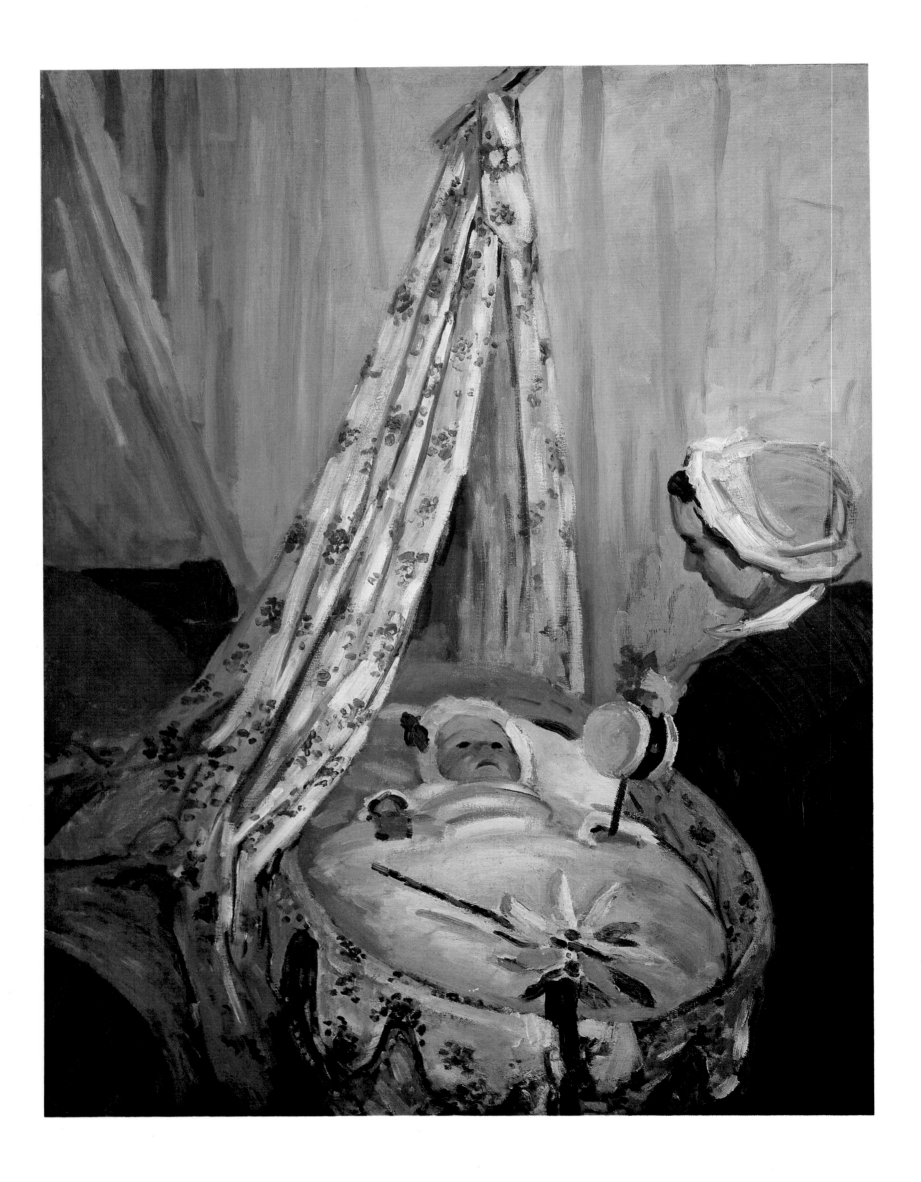

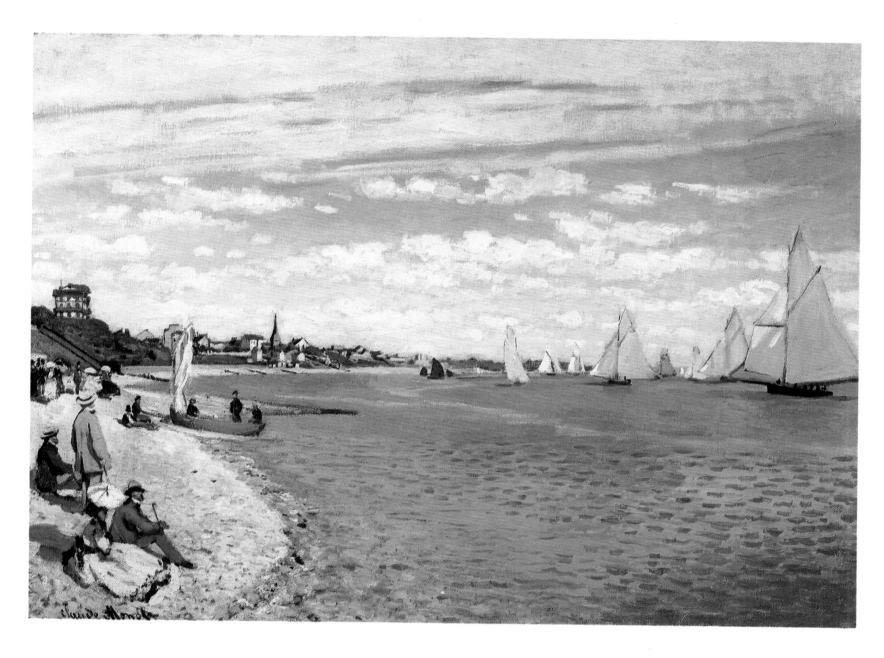

The Regatta at Sainte-Adresse 1867
Oil on canvas
29¾×40in (75.3×101cm)
Metropolitan Museum of Art, New York

Left:
The Cradle – Camille and the Artist's Son
Jean 1867
Oil on canvas
46×35in (116.8×88.9cm)
National Gallery of Art, Washington

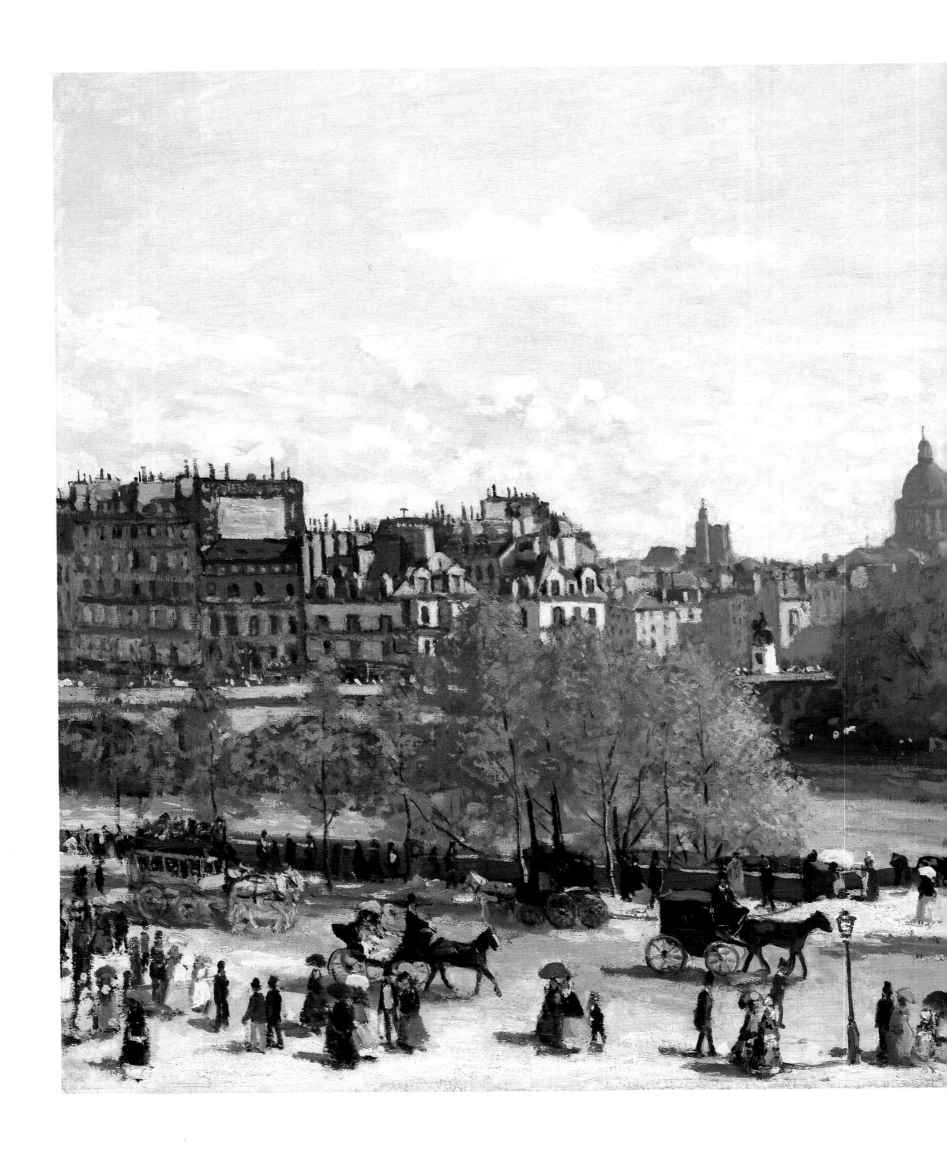

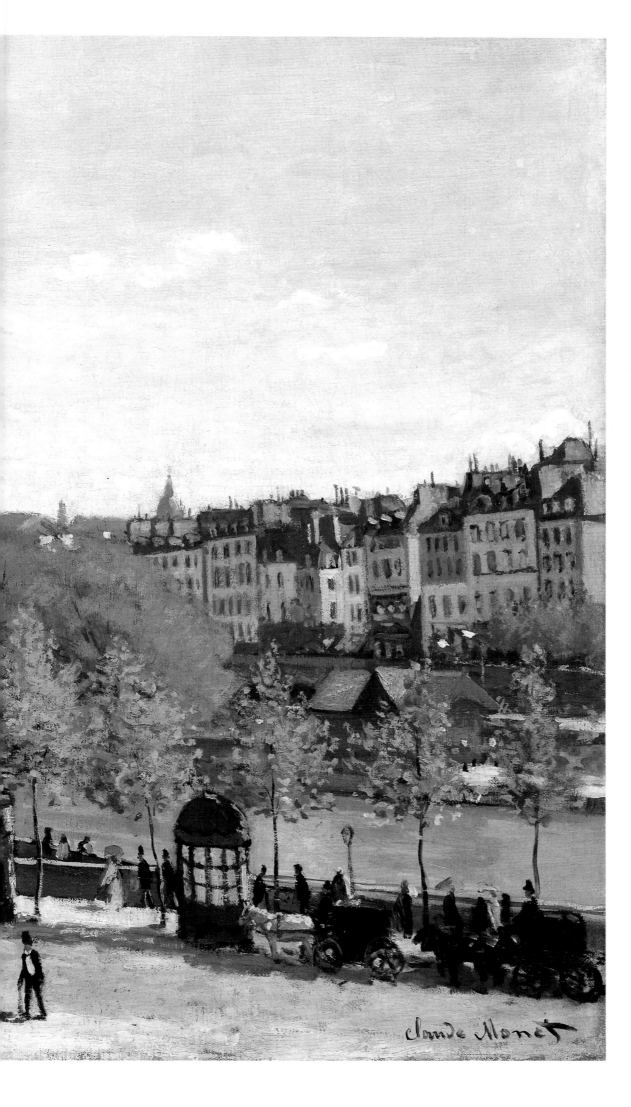

The Quai du Louvre 1867
Oil on canvas
36½×25½in (93×65cm)
Collection Haags Gemeentemuseum,
The Hague

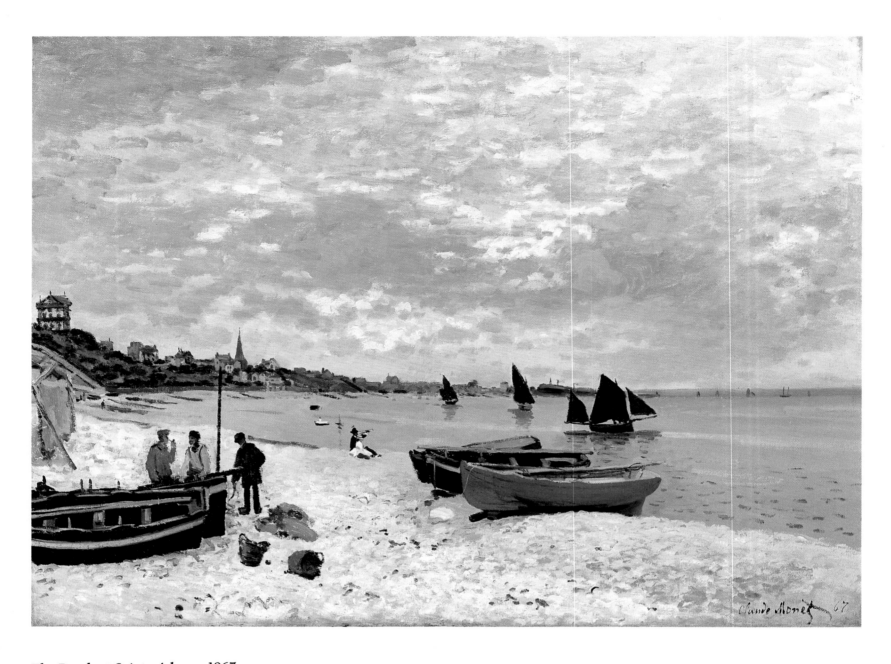

The Beach at Sainte-Adresse 1867
Oil on canvas
29¾×40¾in (75.8×102.5cm)
Art Institute of Chicago

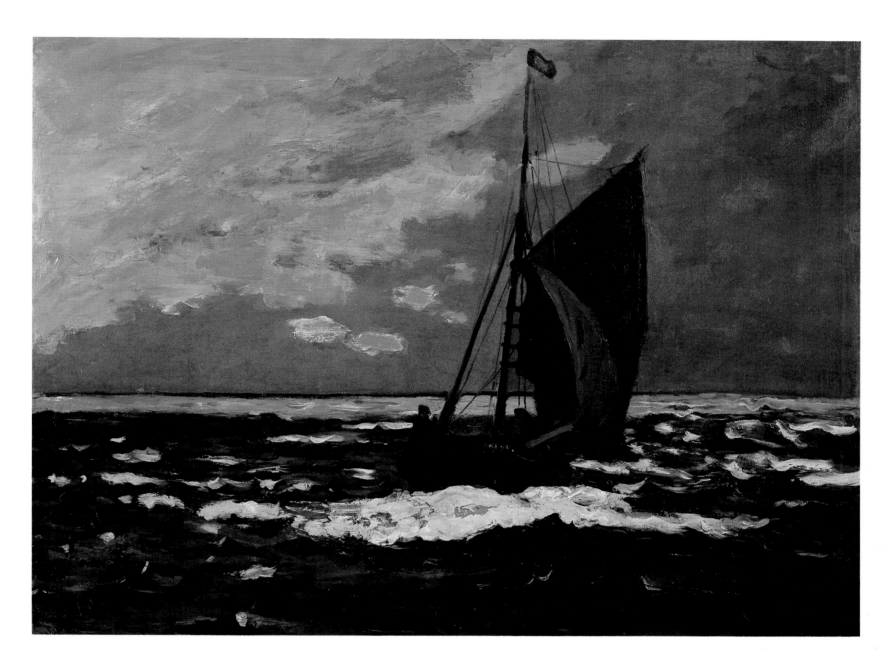

Seascape: Storm c. 1868
Oil on canvas
19³⁄₁₆×25½in (48.7×64.7cm)
Sterling and Francine Clark Art Institute,
Williamstown, Massachusetts

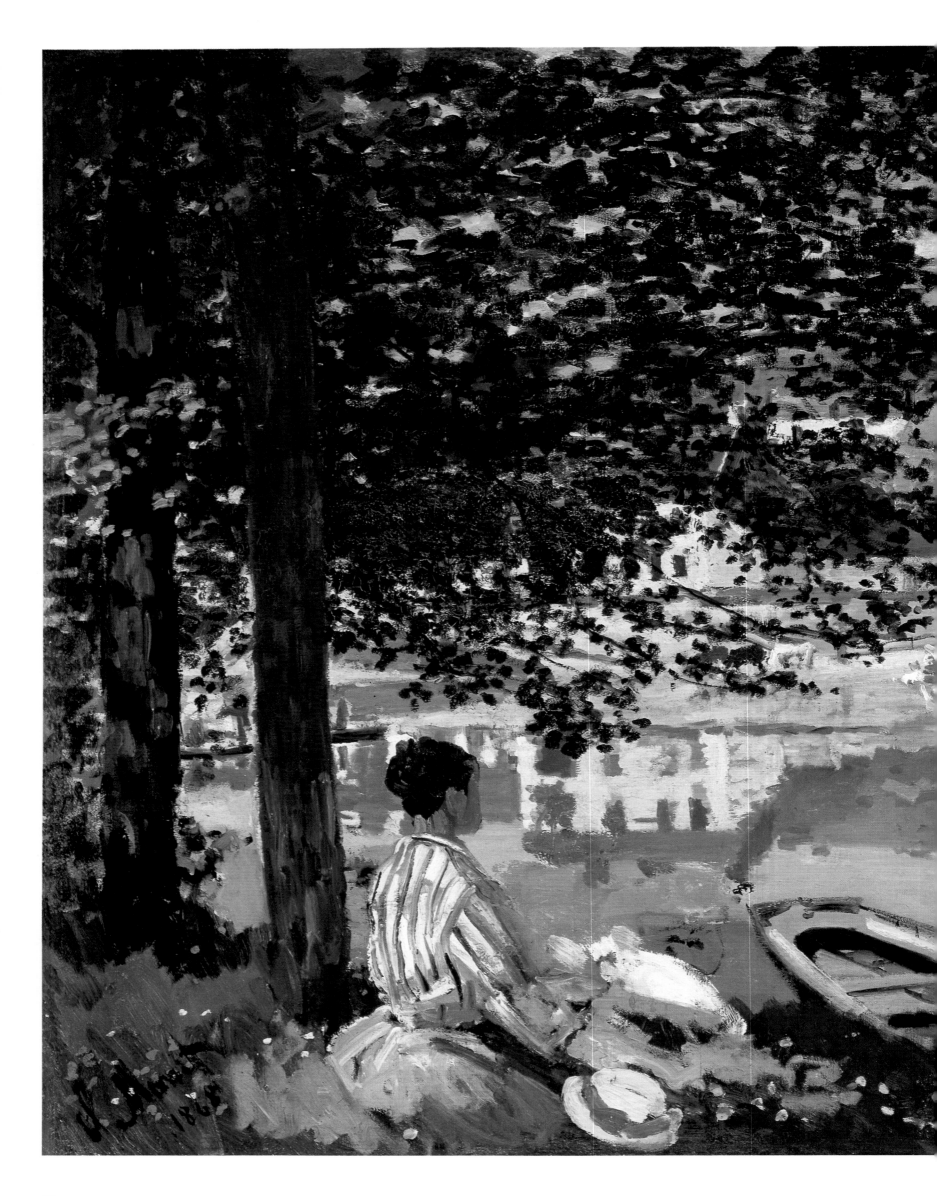

On the Seine at Bennecourt 1868
Oil on canvas
32×39¾in (81.5×100.7cm)
Art Institute of Chicago

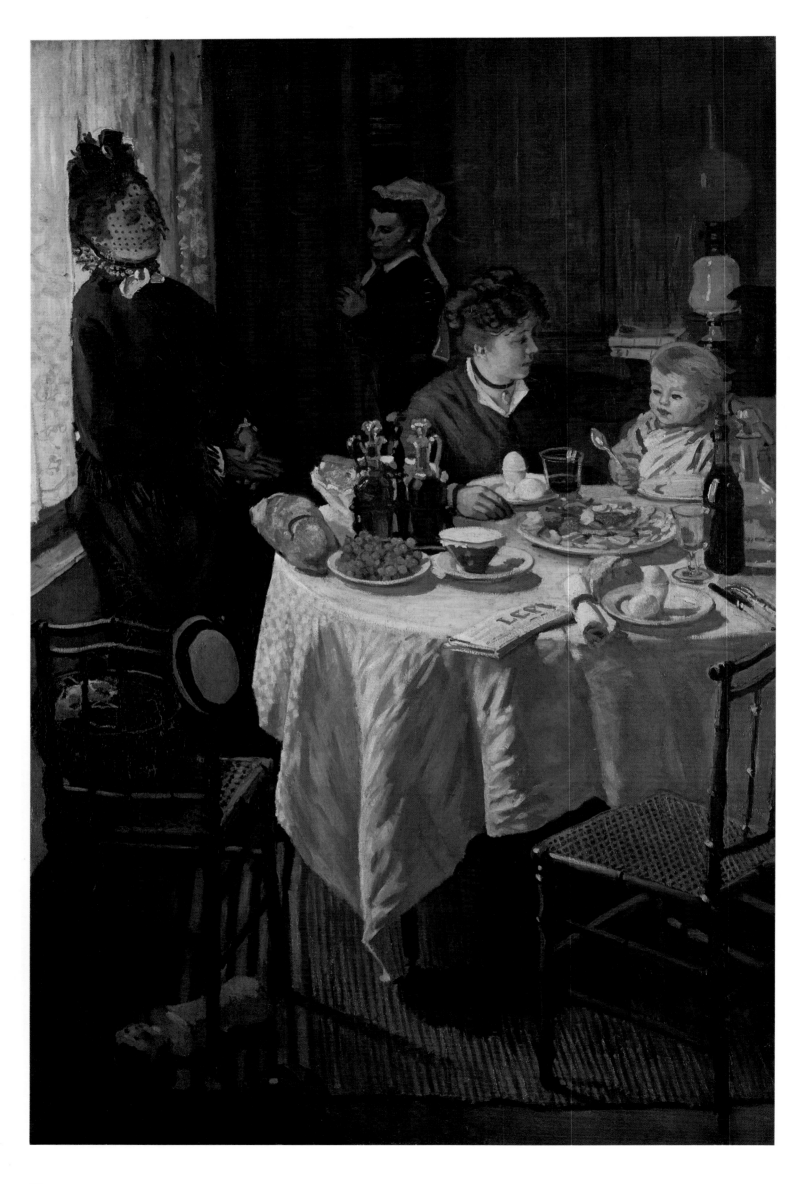

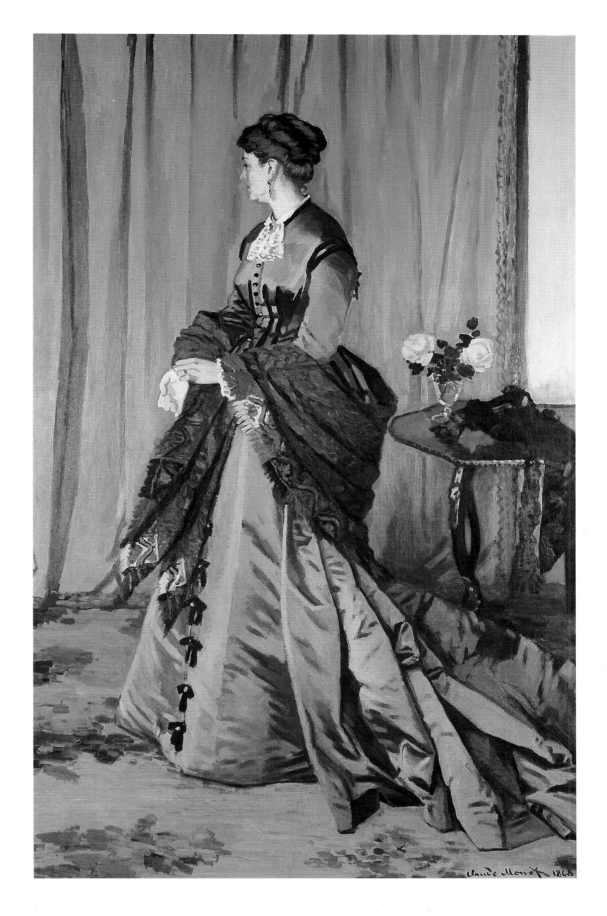

Madame Gaudibert 1868
Oil on canvas
85×54½in (215.9×138.4cm)
Musée d'Orsay, Paris

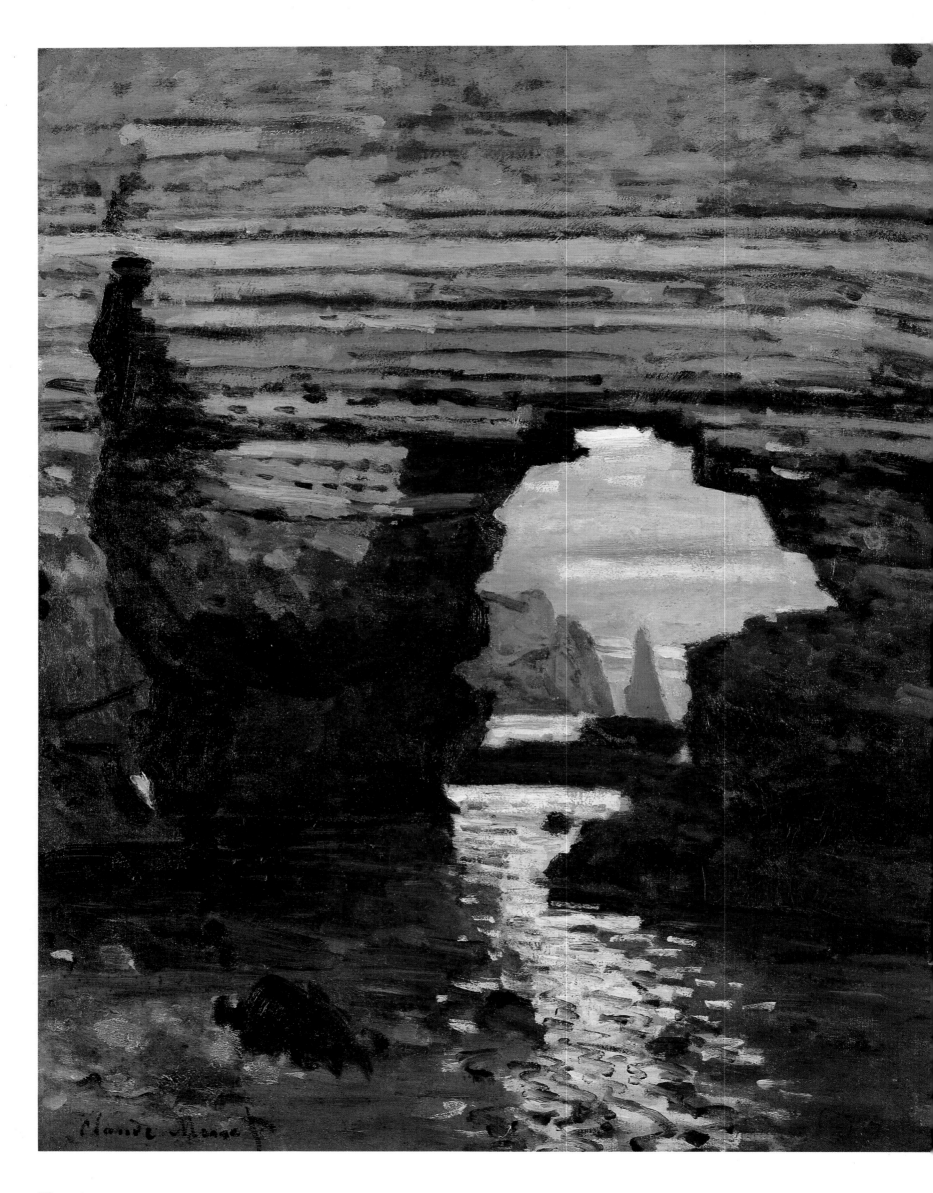

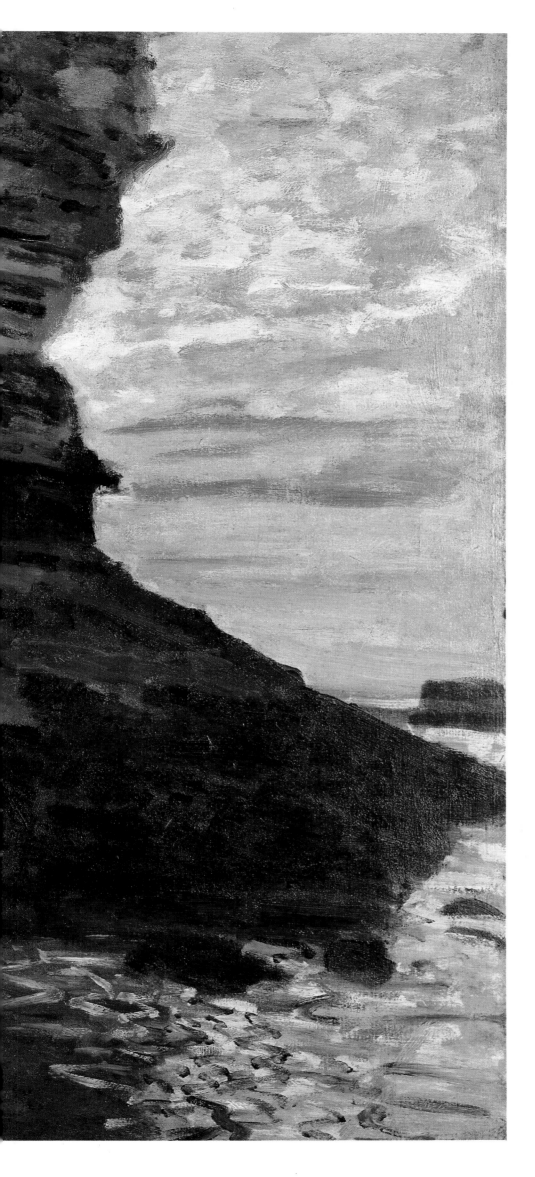

Cliff at Etretat c. 1868
Oil on canvas
32×39¼in (81×100cm)
Fogg Art Museum, Cambridge,
Massachusetts

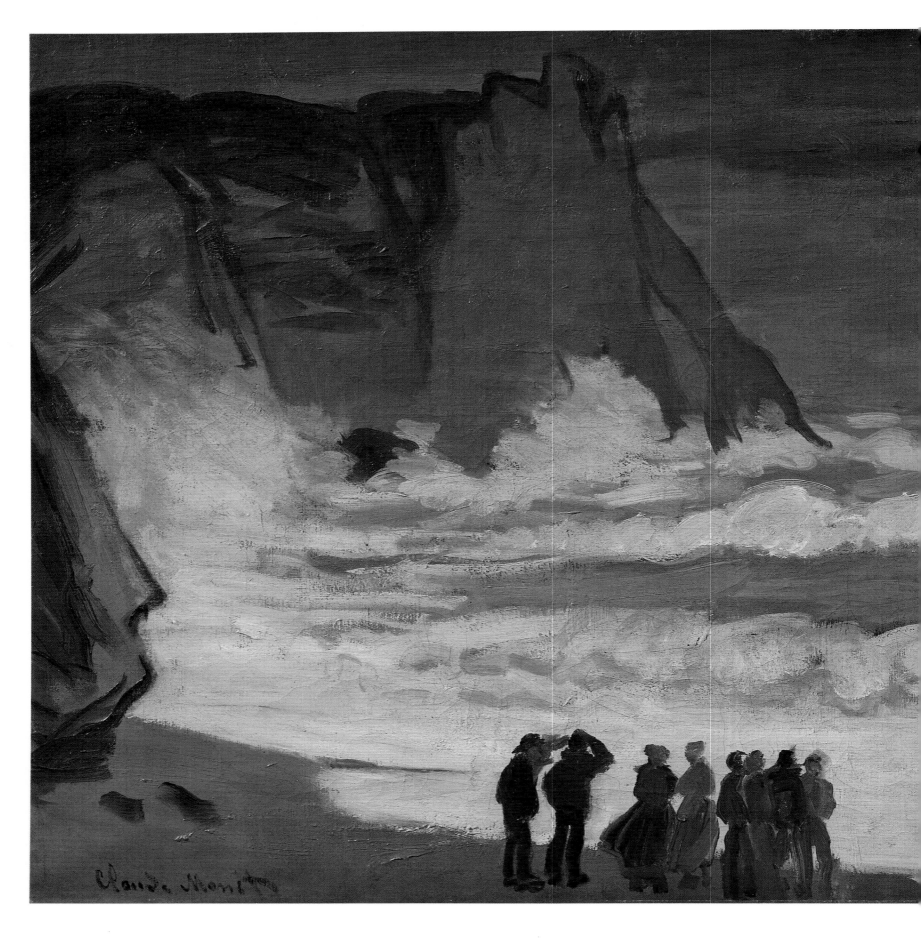

Stormy Sea at Etretat c. 1868-69
Oil on canvas
26×51½in (66×131cm)
Musée d'Orsay, Paris

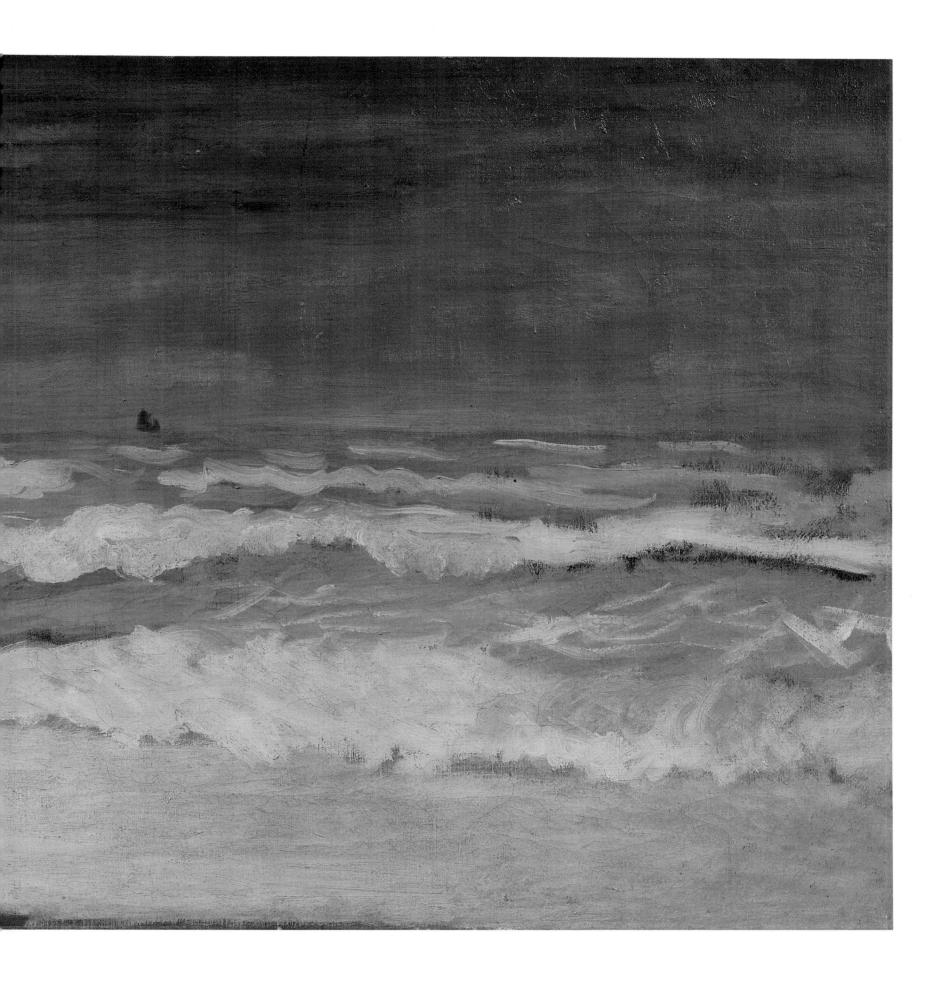

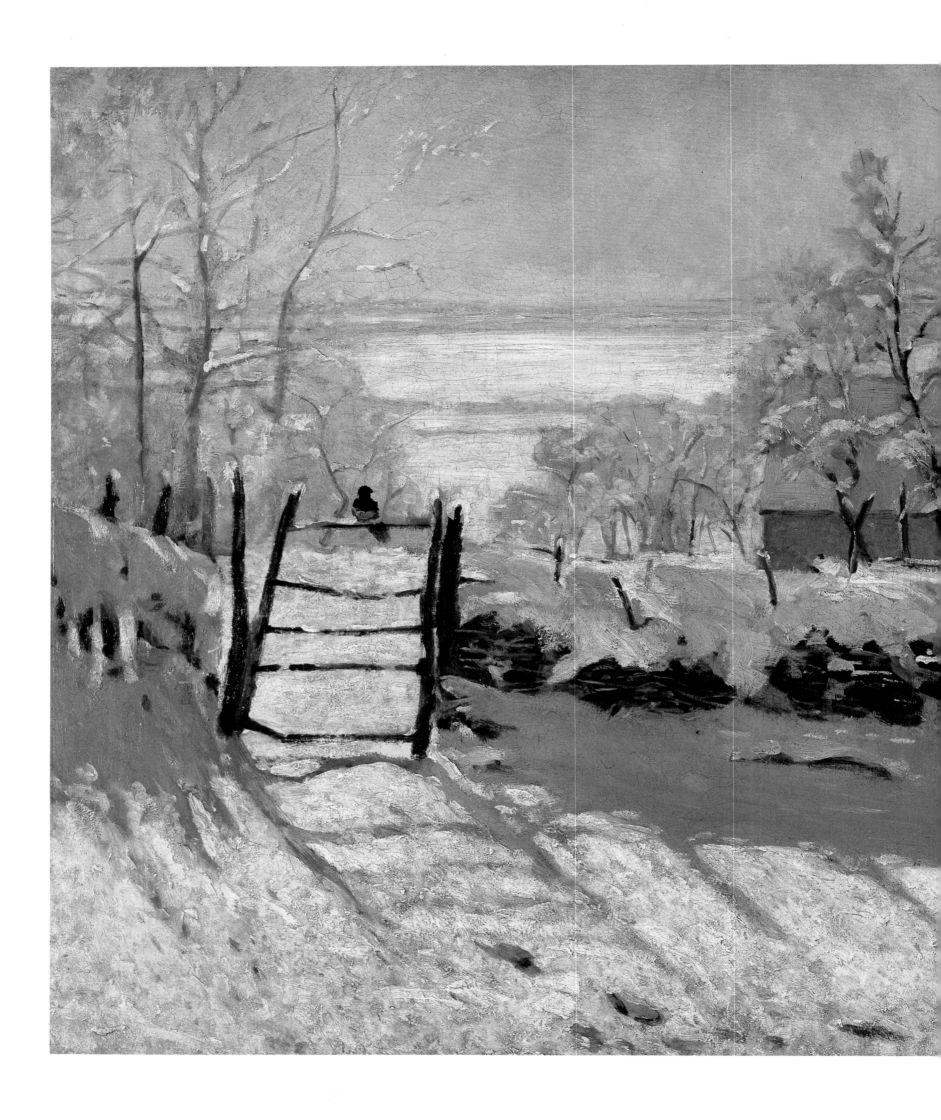

The Magpie, Winter 1868-69
Oil on canvas
35×51¼in (89×130cm)
Musée d'Orsay, Paris

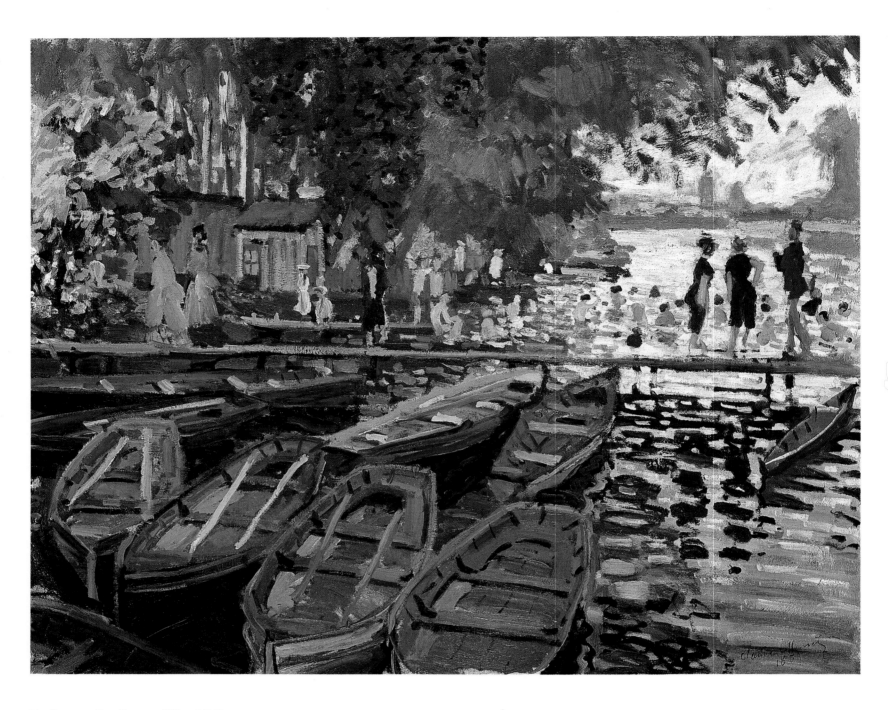

Bathers at La Grenouillère 1869
Oil on canvas
30¼×36¼in (77×92cm)
The National Gallery, London

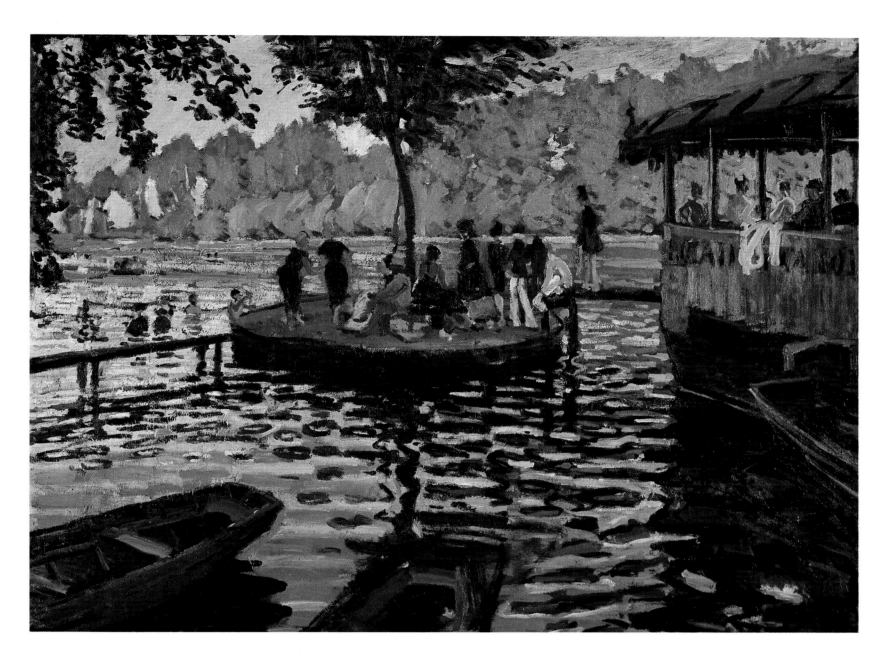

La Grenouillère 1869
Oil on canvas
30¼×39¾in (77×101cm)
Metropolitan Museum of Art, New York

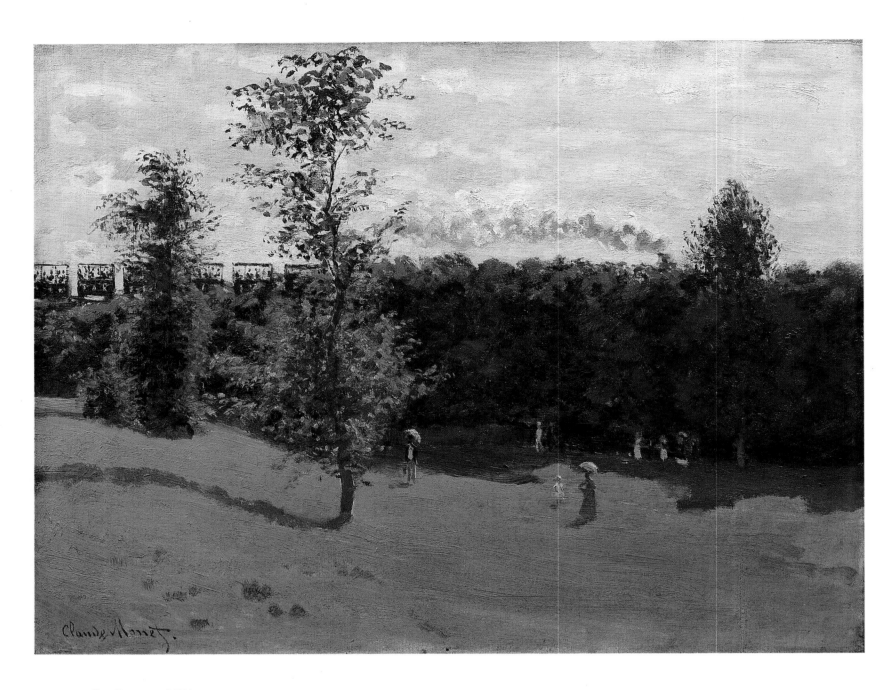

Train in the Country 1870
Oil on canvas
19¾×25½in (50×65cm)
Musée d'Orsay, Paris

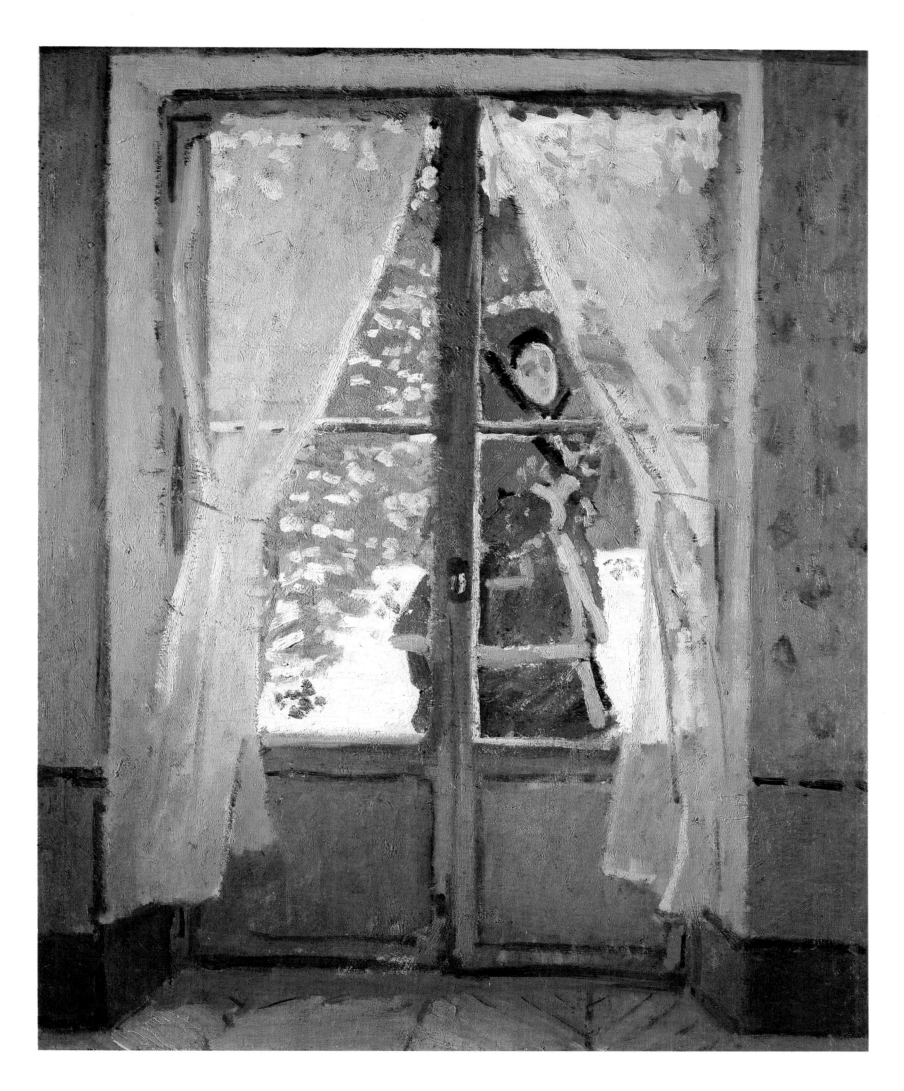

The Red Cape, Madame Monet c. 1870
Oil on canvas
39½×31½in (100×80cm)
Cleveland Museum of Art, Cleveland, Ohio

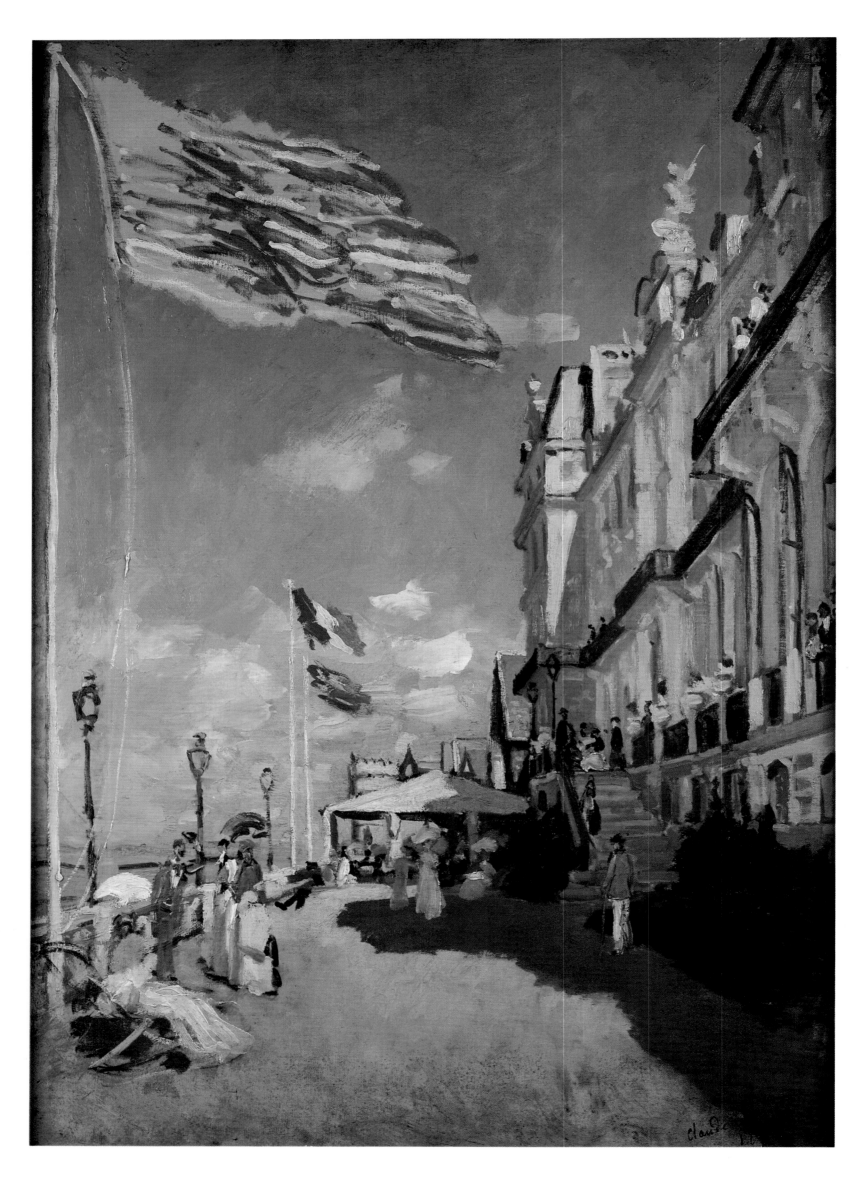

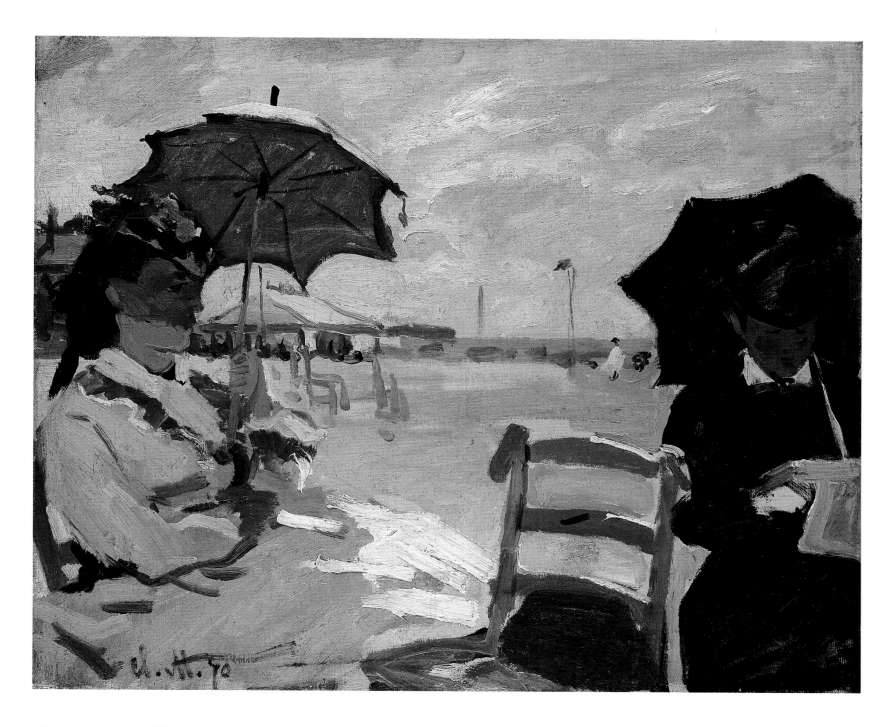

The Beach at Trouville 1870
Oil on canvas
14¾×18in (37.5×45.7cm)
The National Gallery, London

Left:
The Hôtel des Roches Noires at Trouville
1870
Oil on canvas
31½×21¾in (80×55cm)
Musée d'Orsay, Paris

The Independent Painter

1 8 7 0 - 1 8 8 0

Armed with their portable easels, white canvases, and tubes of oil paint which made painting in the open air a more feasible project than it had hitherto been, Monet and his friends spent much of their time out of their studios attempting to capture the immediacy of perceptual experience in a series of sketch-like paintings. The high coloration of their works was unusual in a period when, unlike today, the paintings of the Old Masters were still covered in layers of discolored varnish and the work of pre-Renaissance artists with their use of bright, decorative, and symbolic color was not generally appreciated. One of the hallmarks of the work of the great Romantic master, Eugène Delacroix, was the rich surface texture of his paintings and his use of complementary colors. This artist's exploitation of optical mixture, where two separate touches of color in a painting are mixed by the eye to form another, was a great influence on Monet and his friends. Monet's awareness of Delacroix's large mural paintings may have helped him to take the radical step of heightening the coloristic and textural properties of his own canvases. No longer would painting need to suffer from the gloomy shadows that dulled the tonal values of many of the paintings of his contemporaries.

The example of Corot and Boudin helped Monet to raise the luminosity of his canvases and the revelation of Japanese prints gave him a repertoire of unusual compositional motifs that he could assimilate into his own work. Like photography, Japanese prints offered Monet alternative ways of depicting reality to those taught in the state-supported art schools and helped him in his ambition to regain an 'innocent eye.' This idea played a large part in the Monet myth that is best summed up in the words of the writer and critic Jules Laforgue who wrote in an article in 1883 that the Impressionist artist was one, who,

forgetting the pictures amassed in the museums, forgetting his optical art school training – line, perspective, color – by dint of living and seeing frankly and primitively in the bright open air . . . outside the poorly lit studio – has succeeded in remaking for himself a natural eye, and in seeing naturally and painting as simply as he sees.

The translation of visual experience into painting is a much more complicated and fraught affair than the critic's statement would suggest. The studied detachment of Monet's approach could lead to paintings of great sensitivity such as the haunting image of Camille at the window, known as *The Red Cape* (page 65) of about 1870. If part of the Impressionist ethos was the capturing of a single moment in time, then it was never done with more poignancy than in this simple image that exists in bitter-sweet harmony with Monet's later painting of the model on her deathbed.

Monet's subject matter of the 1870s continued his interests of the 1860s and was similarly divided between scenes of his family, evocations of Parisian life, and images of the landscape around the railroad that led from Paris to the Normandy coast. It is not surprising, therefore, that trains and stations played a large part in Monet's

work. With his incessant traveling he must have spent a great deal of time waiting for trains. The *Train in the Country* (page 64) of 1870 is Monet's first surviving painting of the phenomenon of steam travel. The unusual character of the double-decker carriages suggests that it represents the line between Paris and Saint-Germain. Monet's depictions of the railway became more sophisticated, but this early example retains something of the naivety of the popular print and presents the train as an awkward interloper on the rural scene.

Geographical areas have their own particular light and northern France is no exception. The pale opalescent light of the Normandy landscape has caused it to be called Côte d'Albâtre. Monet recorded the differing light effects from the milky light of morning through to the hot light of the late afternoon and early evening when the white cliffs glow with the deep and incandescent oranges and rich ochers that are found in many of Monet's depictions of the area. With equal mastery he captured the multifarious changes of weather from driving wind and rain to the calm summer's day. The clarity of the midday light is caught, with an apparent lack of effort, in Monet's briskly painted *Hôtel des Roches Noires* of 1870. His desire to give the impression of a fluent response to the motif can be appreciated by his virtuoso handling of the flag that fills the upper lefthand corner of the painting. The pale creamy ground of the canvas describes the substance of the flag while the blue sky defines its contours as flutters in the stiff breeze blowing in from the sea. Much of the painting's sense of movement and atmosphere comes from the open weave of roughly parallel lines of its red and yellow pattern.

Like a modern-day holiday snapshot, but unlike anything known to nineteenth-century technology, Camille and a companion appear in a close-focussed composition of the same period, *On the Beach at Trouville* (page 67). The two self-absorbed women sit on either side of a beach chair on which hangs a solitary child's shoe, probably belonging to Monet's son, Jean. The figure on the right of the canvas, dressed in a smart black ensemble, affirms the bourgeois status of the sitters and recalls the countless images of holiday makers in the work of Boudin. However, the freedom with which Monet has described this scene far surpasses anything in the work of his first mentor. He has allowed the light gray canvas to play an active role in the painting, showing through the open weave of the brushstrokes to unify the picture and modulate the broken rhythm of the brushmarks. When this painting was cleaned in 1965, particles of sand were found embedded in the pigment.

Monet produced a number of major figure-compositions using Camille, including two that use oriental motifs in very distinct ways. One, which he called *Meditation, Madame Monet* (pages 72-73), is a relatively traditional piece given a certain modishness by the subtle introduction of a Japanese fan. It was exhibited at the London International Exhibition of 1870-71 and contrasts markedly with the magnificently gaudy *La Japonaise* (page 109) of

1875-6 which exults in its vulgar display of oriental consumer products, such as the fans and Camille's kimono.

The *Luncheon* (pages 84-85), a decorative piece of 1873, may be considered as another portrait of a family, although the identity of those in the picture is unclear. The rich effects of the outdoor light contrast dramatically with *A Corner of the Apartment* (page 107) of 1875, which is a masterly study in the balancing of light and shade as it illuminates a shadowy interior. Only the silhouette of the young boy and the half-hidden figure of the seated woman break the strict symmetry of the composition.

This decade saw the creation of some of the most familiar paintings of Monet's career, and covers all the familiar territory of the Impressionist enterprise. In contrast with Renoir's brilliantly illuminated version of the same subject, Monet's view of the *Pont Neuf* (pages 78-79) of 1872 suggests the constant flux of the urban crowd. In his famous *Wild Poppies* (pages 96-97) of 1873 and countless views of the River Seine and its boating establishments he celebrated the various kinds of leisure activities that were within easy reach of those with the time and money to afford them. Monet had followed the example of the older painter Daubigny and had acquired a studio boat which as well as becoming a subject for several of his paintings served as one of his major means of depicting the river. The novelty of this low viewpoint gave his paintings of the surrounding countryside an immediacy and suggested unconventional compositions which may be appreciated in those works he painted in the vicinity of Argenteuil and Vétheuil.

In his *Impression, Sunrise* (pages 92-93) of 1872, the harbor at Le Havre became the site of one of the most well-known paintings in the entire history of art. This work is so familiar that it is worth looking at again in some detail in order to see it afresh. It was this painting that gave rise to the term 'Impressionism,' by which Monet and his friends came to be known throughout the world, and yet the painting is really only a sketch. A thin wash of color is brushed across the canvas establishing the unity between the water and sky. From the early morning mist a few indistinct forms emerge, their presence evoked with a superb economy of means. Like a latter-day Claude or Turner, Monet has given himself the problem of painting the sun head on, and his solution of this technical difficulty is one of the main strengths of the sketch. Monet said later that he had not thought of giving the work a title, and had only decided on the one that has since become famous at the insistence of his friends. *Impression, Sunrise,* exhibited at Nadar's photographic studios with the paintings of his colleagues, was picked out by the critic Leroy to characterize the types of works on view. Despite the fact that there were many other kinds of paintings in the exhibition, the term eventually became accepted by everyone as referring to this new phenomenon. Even to those actively involved in the Impressionist circle the term was the cause of some confusion and like most artistic terms does not adequately serve to define either the works or the people who produced them.

Monet painted the *Boulevard des Capucines* in 1873, and by the time he painted *La Rue Montorgueil* in 1878 (page 116), the individual 'licks' of paint which defined the figures in his earlier painting had fused into of flurry of paint denoting figures, flags, and houses, almost indiscriminately. As the Italian critic Diego Martelli observed: 'They are painted in such a way that if one goes up close to them, one finds only scribbles of various colors. . . . But, looking at these pictures from the right viewpoint, not only does one find form, but even movement, and flags flying and people strolling.'

The paintings of this decade culminate in the series produced at the station of Saint-Lazare. The more finished of the two illustrated here is the frontal view looking out from under the subdued light of the station canopy into the brilliant light beyond. The light is transformed into a dazzling display of shifting swirling patterns as the steam is expelled from the locomotives below. Monet has played down any suggestion of the social significance of the locomotive or the fact that people are hard at work in this setting; instead he has concentrated his efforts on analyzing the infinite variations and gradations of color as the light passes through the steam-filled atmosphere of the station. The *Exterior of the Gare Saint-Lazare (The Signal)* (page 115) was bought by Caillebotte from the Third Impressionist exhibition. It is equally evocative, but perhaps less familiar than some of his other versions of the same theme. The dark gray silhouettes of the signals loom out of the confusion and create an almost tangible sense of ambiguity and excitement. The oddness of their shapes and the importance Monet has given them within the composition gives the painting the added impact of the unexpected.

Very different in subject matter and mood from his countless views of the boulevards, stations, river scenes, and landscapes, is the deathbed portrait of his wife, Camille, who died in 1879 (page 117). She had been his model, companion, and fellow-sufferer, and Monet later told his friend Georges Clemenceau how he found himself at her side unconsciously analyzing the hues of color that death had brought to her face. Whether Clemenceau's memory of Monet's recollection is strictly accurate is open to question, but the artist's final painting of Camille Doncieux has an unforgettable quality which reflects the circumstances of its conception:

It is the haunting, the joy, the torment of my days. To the extent that one day, finding myself at the bedside of a dead woman who had been and still was very dear to me, I surprised myself. My eyes fixed on her tragic brow, in the act of mechanically seeking the degradation of colors, that death had imposed upon her immobile face. Shades of blue, of yellow, of gray, what do I know? I had come to this. How natural the wish to reproduce the last image of her who was leaving us forever. But even before the idea came to me of fixing the features to which I was so profoundly attached, my organic automatism first trembled at the shocks of color, and my reflexes engaged me, in spite of myself, in an unconscious operation in which the everyday course of my life took up again.

The Thames and Westminster 1871
Oil on canvas
18½×17in (47×43cm)
The National Gallery, London

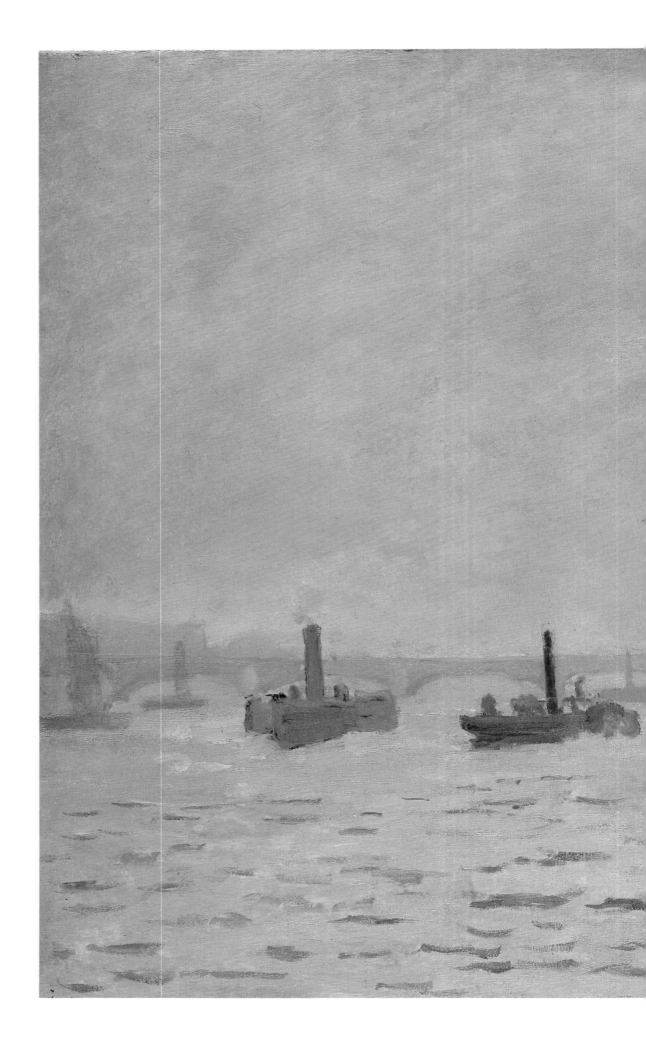

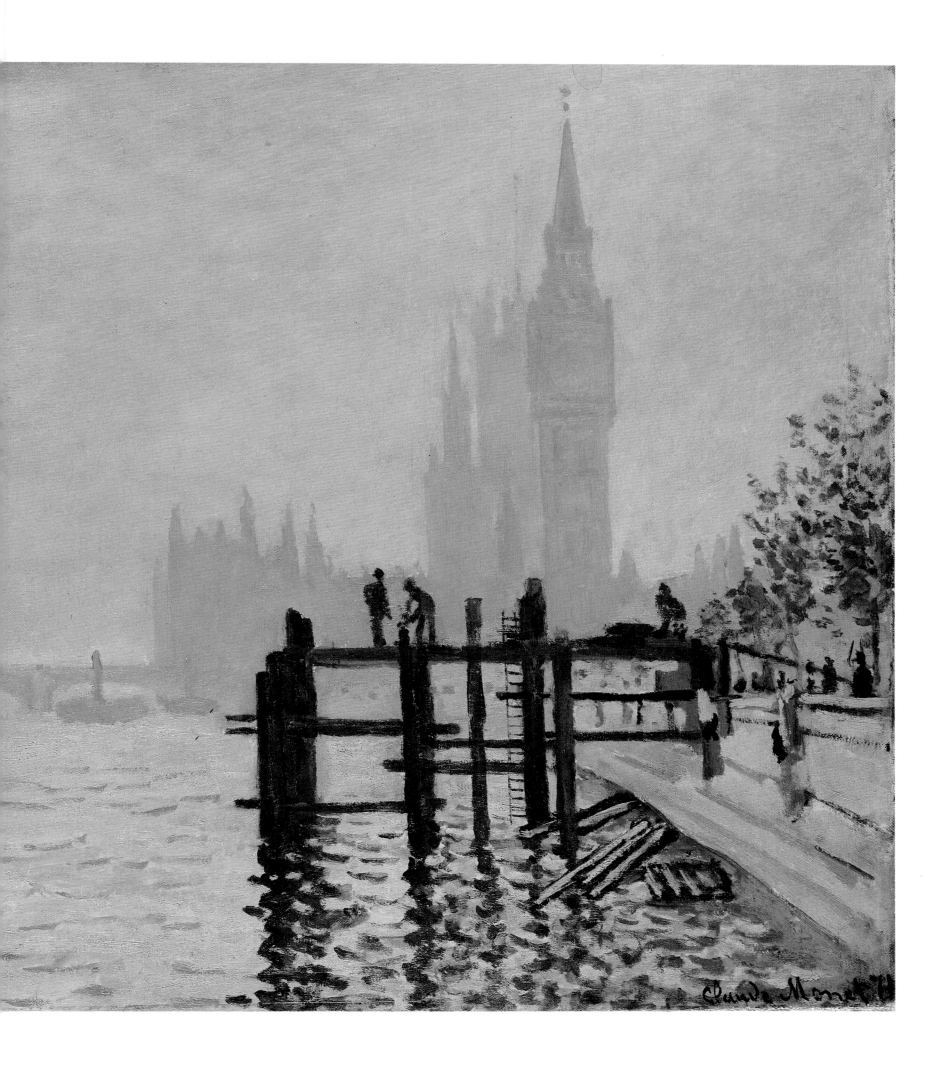

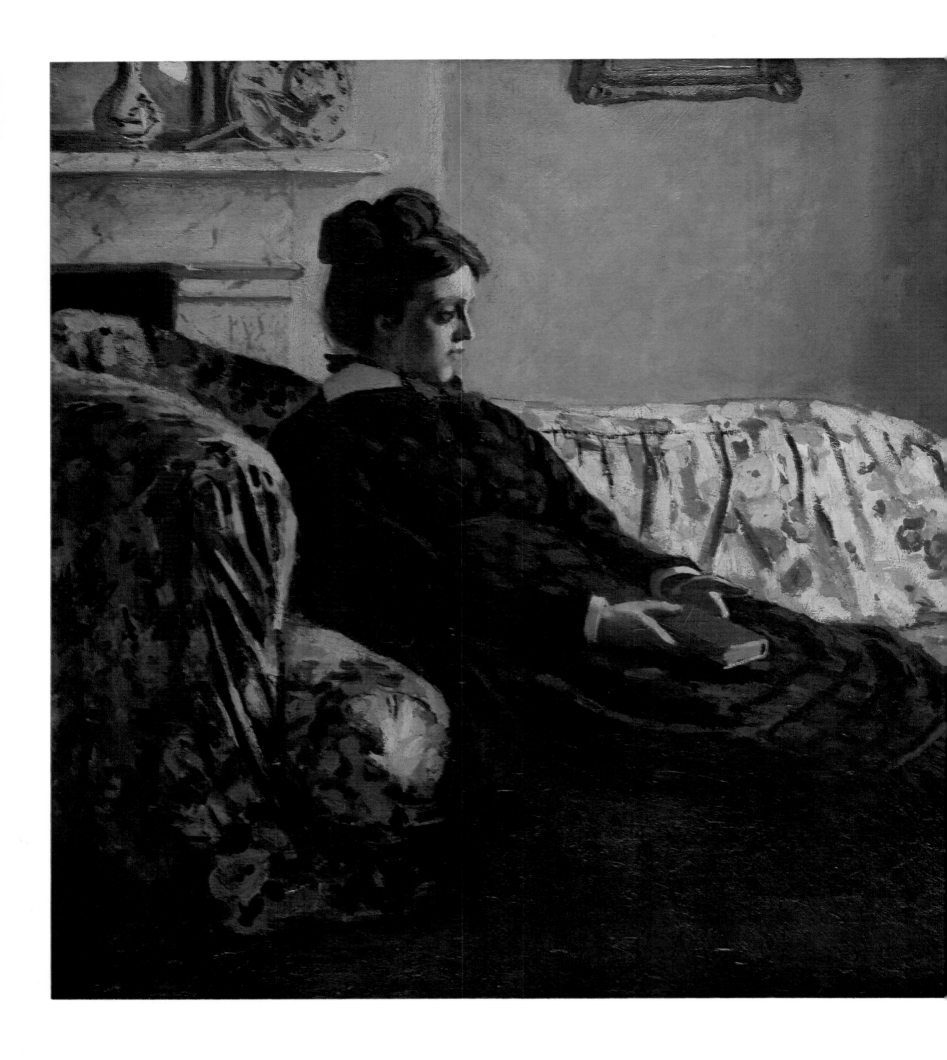

Meditation, Madame Monet c. 1870-71
Oil on canvas
19×29.5in (48×75cm)
Musée d'Orsay, Paris

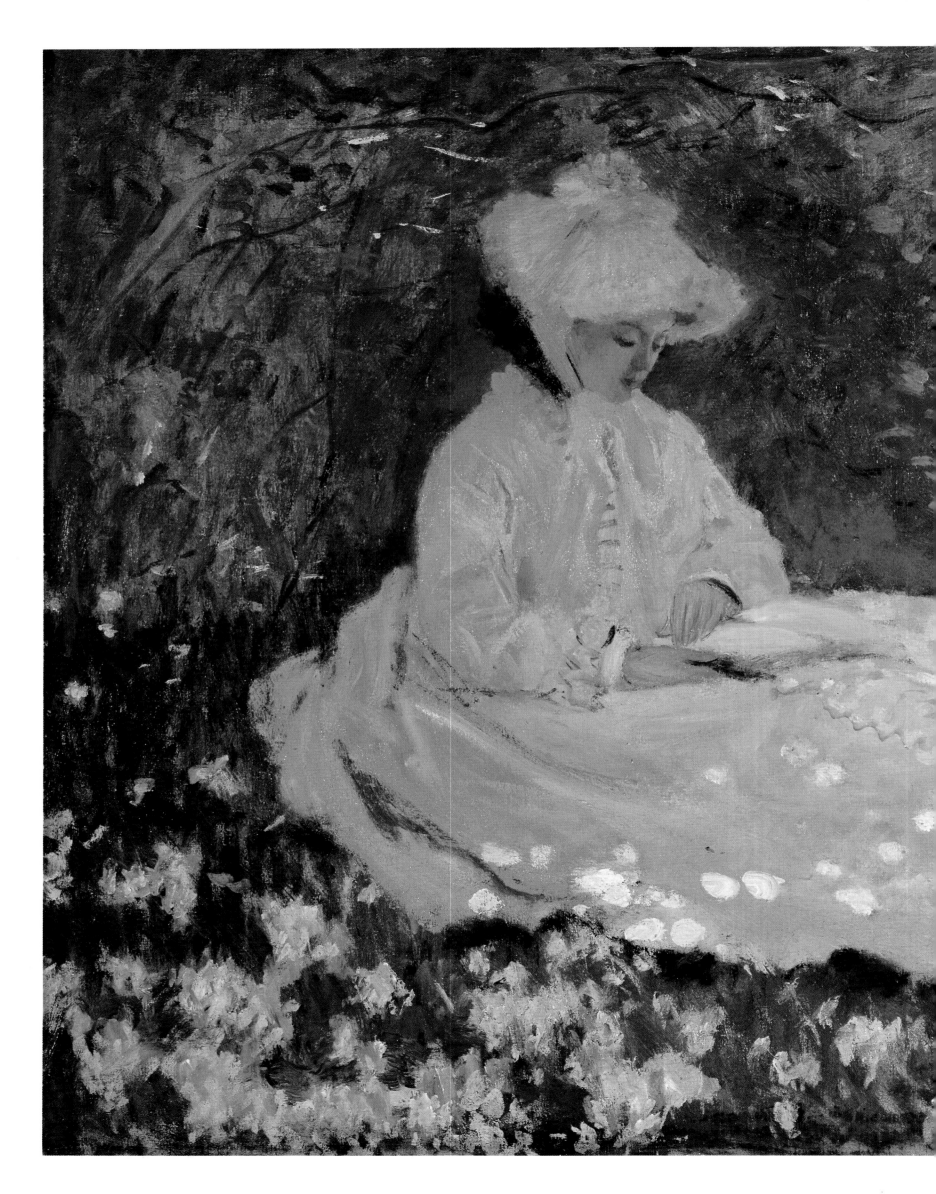

Springtime c. 1872-74
Oil on canvas
19¾×25½in (50×65cm)
Walters Art Gallery, Baltimore

Still Life with Melon c. 1872
Oil on canvas
21×28¾in (53×73cm)
Calouste Gulbenkian Foundation
Museum, Lisbon

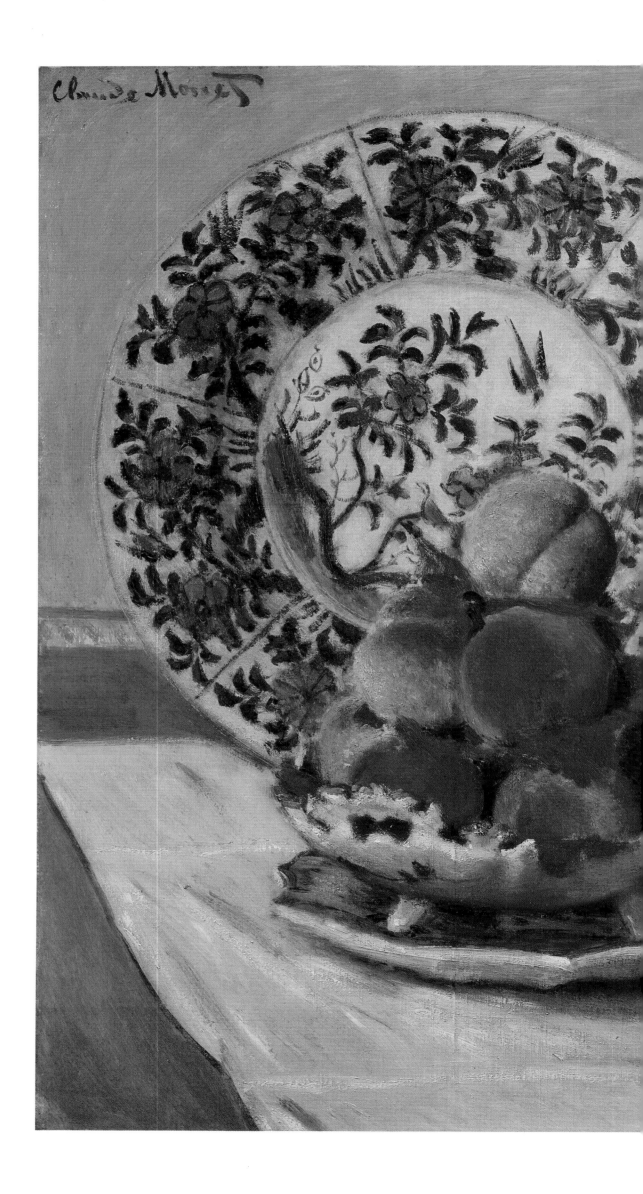

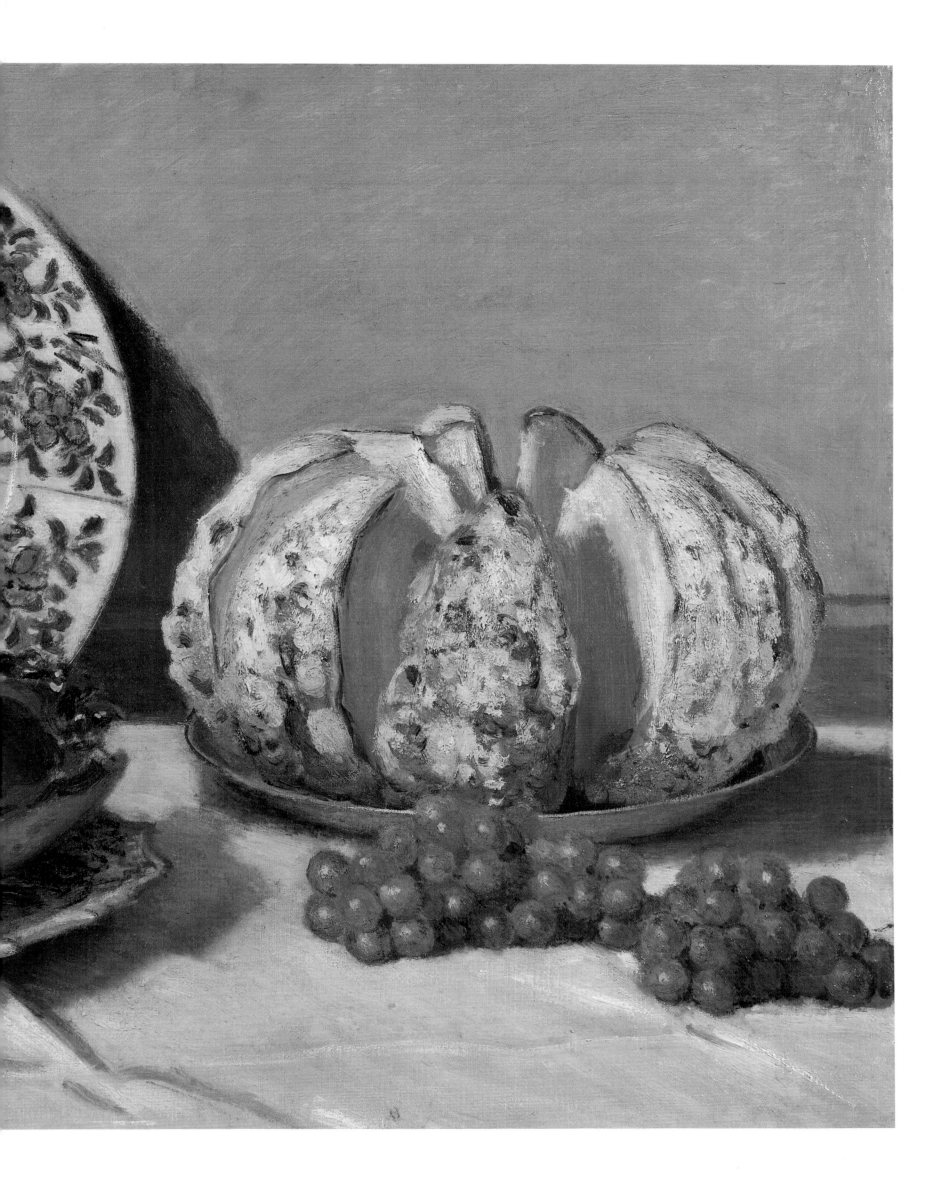

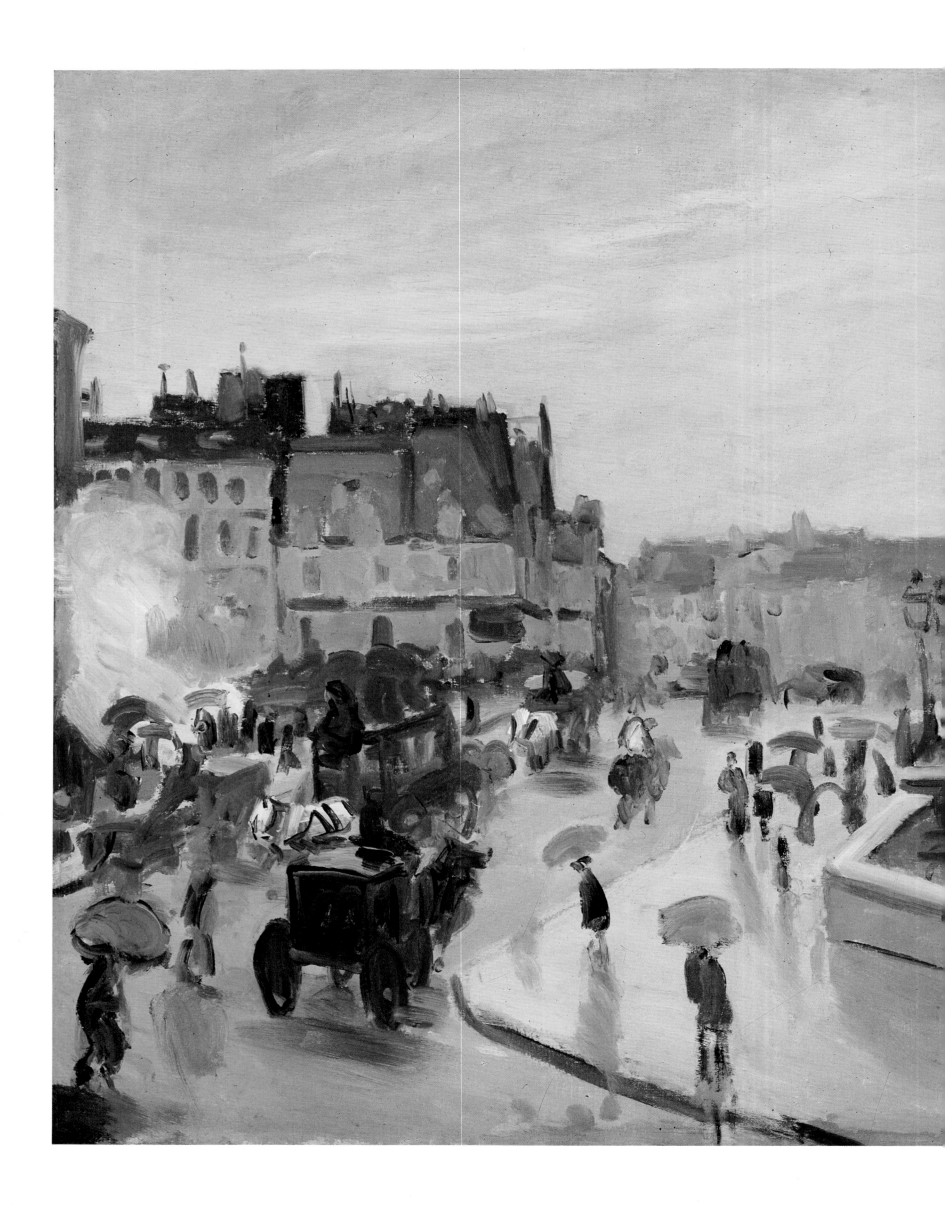

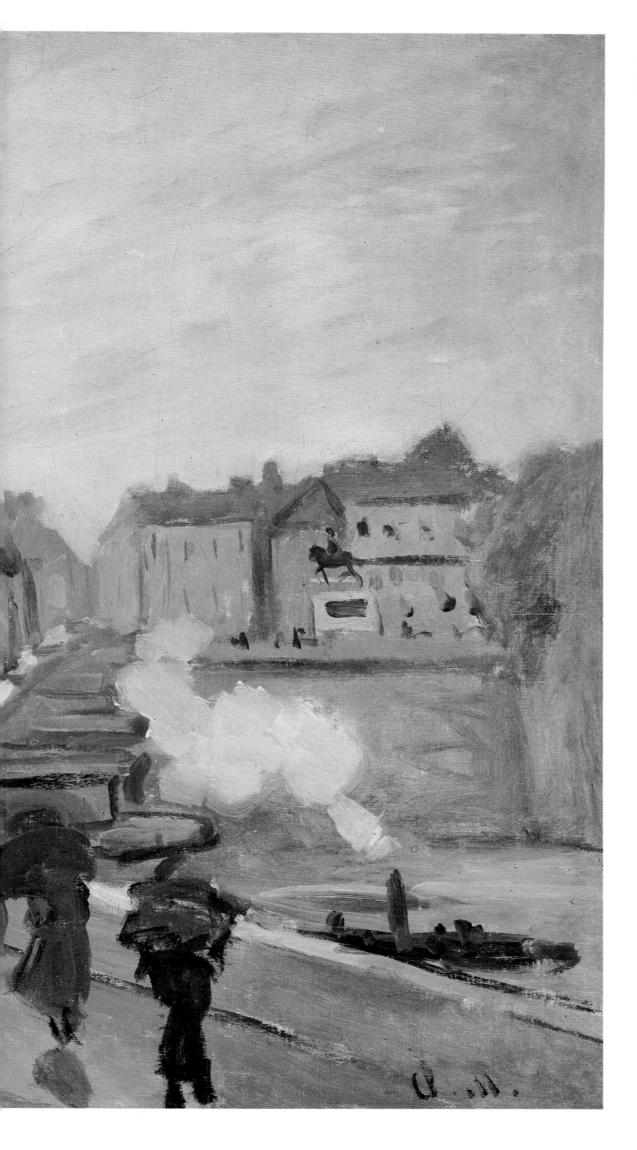

The Pont Neuf, Paris 1872
Oil on canvas
21×28½in (53.2×72.4cm)
Dallas Museum of Art

Bridge at Argenteuil under Repair 1872
Oil on canvas
23½×31¾in (60×80.5cm)
Fitzwilliam Museum, Cambridge

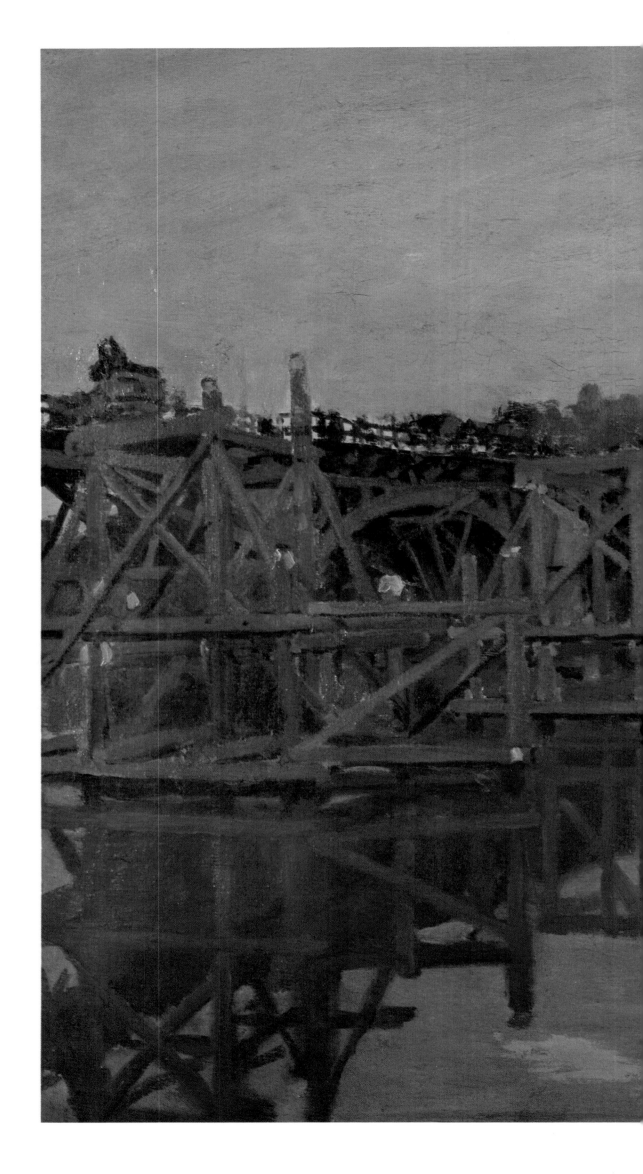

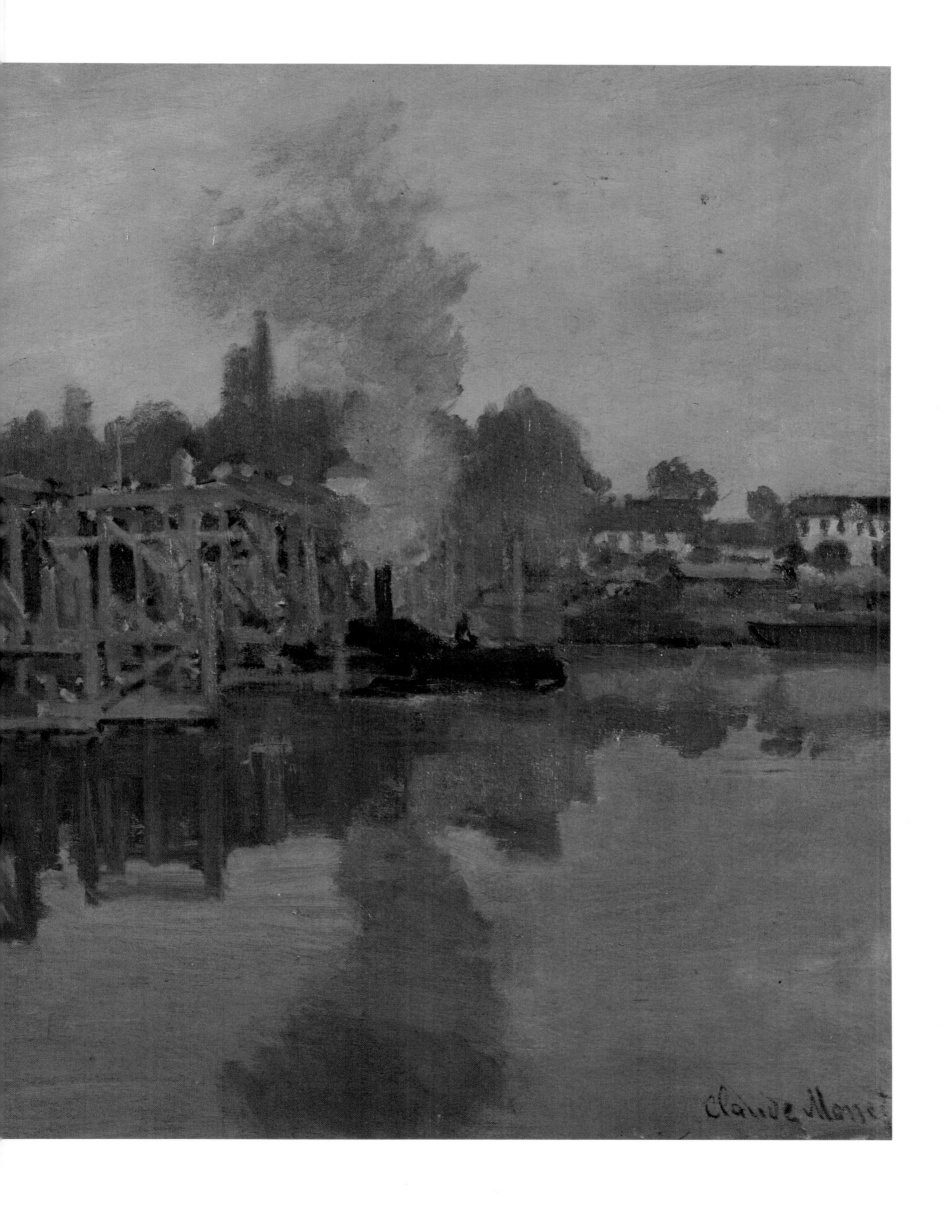

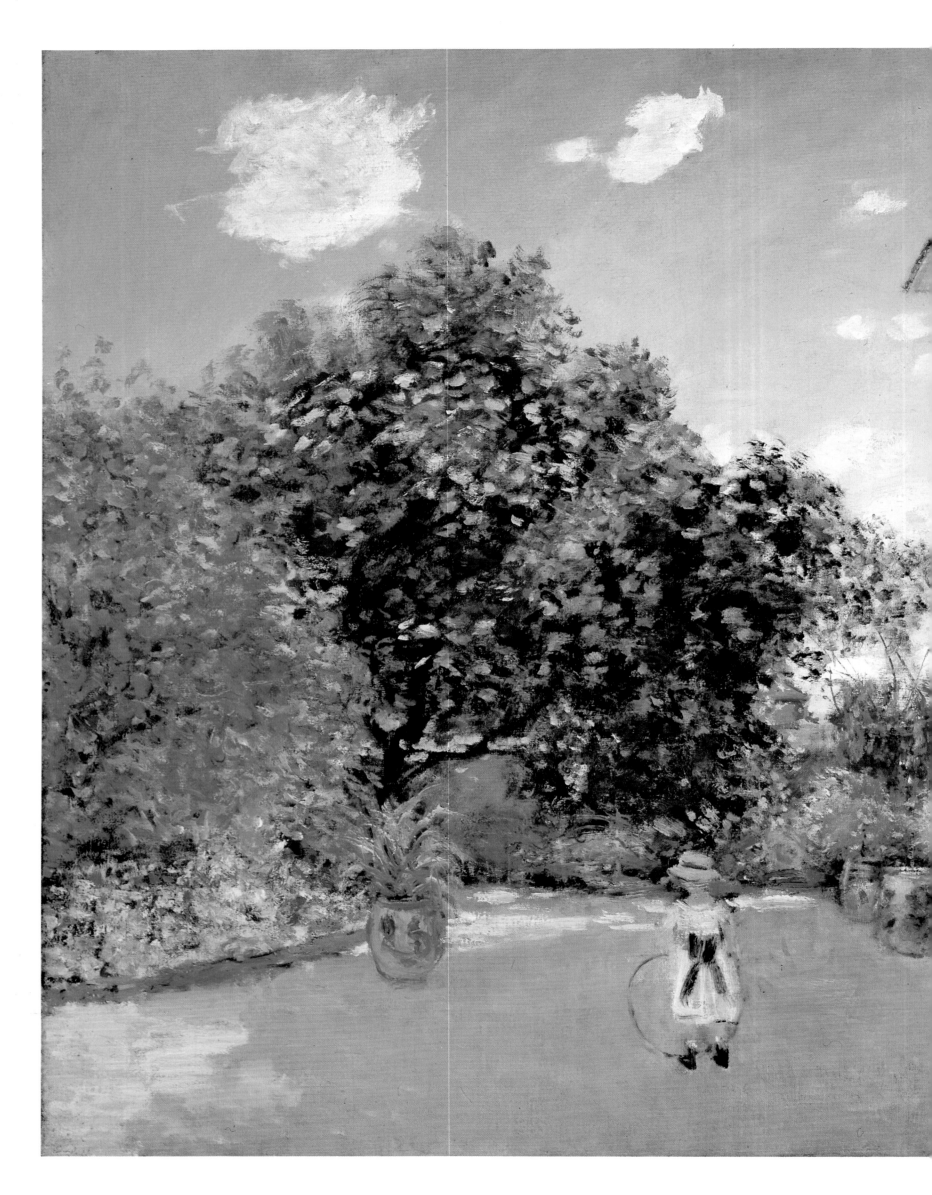

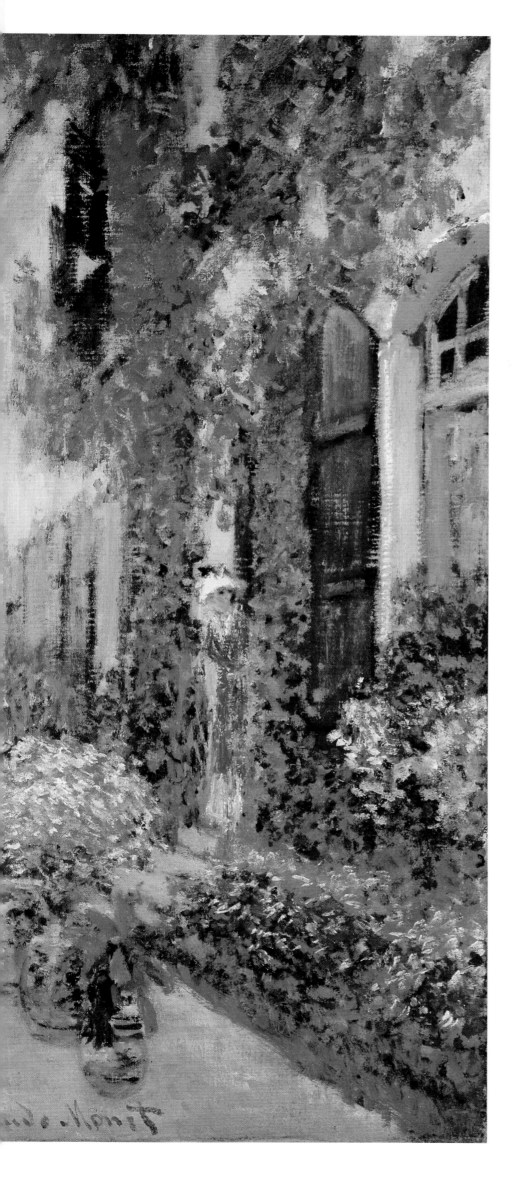

Monet's House at Argenteuil 1873
Oil on canvas
23¾×34½in (60.2×73.3cm)
Art Institute of Chicago

The Luncheon c. 1873-74
Oil on canvas
63×79¼in (160×201cm)
Musée d'Orsay, Paris

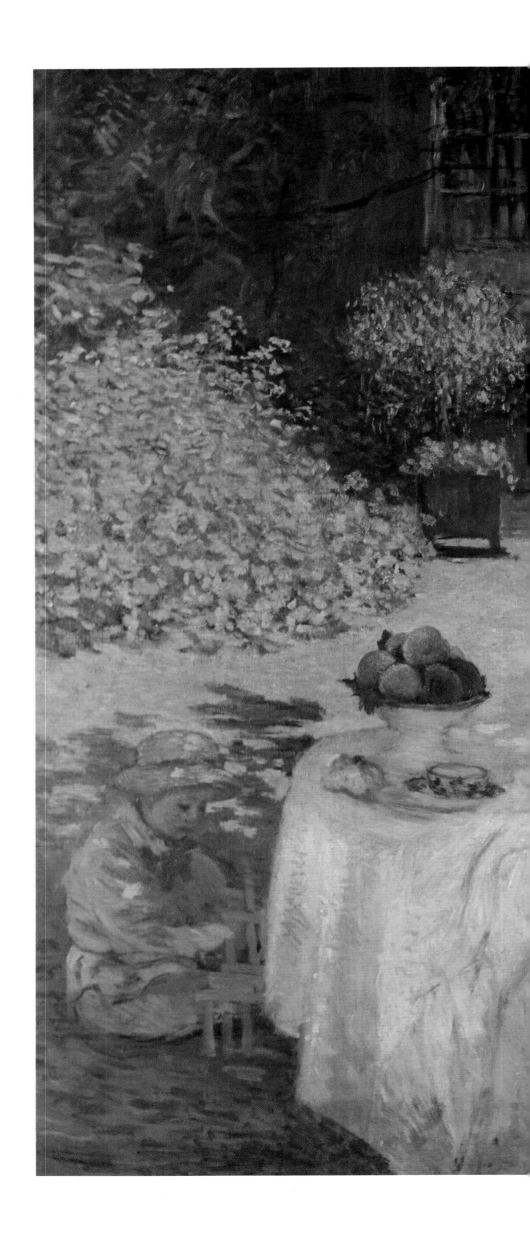

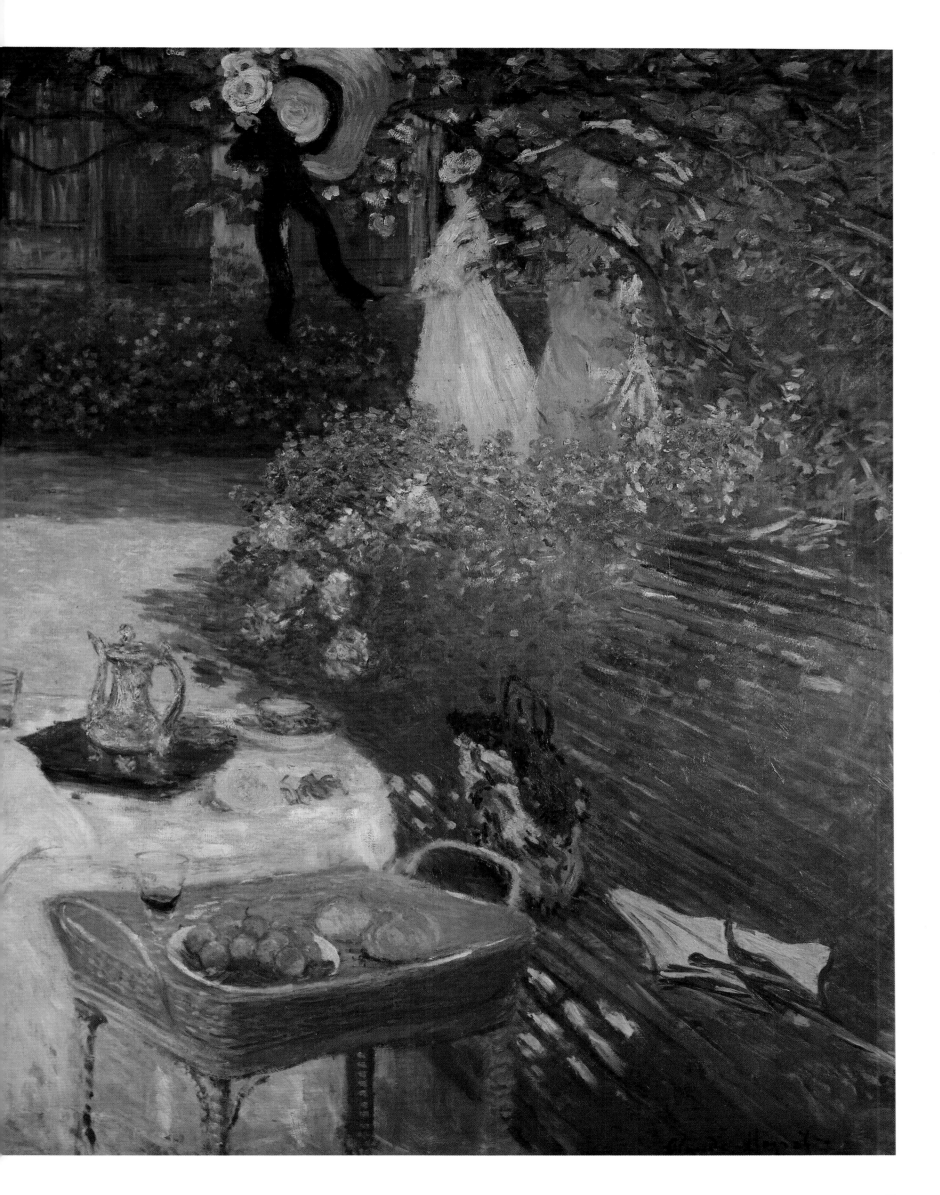

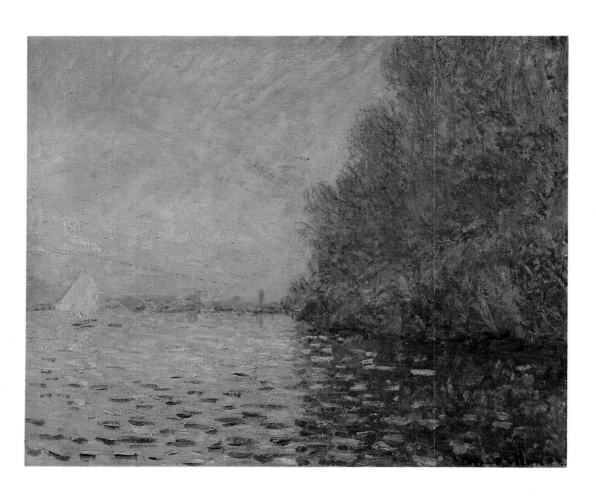

A River Scene, Autumn c. 1874
Oil on canvas
21¾×25½in (55×65cm)
National Gallery of Ireland, Dublin

The Seine at Argenteuil 1872
Oil on canvas
22×29½in (56×75cm)
Courtauld Institute Galleries, London

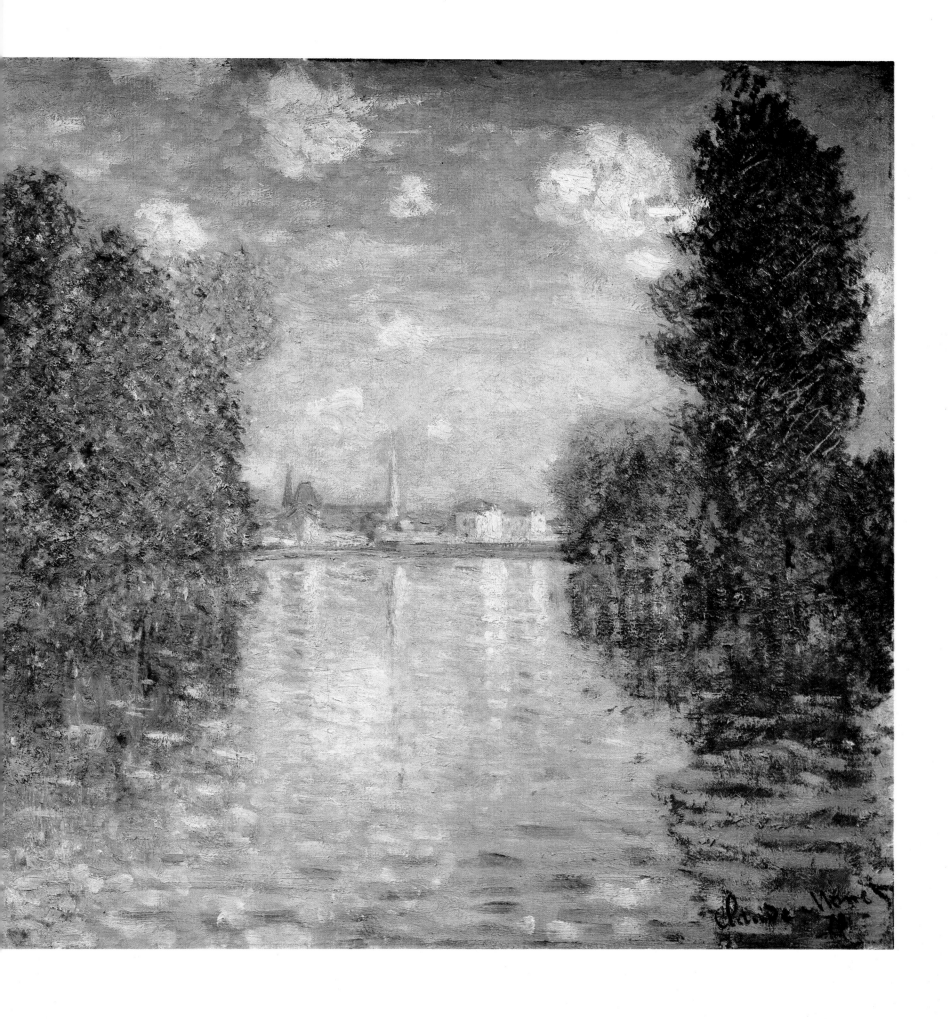

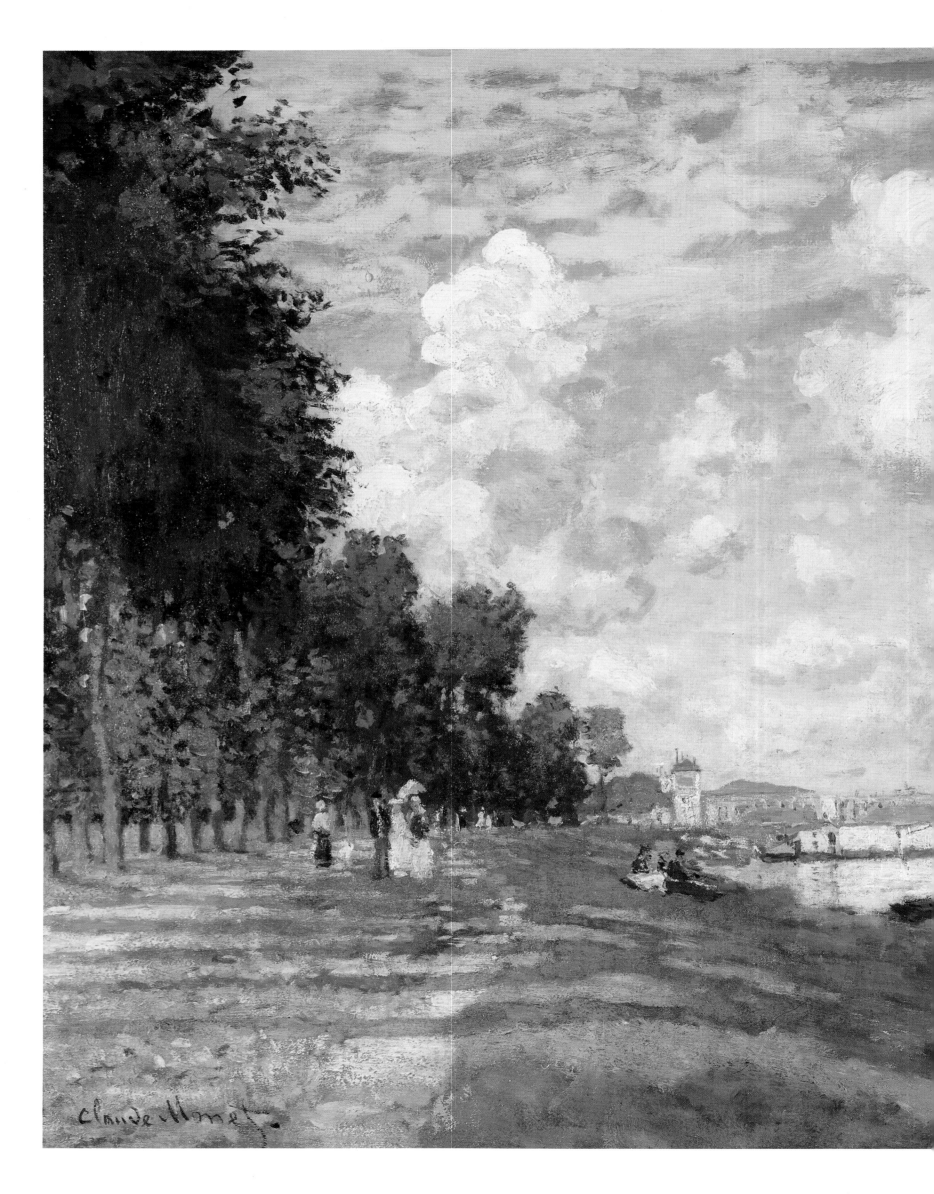

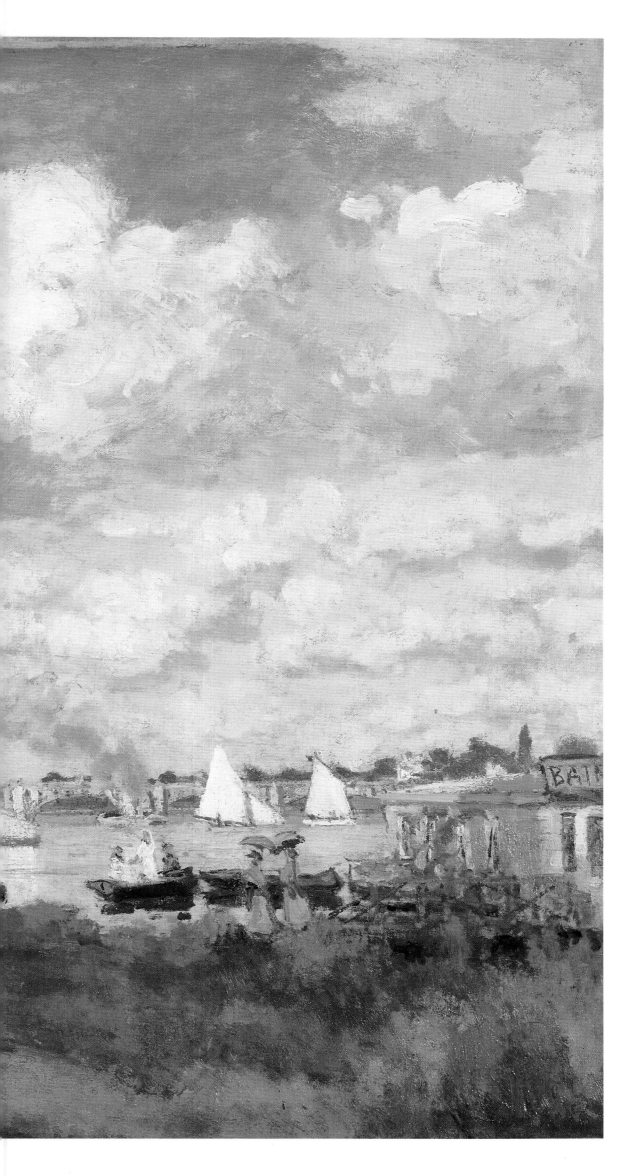

River Basin at Argenteuil 1872
Oil on canvas
23½×31¾in (60×80.5cm)
Musée d'Orsay, Paris

Ships in a Harbor 1873
Oil on canvas
19½×23¾in (49.8×60.3cm)
Museum of Fine Arts, Boston

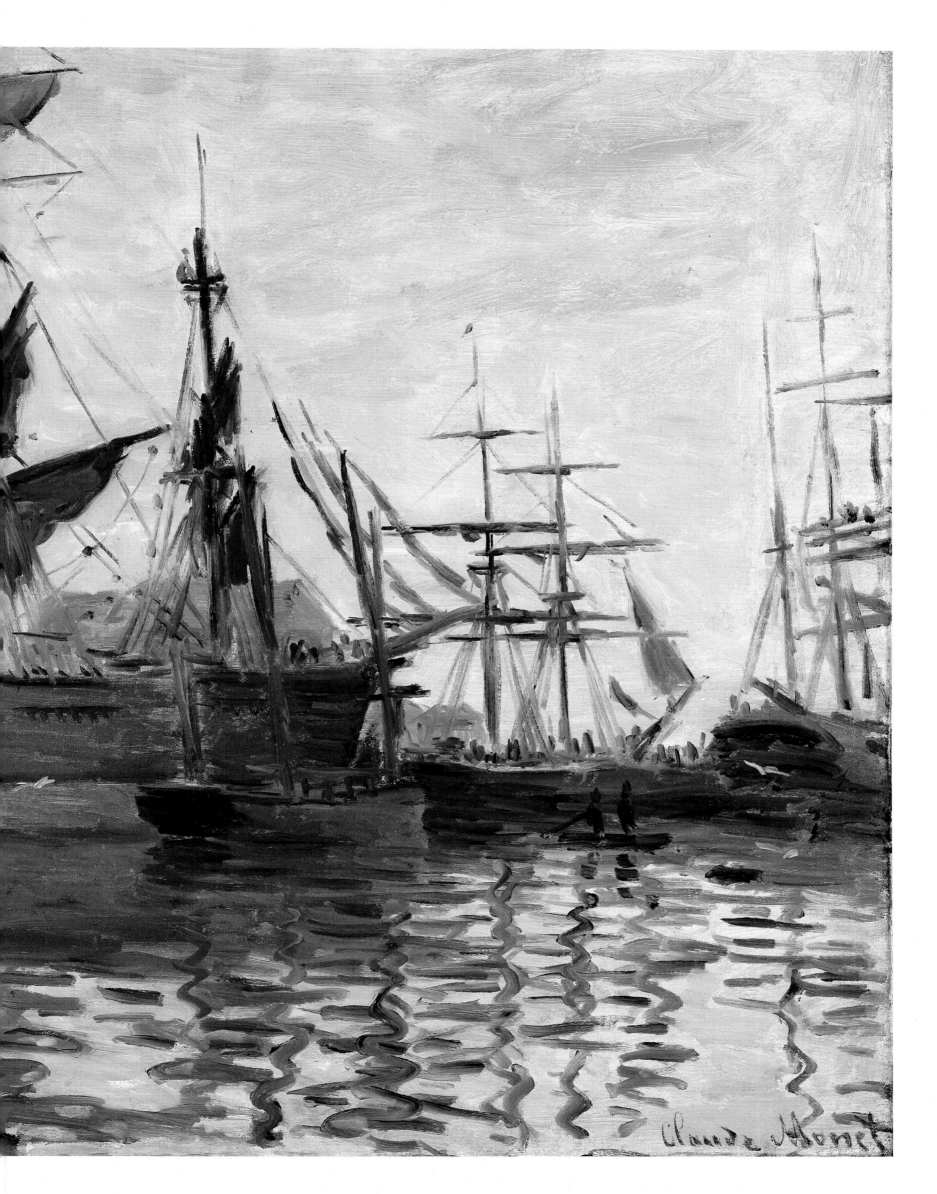

Impression, Sunrise 1872
Oil on canvas
19×24¾in (48×63cm)
Musée Marmottan, Paris

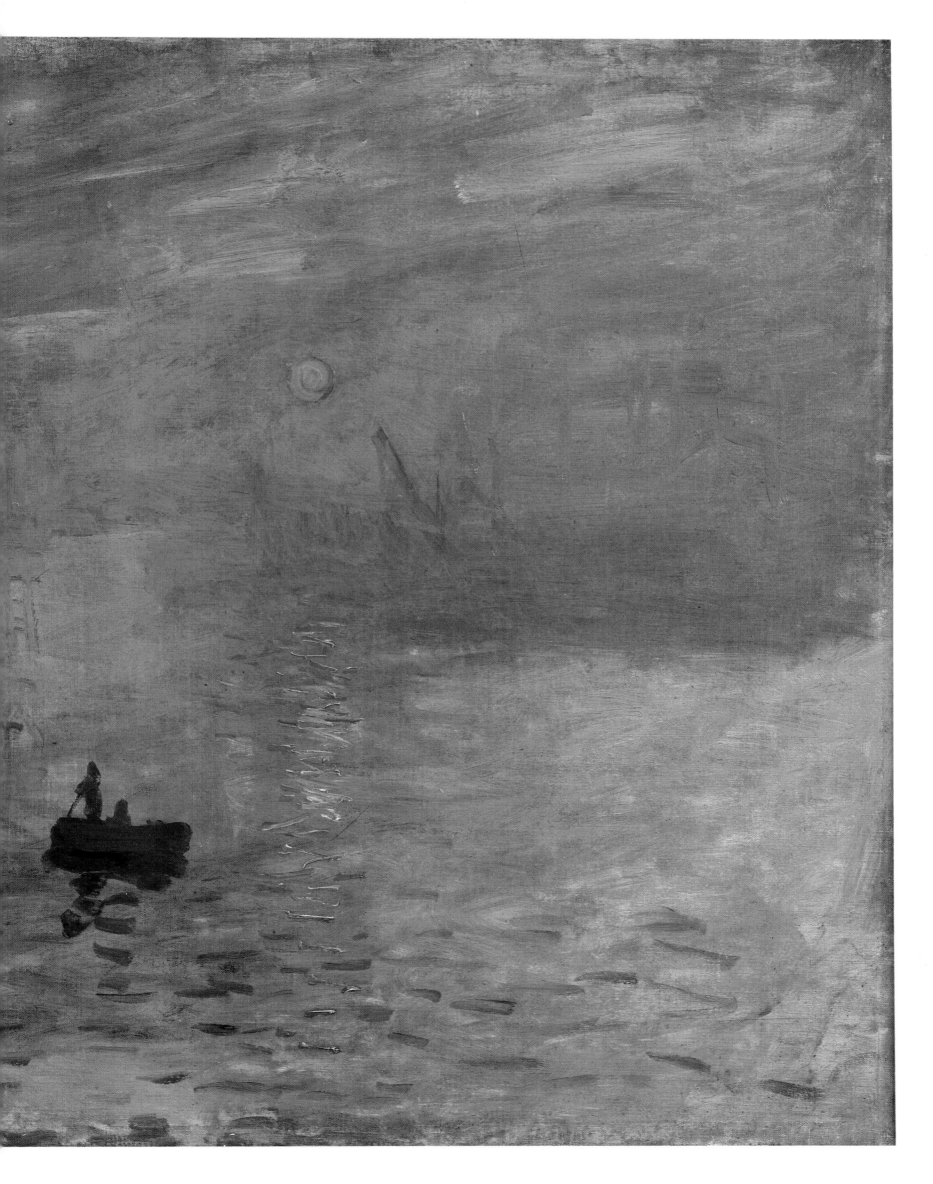

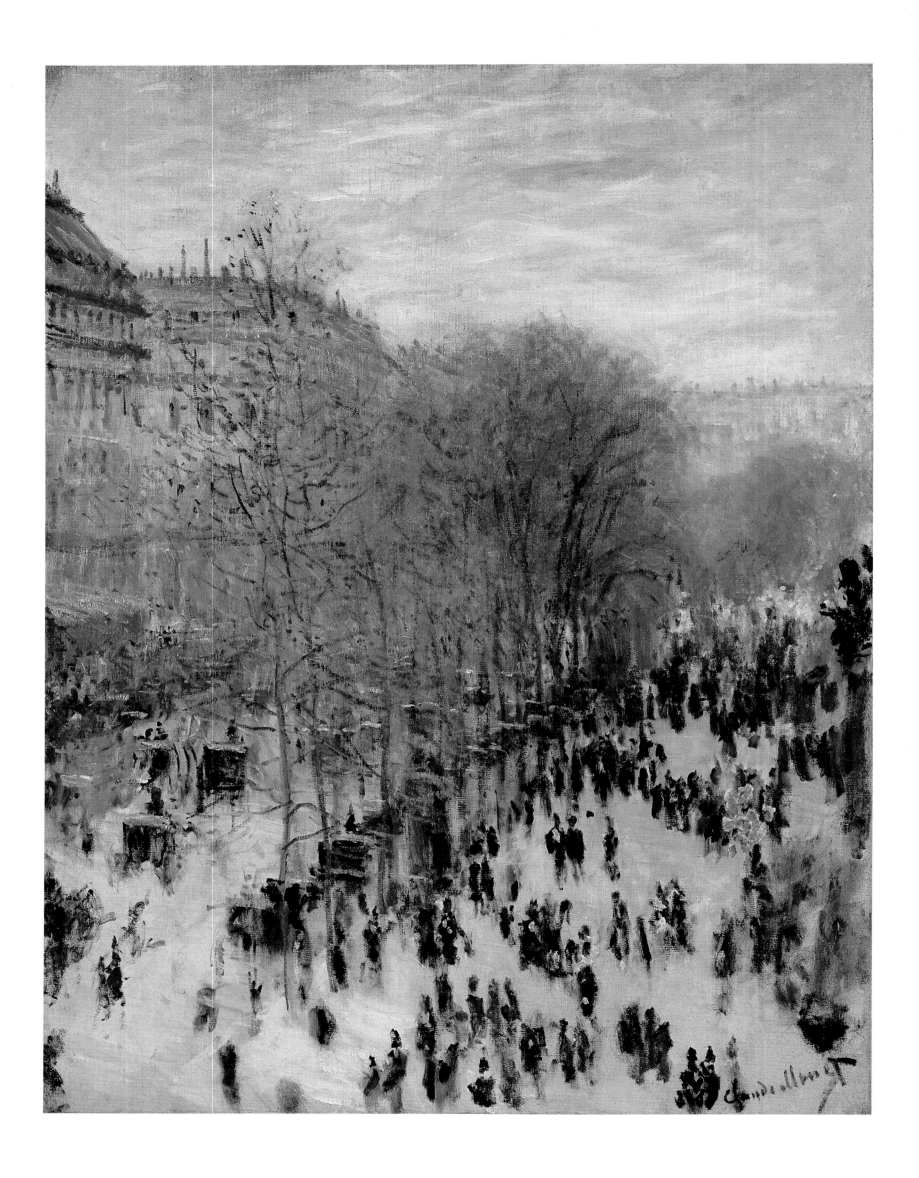

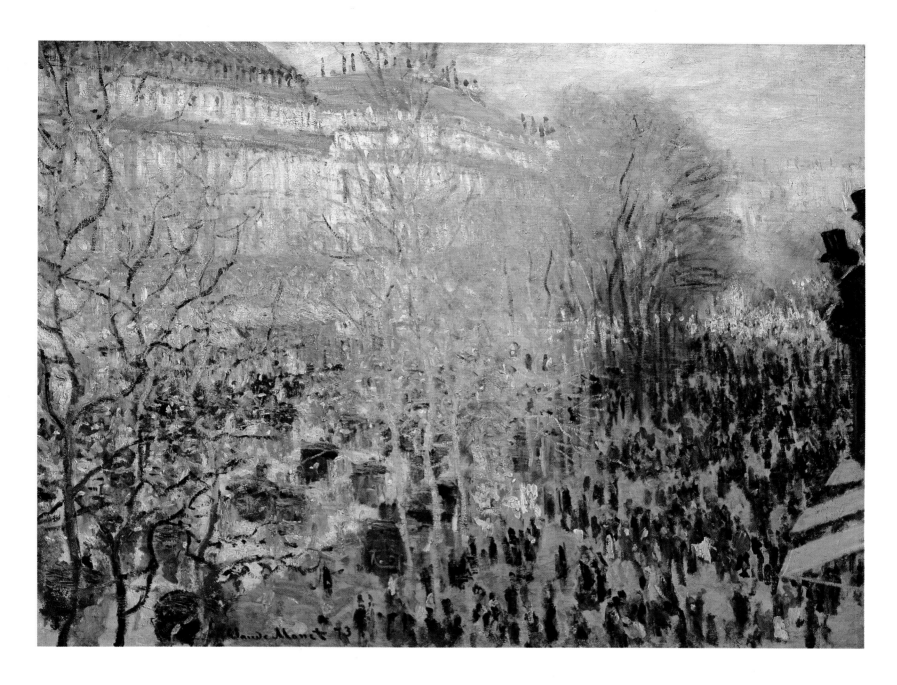

Boulevard des Capucines 1873
Oil on canvas
23½×31½in (60×80cm)
Pushkin Museum, Moscow

Left:
Boulevard des Capucines 1873
Oil on canvas
31½×23¼in (80×59cm)
The Nelson-Atkins Museum of Art, Kansas

Wild Poppies 1873
Oil on canvas
19¾×25½in (50×65cm)
Musée d'Orsay, Paris

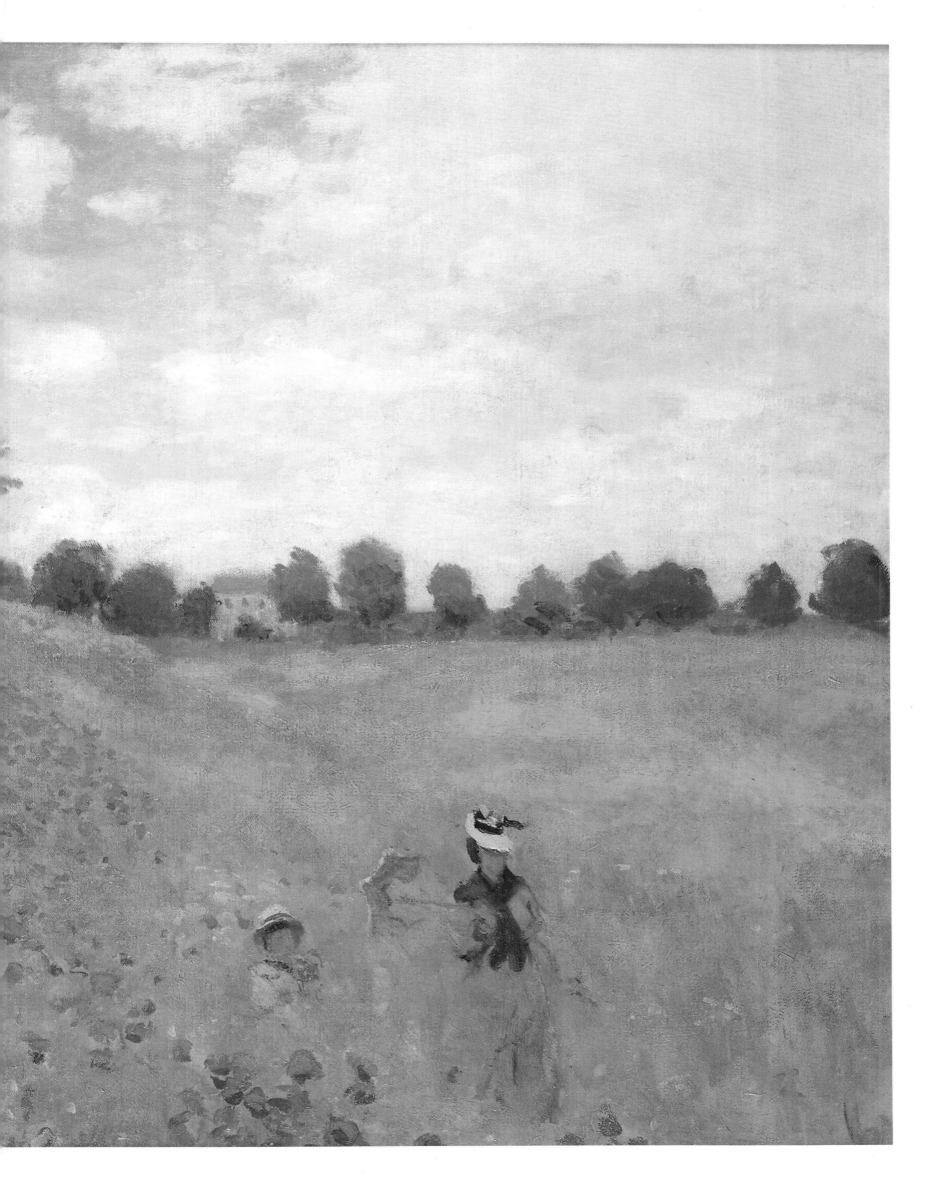

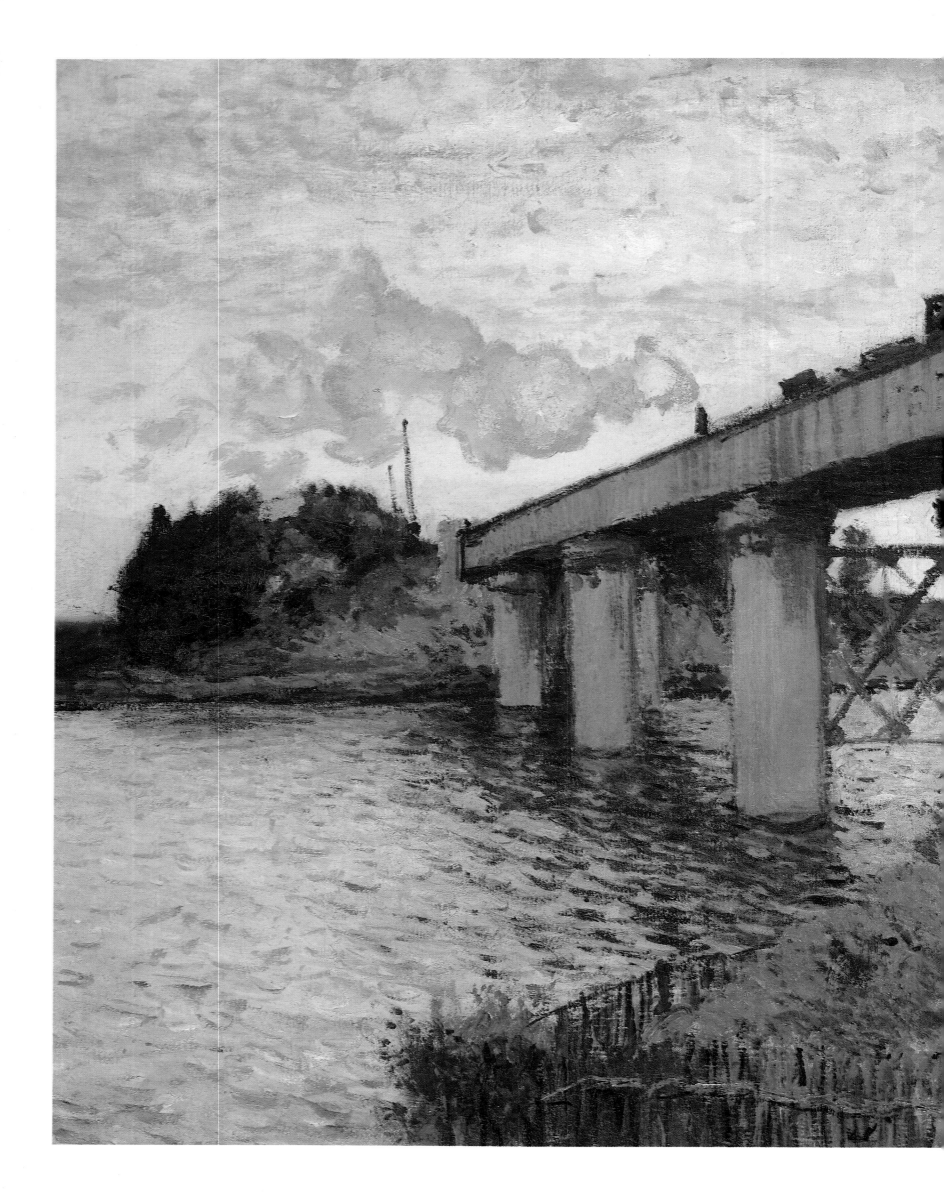

Railway Bridge at Argenteuil 1874
Oil on canvas
21¾×28½in (55×72cm)
Musée d'Orsay, Paris

Bridge at Argenteuil on a Gray Day
c. 1876
Oil on canvas
24×31¾in (61×80.5cm)
National Gallery of Art, Washington

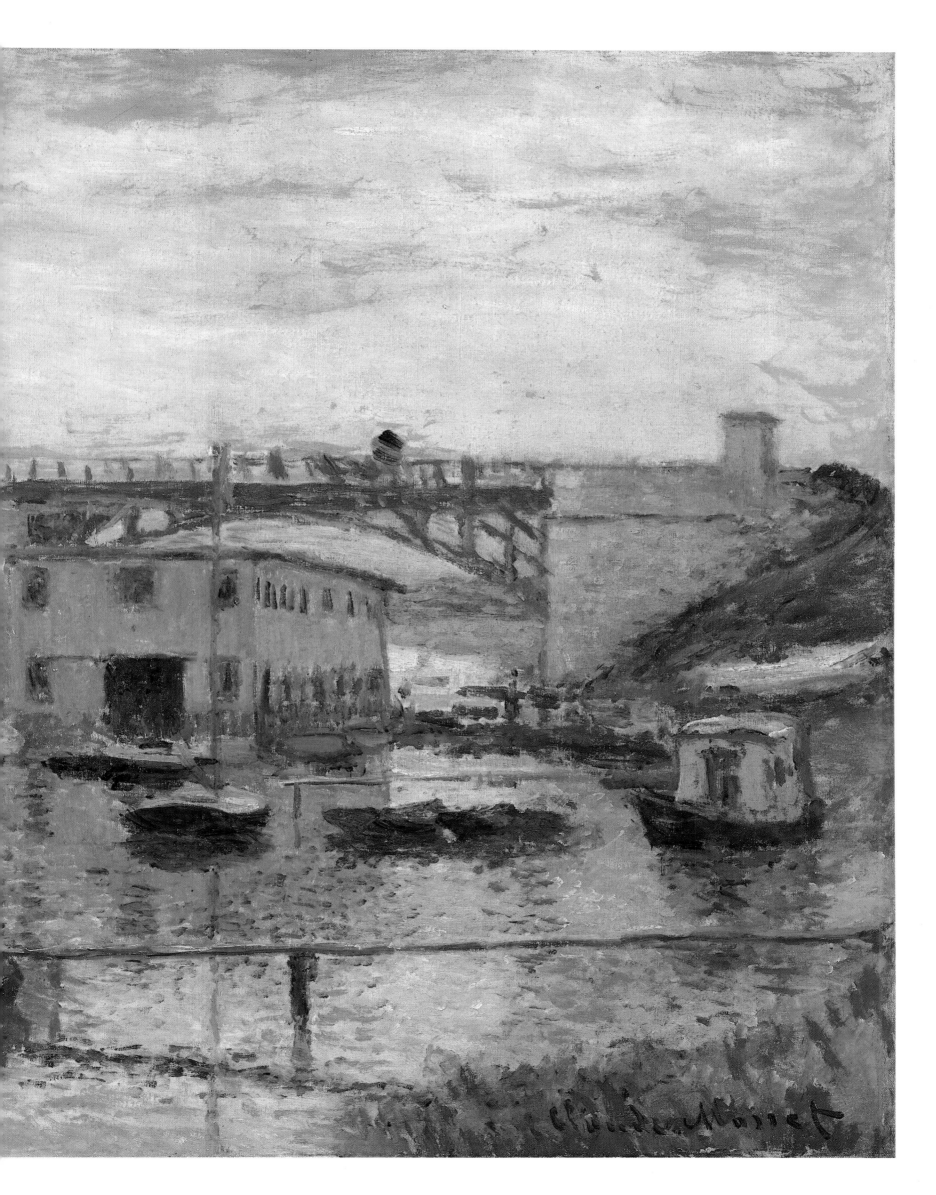

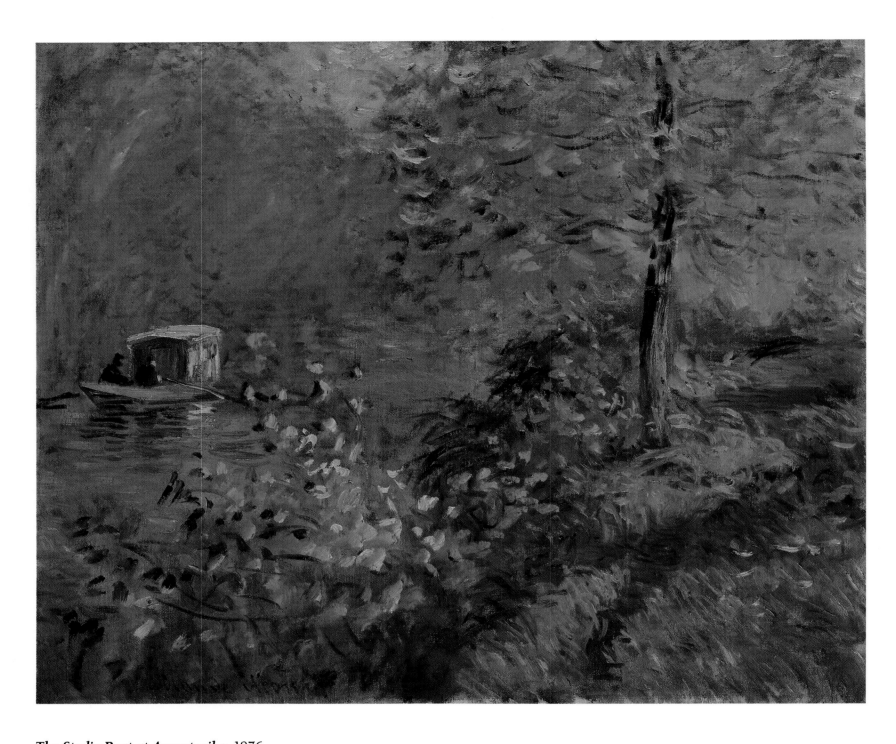

The Studio Boat at Argenteuil c. 1876
Oil on canvas
21¼×25½in (54×65cm)
Musée d'Art et d'Histoire, Neuchâtel

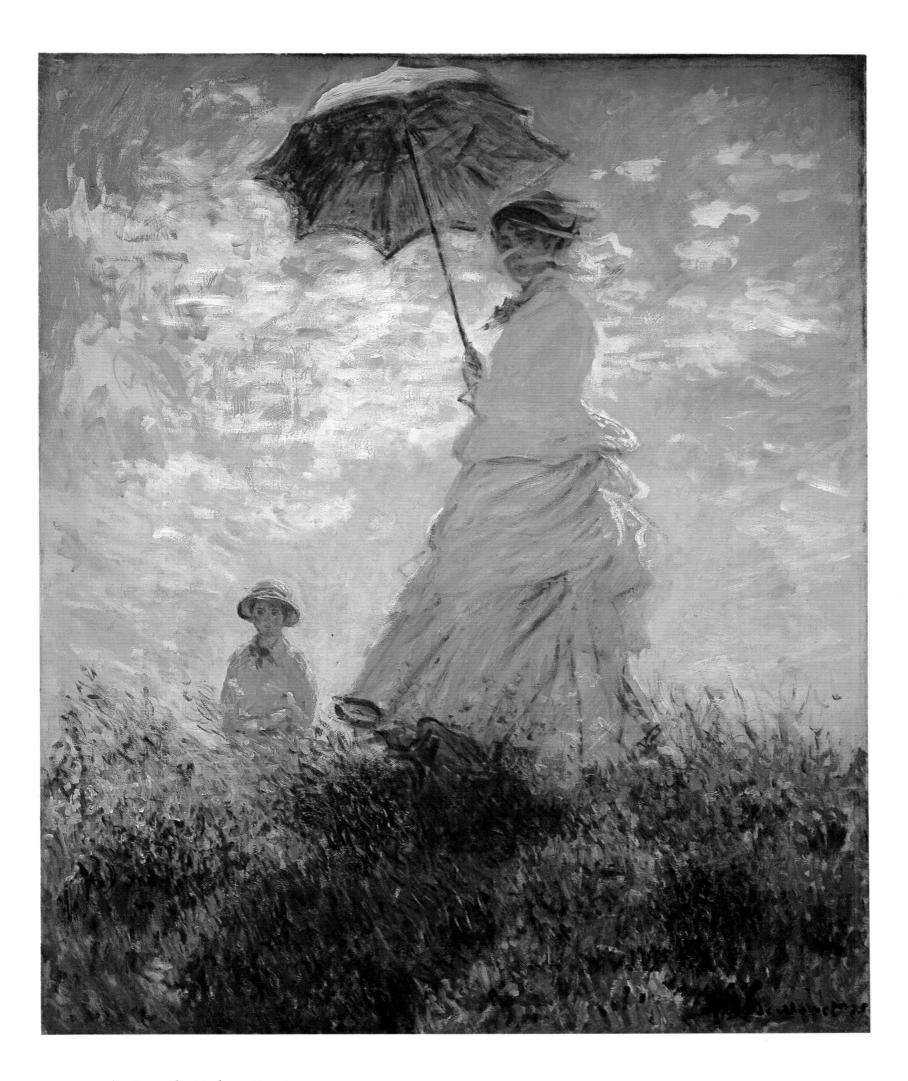

Woman with a Parasol – Madame Monet
and Her Son 1875
Oil on canvas
39½×31¼in (100×81cm)
National Gallery of Art, Washington

Train in the Snow 1875
Oil on canvas
23¼×30¾in (59×78cm)
Musée Marmottan, Paris

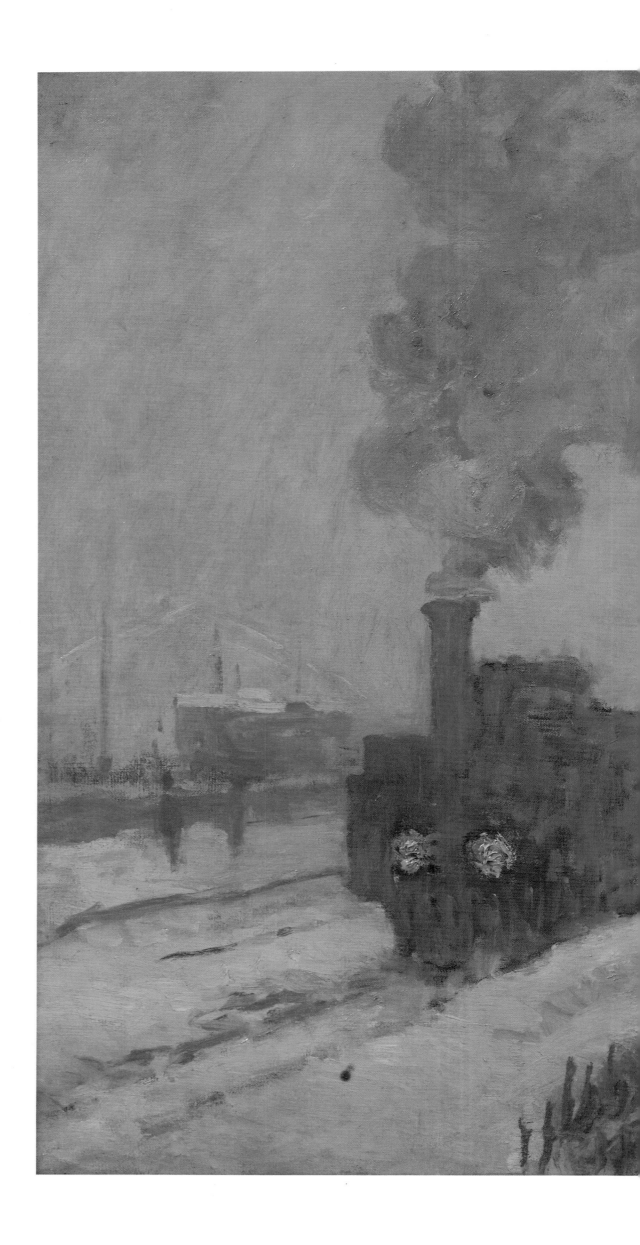

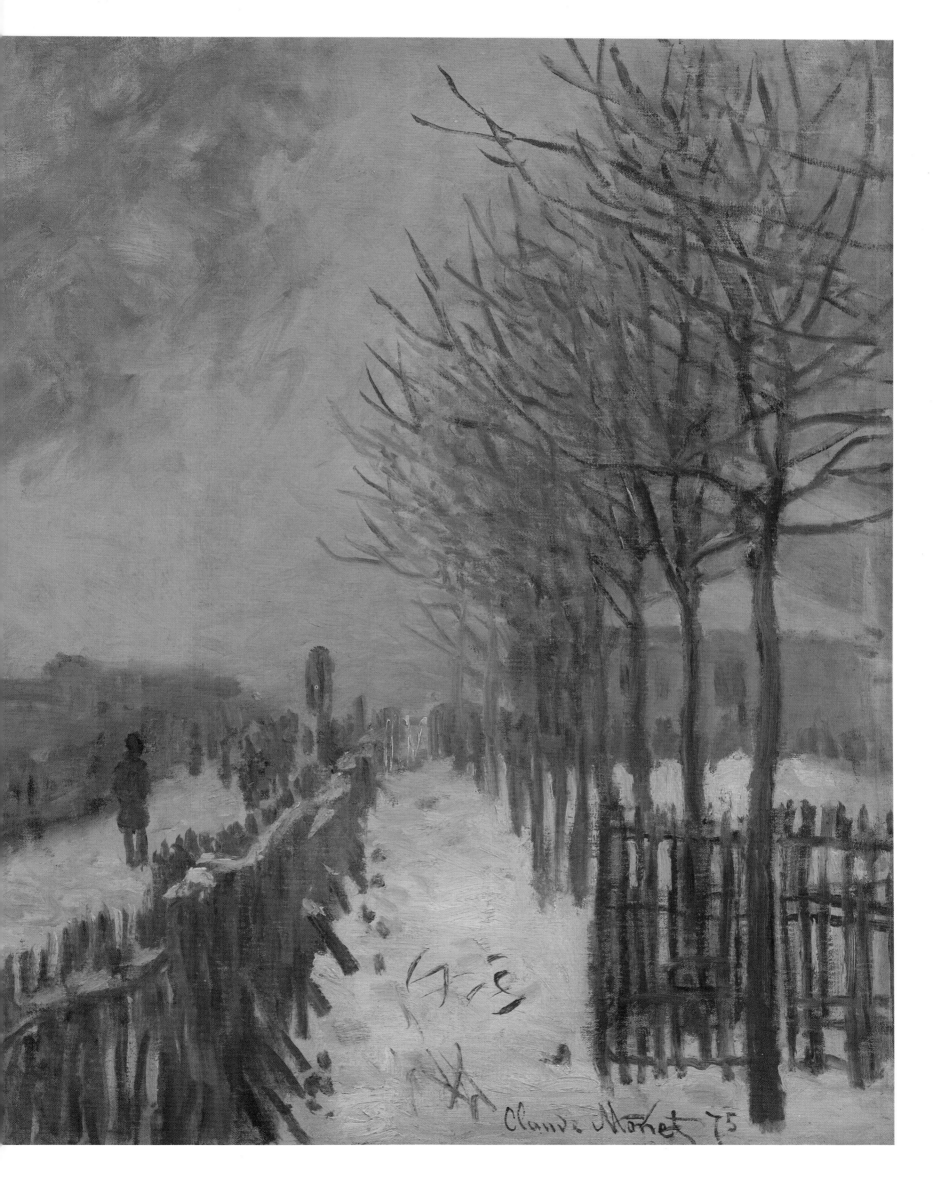

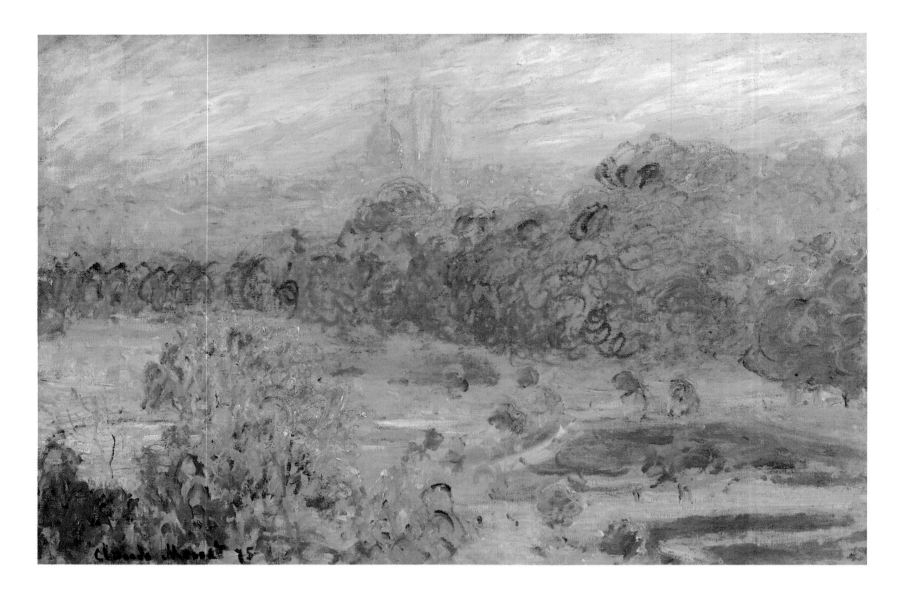

The Tuileries – Etude 1875
Oil on canvas
19¾×29½in (50×75cm)
Musée d'Orsay, Paris.

Right:
A Corner of the Apartment 1875
Oil on canvas
32×23¾in (81.5×60.5cm)
Musée d'Orsay, Paris

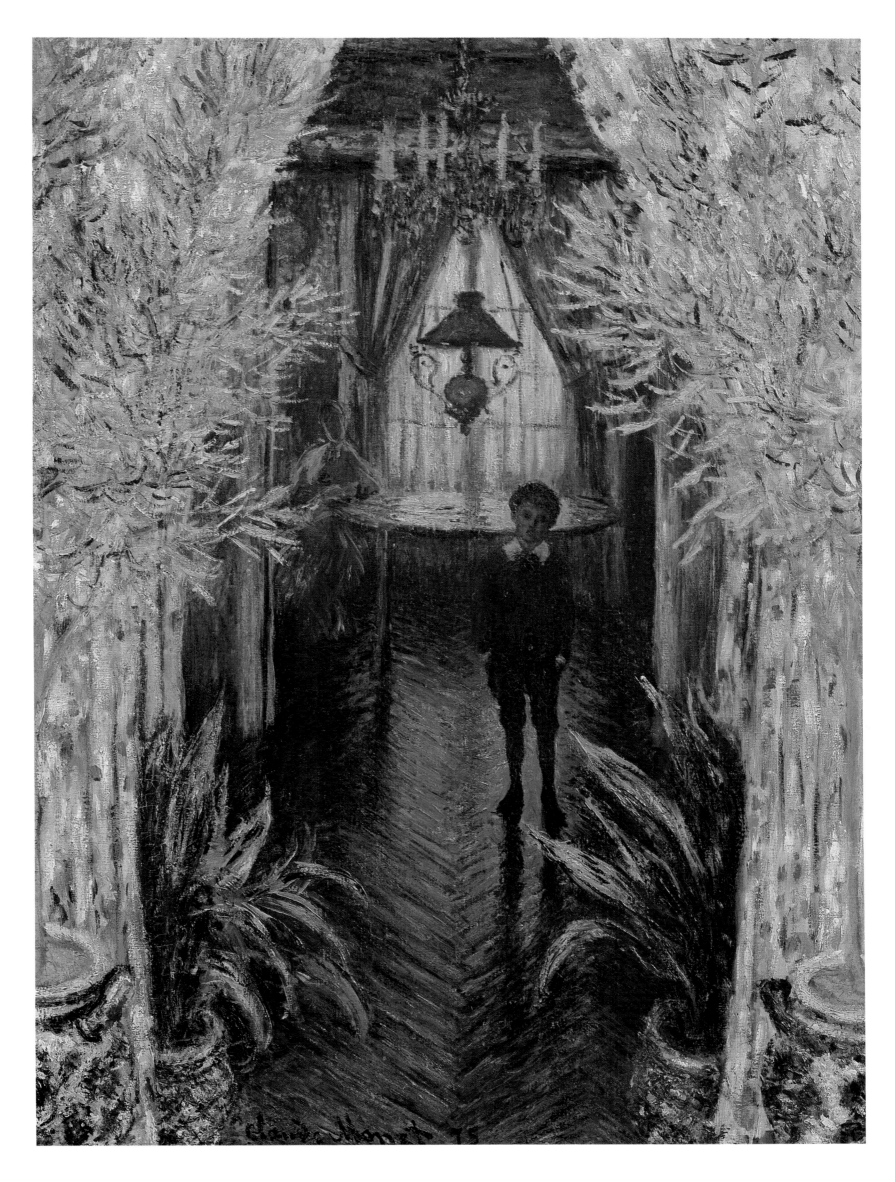

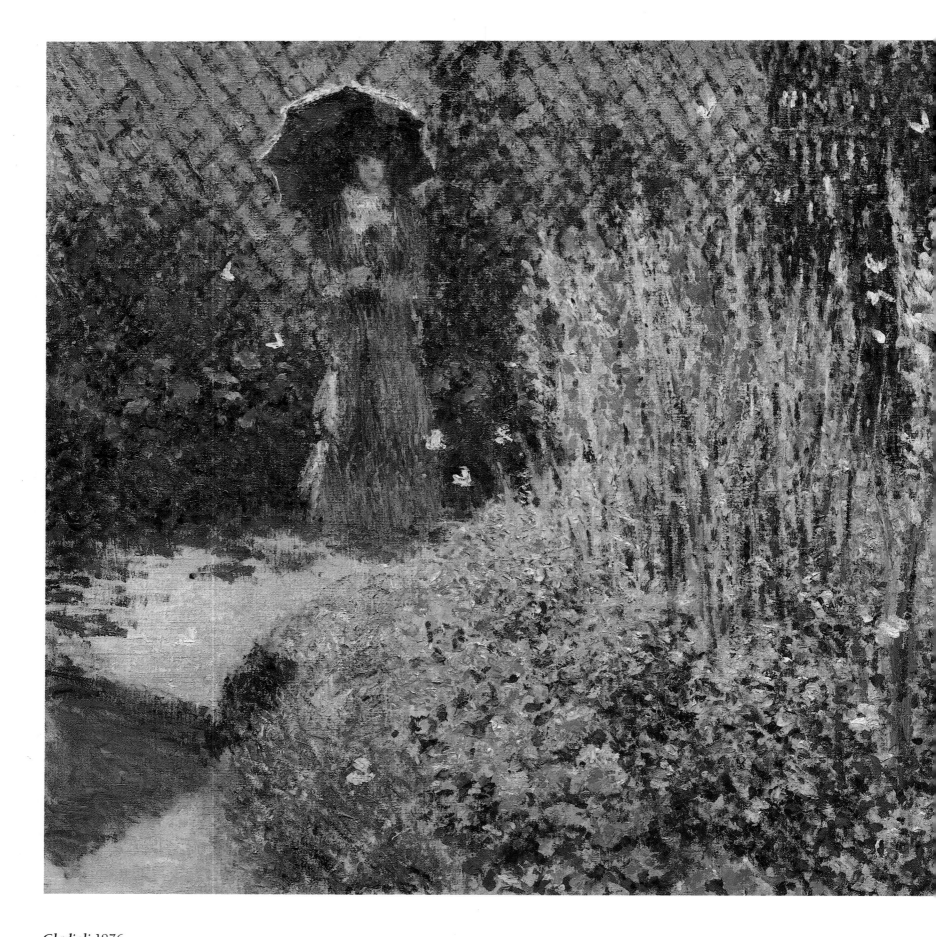

Gladioli 1876
Oil on canvas
21¾×32¼in (55×82cm)
The Detroit Institute of Arts, Detroit

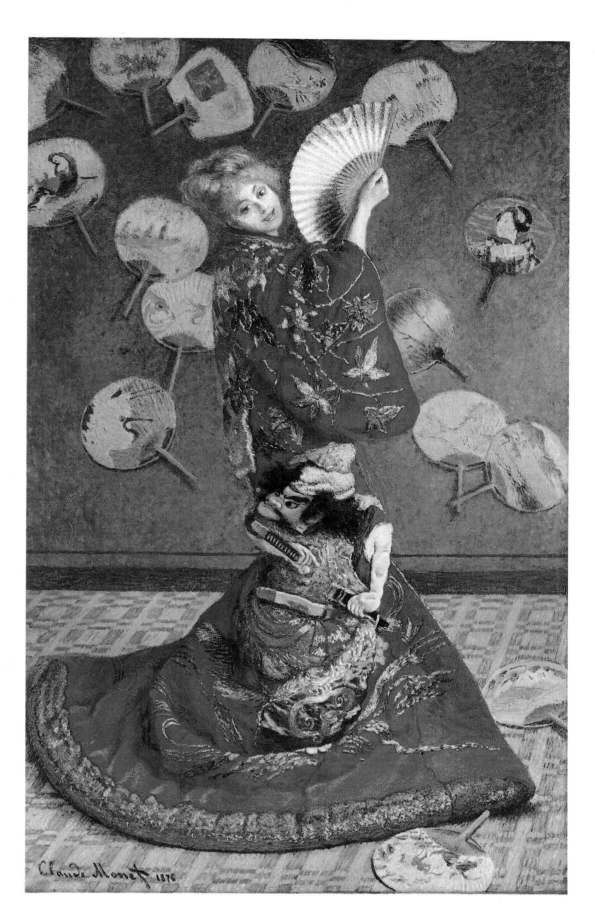

La Japonaise 1875-76
Oil on canvas
91¼×56in (231.6×142.3cm)
Museum of Fine Arts, Boston

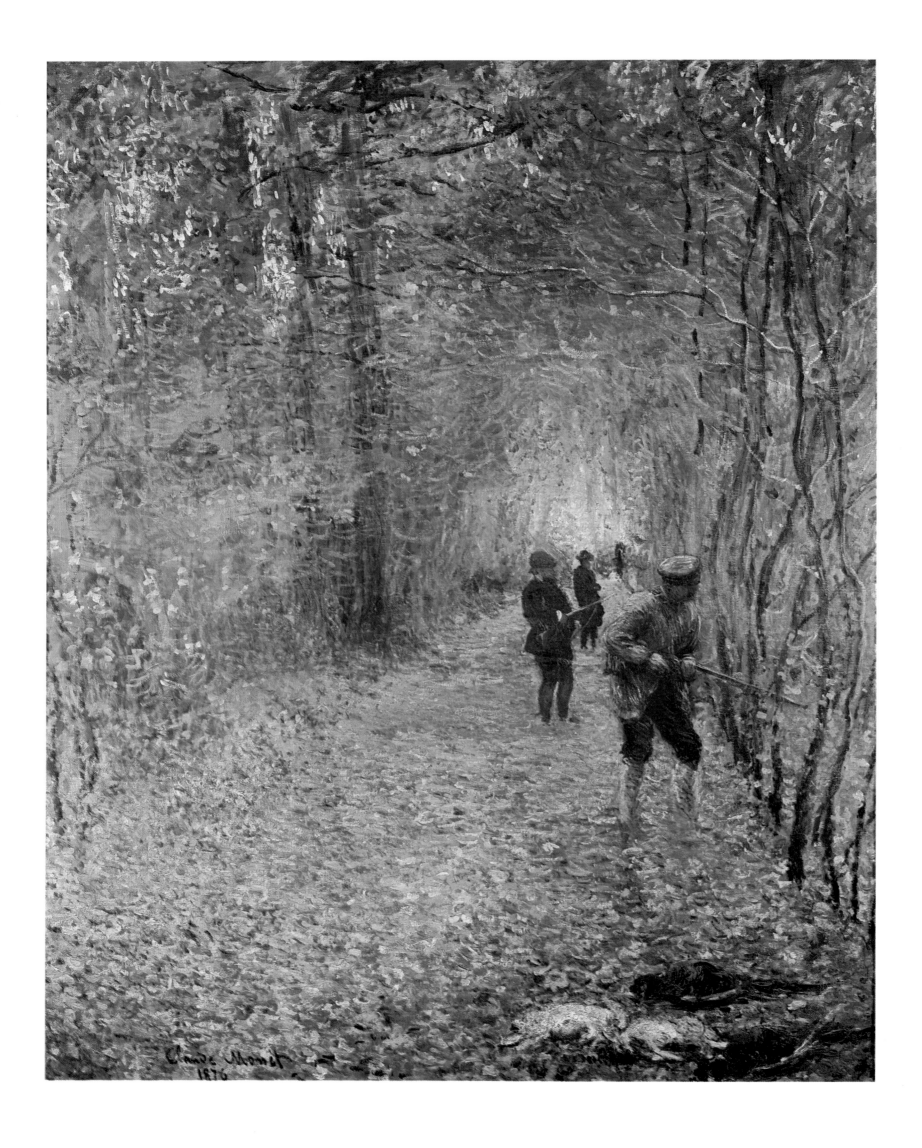

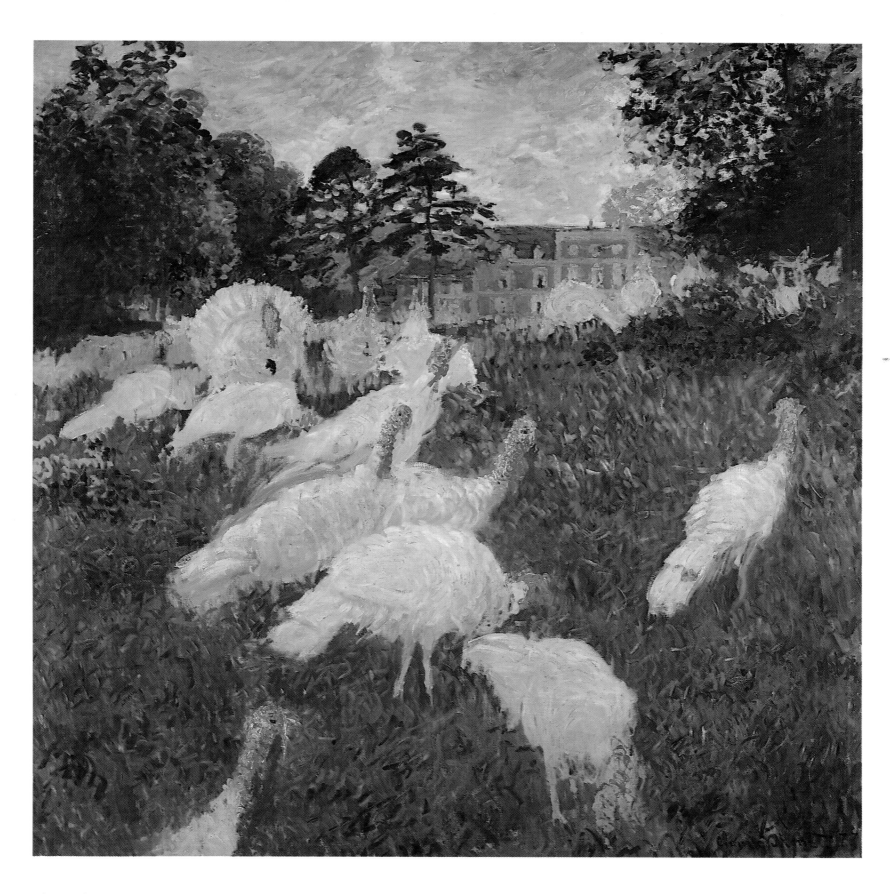

The Turkeys 1876
Oil on canvas
67¾×69in (172×175cm)
Musée d'Orsay, Paris

Left:
The Hunt 1876
Oil on canvas
67×54in (170×137cm)
Collection Durand-Ruel, Paris

The Gare Saint-Lazare 1877
Oil on canvas
29¾×41in (75.5×104cm)
Musée d'Orsay, Paris

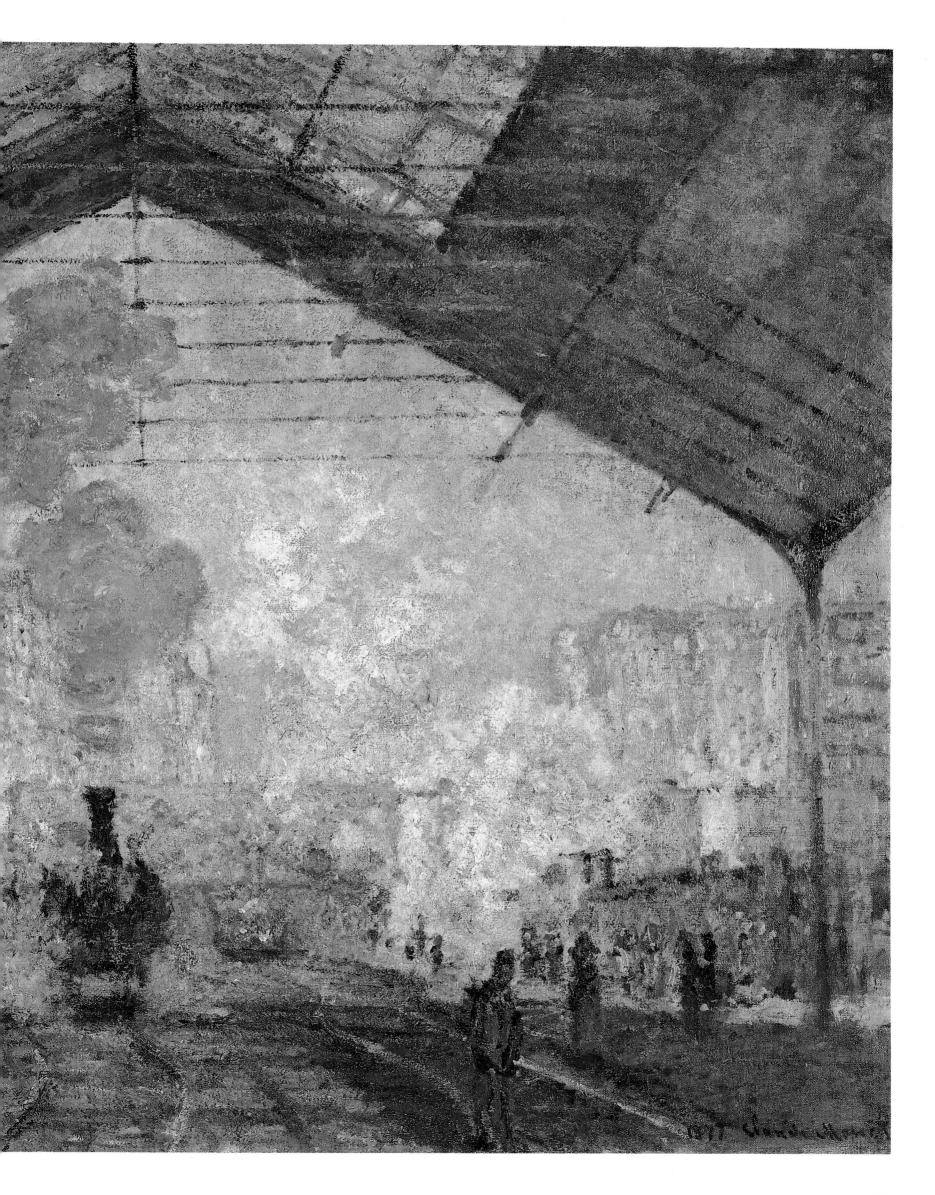

The Pont de l'Europe 1877
Oil on canvas
25¼×38in (64×81cm)
Musée Marmottan, Paris

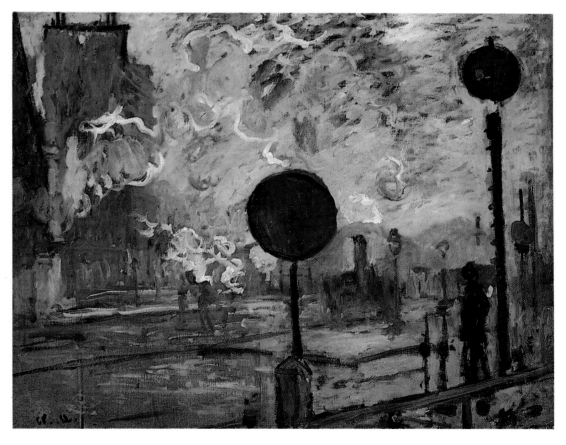

Outside the Gare Saint-Lazare, (The Signal) 1877
Oil on canvas
25¾×32¼in (65.5×82cm)
Niedersächsisches Landesmuseum, Hannover

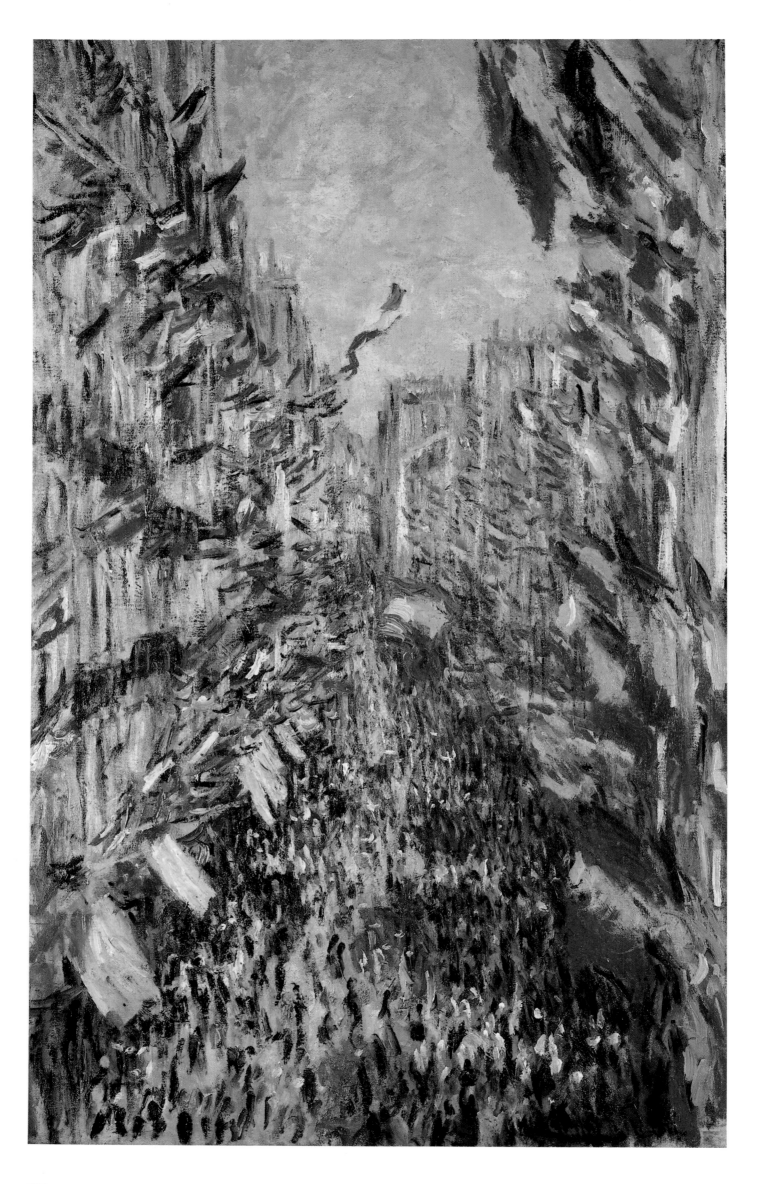

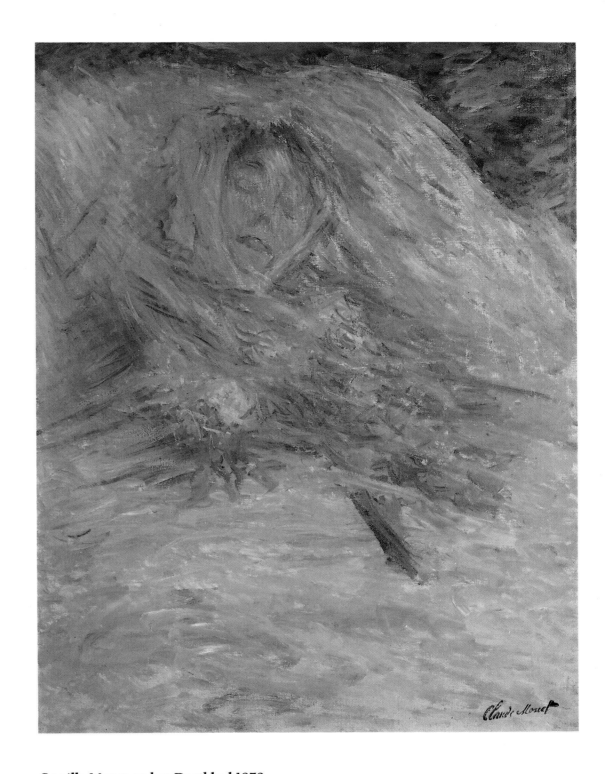

Camille Monet on her Deathbed 1879
Oil on canvas
35½×26¾in (90×68cm)
Musée d'Orsay, Paris

La Rue Montorgueil,
La fête du 30 juin, 1878 1878
Oil on canvas
31½×20in (80×50.5cm)
Musée d'Orsay, Paris

Toward a Grander Vision

Monet's first landscapes of the decade featured the breaking up of the ice on the River Seine as the terrible winter of 1880 neared its end. Despite their subject matter and scale, the format of these paintings foreshadows the water lily paintings of his last years. He produced 16 views of the river which reveal a move away from a specifically modern subject matter to a concentration on expressing the elemental aspects of nature. *The Ice Floes* (page 120) contains no obvious center of interest, but directs the spectator to contemplate the scene in its entirety laid out across the canvas. No hint of narrative disturbs the overriding bleakness of the scene and the bitter chill of the icy weather is emphasized by the cool tones established in the blues and pinks of the sunless sky which are echoed in the river surface punctuated by the melting ice floes. Other paintings of the time include *View of Vétheuil, Winter* (page 121) of 1878-9, its somber frieze-like composition and tightly-knit weave of ocher tones set against the white of the snow compound the melancholy and desolate nature of the scene. These works have little of the intimacy of his earlier snowpieces. They represent a move towards a gradual generalization of the motif that suggests the artist's desire to instill a grander and more enigmatic quality into the landscape.

The flower-paintings that he produced between 1878 and 1882 are a startling contrast to these scenes of winter gloom. In them Monet has taken up the eighteenth-century tradition of flower-paintings given new life by Delacroix in the 1840s and continued by Degas, Caillebotte and, perhaps most famously, by Van Gogh, who must have been aware of Monet's *Bouquet of Sunflowers* (page 122) of 1880-81 when he produced his own series of the subject in anticipation of Gauguin's arrival in Arles in 1888. In the first year of the decade he dedicated his energies to a number of explosive flower-studies. The blossoms spill out of their containers, filling the canvas with a textural and coloristic mass that is almost palpable. In the early years of the 1890s he produced a number of paintings which directly relate to the prints of Hokusai and to paintings by his friend Caillebotte. Monet's *Chrysanthemums* of 1897(pages 164-65), like Caillebotte's paintings, consist of dense, impenetrable masses of flower heads so closely packed as to create a richly ambiguous sense of space and, in quite a different way from the paintings of the ice-floes, these works may also be seen to lay the foundations for his *Nymphéas*.

From the early years of his career Monet was aware of the opportunities that a garden environment could offer a painter. One of his most popular and optimistic paintings is the light-filled celebration *Garden at Vétheuil* (page 123) which shows his son Jean standing by his toy cart, dwarfed by the giant sunflowers which Monet must have used for his still-life painting referred to earlier.

His extensive visits to the Normandy coast continued and resulted in a number of works that describe the landscape of that part of France. In the *Sunken Pathway in the Cliffs at Varengeville* of 1882 (page 124) Monet has chosen a typical but unspectacular feature of

the region. To experience a number of these paintings, even in reproduction, is to gain a magnificent compendium of the varied character of the landscape of the coast. He examined and recorded the cliffs from every conceivable viewpoint; the view from the base of the cliffs up to the churches that break the undulating skyline contrasts sharply with the breath-taking fall of the cliff face as it drops away from the viewer's feet in the *Cliff at Dieppe* of 1882 (page 125). The variety of viewpoint and composition is matched by the varied coloration of the canvases as they chart the ever-changing atmosphere of that part of the channel coast.

The winter being an unseasonal time for painting out of doors on the exposed coast of northern France, Monet traveled south with Renoir to search for subjects to paint on the kinder coast of the Midi. He returned to the region alone in January 1884 and attempted to put his impressions of the area on canvas. As usual his letters are full of the problems of painting the effects he experienced. The light and coloration of the coast were so vivid and unexpected that he felt he had to tone down his palette for fear that the Paris-based critics would baulk at such a high-keyed and varied range of saturated bright colors. *Cap Martin, near Menton* (pages 134-35) is a good example of Monet's reaction to the new terrain and shows his confidence in setting down bold contrasts of color and brushwork.

In 1886 Monet traveled to the rugged island of Belle-Ile, situated off the south coast of Britanny. He described the island as being 'a superbly savage country, a mass of terrible rocks surrounded by a sea of incredible colors.' Belle-Ile is a high platform of rock and its rugged southern coast splinters dramatically into the sea to cause the 'pyramids' or 'needles' whose spiky outlines feature in many of Monet's paintings of the time. He lived in relative solitude, in what appear to have been very primitive conditions. His paintings document his passionate and romantic identification with the coming together of the separate elements of land, sea, and sky. It has been pointed out by a number of Monet scholars that, despite the seeming spontaneity of these paintings, they were, in fact, like all Monet's works, carefully considered, their simplicity of form, general coloration, composition and subject matter owing a great deal to the careful perusal of Japanese prints.

More subdued in feeling, but equally powerful in execution are the brooding masses of the Creuse Valley, that he painted from March to mid-May in 1889. Monet was particularly fascinated by the narrow gorge where the Grande Creuse and the Petite Creuse converge to form a single stream. He ignored the circumstantial detail of the landscape and concentrated upon expressing the primordial nature of the scene before him. In the *Creuse Valley, Sunset* (page 150) Monet has obviously relished the ambiguity of effect and the generality of form that the landscape takes on as the sun sets, and has used contrasting oppositions of colors that generate a powerful and expressive evocation of mood. Incandescent pinks and oranges are smothered in an open weave of darker pulses of

violet and green which vie with each other to create somber harmonies that are almost musical in their intensity.

With Belle-Ile and the landscape of the Creuse Valley, Monet had found two motifs that had struck a powerful chord within him. Increasingly, one suspects, Monet deliberately sought out motifs that would accord with his aspects of his own temperament. Like the work of Cézanne, Monet's art was firmly based upon the direct and prolonged analysis of nature; their ideal was to capture the sensation it inspired. In the late 1880s and early 1890s Monet found his source of inspiration close at hand in the fields that flanked his property at Giverny. These paintings are, without doubt, some of the oddest works in Monet's career, and some of the most deeply moving.

Producing series of paintings claiming to represent views of the same motif from approximately the same position at different times of the day and under different weather conditions was already one of Monet's firmly established working practices. He had not, however, fully developed the implications contained within such a manner of working until after 1890, when he set about producing painting after painting of the stacks of cereal grain which he could easily study in the fields around his home. The prosaic subject matter does not prepare the viewer for the spectral apparitions that dominate the landscape like alien beings. They are saturated with an almost unimaginable intensity of coloration that is spread evenly throughout the rest of the canvas. The formats of the paintings vary; often, as in the examples illustrated here, the stacks are set close to the viewer, so close that their edges are cropped by the sides of the canvas, or in the middle distance so that their shapes merge with the buildings on the far edge of the field.

The freedom with which Monet treated the grainstacks was repeated in his series based on a group of poplar trees that lined the nearby River Epte. His initial paintings of the motif are relatively naturalistic, but as the series developed the realities of nature were adapted to the will of the artist, even to the extent of the trees' young shoots being pruned back as they began to sprout and disturb Monet's sense of design. In the three paintings reproduced here, it is possible to see Monet's progress toward a more abstracted rendition of the subject. His *Poplars* (page 155) of 1891 remained relatively faithful to traditional means of rendering the recession of the trees as they followed the meandering course of the river. In his *Four Poplars* (page 156) painted later that year, the trees are seen cut by the picture frame to form the thin filaments of a rectilinear grid. The strip of water at the bottom of the canvas reflects the bank and the trees, extending their verticals beyond the edge of the canvas, and they may be extended into infinity in the imagination of the viewer. The coloristic innovations of this period are increasingly dependent upon Monet's own desire to experiment with the entire range of colors at his disposal. Although the dialogue with nature was essential as the basis of a painting, much of the work on any one canvas was the result of considerable retouching in the studio.

The paintings of the Cathedral at Rouen are reminiscent of his Belle-Ile paintings with their rock faces pitted and seen in close focus, filling the whole canvas in a single encrustation of pigment. Monet was not a religious man in the conventional sense, but his pantheistic regard for the guiding principle that lay behind the multifarious aspects of nature led him to attach more and more importance to the unifying and generalizing properties of light. Such interests were becoming more prevalent in the art world generally in the 1880s and this allowed his work, always begun in a spirit of empirical investigation, to be interpreted by the younger generation of critics as being of an essentially Symbolist nature.

Landscapes featuring ice and snow attracted Monet both because of the technical problems they presented and the harmonious effects that such conditions bring to nature. At the end of the decade, Monet returned to the subject of ice on the river. In his painting of the *Ice Floe* (page 160) of 1893 a central mass of mist-wreathed trees stands reflected in the icy waters below. Monet, like many artists, was captivated by the charm and the technical innovations of Japanese prints and had an extensive collection of them which may be seen to this day at Giverny. The snow-filled landscapes of Hokusai and Hiroshige are immediately brought to mind in looking at his transformation of a very functional and prosaic bridge in the Norwegian village of Sandvika into something suspiciously close to a scene from a Walt Disney movie (page 161).

Monet continued to make visits across the English Channel which culminated in the series of paintings dedicated to the Houses of Parliament. The fog, once so much a part of the London scene, was the only aspect of the capital that Monet really admired, and he produced many compositions in which the Parliament buildings were transformed into immaterial swathes of color more suitable to suggest the medieval legend of the drowned city of Ys rather than the active hub of the British Empire.

For a painter so completely obsessed with the interaction between light and water it is surprising that Monet did not visit Venice earlier in his career. His paintings of the city are contemporary with his water-lily paintings and share many of the same concerns. They were exhibited in Paris in 1912, but Monet was dissatisfied with them. He wrote:

They are horrible. They are worthless . . . I went to Venice with my wife. I took notes and should have gone back there. But my wife died and I never had the courage. So I finished them off from memory . . . and nature has had its revenge.

The finished canvases are very much studio works and glisten in a haze of reflected light and color. Contrasting with these rather overworked canvases is a large and powerful study of a gondola, confidently drawn with a full brush, leaving the white canvas to evoke the light-filled mist that surrounds and envelops the high-prowed boat. It has a sense of freshness that we find in the sketches and initial lay-ins that remained in the painter's studio at his death.

The Ice Floes 1880
Oil on canvas
38¼×59in (97×150cm)
Shelburne Museum,
Shelburne, Vermont

View of Vétheuil, Winter 1879
Oil on canvas
20½×28in (52×71cm)
Musée d'Orsay, Paris

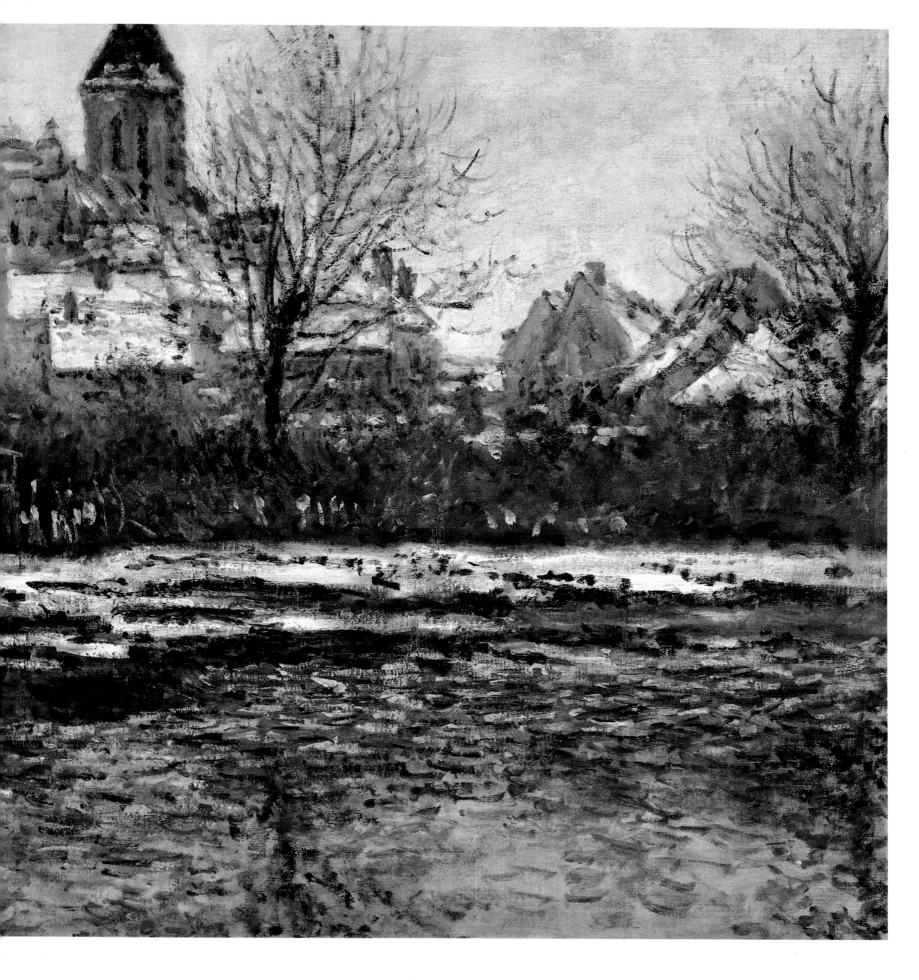

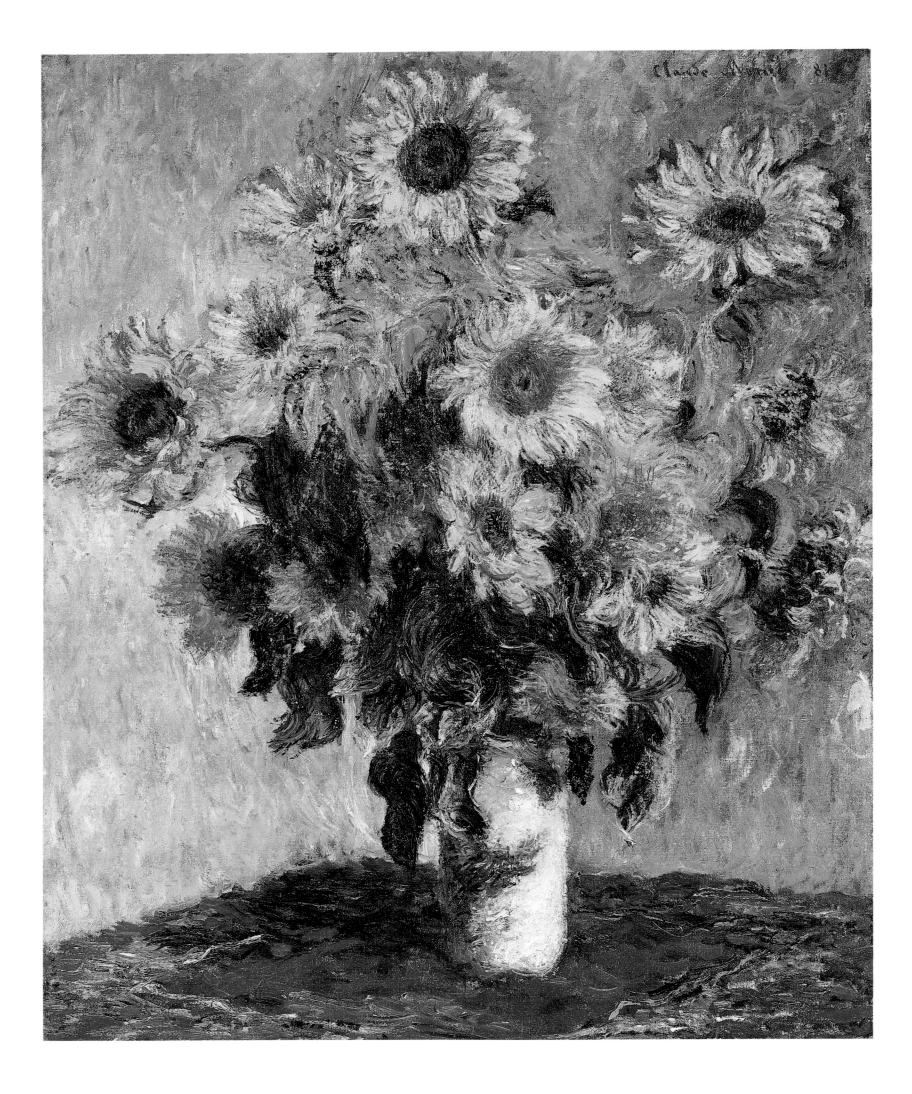

Bouquet of Sunflowers 1880-81
Oil on canvas
39¾×32in (101×81.3cm)
Metropolitan Museum of Art, New York

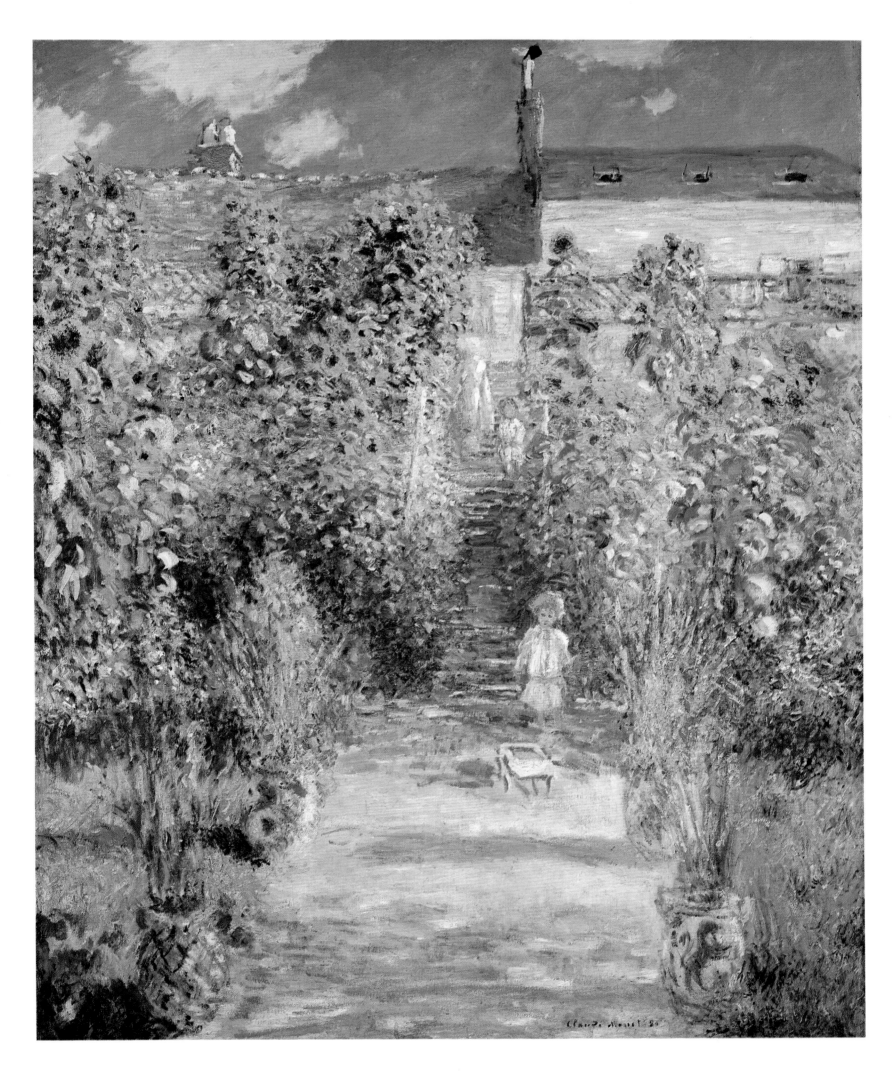

The Artist's Garden at Vétheuil 1880
Oil on canvas
59¾×47¾in (151.4×121cm)
National Gallery of Art, Washington

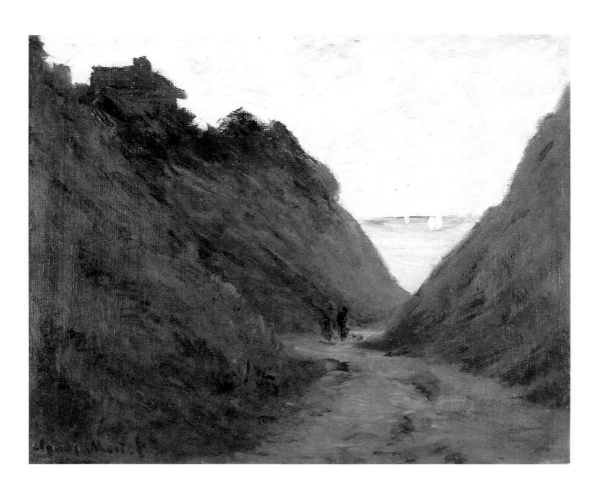

**Sunken Pathway in the Cliffs at
Varengeville** 1882
Oil on canvas
23½×28¾in (60×73cm)
Walsall Art Gallery, England

Cliff at Dieppe 1882
Oil on canvas
25½×32in (65×81cm)
Kunsthaus, Zurich

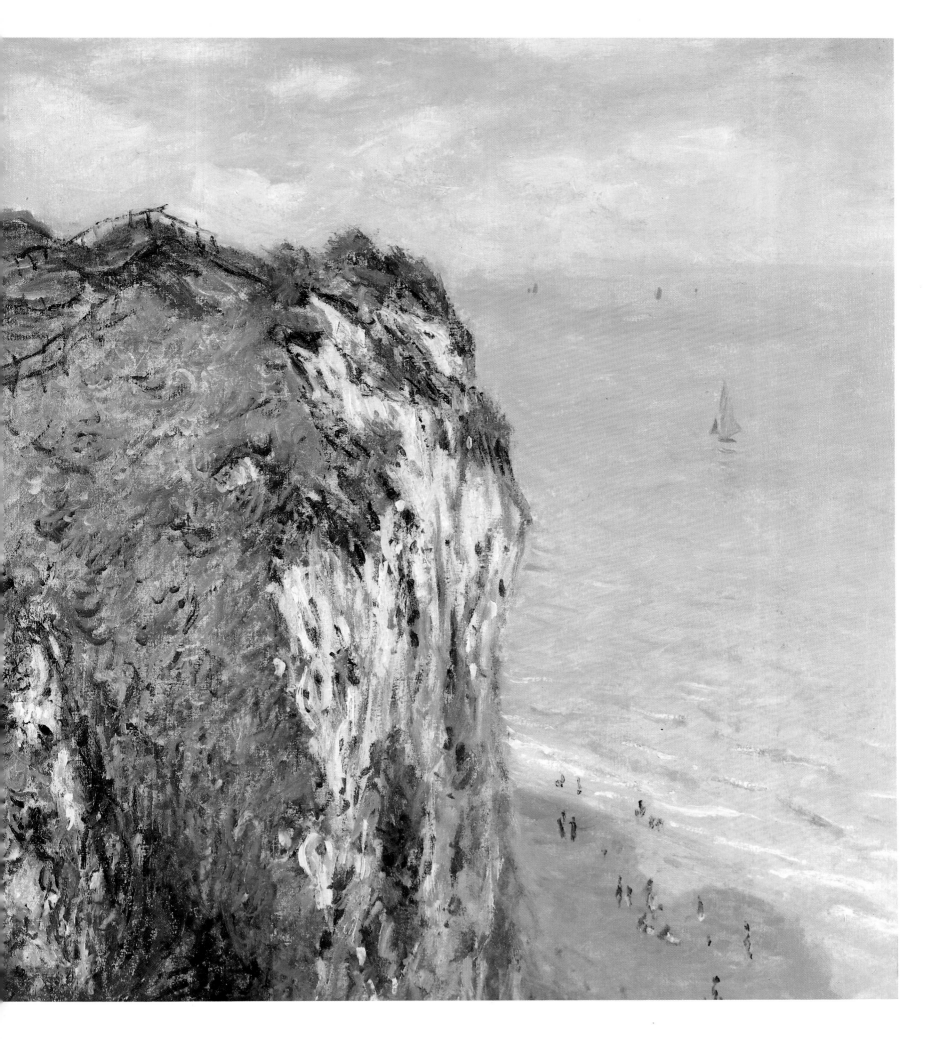

Stormy Sea at Etretat 1883
Oil on canvas
32×39¼in (81×100cm)
Musée des Beaux-Arts, Lyon

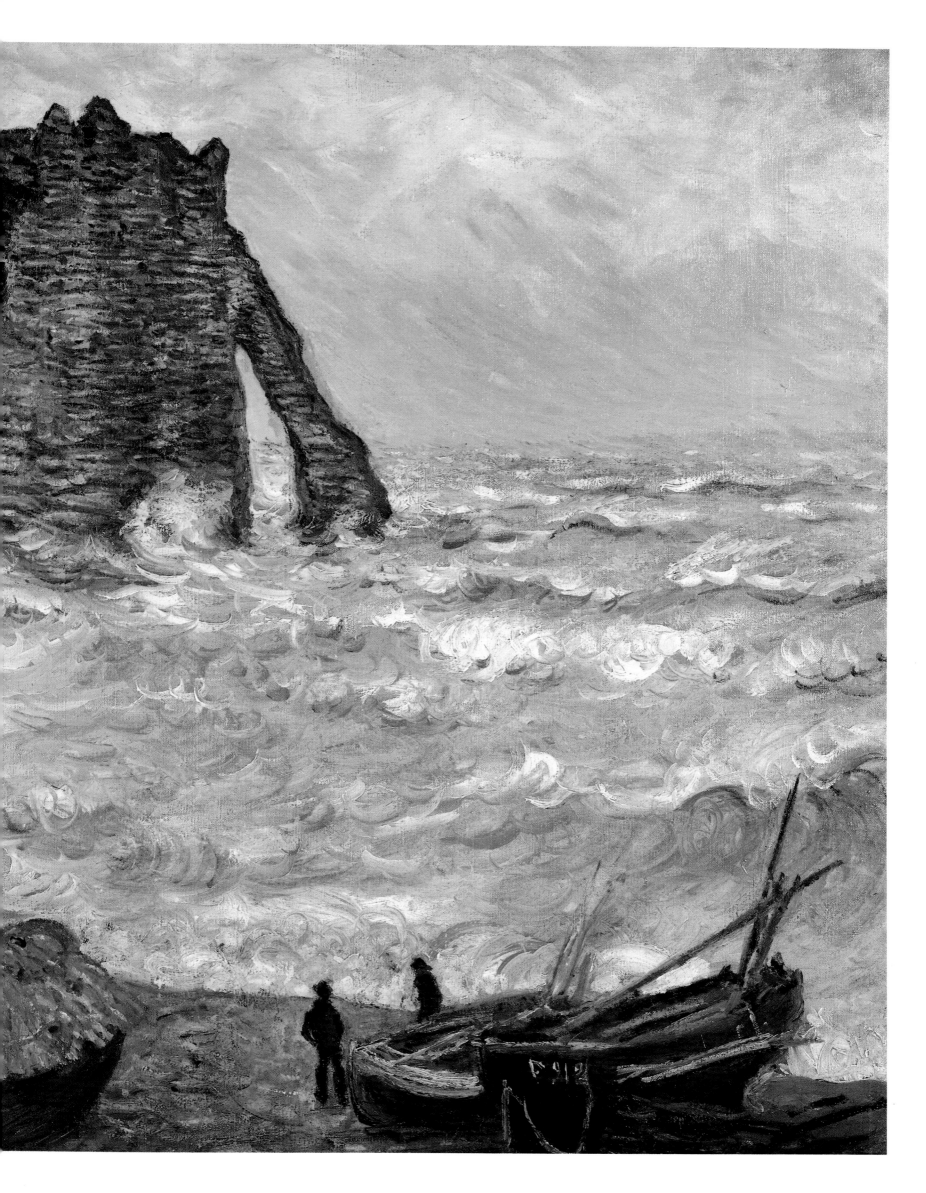

The Nets 1882
Oil on canvas
23¾×32in (60×81cm)
Collection Haags,
Gemeentemuseum, The Hague

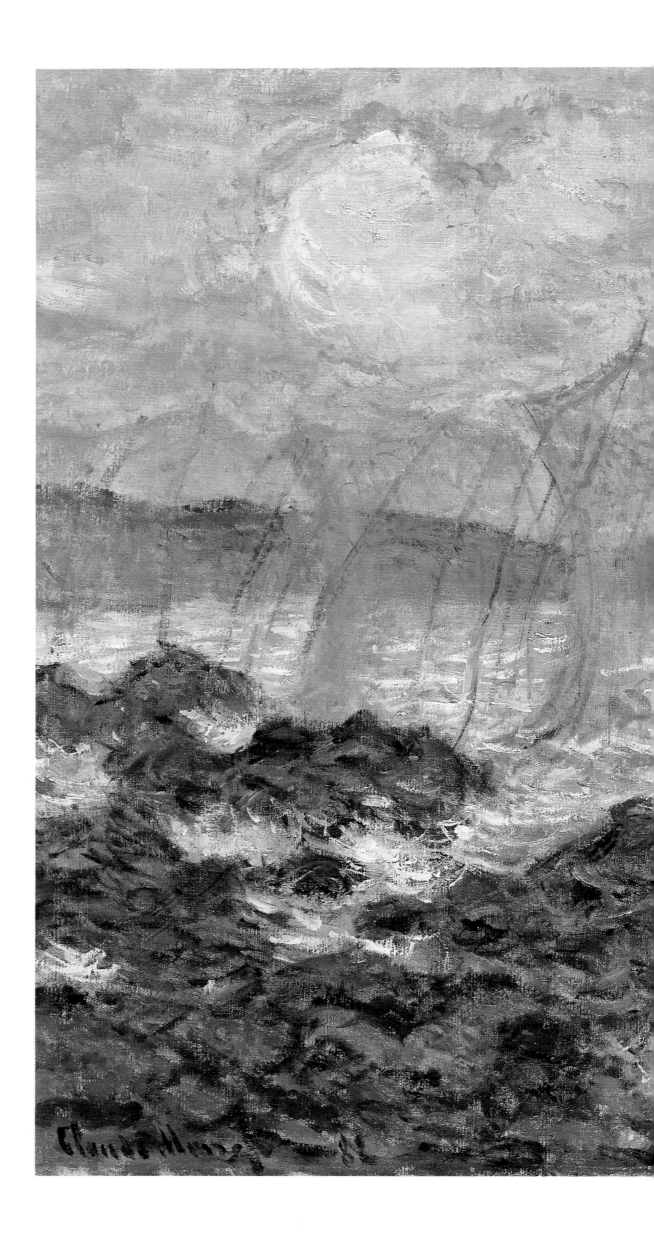

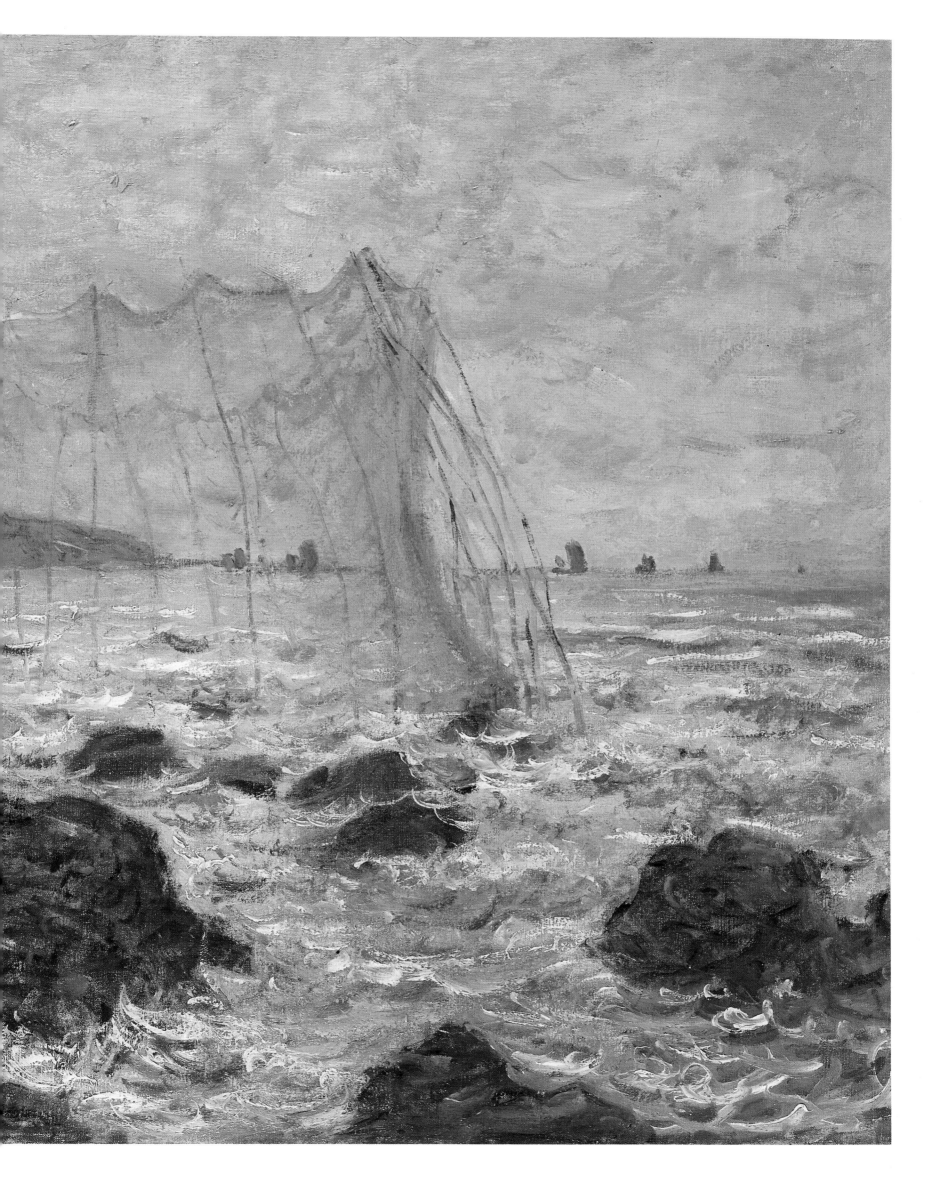

The Church at Varengeville 1882
Oil on canvas
25½×32in (65×81cm)
Barber Institute of Fine Arts,
University of Birmingham

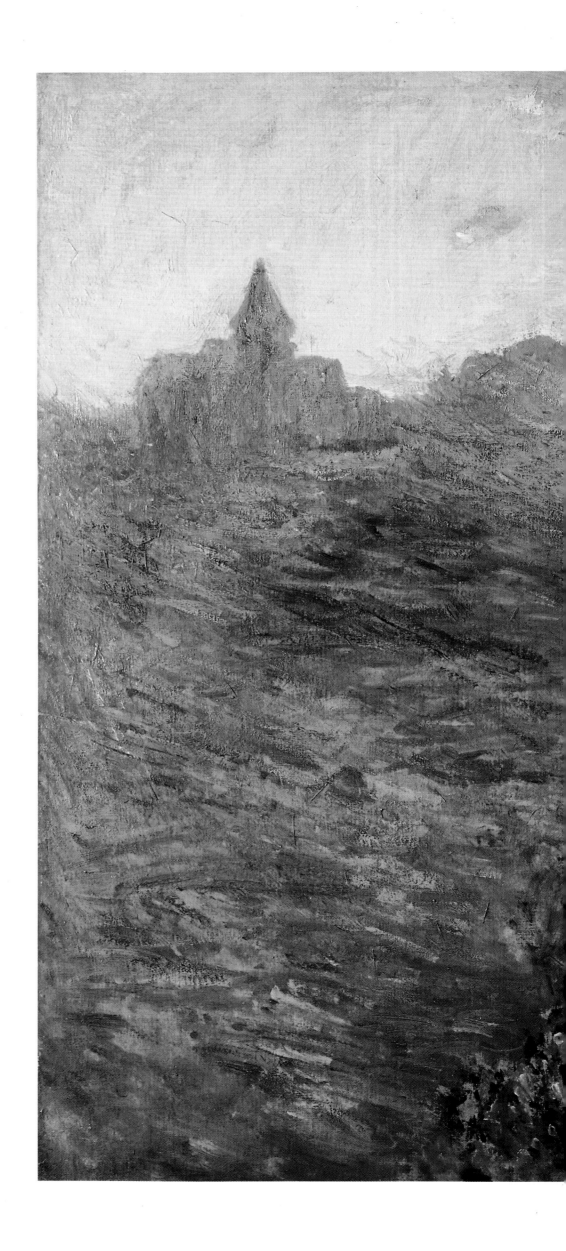

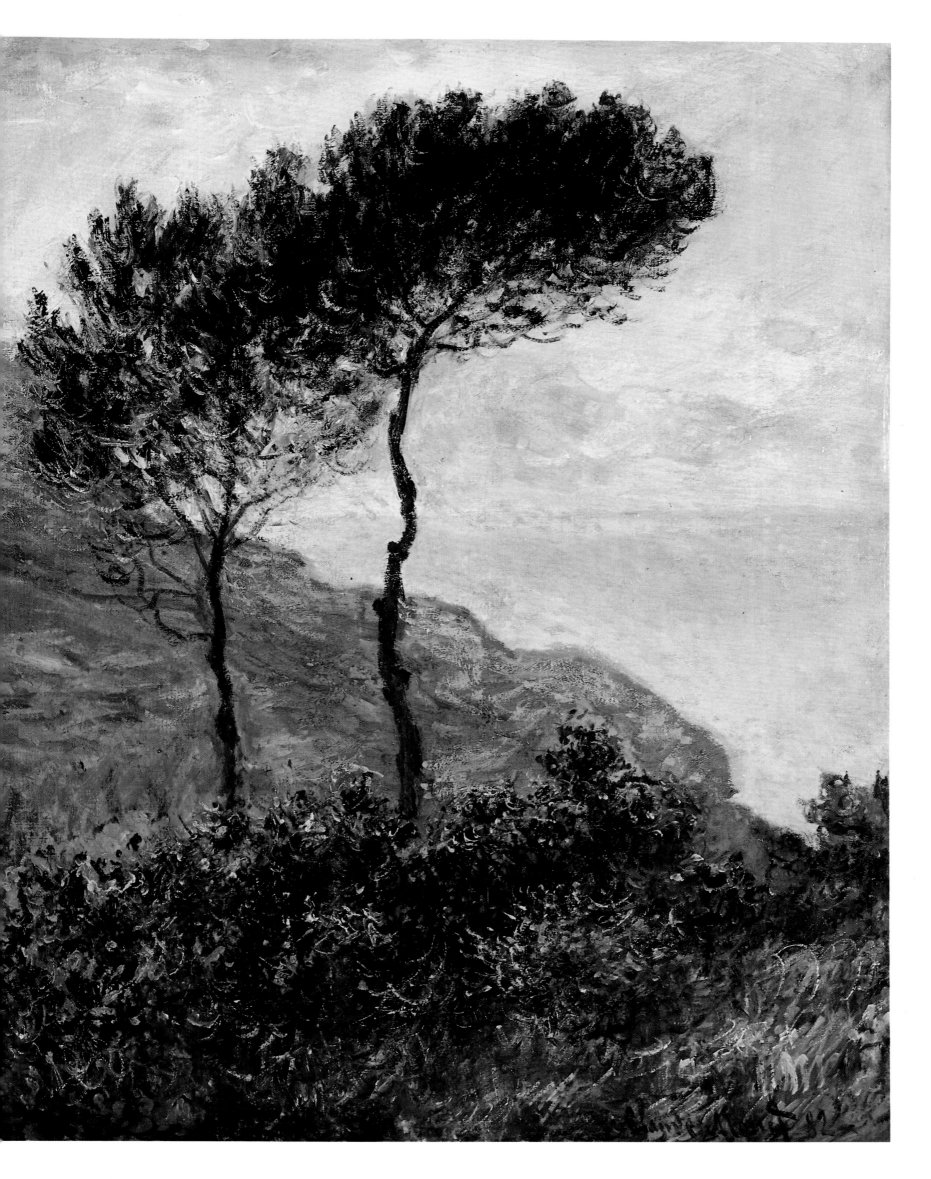

The Cliffs at Etretat 1885
Oil on canvas
25⁹⁄₁₆×31¹⁵⁄₁₆in (64.9×81cm)
Sterling and Francine Clark Art Institute,
Williamstown, Massachusetts

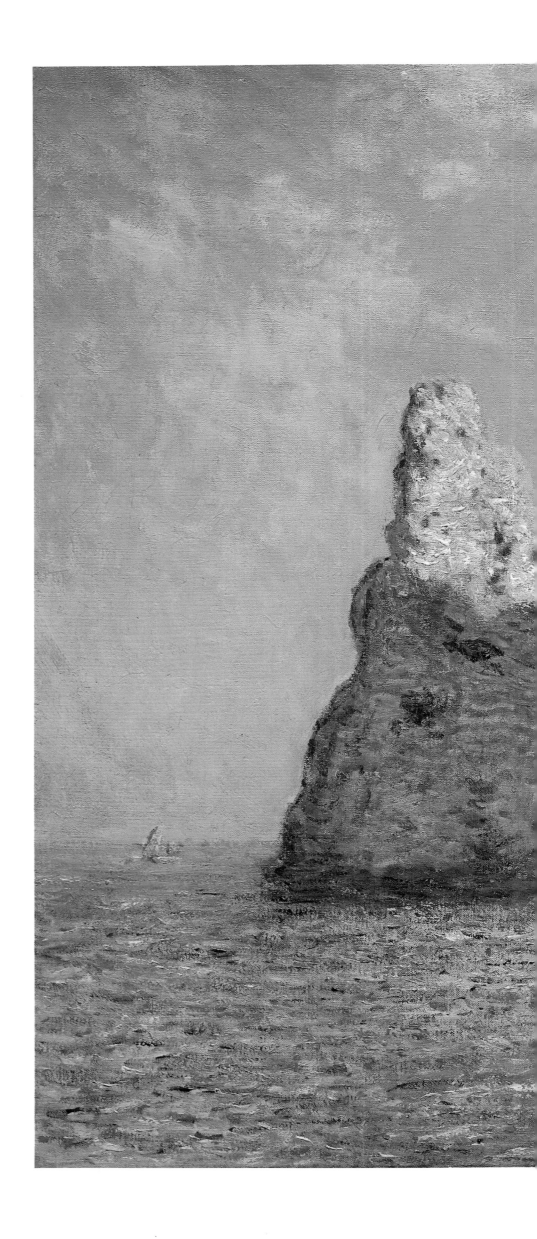

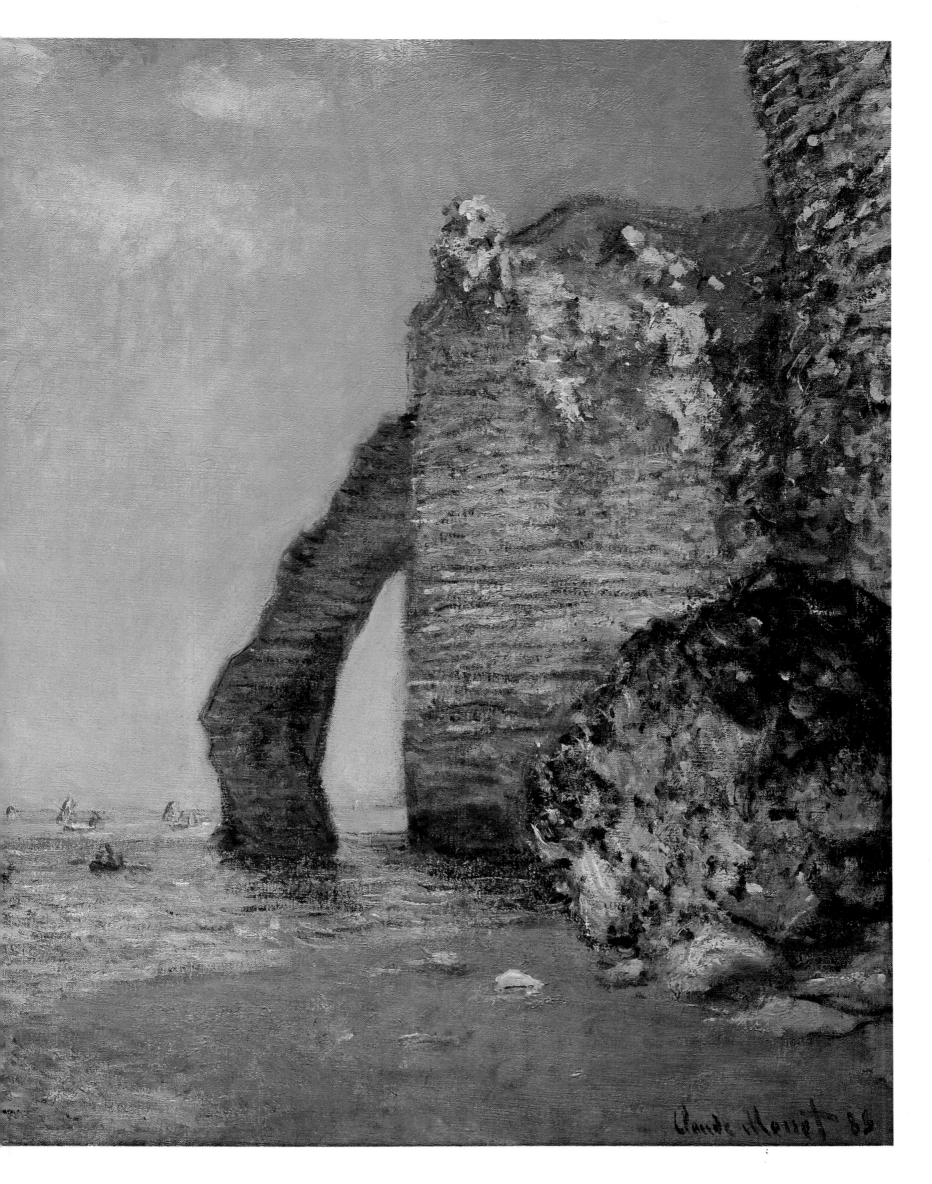

Claude Monet 88

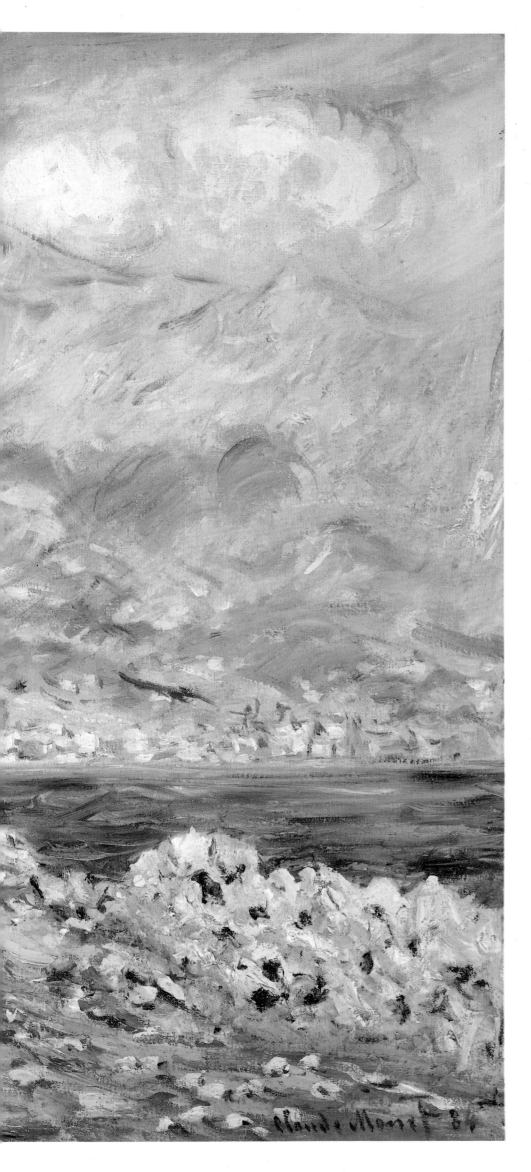

Cap Martin, near Menton 1885
Oil on canvas
25¾×31¾in (65.5×81cm)
Museum of Fine Arts, Boston

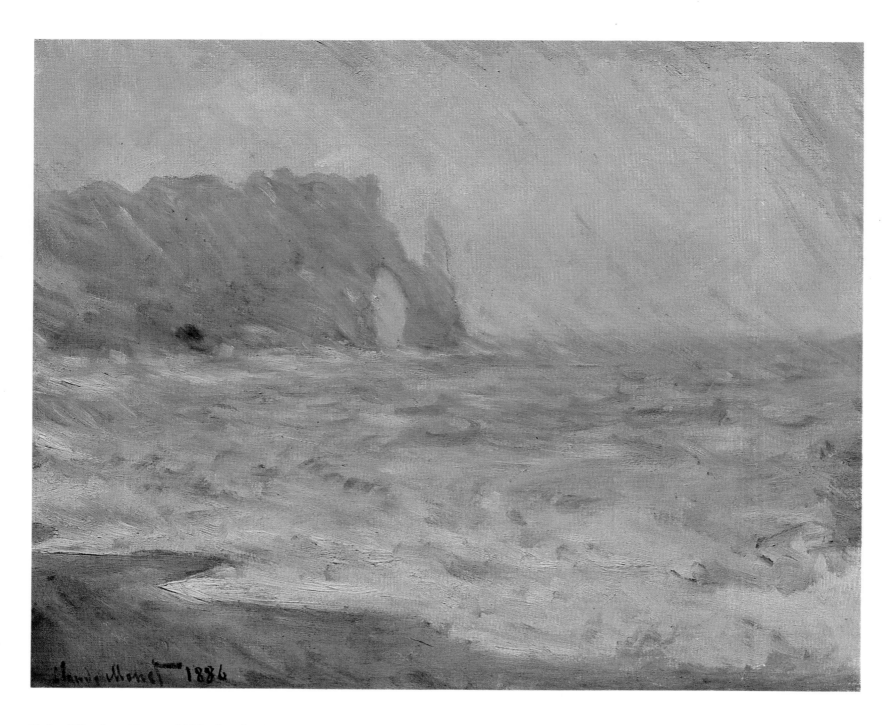

Rainy Weather, Etretat 1885, dated 1886
Oil on canvas
23¾×29in (60.5×73.5cm)
Nasjonalgalleriet, Oslo

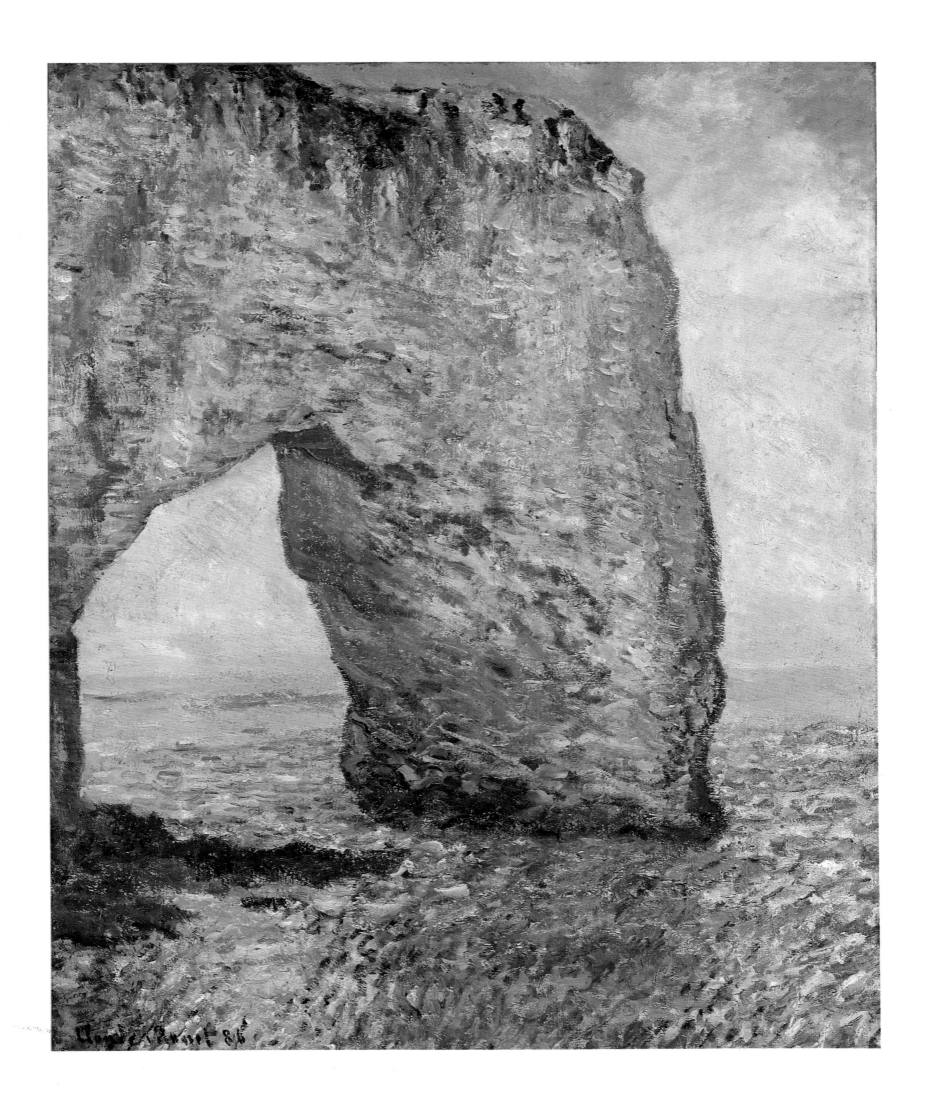

The Manneporte 1886
Oil on canvas
32×25¾in (81.3×65.4cm)
Metropolitan Museum of Art, New York

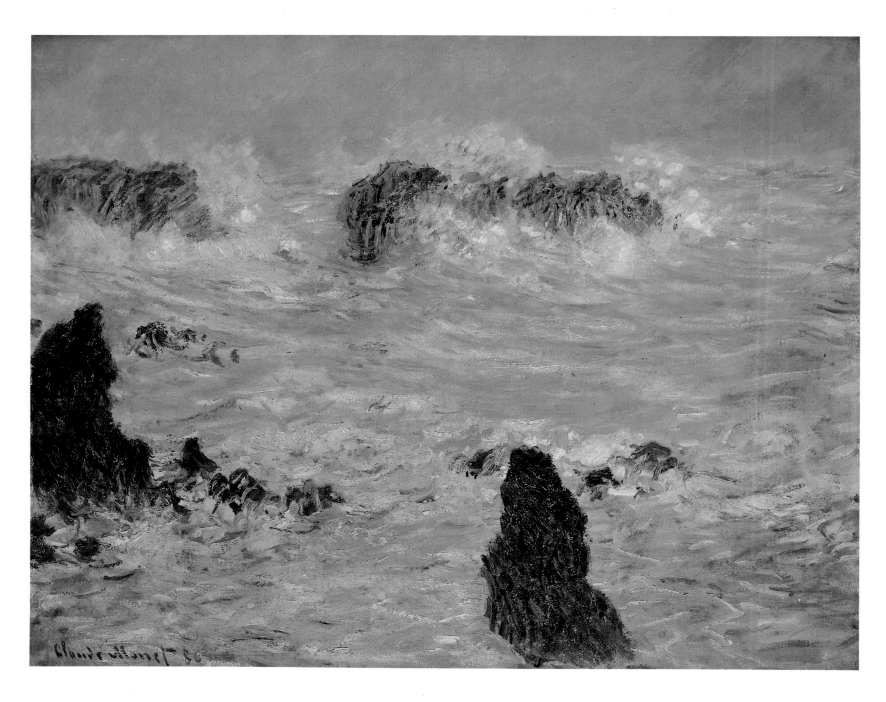

Tempest, Coast of Belle-Ile 1886
Oil on canvas
25½×32in (65×81cm)
Musée d'Orsay, Paris

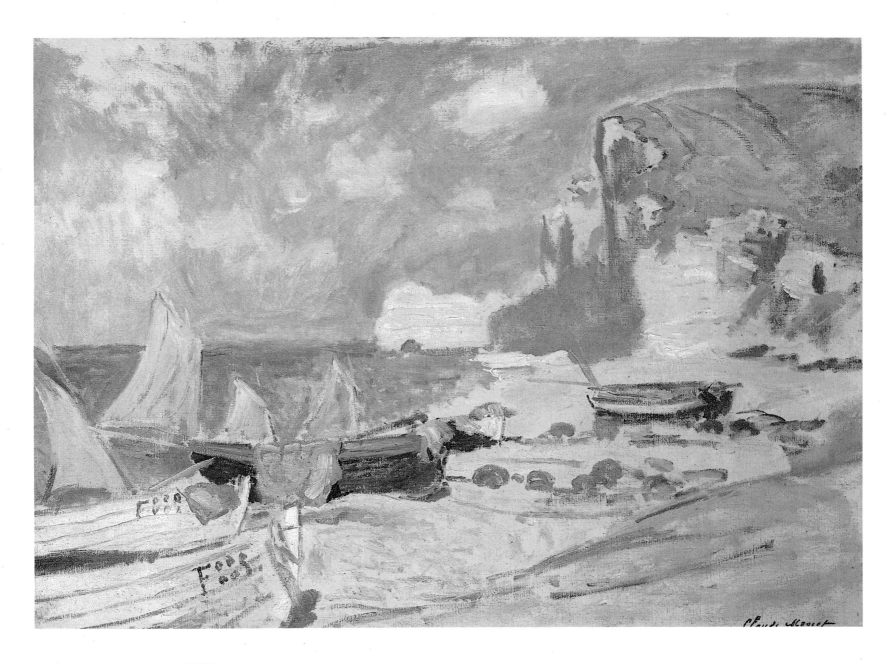

Fishing Boats, Etretat c. 1885
Oil on canvas
23¾×32in (60×81cm)
Musée Eugène Boudin, Le Havre

The Pyramides at Port-Coton 1886
Oil on canvas
25½×32in (65×81cm)
Pushkin Museum, Moscow

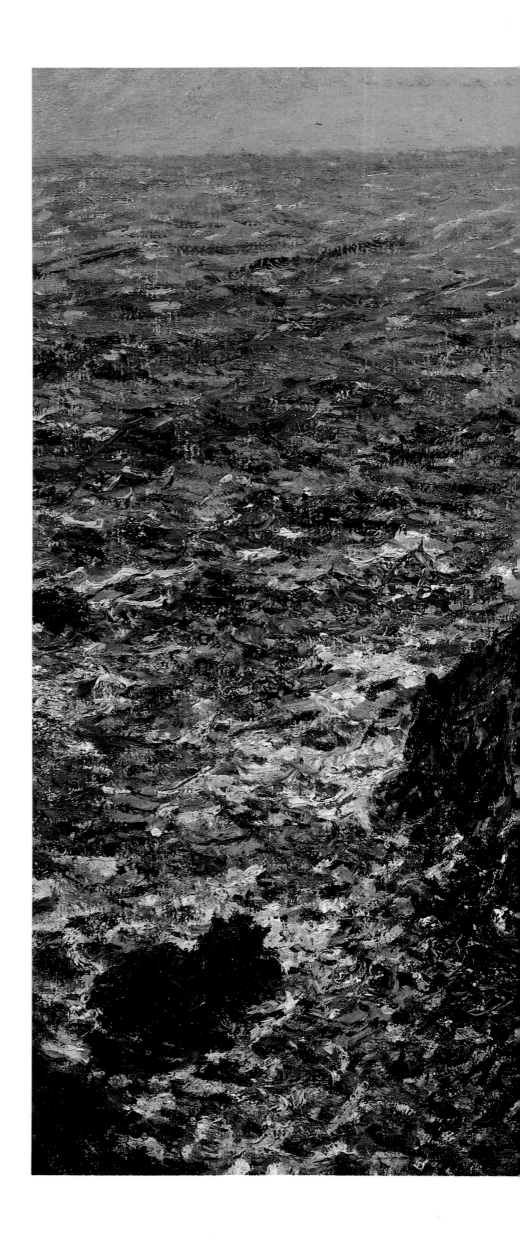

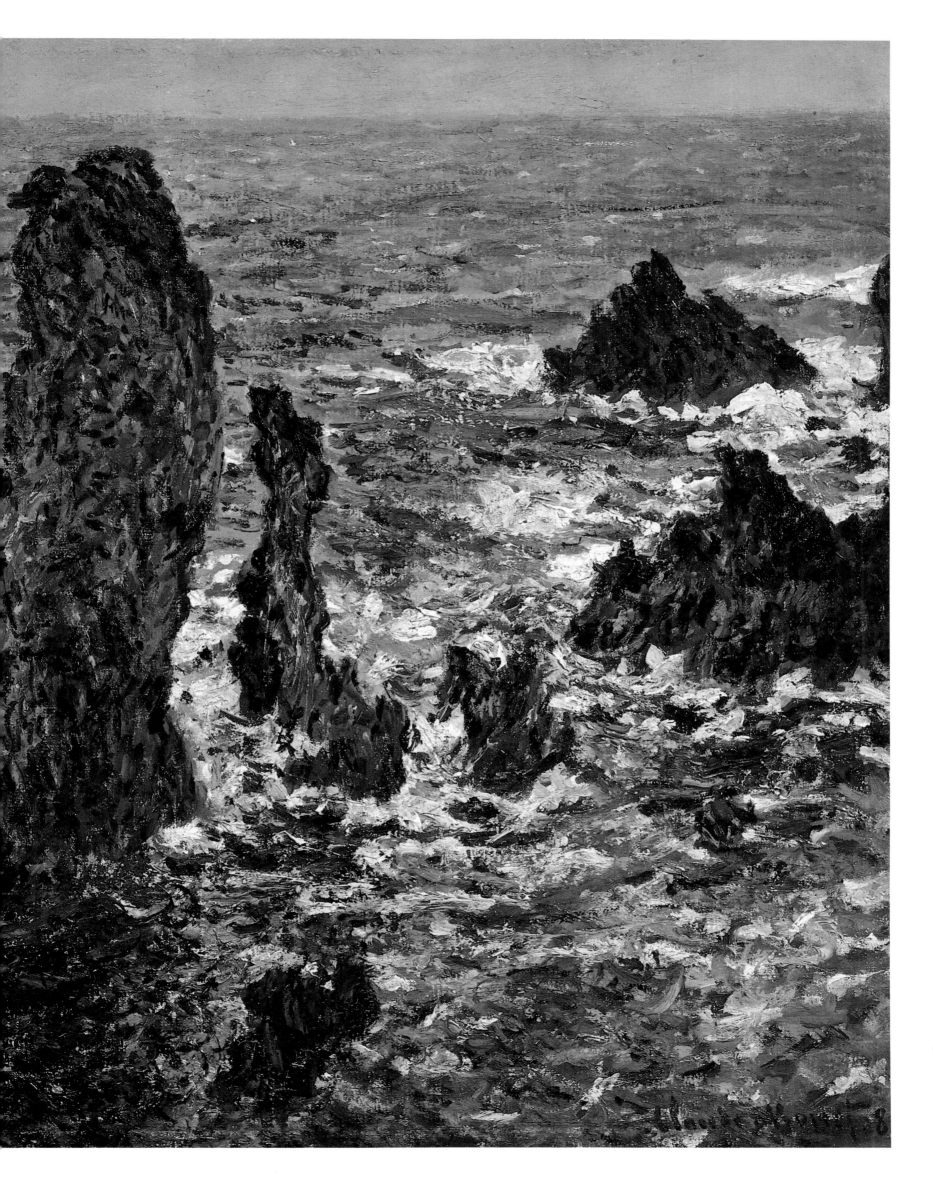

Boat at Giverny c. 1887
Oil on canvas
38½×51½in (98×131cm)
Musée d'Orsay, Paris

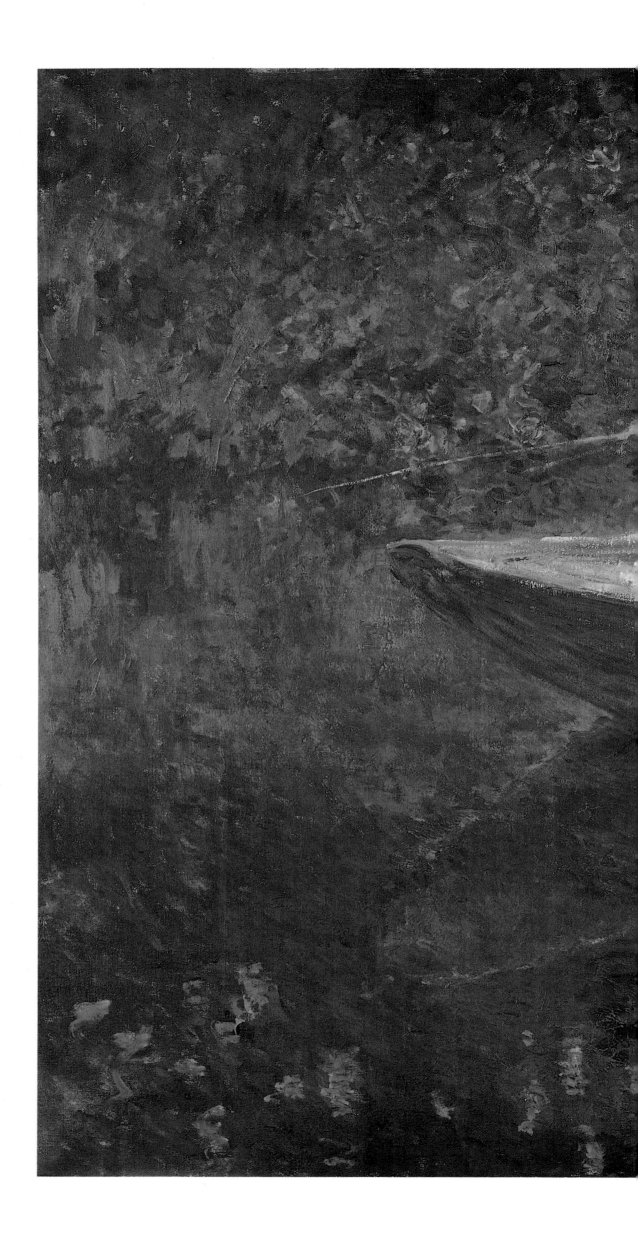

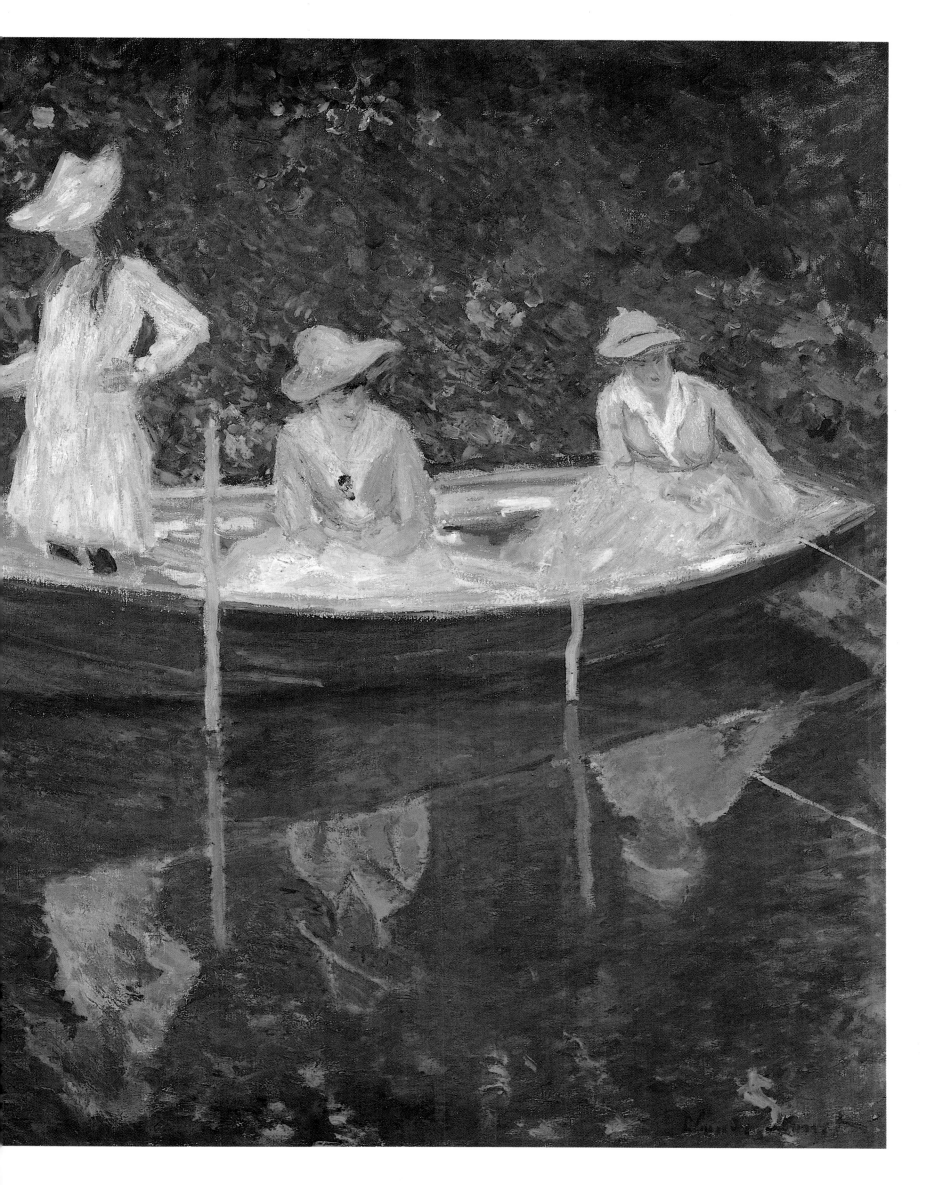

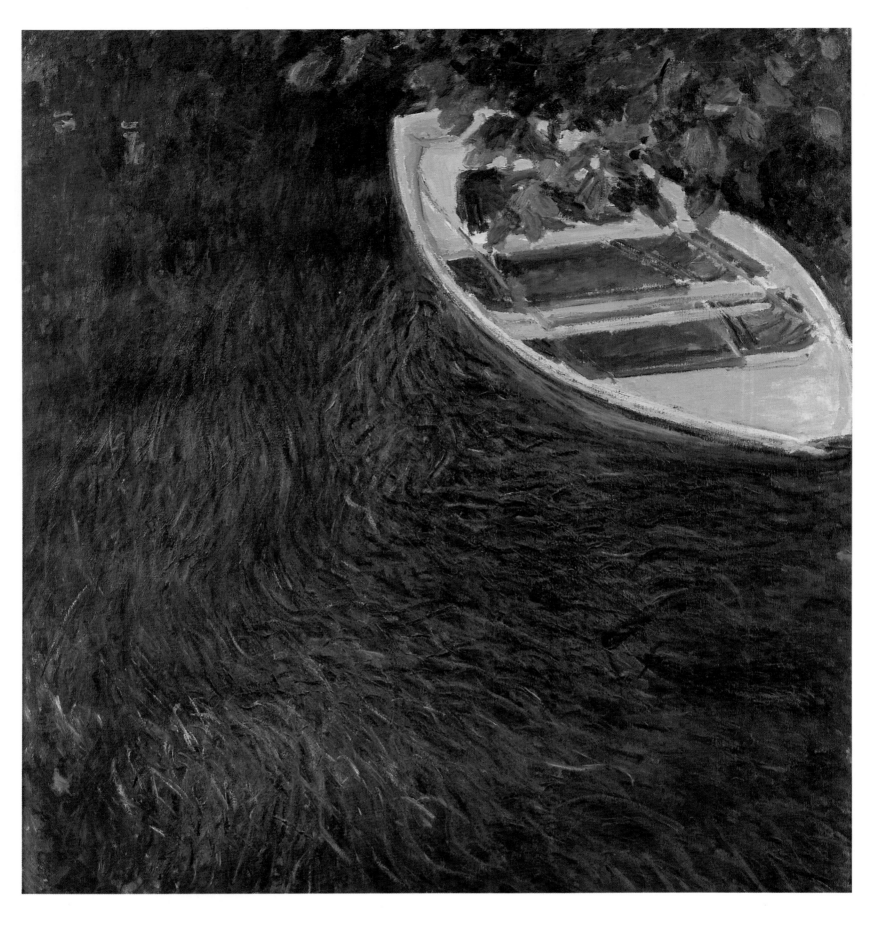

Boat 1887
Oil on canvas
57½×52¼in (146×133cm)
Musée Marmottan, Paris

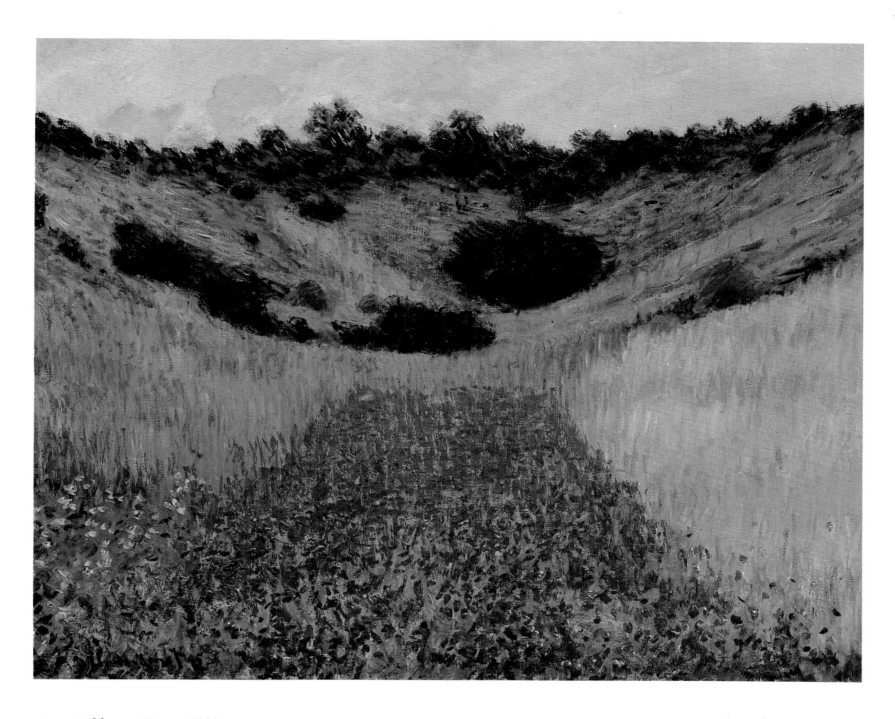

Poppy Field near Giverny 1885
Oil on canvas
25½×32in (65×81cm)
Museum of Fine Arts, Boston

Champs de Tulipes en Hollande 1886
Oil on canvas
25¼×31¾in (65×81cm)
Musée d'Orsay, Paris

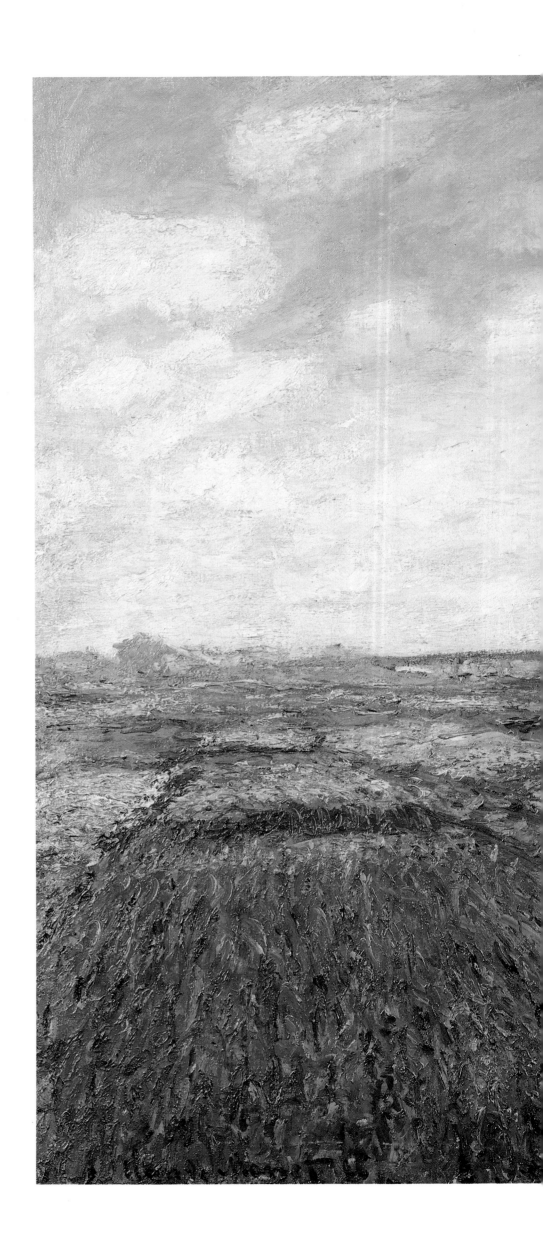

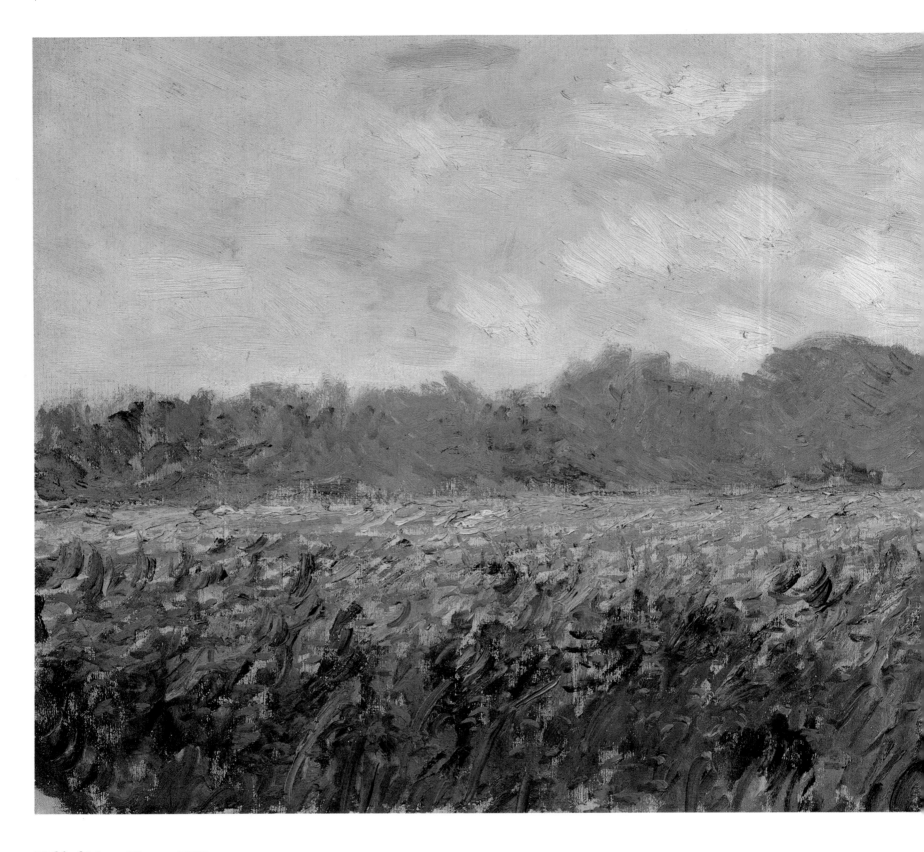

Field of Iris at Giverny 1887
Oil on canvas
17¾×39¼in (45×100cm)
Musée Marmottan, Paris

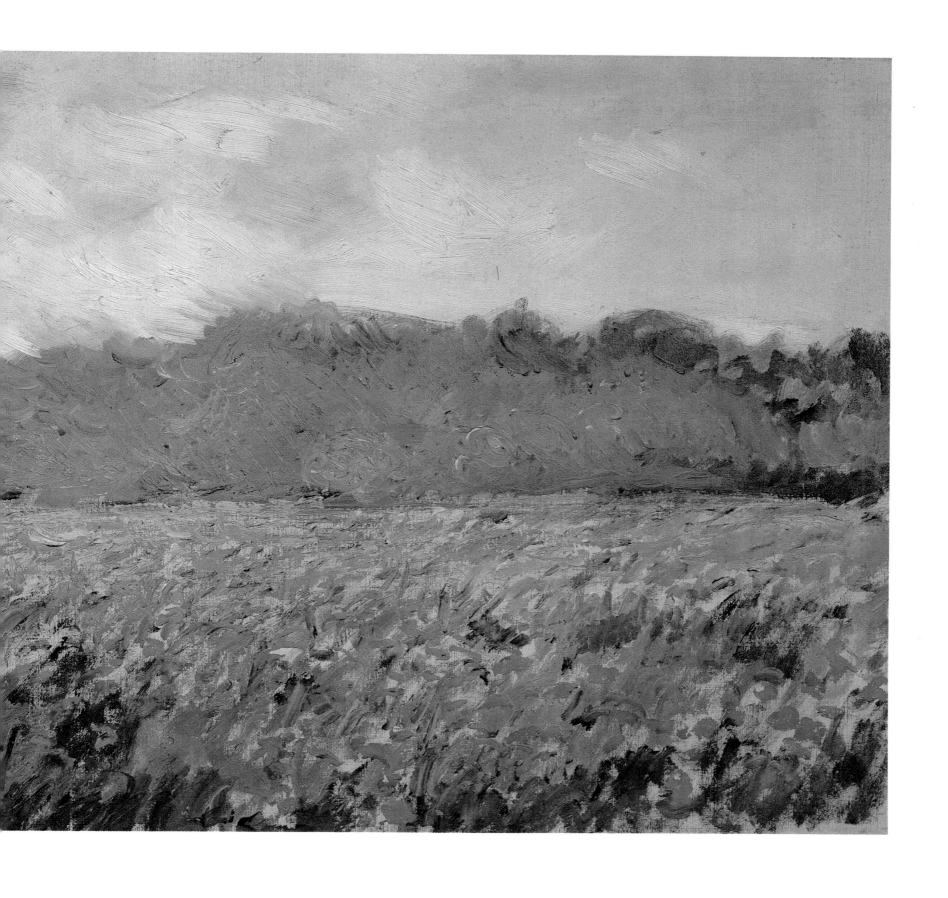

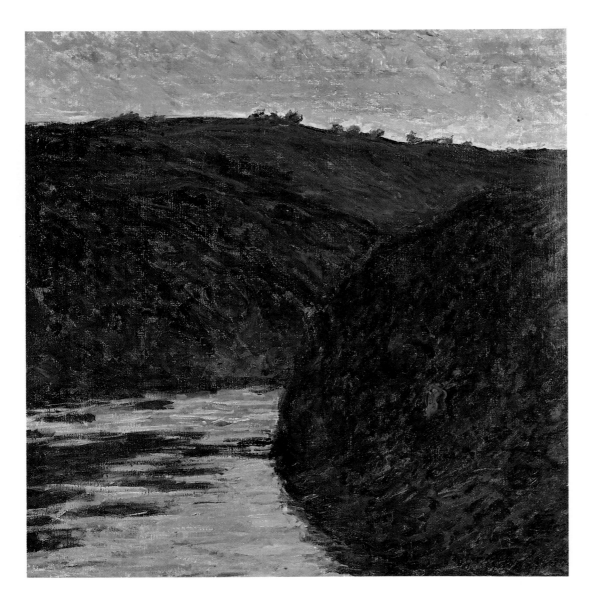

Valley of the Creuse, Sunset 1889
Oil on canvas
27½×28¾in (70×73cm)
Musée d'Unterlinden, Colmar

Haystack in Winter 1891
Oil on canvas
25¾×36¼in (65.4×92.3cm)
Museum of Fine Arts, Boston

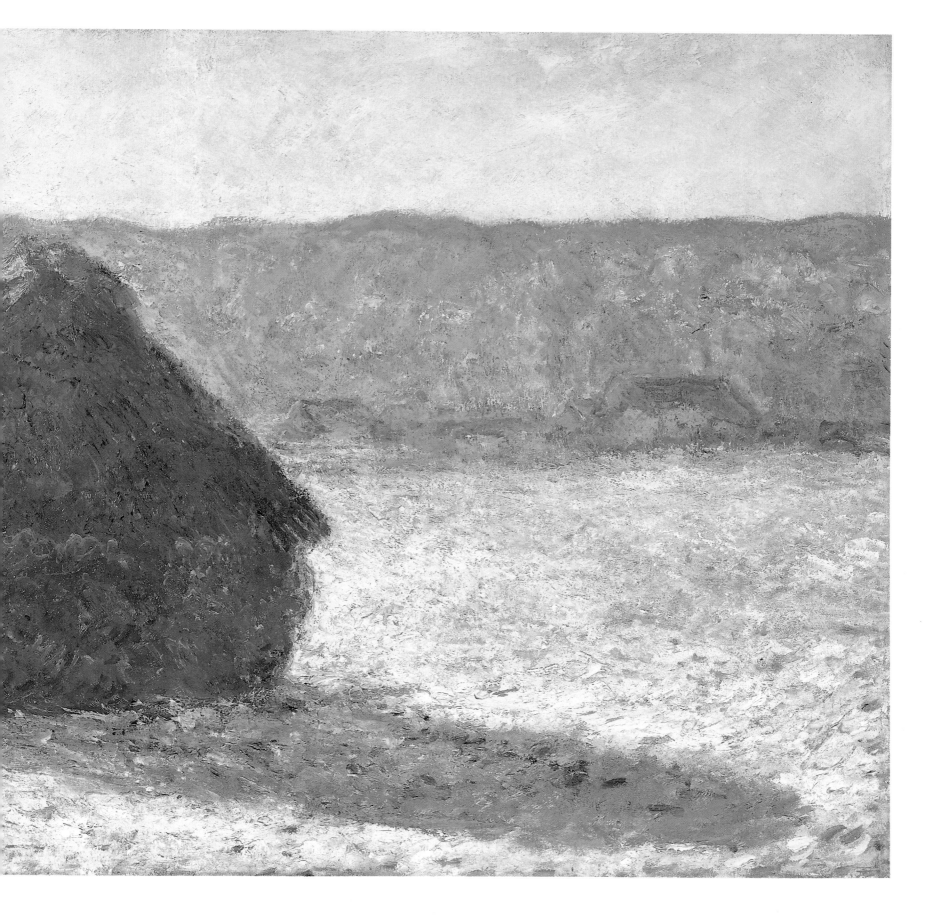

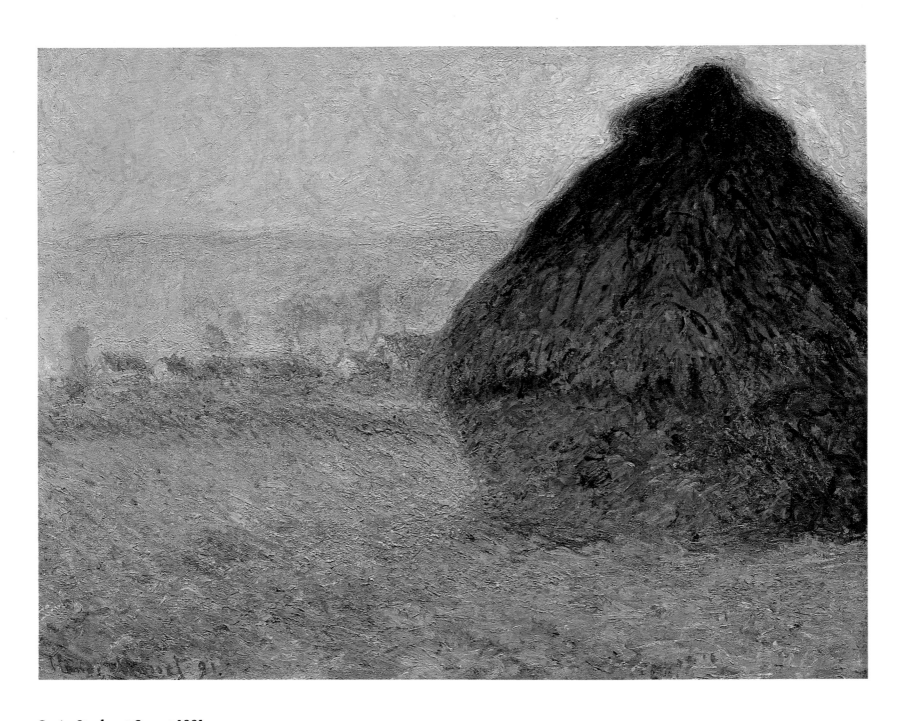

Grain Stacks at Sunset 1891
Oil on canvas
25¾×36½in (73.3×92.6cm)
Museum of Fine Arts, Boston

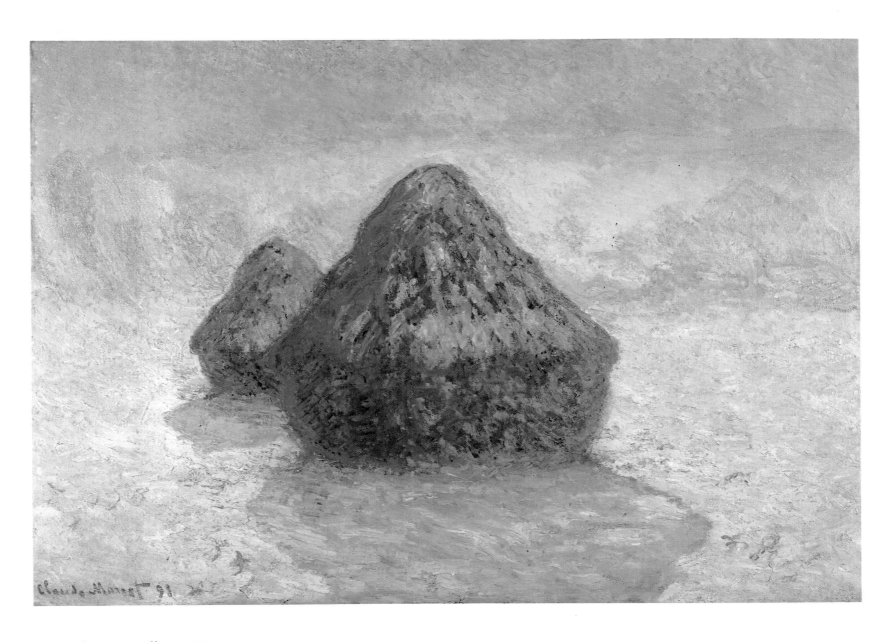

Haystacks: Snow Effect 1891
Oil on canvas
25¼×36¼in (65×81cm)
National Gallery of Scotland, Edinburgh

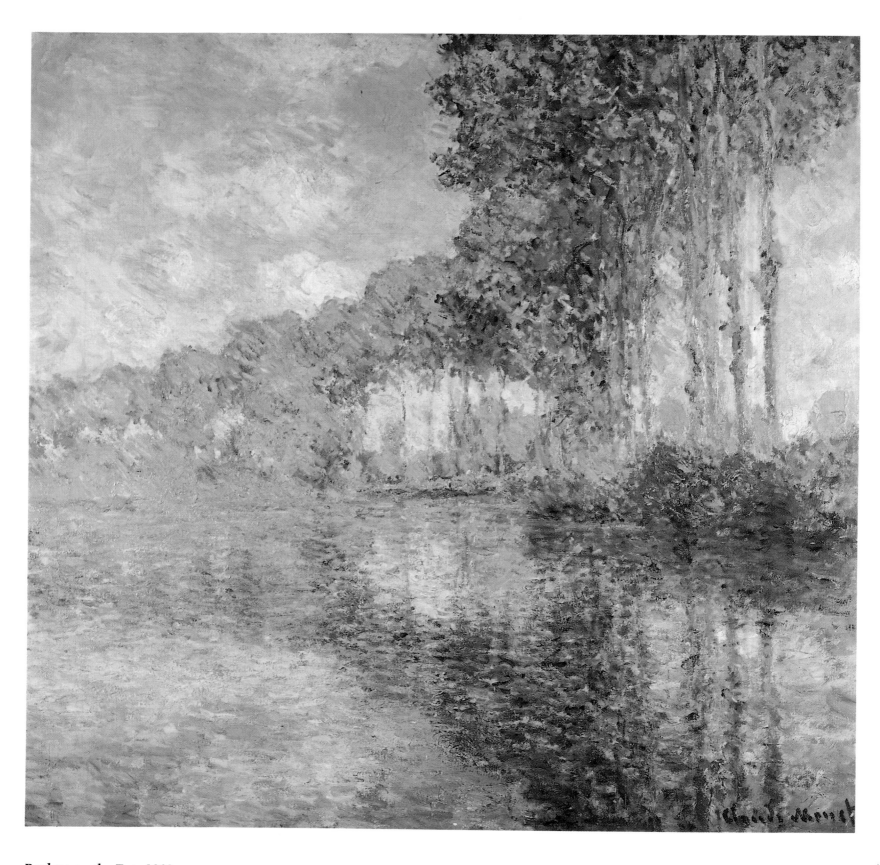

Poplars on the Epte 1891
Oil on canvas
32¼×32in (81.9×81.3cm)
National Gallery of Scotland, Edinburgh

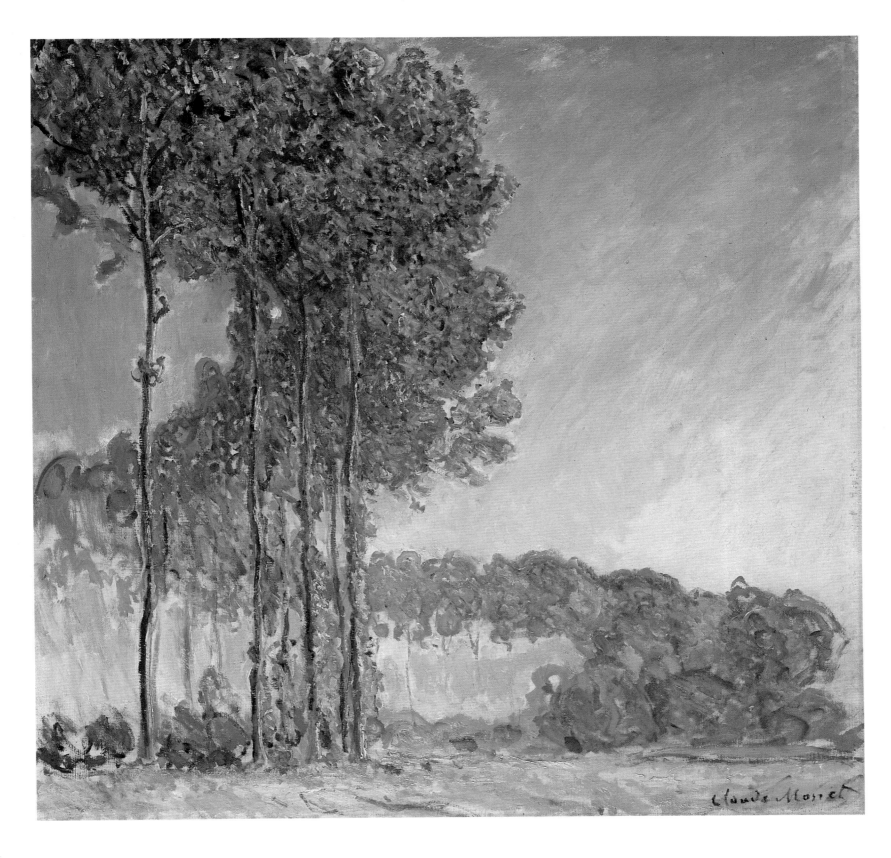

Poplars 1891
Oil on canvas
35½×36½in (90×93cm)
Fitzwilliam Museum, Cambridge

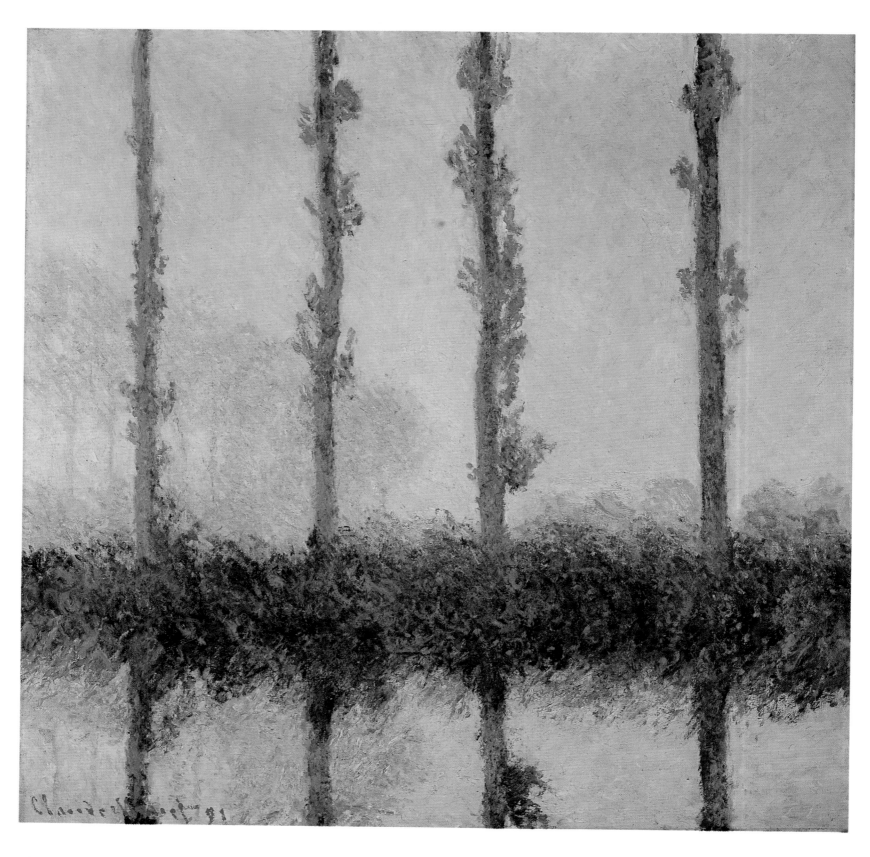

The Four Poplars 1891
Oil on canvas
32¼×32in (82×81.5cm)
Metropolitan Museum of Art, New York

Rouen Cathedral – Tour d'Albane,
Early Morning 1894
Oil on canvas
41¾×29in (105×73.7cm)
Museum of Fine Arts, Boston

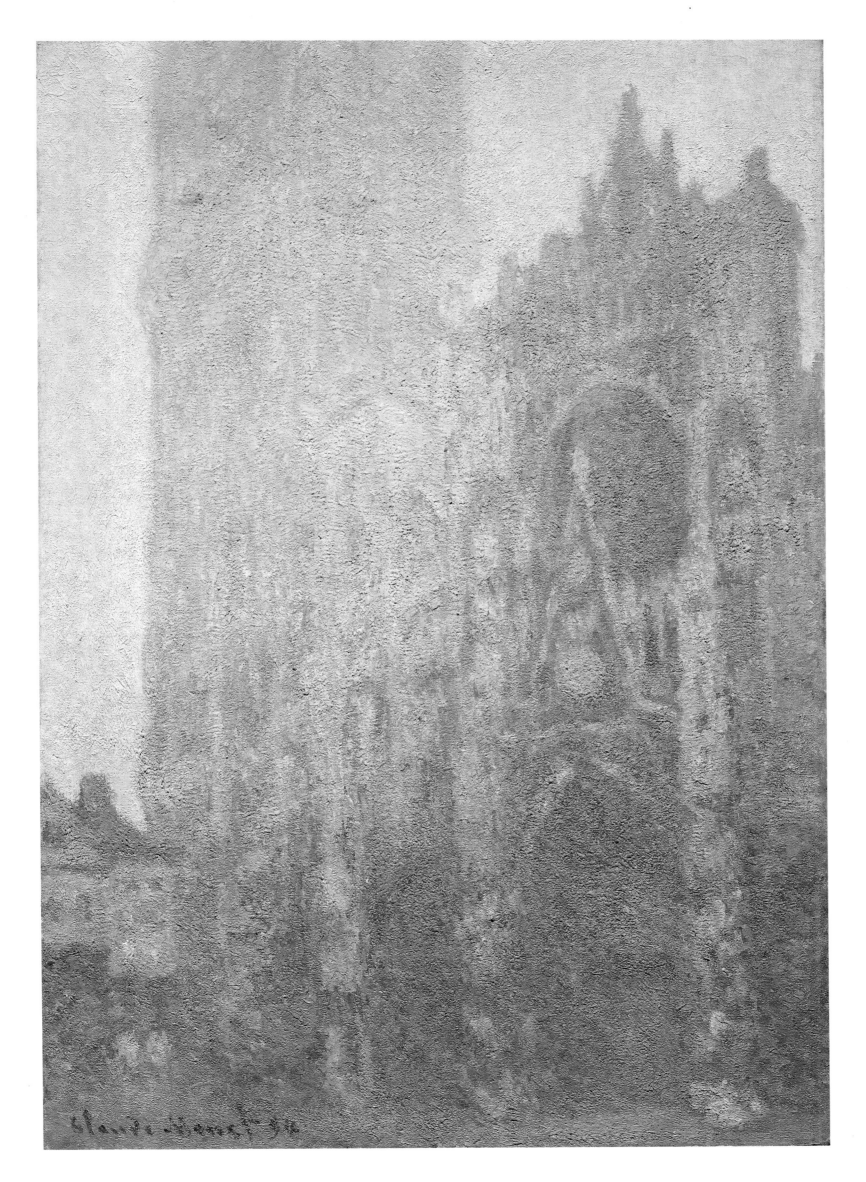

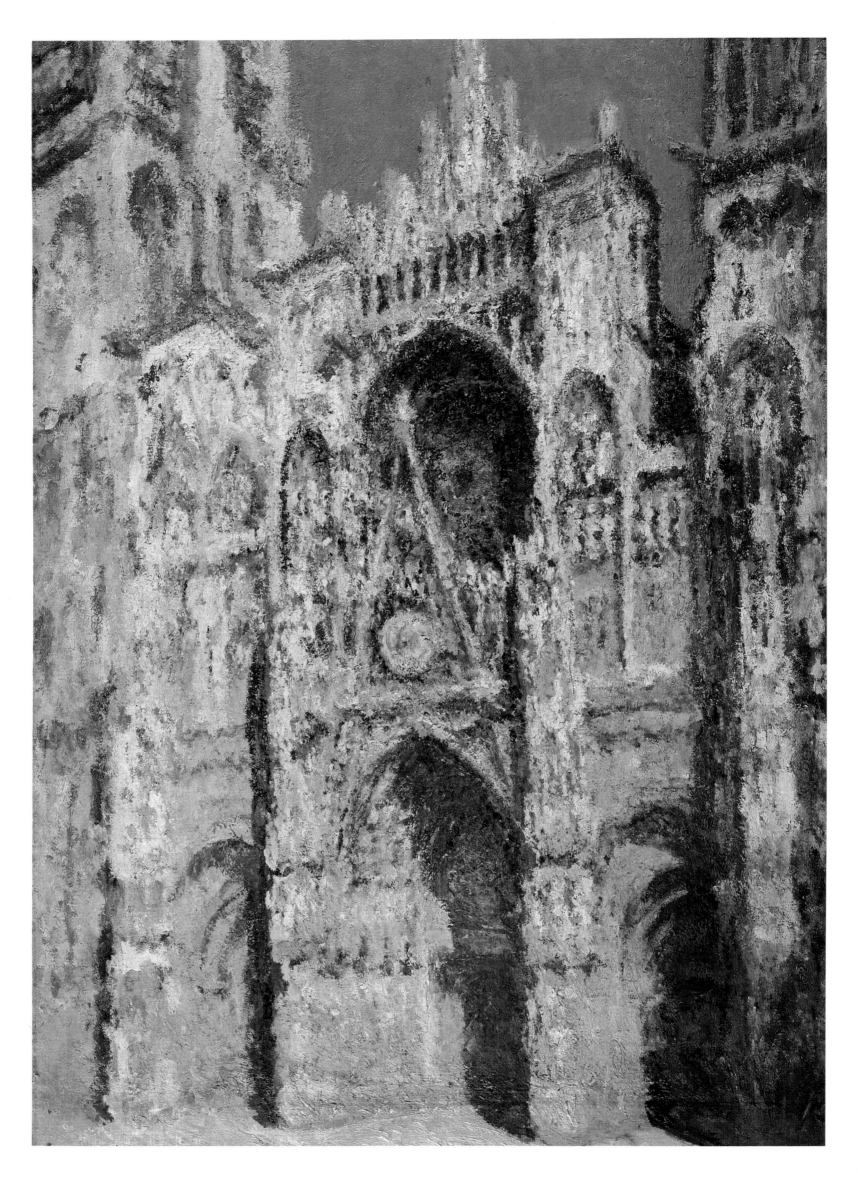

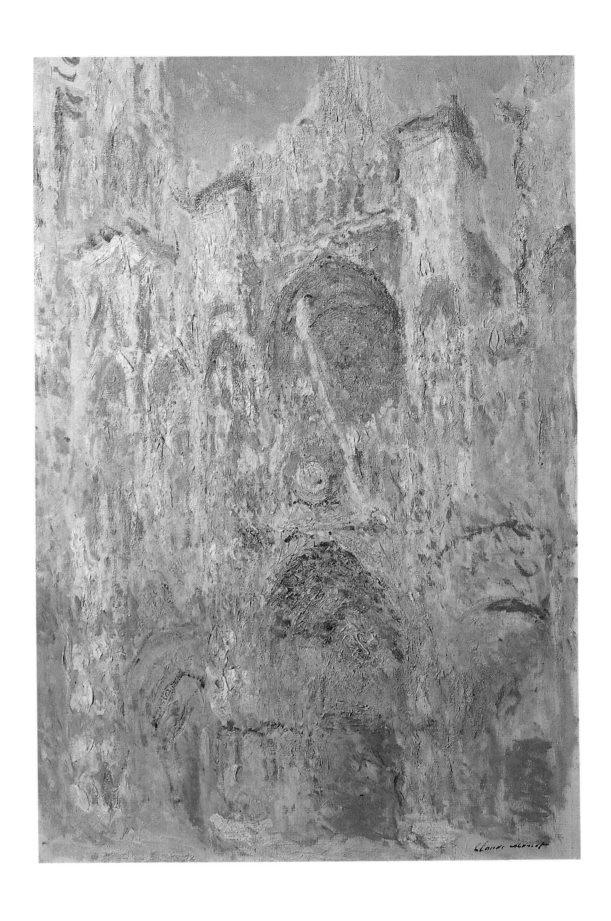

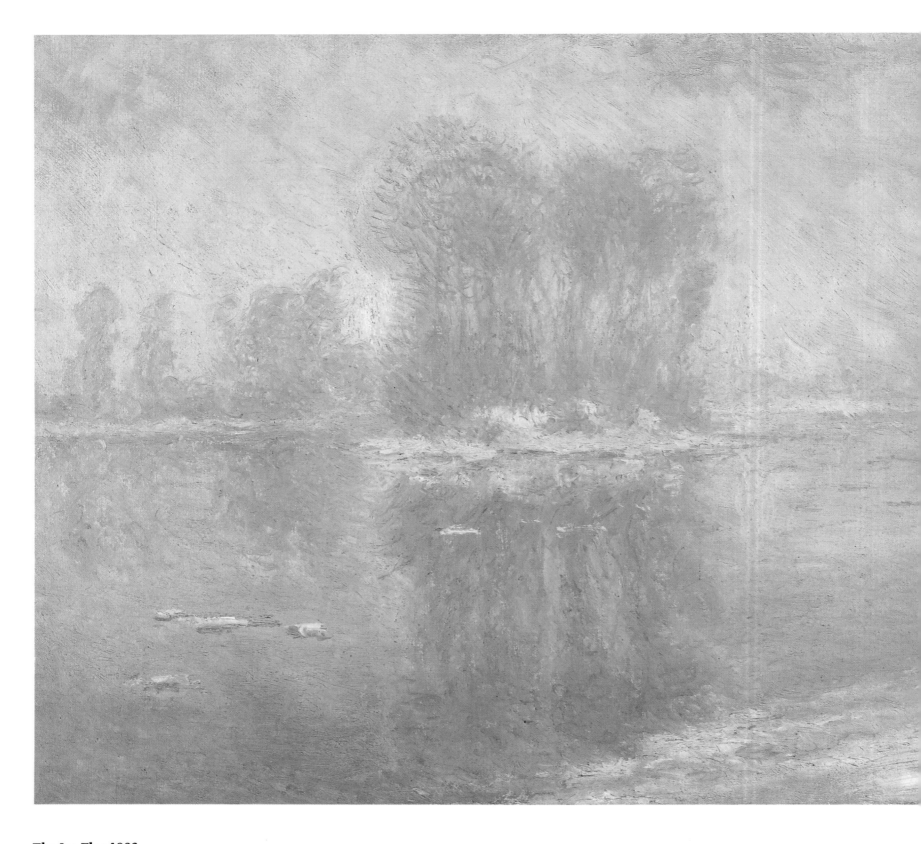

The Ice Floe 1893
Oil on canvas
25½×39¼in (65×100cm)
Metropolitan Museum of Art, New York

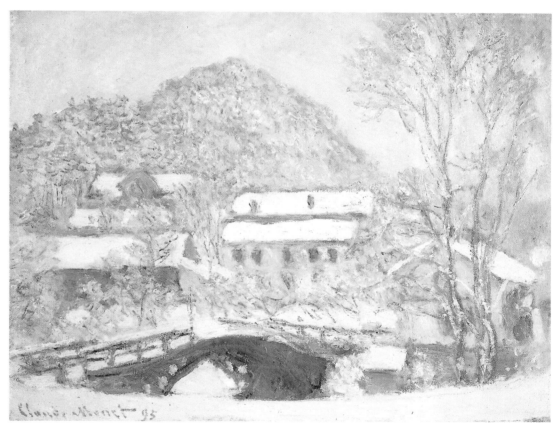

Sandvika, Norway 1895
Oil on canvas
28¾×27½in (73.4×92.5cm)
Art Institute of Chicago

Branch of the Seine near Giverny (II)
1897
Oil on canvas
32×36½in (81.4×92.7cm)
Museum of Fine Arts, Boston

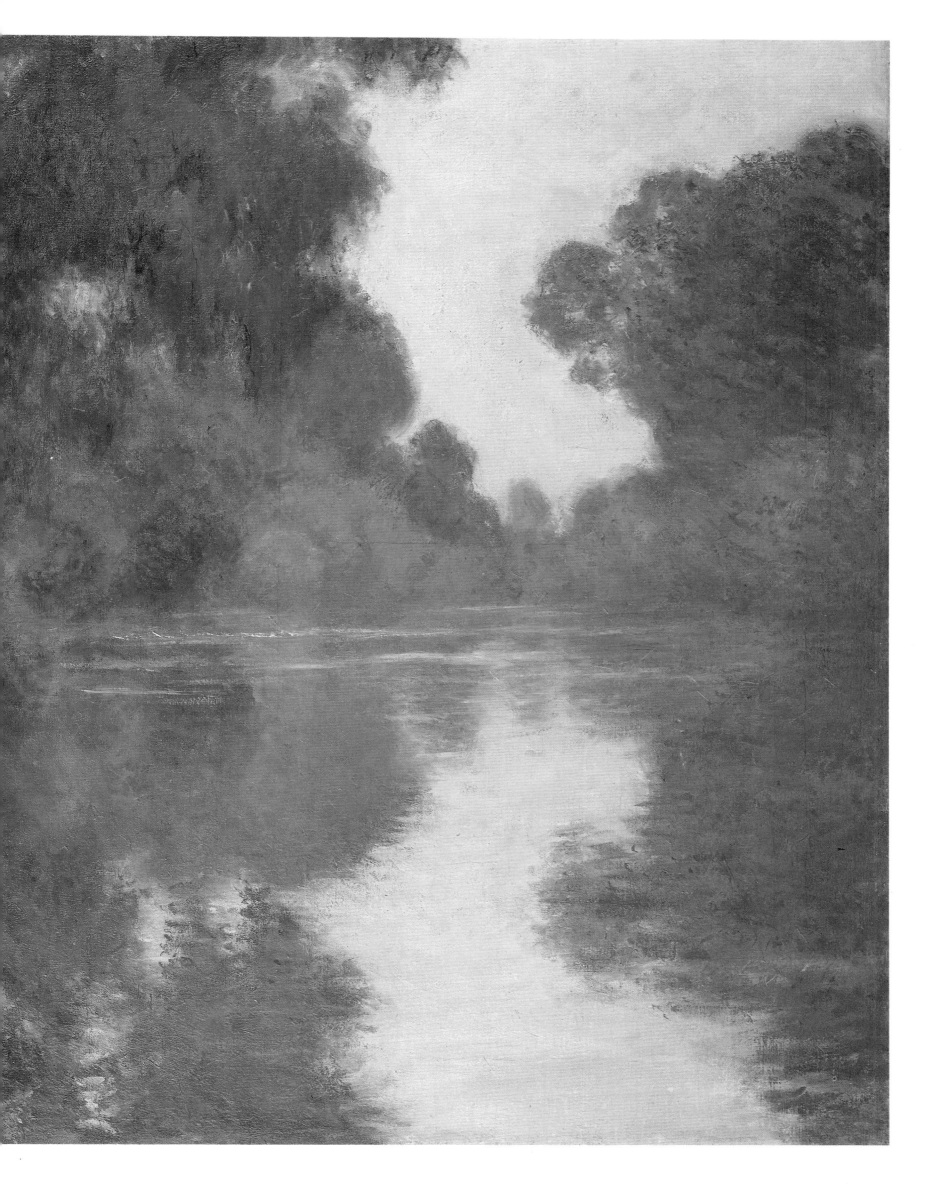

Chrysanthemums 1897
Oil on canvas
31¾×39¼in (81×100cm)
Offentliche Kunstsammlung, Basel

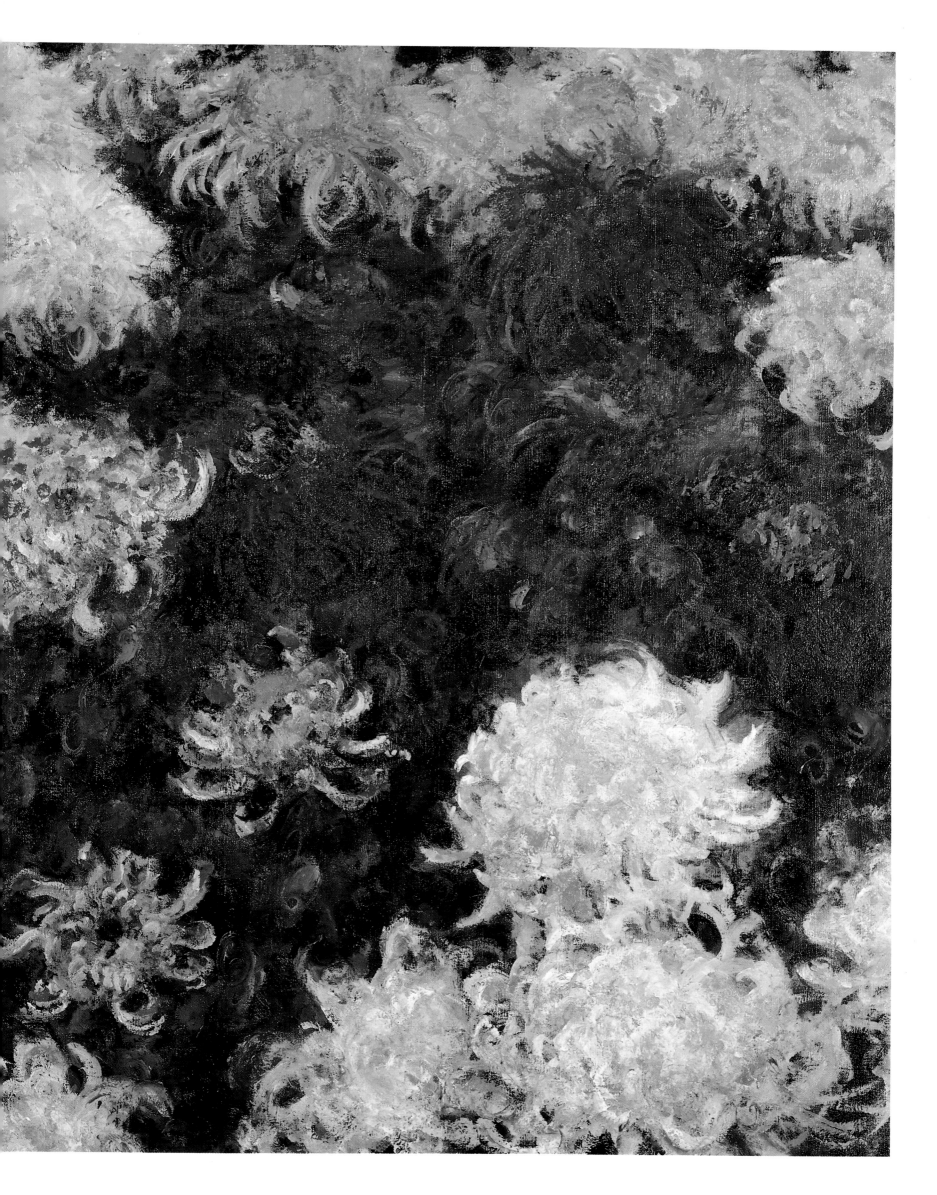

London, Houses of Parliament, Sunset
1903
Oil on canvas
30×36in (76.2×91.4cm)
Private Collection

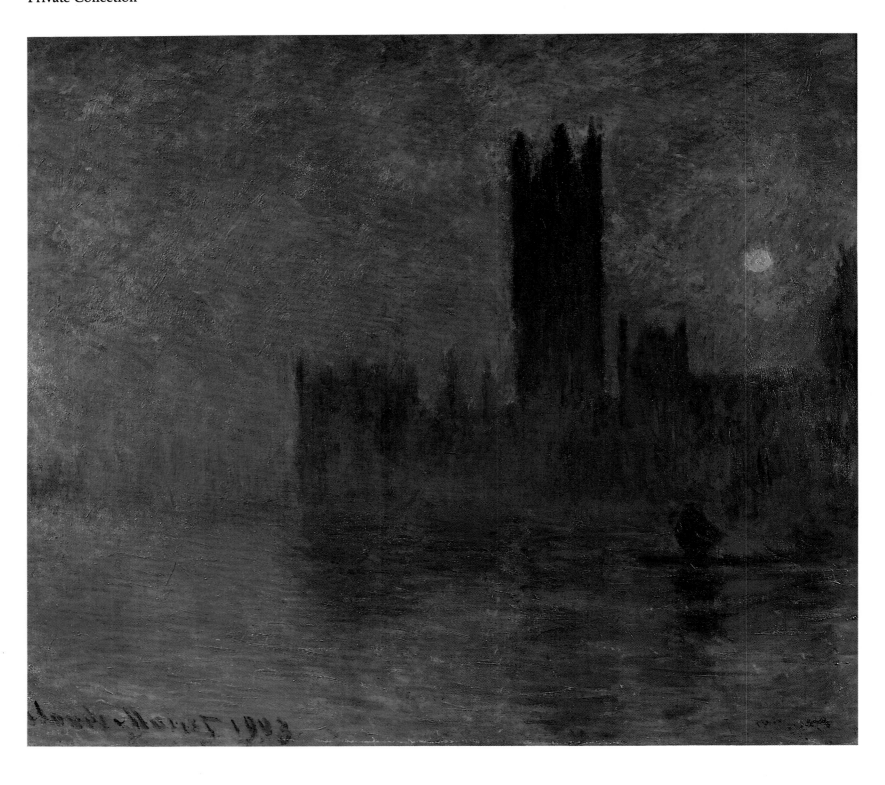

London, Houses of Parliament 1905
Oil on canvas
31¾×36¼in (81×92cm)
Musée Marmottan, Paris

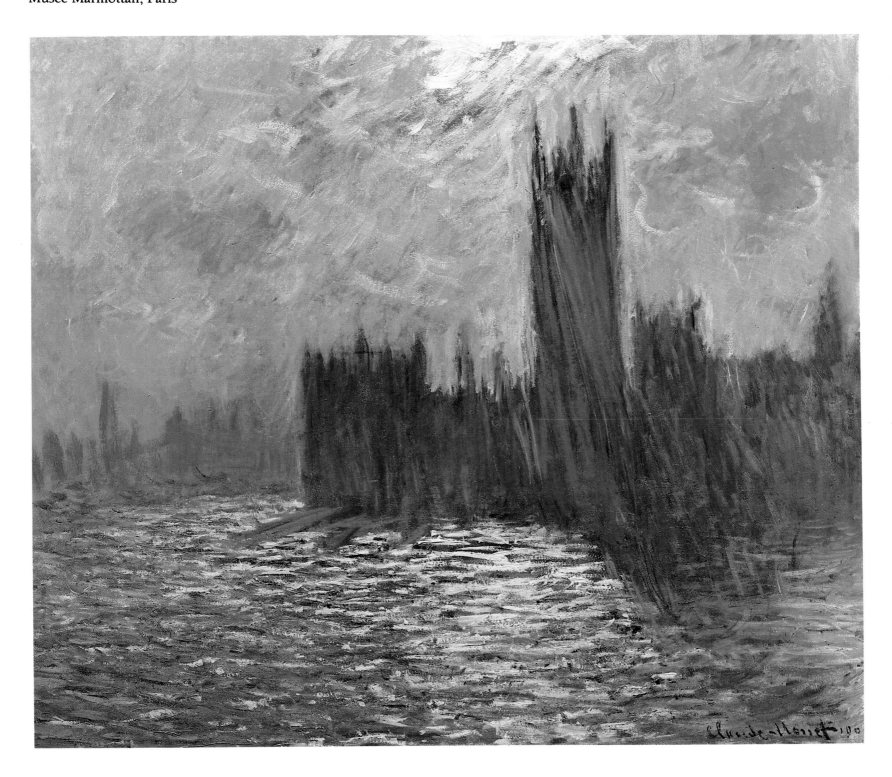

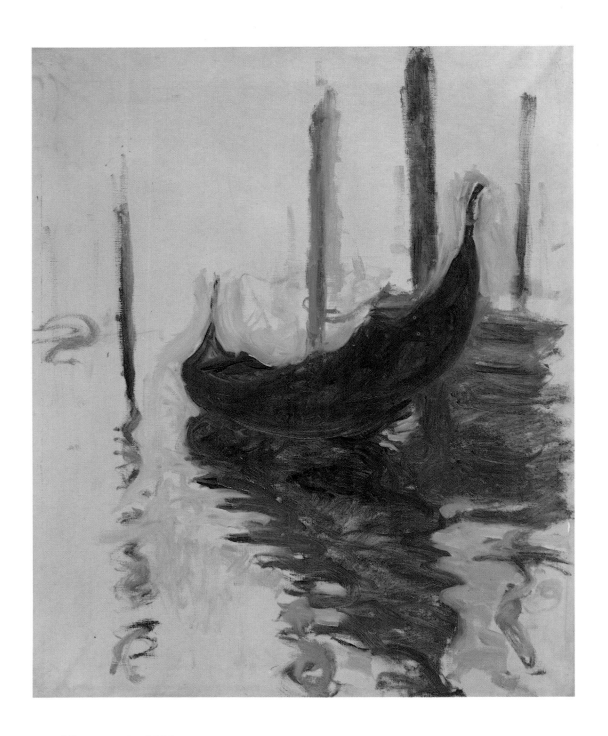

Gondola at Venice 1908
Oil on canvas
31¾×21¾in (81×55cm)
Musée des Beaux-Arts, Nantes

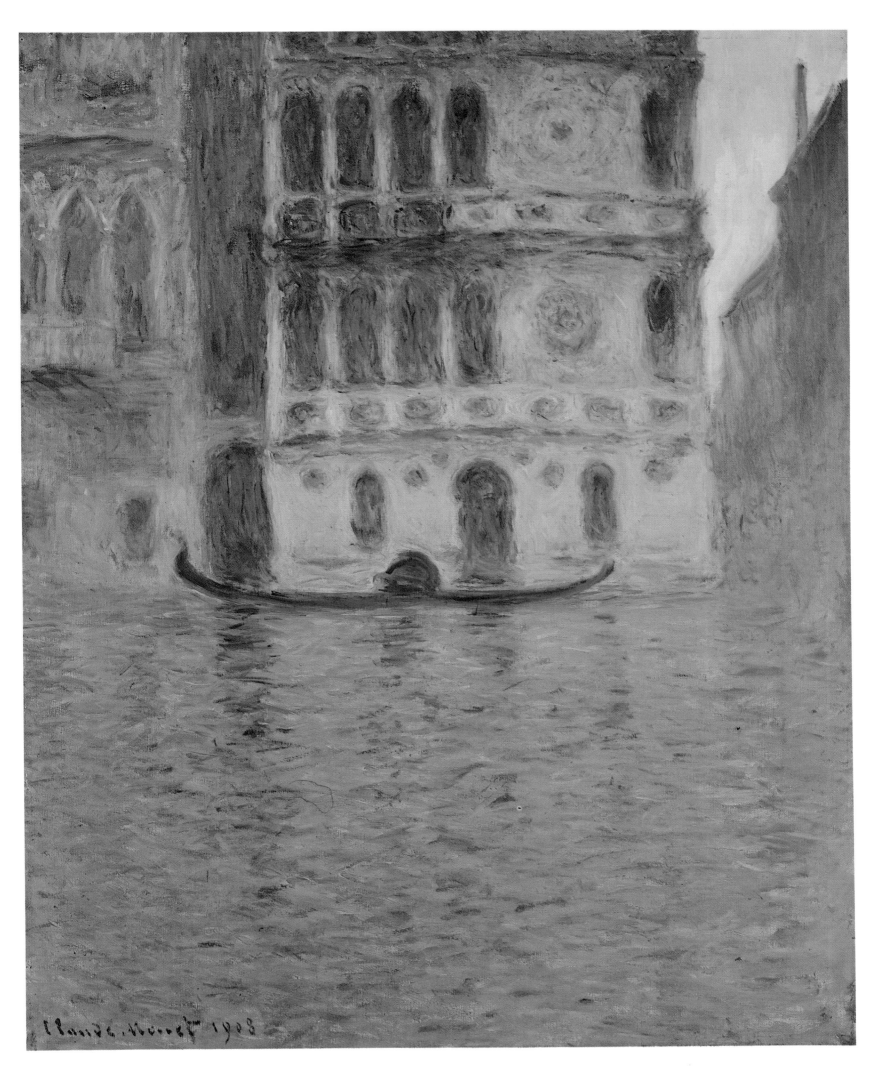

The Dario Palace, Venice 1908
Oil on canvas
36¼×28¾in (92×73cm)
National Museum of Wales, Cardiff

The Grand Canal, Venice 1908
Oil on canvas
29×36½in (73.5×92.5cm)
Museum of Fine Arts, Boston

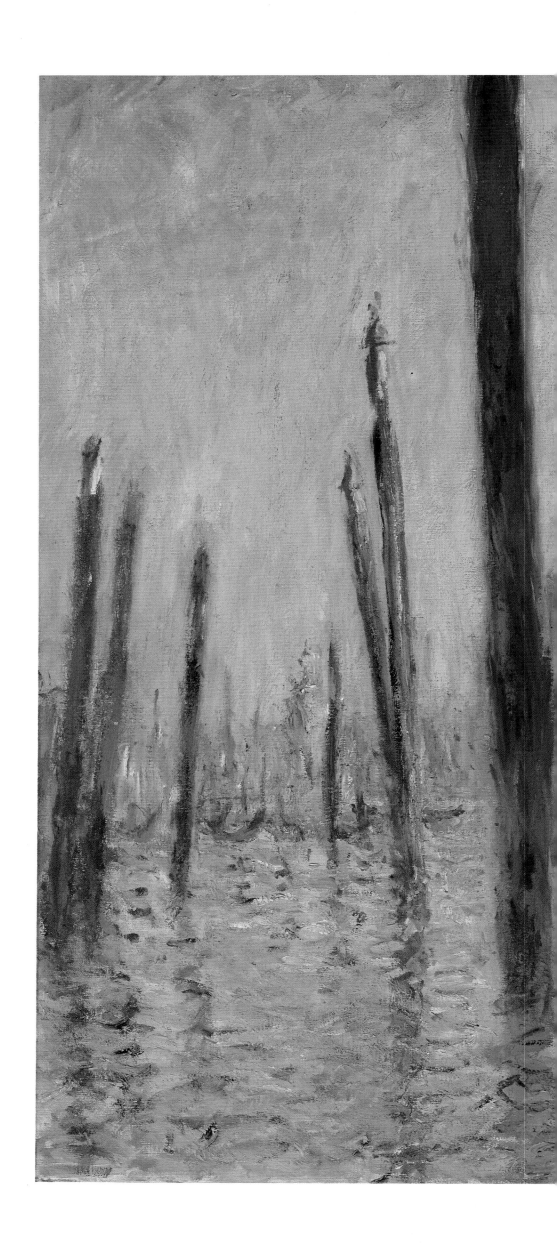

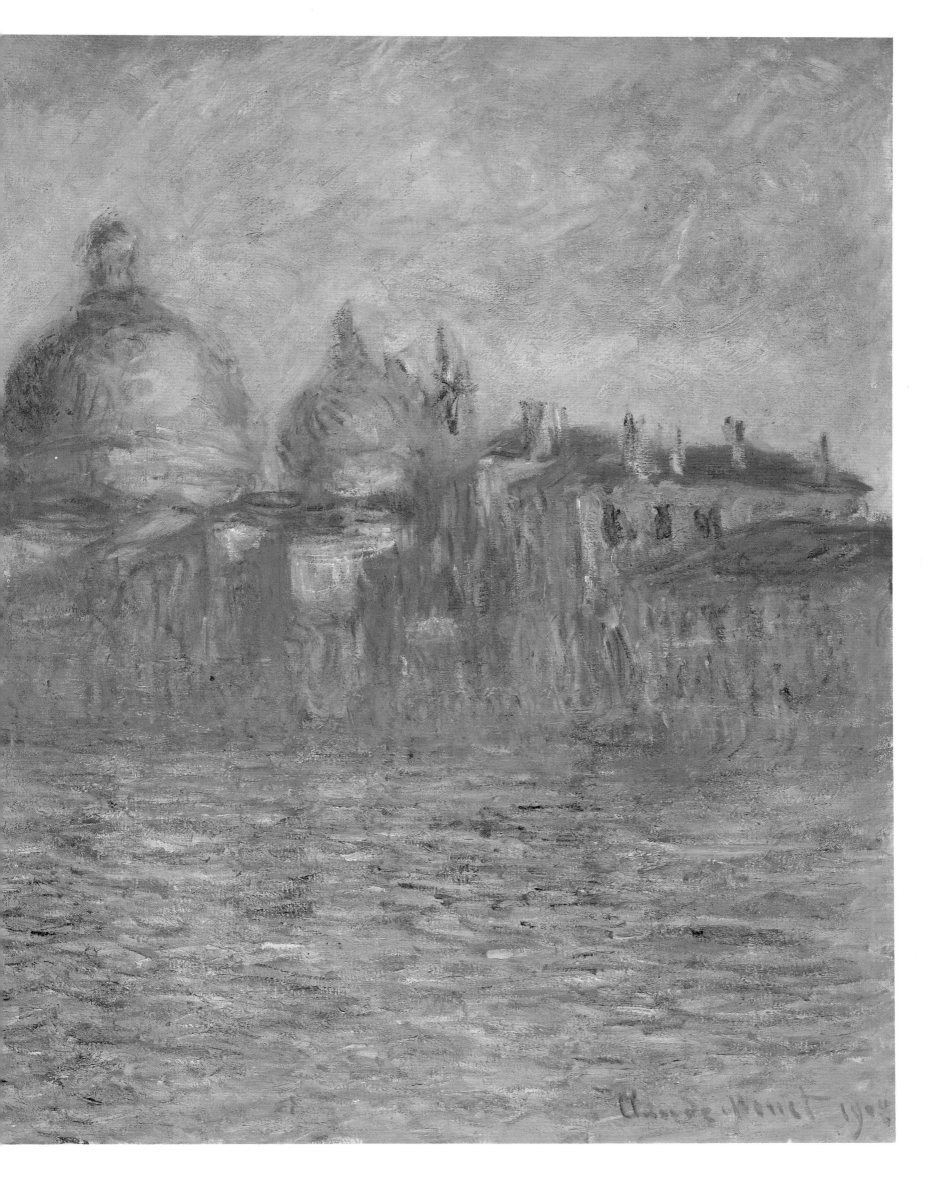

The Garden at Giverny

With the opening of the Monet museum at Giverny it has become possible to visit the artist's house and the gardens that formed the basis of his work during the final three decades of his life. Here he found an environment totally suited to his own aesthetic needs; a carefully contrived domain over which he had almost total control. He no longer had to travel to seek the effects and forms he sought in the world outside; all he needed was bound by the limits of his property. Except for the paintings of London that he exhibited in 1904 and those of Venice which were exhibited in 1912, his gardens became the sole source of his inspiration.

In 1901 Monet enlarged the garden so that its oval pond, spanned by the Japanese bridge stretched sixty yards (55 meters) from end to end and measured about 20 yards (18 meters) across its widest point. It was created on a piece of land separated from the house by a road and a single-track railway line. The pool is surrounded by a path and flanked by the brook known as the Ru, which runs into the Epte which in turn is a tributary of the Seine. His paintings of the pond became increasingly exciting as he directed his formidable gifts to an ever more penetrating examination of the reflected qualities of its surface.

The garden is smaller in reality than one might imagine from looking at the paintings. This is surprising until one realizes just how cunningly Monet designed his paintings to give little sense of the garden's size or even its general layout. A visit to Giverny gives the viewer the opportunity to appreciate the complexities of Monet's achievement and the sophisticated manner in which he gave shape to his paintings. The distance between present-day viewers' visual perceptions of the garden and the physical actuality of Monet's paintings may be appreciated in Georges Clemenceau's sympathetic account:

Like everyone else, I have noticed that at the distance at which Monet must place himself in order to paint, the onlooker can only perceive a tempest of wildly brewed colors on the canvas. A few steps back and then, on the same panel, nature is miraculously recomposed and organized through the inextricable jumble of multicolored blobs which disconcert us at first glance. A marvellous symphony of tones succeeds this undergrowth of tangled colors.

How was Monet, who did not move around, able to capture from the same vantage point, the decomposition and recomposition of those tones which enabled him to obtain the desired effect?

One of the keys to Monet's vision was his responsiveness to the atmosphere that envelops objects. Monet has been quoted as having said: 'I want to paint the air in which are situated the bridge, the house, the boat. The beauty of the air where they are . . . and it is nothing other than impossible.'

The various paintings of Giverny have very different aims and may be organized into a number of recognizable groups. His initial interest in the gardens as a motif culminated in 16 finished canvases, 12 of which were exhibited at Durand-Ruel's gallery in 1900.

These were comparatively straightforward studies of the pond and its environs, clothed in its local color and lacking the distinctive atmospheric wrap that is associated with the slightly earlier *Matinées sur la Seine* series of 1897.

His second exhibition of water-lily paintings took place in a single room at Durand-Ruel's gallery in May to June 1909. The hanging of the pictures was directly supervised by Monet as a sequence of 48 canvases, and was entitled *Les Nymphéas, Paysages d'eau*, and painted between 1903 and 1908. These paintings were very different from those shown in the previous exhibition; the lily-strewn surface of the water covered the entire surface of the canvas, and reference to the surrounding vegetation was confined to the branches hanging down to the water or to what could be seen reflected upon its surface. This exclusion of the surrounding banks may have been suggested by the high vantage point of the Japanese bridge and the proximity of the pathway to the water. His habit of painting from his boats would also have suggested similar novel compositional ideas. Thanks to the various donations to the Musée Marmottan, it is possible to study the evolution of these paintings from the initial lay in, through to the gradual encrustation of the entire paint surface. His usual procedure was to begin by blocking in major areas of tonal contrast to establish the foundation of the painting and then to work in rich accents of color until it achieved a particular color harmony. When examined in a gallery it is often possible to perceive the degree to which Monet has retouched or reworked the paintings over a period of time. John House has made the point that as water lilies only flower from May to the end of September, much of the actual painting of these works could only have been done from memory and recourse to his other paintings, which he liked to keep around him in his studio as constant means of reference. The immense difficulty of the project took its toll on the artist and it is known that on at least two occasions during this period he destroyed a number of these canvases, unsure as to whether they lived up to his own high expectations.

The complex possibilities of his chosen motif are best described by Monet himself. In the *Revue de l'art* published in July 1927 Thiébault-Sisson quoted the painter as saying:

I have painted these water lilies many times, modifying my viewpoint each time in accordance with the season and the different light effects each season brings. Besides, the effects vary constantly, not only from one season to the next, but from one minute to the next, since the water flowers are far from being the whole scene; really they are just the accompaniment. The essence of the motif is the mirror of water whose appearance alters at every moment, thanks to the patches of sky which are reflected in it, and which give it its light and its movement. The passing cloud, the freshening breeze, the storm which threatens and breaks, the wind which blows hard and suddenly abates, the light growing dim and then bright again – so many factors, undetectable to the uninitiated eye, which transform the coloring and disturb the planes of the water.

We can follow his attempts to paint a single moment in a work like his 1890 version of *The Cloud* and compare it with the much more generalized *Nymphéas* decorations at the Orangerie. Despite his specific titles his later works referred less to a particular moment of time but, rather like Debussy's music, were conceived as evocations of mood; decorations made for contemplation, away from the hustle and bustle of the outside world.

The works for the *Orangerie* were begun between 1914 and 1916 in the large studio that had been specially constructed for the purpose. Their composition puts the viewer into direct confrontation with the surface of the water. Monet has completely abandoned the traditional idea of the picture being a window through which we see the world. The conventions of spatial recession, common in Western art since the Renaissance, have been replaced with a new, wholly original way of ordering experience. No neat horizontal line separates the land from the sky and no tricks of perspective direct the eye to significant areas. Instead Monet has presented an open space in which no one area dominates another; the viewer is allowed freedom to move easily about the painting focussing on details at will.

Like the conductor of an orchestra, Monet maintained order and control over this great enterprise without losing any freshness of touch or clarity of expression. The trace of his brush as it moved across the canvas is recorded in a series of calligraphic marks which form an intricate weave of color and light across the surface of the paintings.

At the same time that he was working on the decorations for the Orangerie, Monet also produced canvases featuring other views of his garden. Popular appreciation of these works was a relatively slow affair, and many remained in private hands until the early 1950s when they were eagerly received by the new generation of young American artists associated with Abstract Expressionism. Even as we reach the last decades of the twentieth century, these paintings, in their paradoxical combination of raw energy and baroque splendor, must make many of the *enfants terribles* of modern painting look to their laurels. Without reference to the title the starting point of some of these works is sometimes difficult to decipher, as in the paintings of the *Willows,* for example, which almost disappear in a torrent of swirling brushmarks. Monet's late paintings represent the forces that give form to natural phenomena and not merely the shell of their outer appearance. Paintings that belong to this category include a number of lyrical and turbulent interpretations of the garden, its trellises and the famous Japanese bridge. These paintings have an almost nightmarish sense of desperation and contained energy.

Forms emerge from swirls of paint loosely laced together in a free-wheeling system of gestural marks. Some have the hot colors of wounded flesh, others the subtle medley of cool colors one associates with the sea. They share the same passionate identification with the creative act that is often found in the paintings of Jackson Pollock. Their work, so different in many respects, shares a concern for the qualities of growth and movement that animate the natural world.

Much has been made of Monet's eyesight problems during this period and it is certain that to some degree his disabilities did affect his working practices and consequently, the final form of his pictures. Eye defects in artists have been used to explain the idiosyncrasies of their styles ever since the supposed astigmatism of El Greco. However, one has only to scan through this book to realize how the later paintings may be seen as developing from his earlier work. The subjects of these late works are objects seen in constant movement, the tremulous flickering of vegetation seen reflected on the ever-moving surface of a pond, or the delicate network of branches through which the corner of his house may be glimpsed. The structure of these paintings holds the often tortuous rhythms of paint in place, echoing the natural geometry that gives order to even the most disorderly of natural phenomena. As Monet grew older, his brushmarks, the modular elements that build up the physical substance of the painting, became elongated, swooping, swirling and knotting together. In works such as the Marmottan sketches which were left unfinished, the analogy with knitting or with any other weave process becomes inevitable. This process links the diverse elements of reality into one almost inpenetrable mass and makes it clear that Monet was an artist of great expressive power. He was not concerned with the uniqueness of the individual elements that make up the world, but with those things that give a sense of harmony and unity to experience: light; the envelope of the surrounding atmosphere; and, of course, sight itself which links everything together into one visual field.

A painting gives an immediate impact to the viewer. The image, the pigment, and the canvas carry the weight of meaning. Like Degas and Cézanne, Monet knew that reality is a fugitive affair and that it is in the final analysis, unpaintable. All that the artist can do is to make signs or symbols of their experience of reality by means of their art. Painting is a highly artificial act or, more exactly, series of acts that record an individual's response to a given situation. It is difficult, therefore, for a painting to record a split second of visual experience in the way that a camera may, and in any case that is not how we ourselves experience the world. A painting takes time to create and each time a mark is made, the artist needs to take his or her eyes off the motif to look at the canvas to guide the brush which by necessity has now to be led by the artist's memory of what has just been seen. So the painting is in itself the product of a series of separate moments of time marked by each separate movement of the brush. Monet's paintings of the water lilies are not the record of a single instant but rather a layering of separate moments each woven into a work of art that exists, and is in its turn experienced through time. Either taken individually or considered as a whole, Monet's work embodies the infinite richness of the world and ineffable mystery of our attempts to express our relationship with it.

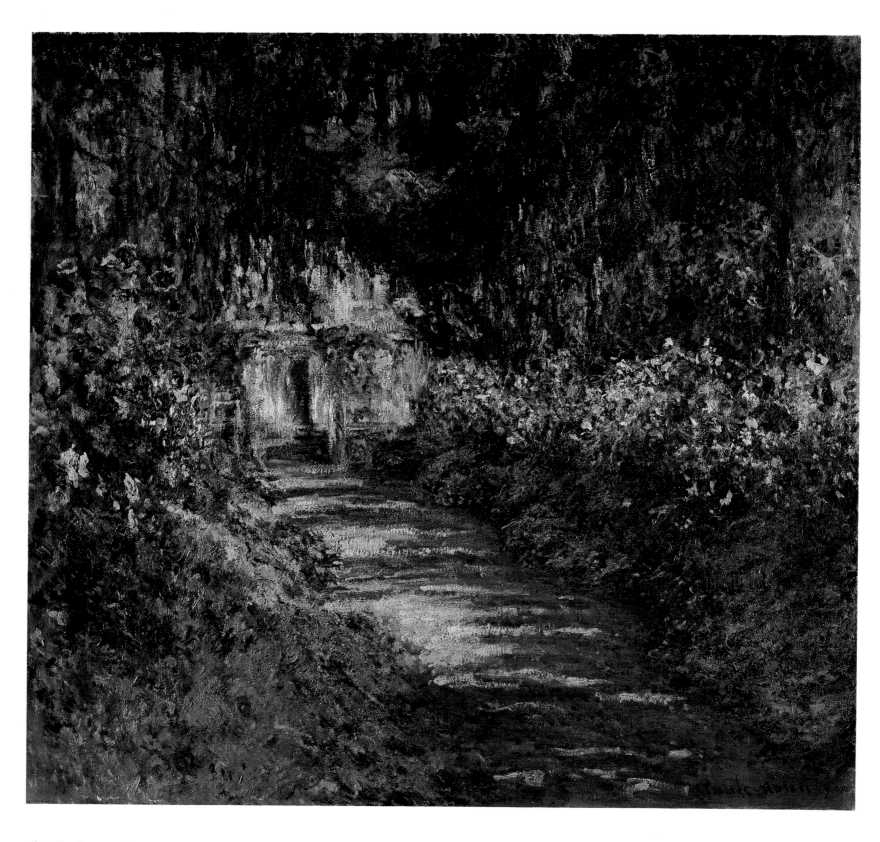

The Garden in Flower 1900
Oil on canvas
35×36¼in (89×92cm)
Private Collection

Pathway in Monet's Garden 1902
Oil on canvas
35×36¼in (89×92cm)
Österreichische Galerie, Vienna

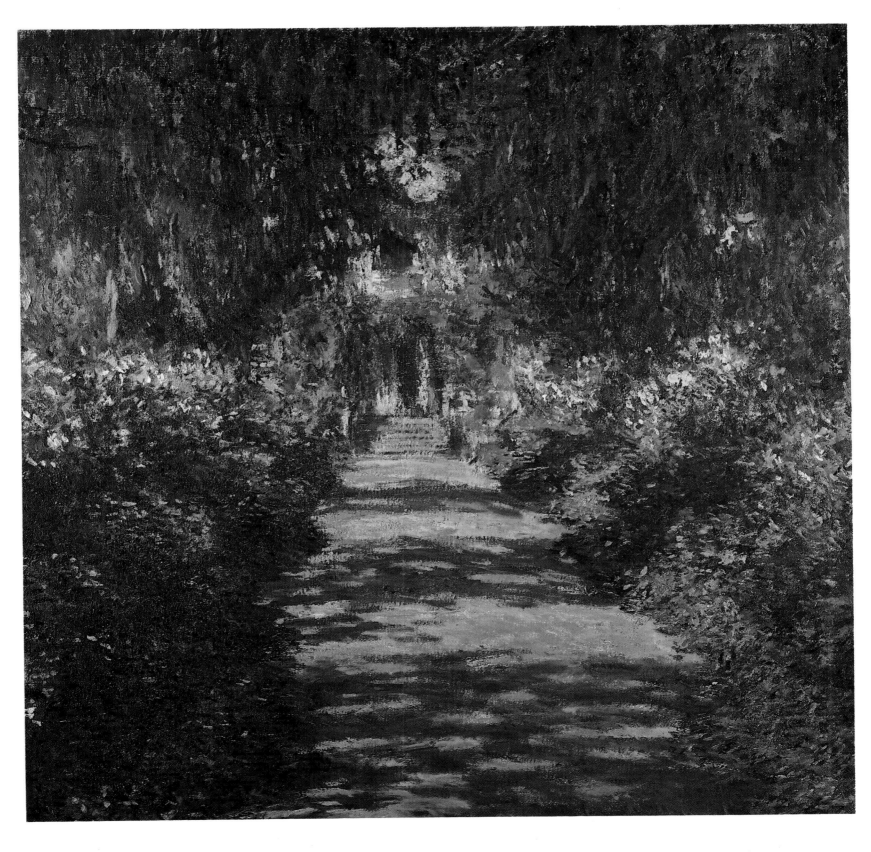

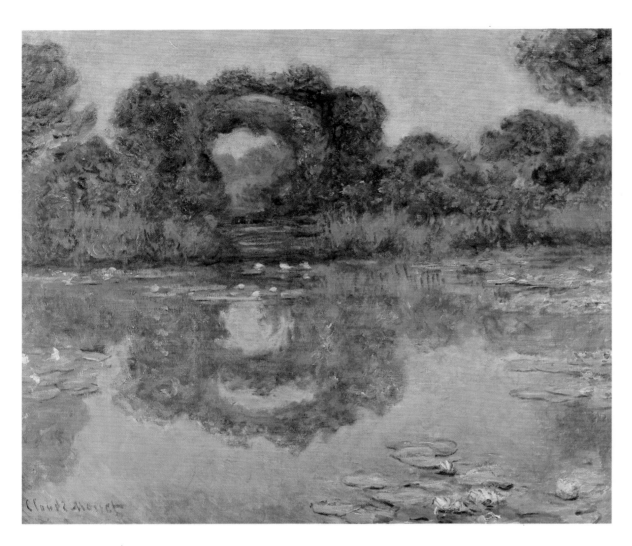

The Flowering Arches 1912-13
Oil on canvas
31¾×36¼in (80.9×92.4cm)
Phoenix Art Museum, Phoenix, Arizona

Right:
***The Japanese Bridge (Le Bassin aux
Nymphéas)*** 1899
Oil on canvas
34¾×36¼in (88.2×92cm)
The National Gallery, London

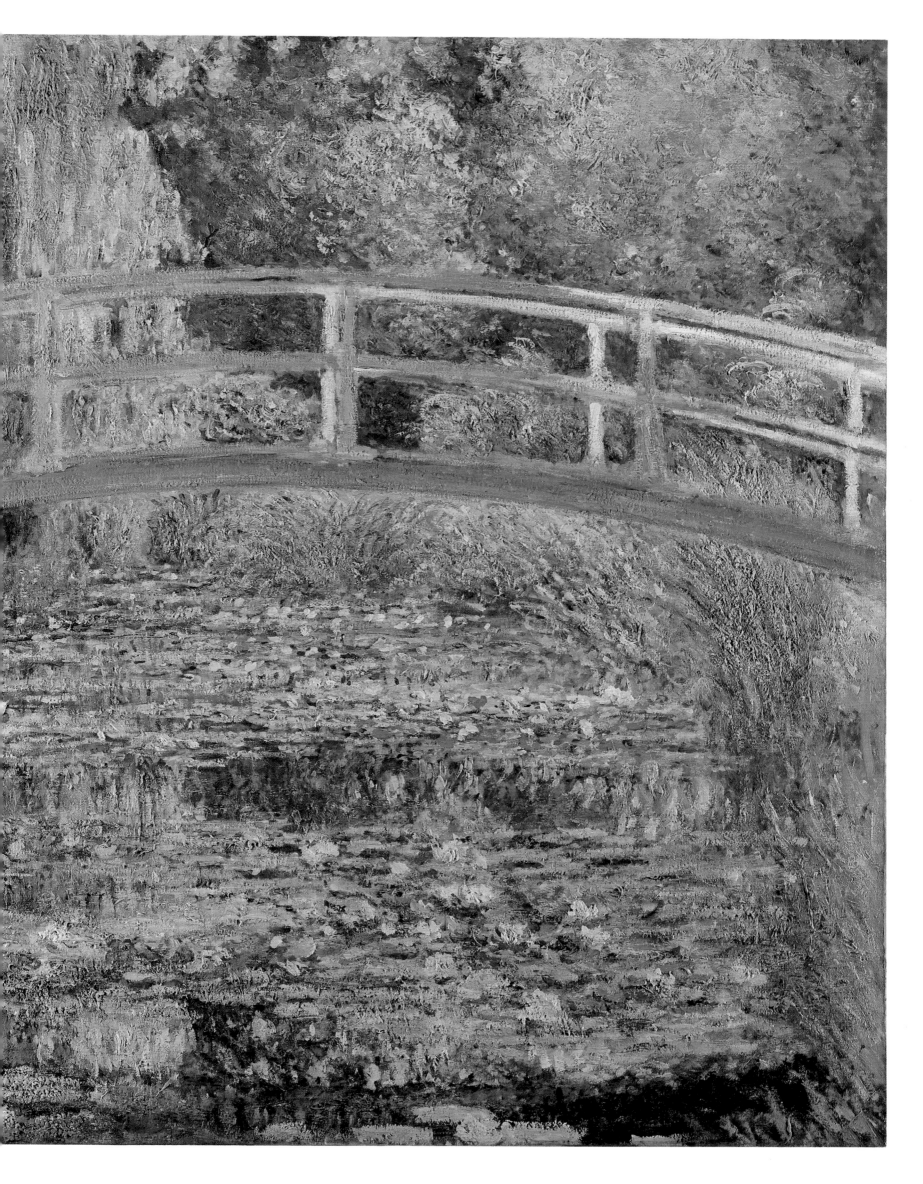

The Japanese Bridge c. 1922
Oil on canvas
35×45¾in (89×116cm)
The Minneapolis Institute of Arts

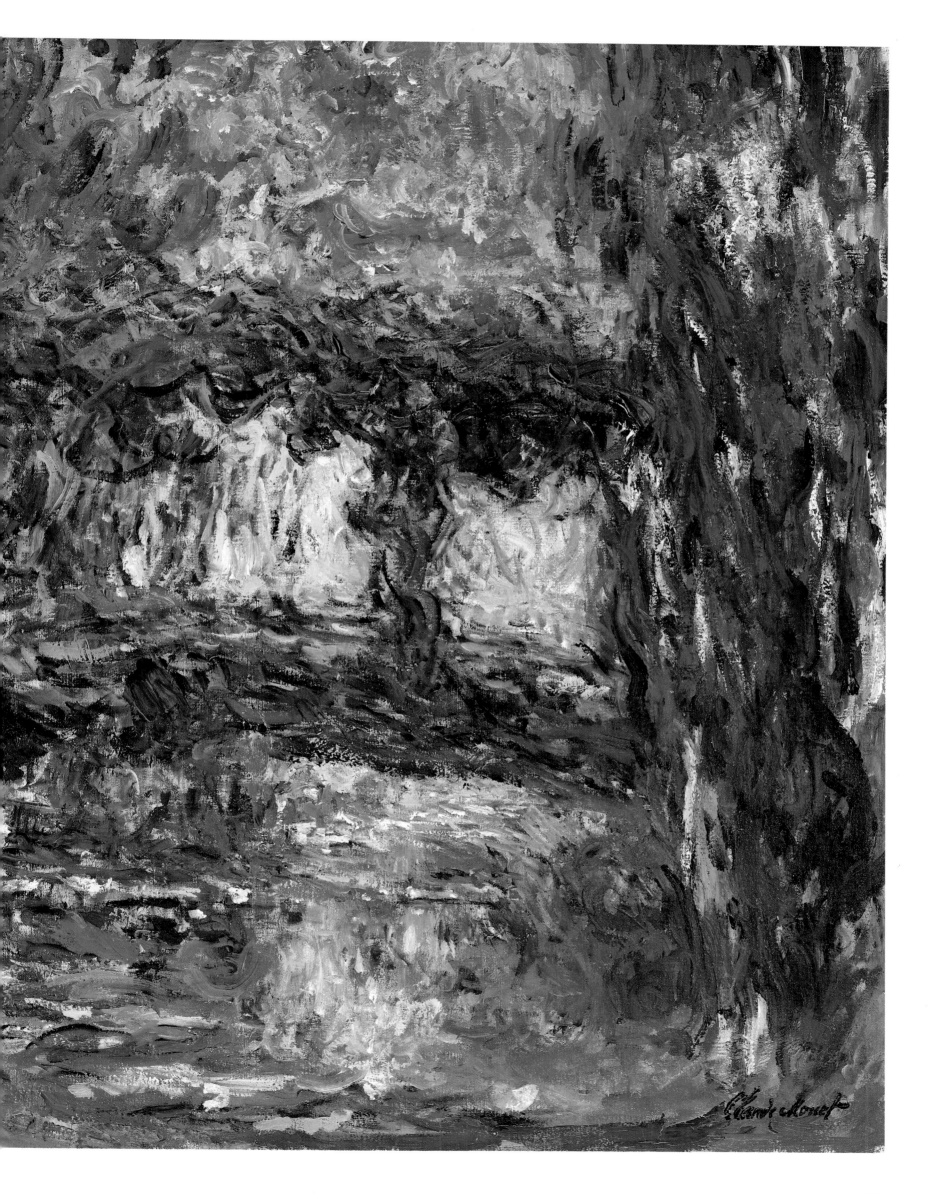

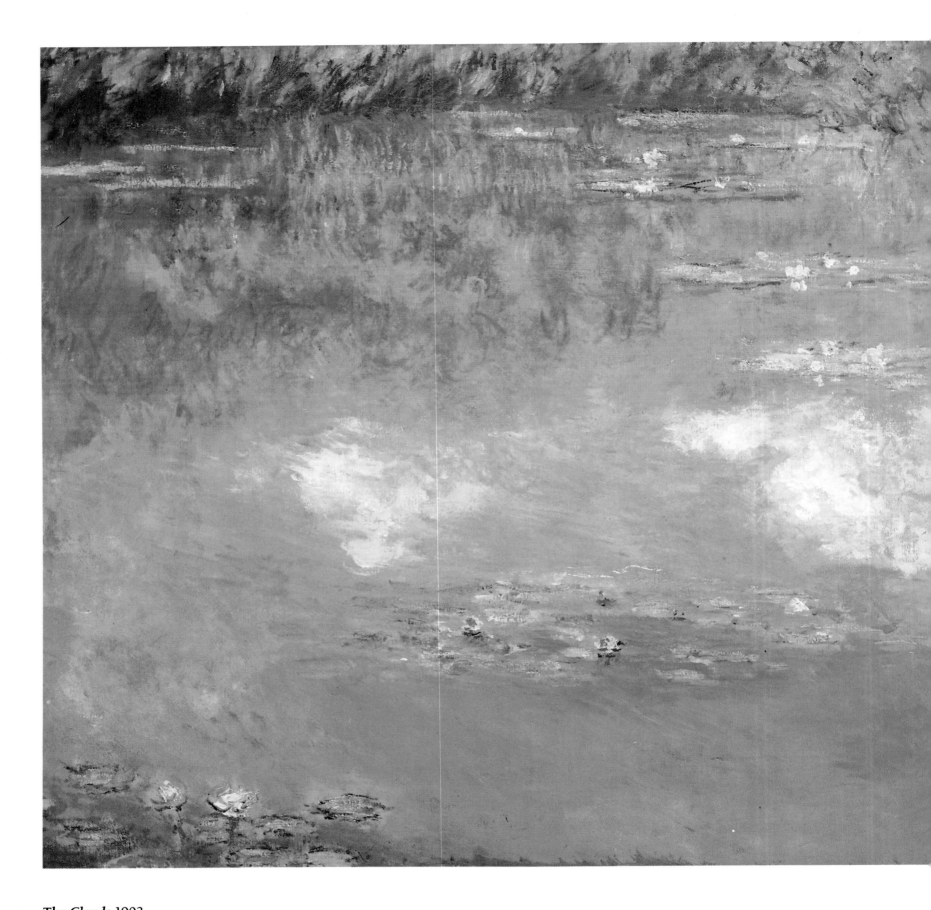

The Clouds 1903
Oil on canvas
23¾×39¼in (73×100cm)
Private Collection

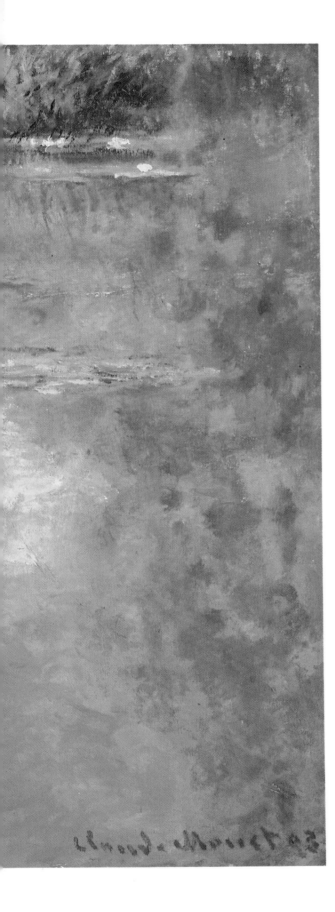

Waterlilies 1904
Oil on canvas
35½×35¾in (90×92cm)
Musée des Beaux-Arts, Caen

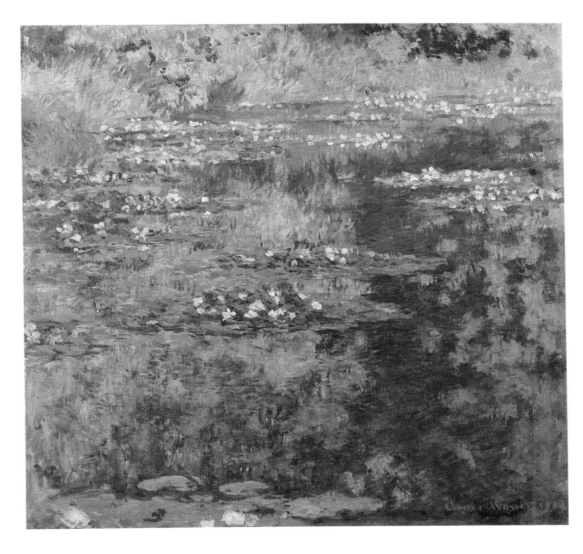

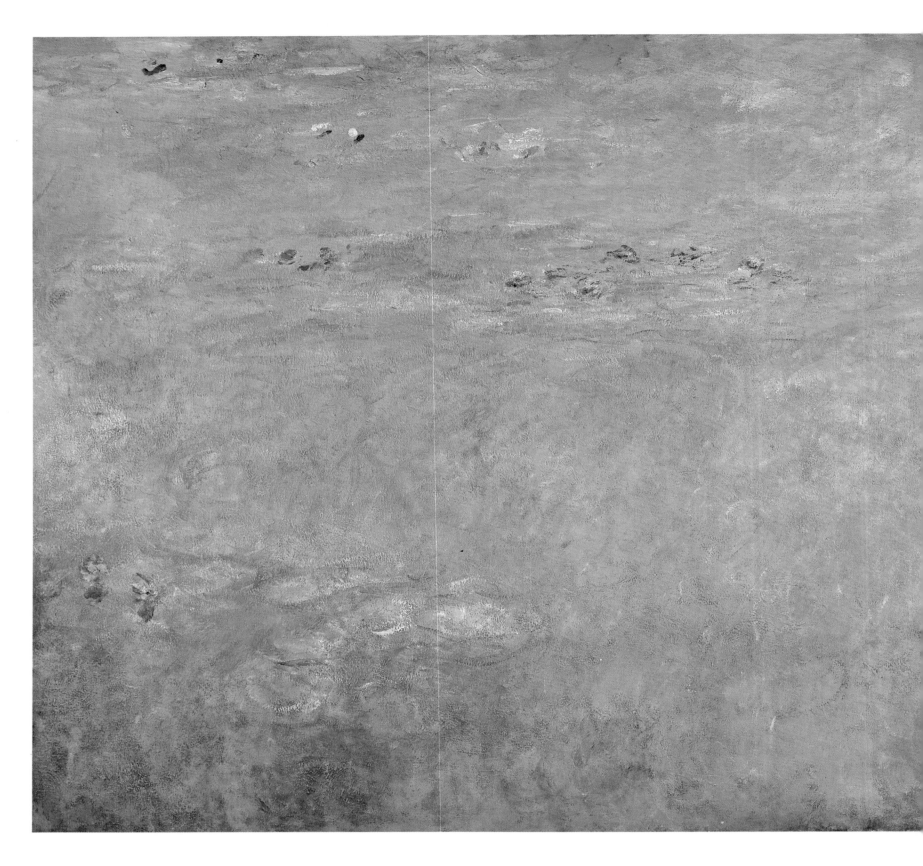

Waterlilies 1916
Oil on canvas
78¾×168in (200.7×426.7cm)
The National Gallery, London

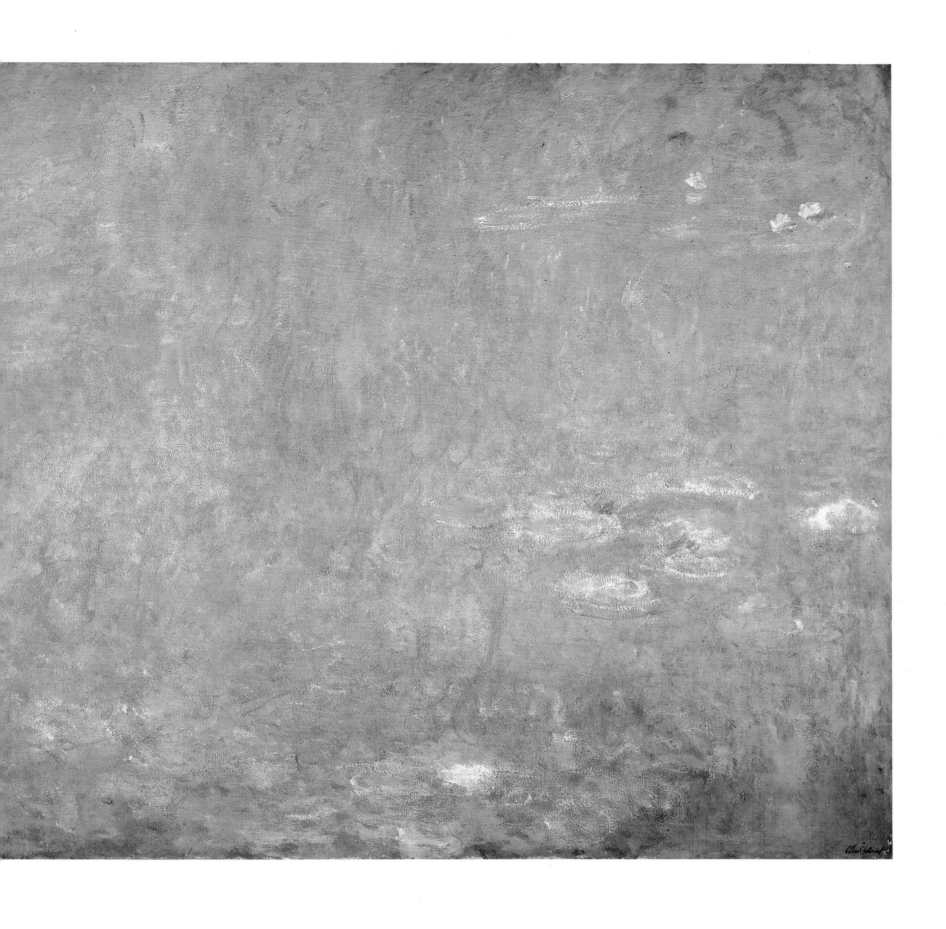

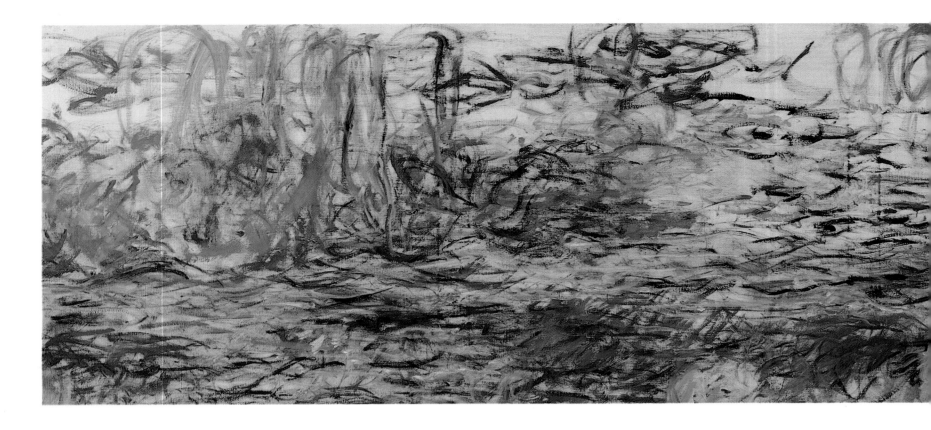

Above:
Waterlilies c. 1920
Oil on canvas
51¼×78¾in (130×200cm)
Musée Marmottan, Paris

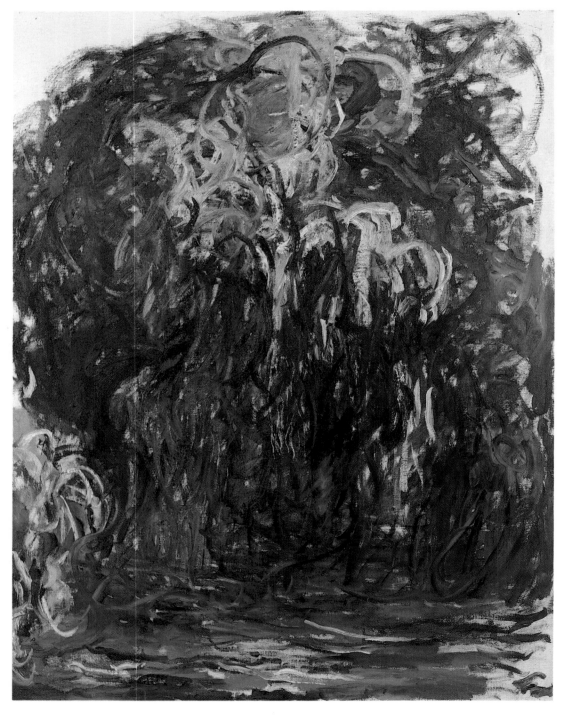

Left:
Weeping Willow 1920-22
Oil on canvas
45¾×35in (116×89cm)
Musée Marmottan, Paris

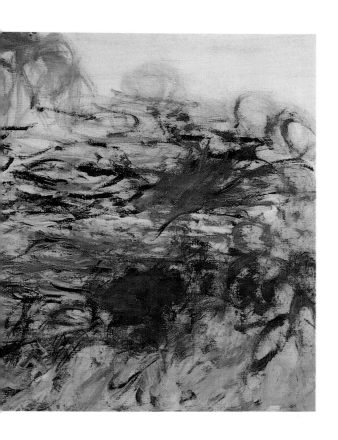

The Path with Rose Trellis c. 1922
Oil on canvas
35¼×36¼in (90×92cm)
Musée Marmottan, Paris

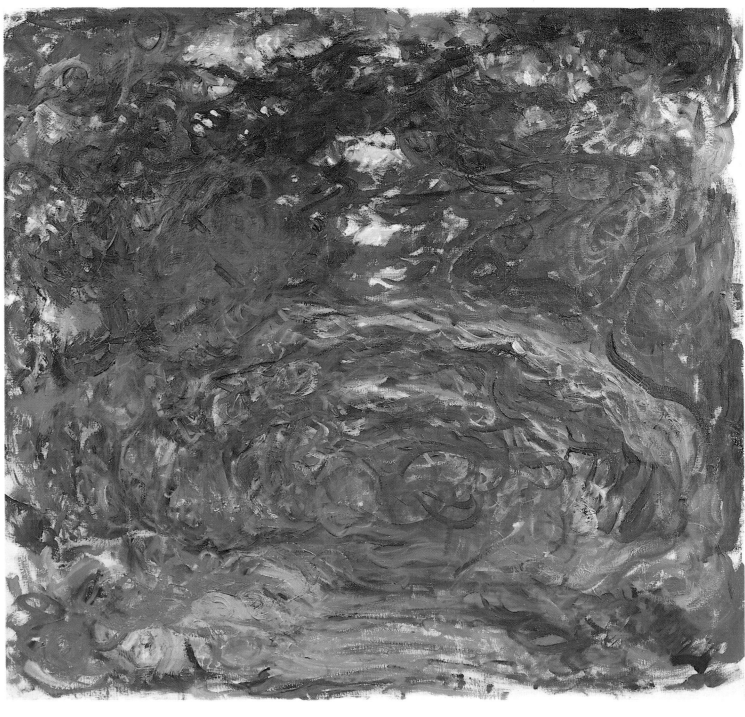

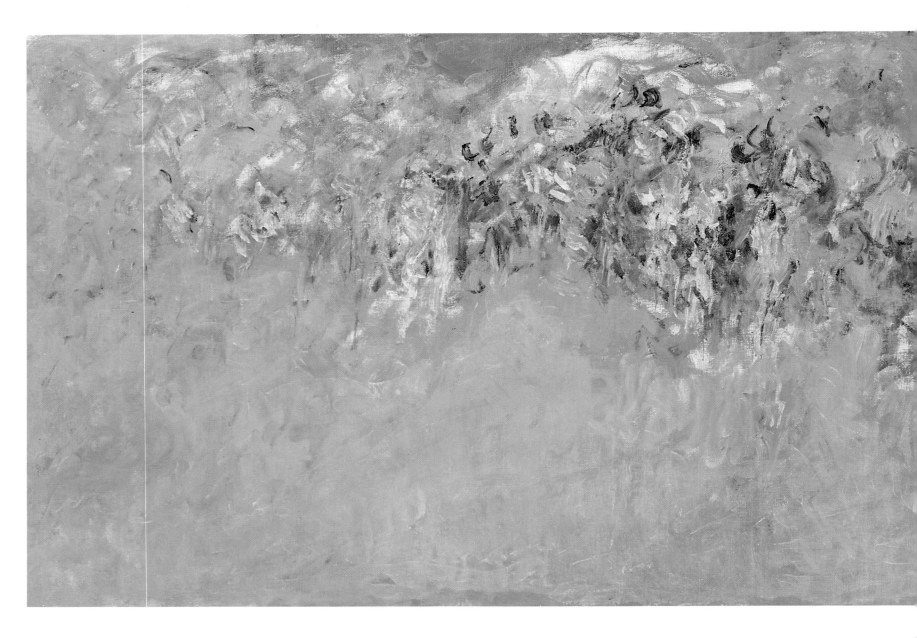

Wisteria c. 1920
Oil on canvas
39¼×118in (100×300cm)
Musée Marmottan, Paris

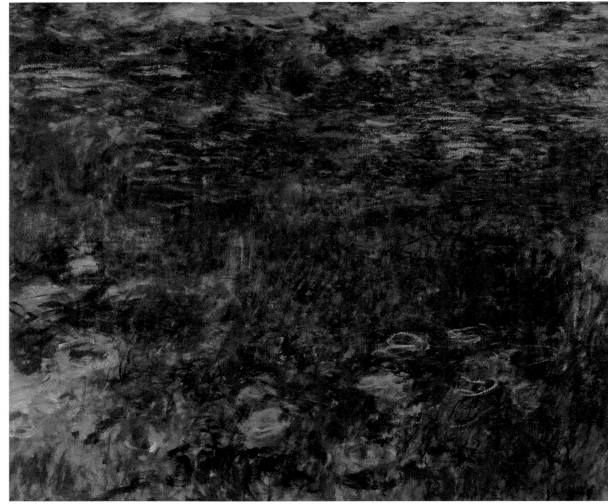

Right:
Clouds (detail) c. 1914-18
Oil on canvas
78¾×167½in (200×425cm)
Musée de l'Orangerie, Paris

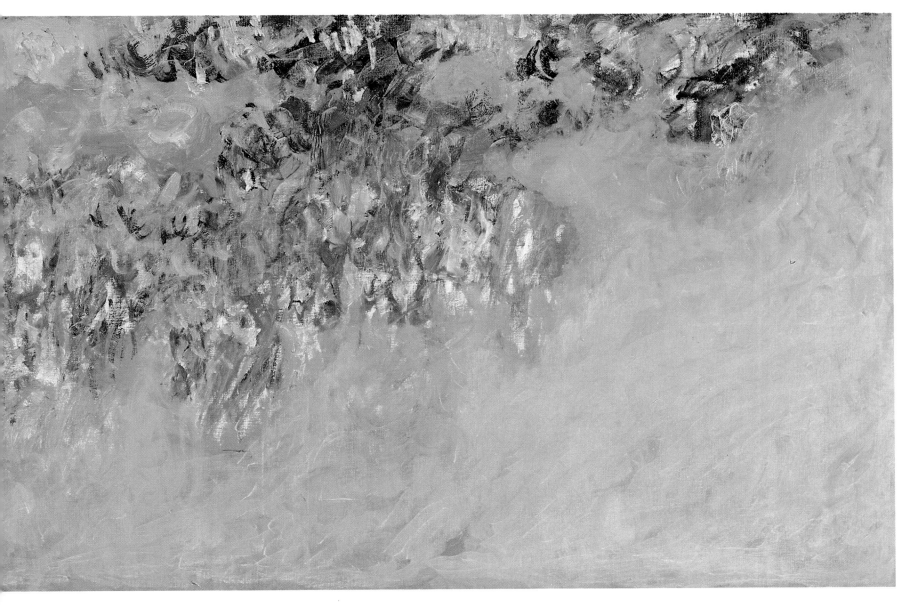

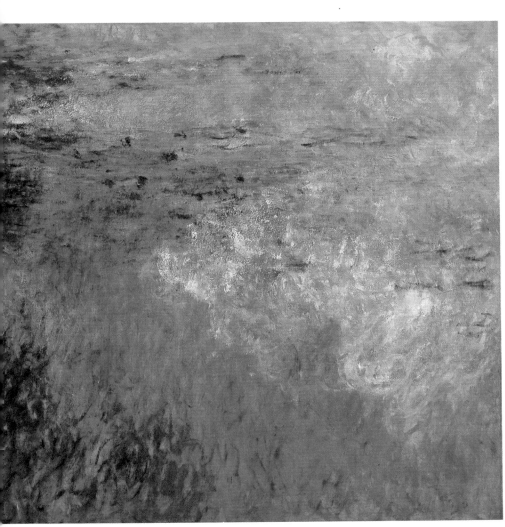

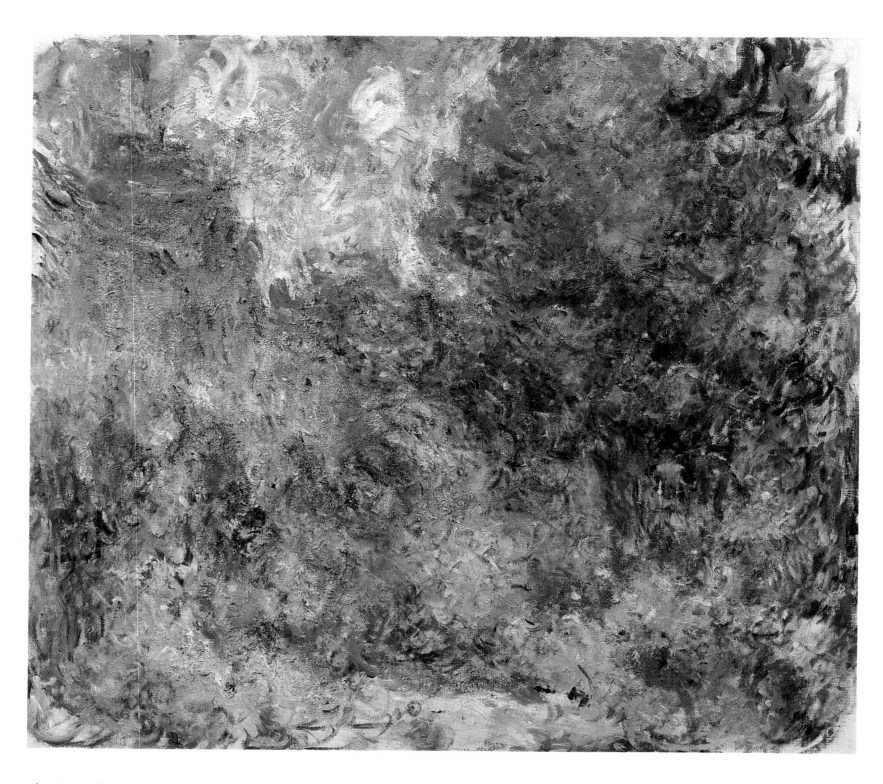

The House from the Garden c. 1922
Oil on canvas
35¼×34½in (89×100cm)
Musée Marmottan, Paris

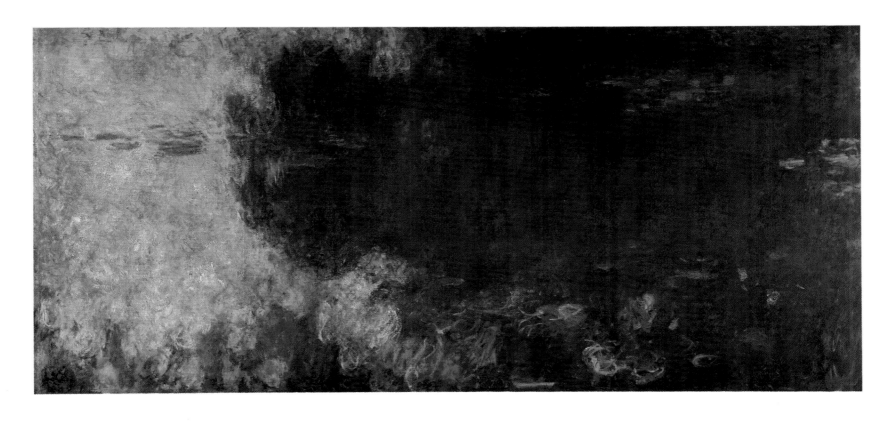

Clouds (detail) c. 1914-18
Oil on canvas
78¾×167½in (200×425cm)
Musée de l'Orangerie, Paris

Weeping Willow, Morning Effect (detail)
1914-18
Oil on canvas
78¾×167½in (200×425cm)
Musée de l'Orangerie, Paris

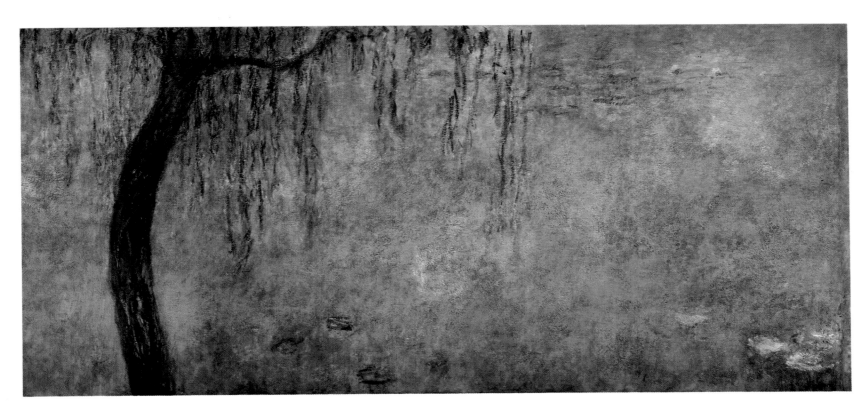

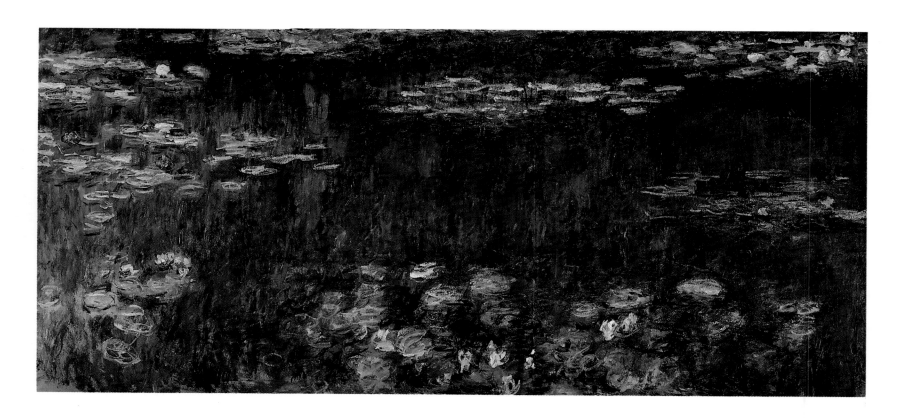

Green Reflection (detail) c. 1916-26
Oil on canvas
78¾×335in (200×850cm) whole width
Musée de l'Orangerie, Paris

Right:
Green Reflection (detail) c. 1916-26
Oil on canvas
78¾×335in (200×850cm)
Musée de l'Orangerie, Paris

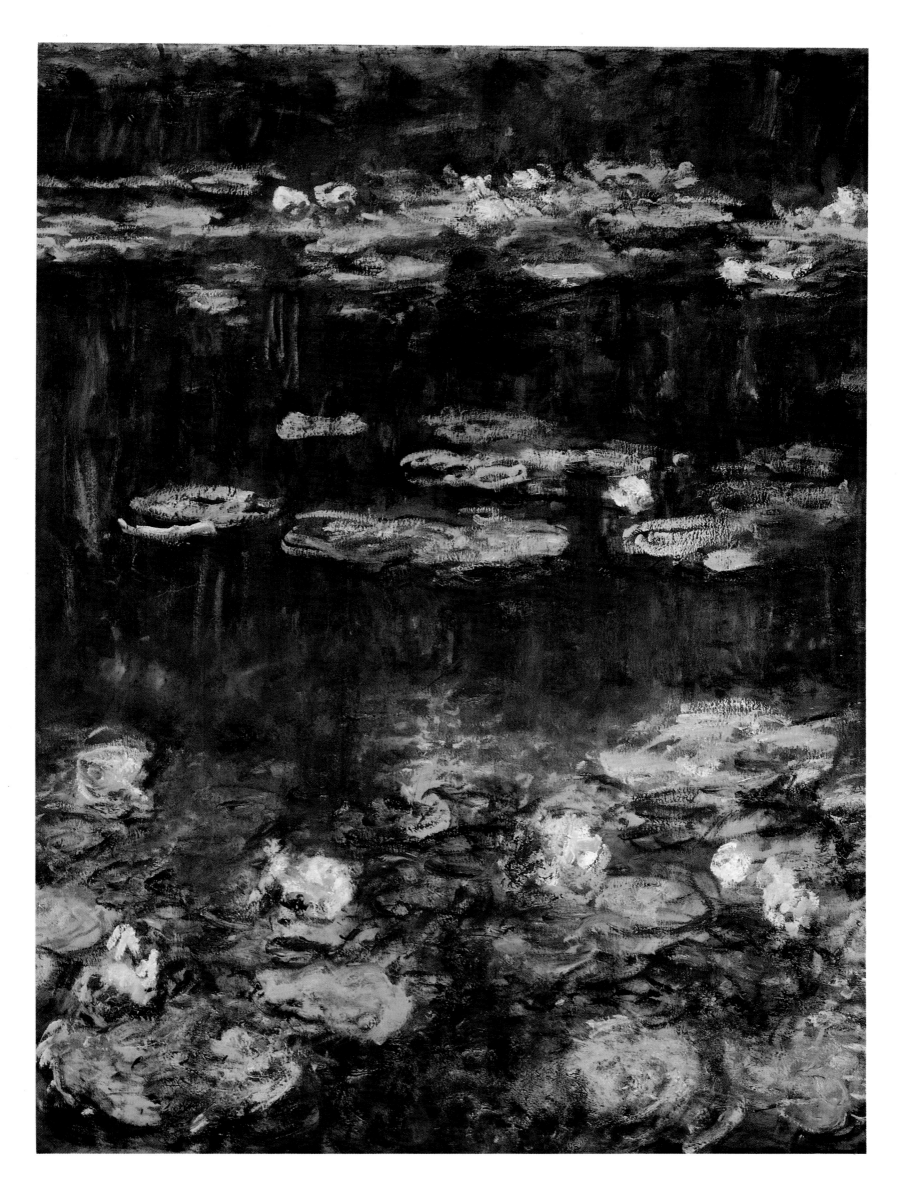

Acknowledgments

The publisher would like to thank Martin Bristow who designed the book; Moira Dykes, the picture researcher; and Aileen Reid, the editor. The author would also like to thank Richard Kendall and Richard and Belinda Thomson for their kind support during the writing of this book, and the ever-helpful staff of Manchester Polytechnic Library. We would also like to thank the following institutions, agencies, and individuals for permission to reproduce the illustrations:

Allen Memorial Art Museum, Oberlin College: page 45 (R T Miller Fund)
The Art Institute of Chicago: page 161 (Gift of Bruce Borland), page 50 (Mr and Mrs Lewis Larned Coburn Memorial Collection), pages 52-53 (Potter Palmer Collection), pages 82-83 (Mr and Mrs Martin A Ryerson Collection), page 7(top) (Louise B and Frank H Woods Purchase Fund)
The Barber Institute of Fine Arts, The University of Birmingham: pages 130-31
Calouste Gulbenkian Foundation Museum, Lisbon: pages 76-77
The Cleveland Museum of Art: page 65 (Bequest of Leonard C Hanna Jr)
Courtauld Institute Galleries (Courtauld Collection): pages 86-87
Dallas Museum of Art: pages 78-79 (The Wendy and Emery Reeves Collection)
Document Archives Durand-Ruel: pages 28(top), 31; /Photo Routhier: page 110; /Weidenfeld Archive: page 26(top)
Documentation Photographique de la Réunion des Musées Nationaux: pages 30, 31(top)
Fitzwilliam Museum, Cambridge: pages 80-81, 155
Founders Society, Detroit Institute of Arts: pages 108-09
The Frick Collection, New York: page 13(below)
Collection Haagsgemeentemuseum, The Hague: pages 48-49, 128-29
Courtesy of The Harvard University Art Museums, Fogg Art Museum: pages 56-57 (Gift of Mr & Mrs Joseph Pulitzer Jr)
Hermitage Museum, Leningrad/SCALA, Florence: page 44
The Hulton Picture Company: pages 9(below), 12(top), 13(top), 22(below), 24, 25
The Illustrated London News Picture Library: page 8(top)

Kimbell Art Museum, Fort Worth, Texas: page 36
Kunsthalle, Bremen: page 42
Kunsthaus Zürich, Vereinigung Zurcher Kunstfreunde: page 125
The Metropolitan Museum of Art, New York: page 137 (Bequest of Lizzie P Bliss, 1931), pages 14, 37, 63, 122, 156, 160-61 (Bequest of Mrs H O Havemeyer, 1929, The Havemeyer Collection), pages 2-3, 47 (Bequest of William Church Osborn, 1951)
The Minneapolis Institute of Arts: pages 178-79 (Bequest of Putnam Dana McMillan)
Musée des Beaux-Arts, Caen: pages 1, 181
Musée des Beaux-Arts, Lyon: pages 126-27
Musée des Beaux-Arts, Cliché Ville de Nantes: page 168
Musée Eugène Boudin, Honfleur: pages 6, 15, 139
Musée Marmottan, Paris/Photo Routhier: pages 7(below), 92-93, 104-05, 114-15, 144, 148-49, 159, 167, 184-85, 186-87(top), 188
Musée de l'Orangerie/Photo RMN: pages 186-87(below), 189(both), 190, 191
Musée d'Orsay, Paris/Photo Réunion des Musées Nationaux: pages 8(below), 9(top), 11, 34, 43, 55, 58-59, 60-61, 64, 66, 72-73, 84-85, 88-89, 96-97, 98-99, 106, 107, 112-13, 116, 117, 121, 138, 142-143, 146-47, 158./ET Archive: page 111, /Roger Viollet: page 41
Musée d'Unterlinden, Colmar: page 150
Musées Royaux des Beaux-Arts de Belgique: page 10(below)
Museum of Fine Arts, Boston: pages 170-71 (Bequest of Alexander Cochrane), page 152 (Julia Cheney Edwards Collection), pages 134-35, 145 (Bequest of Robert J Edwards and gift of Hannah Mary Edwards and Grace M Edwards in memory of their mother), pages 162-63 (Gift of Mrs W Scott Fitz), pages 150-51 (Gift of the Misses Aimee & Rosamond Lamb in Memory of Mr & Mrs Horatio A Lamb), pages 90-91 (Ross Collection, Gift of Denman W Ross), page 21 (Gift of Quincy Adams Shaw through Quincy A Shaw Jr and Mrs Marion Shaw Haughton), page 30 (Bequest of John T Spaulding), page 157 (Tompkins Collection, Purchased by Arthur Gordon Tompkins Residuary Fund), page 109 (1951 Purchase Fund)
The National Gallery, London, Reproduced by courtesy of the Trustees: pages 62, 67, 70-71, 177, 182-83

The National Gallery of Art, Washington: pages 46, 103 (Collection of Mr & Mrs Paul Mellon), pages 100-01, 123 (Ailsa Mellon Bruce Collection), page 23 (Parke-Bernet, Sale 2678, lot 50)
National Gallery of Ireland, Dublin: page 86
National Gallery of Scotland, Edinburgh: pages 153, 154
National Museum of Wales, Cardiff: page 169
The Nelson-Atkins Museum of Art, Kansas City, Missouri: page 94 (Acquired through the Kenneth A and Helen F Spencer Foundation Acquisition Fund),
Neuchâtel, Musée d'Art et d'Histoire: page 102
Neue Pinakothek, Munich/ARTOTHEK: page 17
Niedersächsisches Landesmuseum, Hannover: page 115
Offentliche Kunstsammlung, Basel/Colorphoto Hinz, Allschwill, Basel: page 164-65
The Ordrupgaard Collection, Copenhagen: page 38
Österreichische Galerie, Vienna: page 175
Phoenix Art Museum: page 176 (Gift of Mr & Mrs Donald D Harrington)
Private Collection/Acquavella Galleries, New York: page 166
Private Collection/Document Archives Durand-Ruel: page 39
Private Collection, USA: page 180
Private Collection, USA/Sotheby's, New York: page 174
Pushkin Museum, Moscow/SCALA, Florence: pages 19, 40, 95, 141
Shelburne Museum, Shelburne, Vermont: page 120
Städelsches Kunstinstitut, Frankfurt/ARTOTHEK: page 54
Sterling and Francine Clark Art Institute, Williamstown, Massachusetts: pages 51, 132-33
The Tate Gallery, London: page 18(top), 26(below)
Topham Picture Library: page 27, 29
Collection Viollet: pages 4, 28(below) /Photo Roger-Viollet: page 18 (below)
Wadsworth Atheneum, Hartford: page 16
Walsall Art Gallery: page 124
The Walters Art Gallery, Baltimore: page 74-75
The Weidenfeld Archive: page 10(top), 12(below), 22(top)